Hacking TiVo®

The Expansion, Enhancement, and Development Starter Kit

Hacking TiVo®

The Expansion, Enhancement, and Development Starter Kit

Jeff Keegan

WILEY

Wiley Publishing, Inc.

Hacking TiVo®: The Expansion, Enhancement, and Development Starter Kit

Published by
Wiley Publishing, Inc.
10475 Crosspoint Blvd.
Indianapolis, Indiana 46256
www.wiley.com

Published simultaneously in Canada

Library of Congress Cataloging-in-Publication Data:

ISBN: 0-7645-4336-9

Printed in the United States of America

10 9 8 7 6 5 4 3 2 1

For general information on our other products and services please contact our Customer Care Department within the United States at (800) 762-2974, outside the United States at (317) 572-3993 or fax (317) 572-4002.

Credits

Vice President and Executive Publisher:
Joe Wikert

Editor:
Chris Webb

Development Editor:
Adaobi Obi Tulton

Editorial Manager:
Kathryn Malm

Production Editor:
Angela Smith

Media Development Specialist:
Travis Silvers

Permissions Editor:
Laura Moss

Text Design & Composition:
Wiley Composition Services

Cover Designer:
Anthony Bunyan

I dedicate this book to my best friend in the whole wide world, Laurie.

Acknowledgments

I have many people to thank, and I do so here in no particular order except for the first: my wife Laurie. I am the luckiest man in the world, for Laurie is the sweetest, funniest, most wonderful person I've ever *dreamt* of and I get to tell her I love her every day. This book wouldn't exist if it were not for her unbelievable unending enthusiastic support, confidence in me, kindness, and love (let alone her detailed comments on every page of the book). Thank you Laurie, I love you!!!

To our daughter Emily, thank you for being so cute and loving your Mom and me so much. I hope you haven't missed me too much during your first three months of life! The book's done now, time to take you to the beach!

To my Mom, Dad, and brother (Ilze, Larry, and Jon Keegan), thanks for all of the support and cheerleading. Mom and Dad, thanks for all of the encouragement, attention, and help you've provided. My brother Jonathan, thanks for the enthusiasm, suggestions, and support.

I'd like to thank Aron Insinga for joining Laurie in proofreading most of my book. I can't tell you how helpful that was buddy — thanks.

Darcie and Craig Nuttall deserve special thanks not only for their support, but more importantly for being kind friends to Laurie and Emily when I had to write. That meant the world to her (and me), and I thank you for it!

Kevin and Caroline Stearns, thank you for enduring what must have been an extremely difficult period where you didn't get to bask in the glory of my presence. I know the book dragged on too long, and I'm sorry I couldn't free up more days to drive out there. Kevin, thanks for the times you let me ramble on about the book and helped out with the DirecTiVo research, and Caroline thanks for spending time with Laurie, again, when I had to write. Oh, and thanks for the pen.

Thanks to Tom Royer for at least three things: taking electrical engineering with me in college, being the first person to buy a copy of my book, and for telling me about TiVo long ago. Had it not cost around a thousand dollars at the time, I'd have been enjoying this wonderful toy and hobby for about a year longer than I have been; thanks for planting the seed that grew into this.

A similar thanks to Harry Forsdick, whose work with potential competition caused us both to go buy TiVos to see how good they were. Thanks also for introducing me to David Pallmann, who gave me valuable advice on having a book published and what to expect, and whom I'd also like to thank.

For reading a horribly confusing chapter introduction that I ultimately took out based on their feedback, I thank Samantha Paskal, Rich Barrett, and once again

my brother Jonathan Keegan. I'd also specifically like to thank Sam for a piece of advice she'd heard that she passed on to me — that writers need to get into a daily routine (for instance making a pot of coffee in the morning before working). If it weren't for that simple piece of advice, I can't begin to guess when the book would be done. I guess it's only appropriate to also thank Cuisinart and Dunkin' Donuts here too.

Thanks to even more of my friends for putting up with the ramblings about the book (on the few times that I was able to get out of the house), for understanding when I had to write, and for their support. Thanks to Todd and Audrey Sjolander, Doug Stetson, Zebulon Brundage, Bob Crowling, Cheryl Stearns, Tim and Lynn Kumm, Chris Stirling, Larry Hoyt, Steve Ben Theo and Margaret Paskal, Div Slomin, Scott Salvidio, Jon Lehto, Todd Mancini, Jay O'Leary, Rich Pito, George Brooks, Julie Kirkpatrick, Merle Rachel and Jonas Insinga, David and Sharon Gamache, Carl and Erin Parisi, Mark Russell, Dave Cumming, Michael Benlian, Paul Theresa and Kerry Lussier, Aaron Sherman, Jeff Maziarz, and Frank Sinton.

I'd particularly like to thank Chris Webb and Adaobi Obi Tulton from Wiley for your work with me on this book. A lot of issues came up during the development of the book that required attention, and they both worked through them with me quite well.

Of course none of this would have happened were it not for TiVo Inc. and its great employees for developing the product/service we all enjoy so much. As two extremely happy customers, my wife and I thank you.

It goes without saying that there wouldn't be a book on TiVo hacking if it were not for the TiVo hacking community itself. Credit for this book is shared with all those who have contributed to the tools and methods described in this book, whether directly or indirectly. The release of even the smallest tool can play a part in future tools that take advantage of it, which can play a part in yet other tools, etc. Everyone who has contributed in any way deserves thanks for making this the fun and interesting hobby that it is.

Thanks to the rest of my family, especially Kenny Lussier who'd helped in motivating me to include a chapter I'd considered leaving out.

Thank you to Bungie for creating Halo — the few Halo parties I managed to sneak into my schedule for breaks once in a while helped keep me sane (and gave Laurie a few days off from me!). And of course, thanks to Rush for the majority of the music that got me through the manuscript.

I'd also like to thank a group of people that distracted me to no end — the people who post to the "Happy Hour General Chit-Chat" forum on tivocommunity.com. I won't even start naming names, there are too many of you, but you all know who you are. Thanks for making that a fun place.

If there's anyone else out there I should have thanked but didn't, it wasn't deliberate, and I'm sorry. Thank you!

And it's my book, I can do what I want, so I'm thanking Laurie yet again. Thanks honey, I love you! The book is done now! Woo-hoo!!!

Contents at a Glance

Contents

· ·

Part III: Advanced Work (Going Off on Your Own)

Introduction

TiVo is easily one of the coolest products that I've purchased in the last 10–15 years. That's a bold statement, and there are many separate reasons I say it. If you're a fan of movies or sports, it's an absolute must-have. If you watch TV, it lets you watch more of what you love and less mediocre garbage. It lets you take that suggestion from a friend to check out a show or movie and actually carry through on it, where all you needed to remember was the first word or two of the title. Days or weeks later you'll find a few episodes of it sitting there waiting for you on your TiVo. It can record all shows with "nanotechnology" in the episode description, or all movies that your favorite actors are in.

The reason that TiVo owners seem fanatical when they talk about it is because there are so many reasons why it changes everything, and they're trying to figure out the most important ones to say to you first.

There's another reason why I'm so crazy about TiVo, and it is that it reminds me of cars. Since cars first came out, car owners were able to open the hood and look inside. You could of course decide to never open the hood, and you'd still have an incredible life-changing device that you used every day. You could just peer inside, and marvel at how this machine could turn gallons of liquid into you getting from town to town. Maybe you'd learn a few basics, like tweaking the idle, changing your oil, or how to pour gas directly into your carburetor when the line was dry. Or, if you were really determined, you could take your engine apart piece by piece to see how it worked. After-market parts even let people modify their cars to enhance their performance.

There are a few similarities and differences though. Much like you could open your car, you can also open your TiVo, but unlike opening the hood of your car, opening the case of your TiVo will void your warranty. Like cars, later models aren't as easy to muck around with as earlier models were. Unlike cars, with a small amount of work you can make TiVo around 10 times as powerful and operate it by remote control. Like your car, any surgery you do on it needs to be scheduled accordingly or you'll be stuck without it when you need it.

It's this ability to hack your TiVo that makes an already groundbreaking product into an extremely fascinating hobby that communities have grown around.

Who Is This Book Written For?

I've tried to write the book so that it will be useful to a wide variety of skill levels. Many people love their TiVos, and many would like to play around inside. Some people just want more space, others would love to learn but might need someone to walk them through it all, and others would just like everything gathered in one place and summarized.

Early chapters are accessible even to people afraid of opening their TiVo. People who feel comfortable plugging internal hard drives into their PC's primary and secondary IDE bus should

be able to handle the use and installation of most of the software in the book. People who know how to write code should also be able to manage the development portion of the book, with the help of Appendix B if they don't know Tcl.

Oh, and you *will* need access to a PC — see Chapter 3 for a longer list of what you need.

Is My TiVo Compatible with This Book?

The things described in this book are mostly applicable to any TiVo, *in theory*.

All of the storage upgrades mentioned in Chapter 3 are fully described for all TiVo units in existence at the time of this writing (Series1 standalones, Series1 DirecTiVos, Series2 standalones, and Series2 DirecTiVos). The accompanying CD-ROM supports a non-byteswapping mode for Series2 units, and the backup options for the mfstools utility that are required for Series2 units are provided in Chapter 3.

Installation of *software* on Series2 boxes involves circumventing a protection mechanism that I won't be talking about here. The same can be said about Series1 DirecTiVos as well, though that's a commonly addressed problem that you shouldn't have any difficulty solving on your own with a few searches. I can't help you. Were it not for this protection mechanism, Tcl scripts would for the most part work, as well as any programs cross-compiled with a Series2 cross-compiler.

All that having been said, the book officially addresses just Series1 standalones for the installed software hacks (i.e. if you have one of the other types of TiVos, you have to go read up on how to get a bash prompt on your own — I can't tell you).

How This Book Is Organized

This book progresses in three stages, represented by the three parts of the book. I've written it such that all three parts of the book will appeal to any enthusiastic developer, the first two parts will appeal to someone who doesn't write code but would like to add things to their TiVo, and the first part will still be interesting even for people uneasy with opening up their TiVo at all.

Part I: Nervously Observing from Afar

This first part of the book doesn't require opening your TiVo at all, and should be useful to everyone. I start out by warming up with a description of TiVo, talk about the various models, and the backdoor codes that provide access to hidden features.

Part II: Diving In (Installing Existing Hacks)

Most of the popular hacks are discussed here, with detailed instructions on how to install and use them. Chapters 3 through 6 should be considered prerequisites for most of the chapters that come after them.

Part III: Advanced Work (Going Off on Your Own)

This section will be mostly useful for those with experience writing code, though I tried to make it as interesting as possible to everyone. In this part, we talk about the TiVo internals, both hardware and software. The general intent of this section is to cover what is known about the internals, and to get developers to the point where they can implement ideas they have (and release them to the community).

Appendixes

I include three Appendixes, one of which I consider required reading and two of which I hope are useful to those who need them. Appendix A describes the various forums that make up the TiVo hacking community — I strongly recommend everyone read this. Appendix B provides an introduction to the Tcl programming language, for those who don't know Tcl but want to write their own hacks (or understand TiVo internals). Appendix C is a quick Linux primer, walking users unfamiliar with Linux through the basic steps needed to get around; anyone who doesn't know Linux is strongly urged to read this early on.

Accuracy

All of the hacks I describe in this book derive from work done by people doing this as a hobby. We've all made guesses as to what various things do, how they do them, and why. Experimentation is fun, that's what led to most of this. There's a good chance that some of the guesses about why things are acting the way they do might not be complete (or even accurate) descriptions of what's going on. Most of this is just an educated analysis.

Couldn't Cover Everything

There are many hacks out there — I certainly haven't covered all of them. If I didn't cover your hack, please don't take it personally — there was only so much time. There are also many ways to do certain things, and I made decisions on which ways I'd describe for various reasons. I had many design goals for the book, and I picked methods that best fit those goals. That may make some people say, "Why did he tell them *that* method?" Again, this is just to get you rolling. Anyone buying this book who doesn't eventually start checking out the forums mentioned in Appendix A is missing out.

The Accompanying CD-ROM

One of the reasons I wanted to do the book was to gather together all of the hacks from their respective homes, and put them in one place. Web sites go away (in fact some have during the writing of this book), and this is a way of ensuring the survival of some of the hacks that

otherwise might fade away. At the same time, this does also put you behind the times if a hack is going through a rigorous development schedule.

What I tried to do with this book was accommodate two different usage styles. First, in Chapter 4, I describe steps to move an entire assembled directory tree from the CD-ROM onto your TiVo. Most of the hacks are disabled by default, and in the various chapters where a tool is introduced, I'll describe how to enable it if you have done the installation in Chapter 4. I also though support a second approach, which is that of the reader who decides to thumb directly to a particular chapter. I do go to great lengths to describe the steps needed to install something if you want to do it yourself. These steps may be useful when a new version of that hack comes out as well, if the installation steps are still the same. Use the CD-ROM, but check the various forums as well to see if there are newer versions you might want to obtain (with bug fixes or enhancements).

The CD-ROM is bootable on a PC. Read the directions on the initial boot page and the other pages as well (press F2 and F3 to see them). It will boot into a mini-Linux distribution, from which you can run backup utilities (as described in Chapter 3) or mount drives to initially install software (as described in Chapter 4). It contains a modified kernel that can access TiVo drive partitions. It will then mount the "rest" of the CD under the directory /cdrom. Files in this directory are the same files you would see if you placed the CD-ROM into a running Windows or MacOS box.

Be sure to check the web page for this book, http://keegan.org/hackingtivo, for any corrections or notifications about the code. Wiley is hosting a similar page at http://www.wiley.com/compbooks/keegan.

Capitalization / Spelling

If you're an English major or an editor by trade, you might latch onto the fact that I spell TivoWeb with a lowercase "v," yet I spell TiVo Control Station with an uppercase "V," or some other such example. I've deliberately tried to stick with the capitalization that the author of any particular hack used (without making guesses as to whether it was intentional or not). For my own sanity, I also ignored TiVo's many usage guidelines about the term TiVo; for example, one should never say, "I have two TiVos," and TiVo isn't supposed to be used as a verb. The book is filled with such blatant misuses — my apologies to TiVo Inc.

Hack

Throughout the book (even in the title!) I use the term *hack*, as a noun, a verb, and a gerund. When I refer to hacking your TiVo I'm talking about the act of enhancing it, not attacking it. When I refer to a hack, I mean either a tool, a method, an algorithm, or a how-to written by someone, not an exploit of any kind.

Icons

In the text, you will sometimes see one of the following three icons. They are used to indicate a piece of information you should make sure you read.

 This is the caution icon, which I use to indicate that you should be extremely careful. In the worst case, ignoring these could result in you permanently damaging your TiVo or electrocuting yourself. Don't ignore these!

 This is the note icon. This indicates a piece of information that is . . . wait for it . . . worth noting.

 This icon indicates that a piece of software being talked about is located on the accompanying CD-ROM. I don't always use it, so don't go actively looking for it. Most of the software described in the book is on the CD-ROM, and is installed in Chapter 4 (or in whichever chapter you decide to install it from).

Contacting Me

I'd love to hear if you liked a particular section or if you just want to send along good wishes. Please don't try using me as a help request line though; I'm too busy to help everyone who has a request. A far better way to get help anyway is by searching the forums mentioned in Appendix A, and if that fails, posting for help there; please read my words of advice in Appendix A first.

But as I said, well wishes and words of praise are always welcome! You can contact me at:

 jlkhackingtivo@keegan.org

Accompanying Web Site

As I mentioned above, there is an accompanying web site for the book on my web site, at:

 http://keegan.org/hackingtivo

Wiley is hosting a similar page as well, at:

 http://www.wiley.com/compbooks/keegan

Check it out for information such as errata, updated links, any critical software updates, etc.

Nervously Observing from Afar

The contents of Part I should be of interest to everyone, but the particular benefit it has for beginners is that it doesn't require ripping your TiVo apart yet.

In Chapter 1 I talk about TiVo, the various things it can do, and why it's such a great product — this is a good chapter to show to friends when you're tired of explaining why you seem so obsessed. Long-time owners of TiVos may skim through familiar sections, but there's some info about various models other than yours that you might not know if you've only been exposed to your own TiVo.

Chapter 2 covers the "easter-egg"-like backdoor codes that provide access to hidden features such as 30-second commercial skip, advanced WishLists, and the ability to view your Now Playing list sorted alphabetically. If you want to play around a little before cracking open your TiVo, you can spend a bunch of time here until you feel you're ready to move on.

What Is TiVo?

W hat is TiVo? It's a question that makes TiVo owners experience two or three sensations at once. First, they cringe, as they're forced to remember what watching television was like before TiVo so they can relate to the person asking the question. Second, they feel excited at the prospect of being able to describe such a quality-of-life-changing invention, and make this person's life better. And somewhere in there, there's this slight, hidden feeling of dread, because they know it's not easy to really convey just how good a product it is.

"So it's like a digital VCR?" invariably gets echoed back, often causing the TiVo owner to bite down hard or clench his/her fist, while patiently trying to figure out which feature to talk about first to dispel this oversimplification.

And every TiVo owner who's ever tried describing it to friends has at one time or another briefly felt like he/she was part of a cult.

Unlike brainwashed cult members, though, TiVo owners get something huge in exchange for membership: time, freedom, and unbelievable convenience.

I can't remember a product that changed my day-to-day life more than my TiVo. I've never met *anyone* who owned one who didn't love it. And by my last count, at least 20 TiVos were purchased because of my evangelizing.

Ok, so why is it so great? What does it do? Why isn't my VCR good enough? Read on.

Note If you're wondering what a chapter called "What Is TiVo?" is doing in a book on TiVo hacking, let me explain. Every TiVo owner I know gets asked that question on a regular basis. I myself had answered the question enough times that I wrote a web page about it at http://keegan.org/tivo/ . My thought is that this chapter will serve two purposes. First, it's a good chapter to show to friends who want to know what TiVo is, when you're too tired of explaining it to convey the message well. Second, for curious people browsing through the book, I believe it's a good intro. I know many people who purchased a TiVo with the initial intention of hacking it (to have a platform on which to write hacks for on their TV), who had never actually used TiVo.

The Pitch

Since most people seem to ask if TiVo is like a digital VCR, I think that's a good place to start. First, let me answer the question: Yes, TiVo is like a digital VCR. To put it in context though, TiVo is like a digital VCR in the same way that a butler is like a vending machine. The latter is hardly a good description of the former. A butler can take issues away from you and deal with them entirely on his own, freeing you from having to deal with them. A butler can filter what you're exposed to, to your liking. A butler can go out and fetch things for you upon demand. A butler takes care of you.

There's Always Something *Good* On

With a VCR, you would almost always end up watching what you had recorded. If that weren't the case, over time you'd stop recording things. So for you to record something, it had to be a very deliberate act. And you had to justify those decisions too, because at most you can fit an 8-hour tape in a VCR. Unless you were prepared to have tapes pile up in your living room, you had to watch what was on that tape before other shows came along (statistically speaking).

As a result, most people would never even consider having their VCR record something they didn't *really* want to see. The analogy that pops into my head is what it was like when we had metered Internet access. When people were charged by the hour for access to the web, there better have been a good justification for what they wanted to go fetch. Once a flat monthly rate came along for Internet access, people started casually browsing. I can't even count how many Google searches I do in a day, but if it were metered it would be tough to justify. Even if it were *cheap* but still metered, there would still be a psychological need to be conservative.

That was how it was to record shows on a VCR. You only recorded the things that were on when you wouldn't be around, or specific things that you really wanted to save. Most people didn't record at all, but rather used their VCRs just to play rented movies, because of the inconvenience of recording things.

With TiVo, on the other hand, you can record shows with almost no effort, and there's no cost if you don't watch them and let them expire. There's no trying to find a blank videotape, or trying to find an older one to record over. This lets you have the freedom to record something on a whim, and decide later if you want to watch it or not.

With a VCR, I would never have bothered to record David Letterman each night. I'd either catch the show, or miss it, and I was fine with that. But with TiVo, you can tell it to always keep five episodes of a show around (see Figure 1-1). If you don't watch it, no big deal, it'll be deleted five episodes later. But when you do have a day when you sit down at the TV, you have the *option* of watching Letterman — whenever you want.

Ok, but some overzealous TV enthusiast could still get that same benefit from a VCR if he or she was diligent enough to switch tapes each night, right? Ok, try this on for size. You can create a WishList that records every talk show where Christopher Walken is mentioned in the description (or listed as an actor). That way if you're not a Leno fan, but you really like Christopher Walken, you can rest assured that you'll have every guest appearance he makes on Leno (as well as other talk shows you might not have even known existed).

FIGURE 1-1: Season pass recording options.

A better example is one I mentioned on my web site (http://keegan.org/). My wife and I were planning for our honeymoon to Hawaii. We created a keyword WishList for Hawaii and it started recording lots of travel shows on Hawaii, which was what we wanted. (It also ended up recording the Brady Bunch episode where they went to Hawaii, so we changed the WishList to still search for Hawaii but to be limited to the category "Arts and Living / Travel.") It worked great. We didn't even know these shows existed, nor did we know some of the channels existed.

And if that isn't enough of a way to fill your TiVo with recordings, your TiVo will also record shows *on its own* that it believes you will like, based on what it knows of your preferences. TiVo remotes have a Thumbs-Up and Thumbs-Down button (see Figure 1-2) that you use to rate shows and movies. When you see a show or movie you like, you give it up to three Thumbs Ups (and for things you don't like, up to three Thumbs Downs). This lets it make suggestions (see Figure 1-3) and then record the best of those suggested shows when nothing else is scheduled.

The whole point I'm getting at is that your TiVo will always be *filled* with shows and movies that you either requested or will probably like. When you finally get some free time that you want to spend watching TV, why watch whatever random garbage happens to be on? TiVo means never having to surf past an infomercial. TiVo means never settling for a show you're not crazy about. On a Sunday morning, would you rather watch the filler they placed there because no one would watch it, or see a movie TiVo recorded for you a few nights before?

Have your TiVo record every new episode of your favorite shows, and reruns of your favorite classics. Create WishLists to record a few Discovery Channel shows on topics you find interesting. All of these will be waiting for you when you want to watch TV. Now, there's *always* something on, lots of things in fact, and they're all things you will want to watch.

FIGURE 1-2: Thumbs-Up and Thumbs-Down buttons.

Mystery Science Theater 3000	Sat	3/8	
Back to the Future	Sat	3/8	
The Silence of the Lambs	Sun	3/9	
Moulin Rouge	Mon	3/10	
George Carlin: Back in Town	Tue	3/11	
Heat	Wed	3/12	
The Practice	Thu	3/6	
Little House on the Prairie	Thu	3/6	

FIGURE 1-3: TiVo's Suggestions screen.

Random Access—No Rewinding or Cramming

When people went from audio cassettes to CDs, one of the huge benefits was random access. With a cassette, if you wanted to hear the 10th song you had to fast-forward, hit play to see where you were, maybe hit fast forward again, hit play, find that you had overshot it, then hit rewind, and hit play again. With a CD, all you needed to do was skip to track 10. This ability to jump around turned out to be huge. Rewinding was a thing of the past.

The move from videotape to TiVo is similar, in two ways. First, consider the issue of having multiple recordings on one videotape. If you want to see a show three-quarters of the way into a tape, you have to go through the same headache of fast-forwarding, overshooting, and so on. "Slow" fast-forwarding makes it slightly easier to see where you are, but the picture becomes unviewable. Plus, you'd better hope that's the right tape, because even "fast" fast-forwarding an 8-hour tape is very, very slow.

Second, once you get to the show you want, if you want to fast-forward through it to a particular point, it's slow, and you might skip past the end into the next show.

With TiVo, one button on your remote brings you to the Now Playing screen (see Figure 1-4). As you can see, you're given a list of all of the recordings on your TiVo. From this list you can select any recording and play it, delete it, or save it to VCR. You can set its expiration time (after which it will be eligible for deletion), or mark it as Save Until I Delete. The page with all of these options is shown in Figure 1-5. No more wondering which of many unlabeled tapes a show is on; there are no tapes.

FIGURE 1-4: Now Playing screen.

FIGURE **1-5:** Now Playing recording description screen.

As for fast-forwarding within a show, a progress bar appears at the bottom of the screen displaying how far into the recording you are (see Figure 1-6). There are three different fast-forward/rewind speeds; 3, 18, or 60 times the normal speed. In addition, a skip button lets you easily jump to the beginning or end of the entire recording instantaneously, as well as skipping forward or backward in 15-minute increments.

We've just glossed over another benefit TiVo has over tapes here. With tapes, you recorded something on a particular location of the tape, and that's where it stayed. If you had recorded four 2-hour shows on a tape and wanted to keep the third one, you either carefully recorded around it, or threw in the towel and just kept the tape as is (with the other three unwanted recordings). If you wanted to keep the first and third show, then you couldn't record a 4-hour show over the second and fourth (unwanted) shows, because the recordings were fixed in place on the tape, and there was no space to cram it in.

No such limitation exists with TiVo. You can delete things when you want, schedule their expiration, and so on. The feature mentioned above about keeping five episodes of a show ("Keep At Most - X", where X can range from 1 to 5) actually does automatic deletion of older shows when new ones are recorded.

FIGURE 1-6: Progress bar, with one 15-minute tick mark.

The Power of TV Listings Data

Each night, TiVo uses the phone line (or an Ethernet connection, if present) to call back home for two weeks worth of TV Listings ("guide data"). This data allows it to provide some extremely cool features.

Scheduling Recordings Is a Joke

My wife and I just had our first child, a beautiful girl named Emily Laryssa Keegan. Someday I'm going to have to explain to Emily that people used to subscribe to TV listing magazines (or buy them in stores), bring them home, and keep them near the TV. When you sat down, you'd look for the right issue, thumb through it to the right day, then scan down the list to find what was on TV. I expect to feel very old when I tell that story.

When you hear about a new show or movie from a friend and decide you want to record it, all you need to know is the name of the show. You don't need to know what channel it's on, and you certainly don't have to know what day or time it's on. Figure 1-7 shows what the Search By Title screen looks like. Start entering the name of a show or movie, and a listing appears on the right. Select the one you want, and tell TiVo to record it (see Figure 1-8). That's it. If it's a show (with multiple episodes), you have the option of creating something called a *Season Pass*. A season pass will record every episode of the show, though you can tell it to ignore reruns if you want. Figure 1-1 shows the choices you can make when creating a season pass.

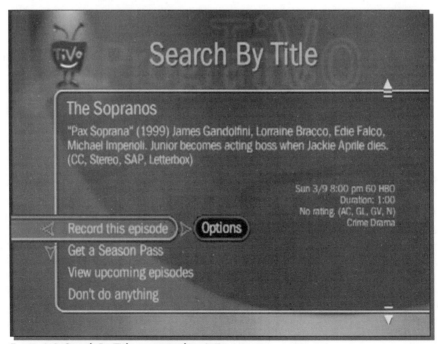

FIGURE 1-7: Search By Title screen.

FIGURE 1-8: Search By Title program description screen.

No More Missing "Special Episodes"

Once you've created a Season Pass for a show, that's it, you don't have to do any more. Suppose that next week Alias is going to be on a special night, Tuesday instead of Sunday. Plus, it's a 2-hour episode instead of 1. With TiVo, you don't have to care about any of this. Because the guide data is fetched every night, changes to the schedule are picked up and handled appropriately. Your TiVo will record Alias; it doesn't matter when it's on, or how long the episode is. If it turns out there's another show you record on Tuesdays (in this example), then TiVo looks at a prioritized list called the Season Pass Manager where you've said which shows have what priority.

WishLists

As I previously mentioned in my Hawaii vacation example, TiVo lets you create WishLists to search for things to record. Your searches can look for actors, directors, particular categories, or just keywords (either in just the title or in the descriptions as well). The guide data TiVo fetches each night is extremely detailed, containing such items as the director, writer, genre, title, description, episode number, first air date, and a list of actors.

When new movies come out that you don't really want to see in the theater, set up a WishList for them, and months later be pleasantly surprised to find them on your TiVo. Like Westerns? Create a category WishList for Movies/Western , and set it up to keep three around at any given time. Better yet, create an actor WishList for Clint Eastwood, limited to the category Movies/Western.

There's also a hidden feature called Advanced WishLists, which you can use if you enter backdoor mode first (see Chapter 2). Advanced WishLists let you create even more combinations, and specify a requirement for individual terms. For example, you could create a WishList for all episodes of Saturday Night Live where either Tom Hanks, Al Gore, or Conan O'Brien hosted. Another example is an Advanced WishList that looks for Comedies in which both Walter Matthau and Jack Lemmon performed.

On-Screen Program Descriptions

Another thing I'll have to tell Emily about someday is the strange thing that used to sometimes happen to you where you'd change channels, see some movie, and not remember what it was. Sometimes (rarely), you'd even go find that magazine and look up what was supposed to be on that channel right now, just to find out.

With TiVo, any time you're watching something, be it live or recorded, one button press will display the show, episode name (if it's a recurring show), and a description of the recording (see Figure 1-9). TiVo is not the first device to do this (satellite receivers certainly do it, and many cable boxes now do as well), but it's nice to always have, and it certainly performs quicker than my cable box.

If you're at the Now Playing program description screen, you'll see something similar to Figure 1-5, conveying the same info plus a little more. From there, if you press Display (or enter on older remotes), you can see even more program details, including more of the actors, the episode number, and the original air date, as in Figure 1-10.

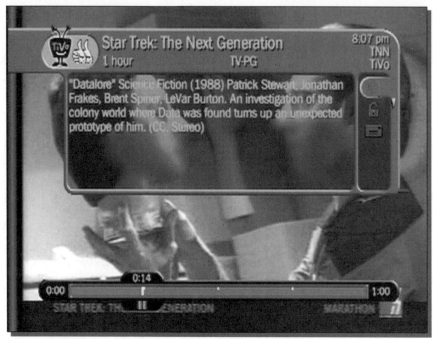

FIGURE 1-9: On-screen recording description, while watching video.

Program Details

Episode Title:	Datalore
Description:	An investigation of the colony world where Data was found turns up an unexpected prototype of him.
Rating:	TV-PG
Actors:	Patrick Stewart, Jonathan Frakes, Brent Spiner, LeVar Burton, Michael Dorn, Gates McFadden, Marina Sirtis, Wil Wheaton
Categories:	Science Fiction
Color Mode:	Color Series
Episode Num:	114
Original Air Date:	1/18/1988

Press SELECT to continue

Press CHAN UP/DOWN to scroll

FIGURE 1-10: Program details screen.

Record and View Recorded Show at Same Time

This feature usually confuses people when it's first mentioned to them. A TiVo owner says, "You can record a show while watching another recorded show," and the response is, "I think my VCR lets me do that already. Can't I watch something while taping something else?" The thing is, I'm not talking about recording something then watching another live channel; I'm talking about recording something at the same time that I watch another *previously recorded show* that's on the TiVo. Unless the person is talking about a dual-deck VCR, which could hold two tapes at once, then no, a VCR can't do that.

What this means is that there's never a time when you can't watch some show you've recorded. There is no, "you can't use the TV now, I'm taping soap operas" moment, ever. It doesn't matter if TiVo is recording something while you're watching something else; in fact, that's very likely to happen, because TiVo might be recording suggestions for you. And since your TiVo is always full of things you want to watch, the things you want are sitting right there, available to you all the time.

This does lead to the questions: "Well what if I wanted to watch CNN, live, while something else is recording?" and "Can I record two different shows at the same time?"

Standalone users (see "Various Models," below) are out of luck. There is only one tuner in a standalone box, so it can only record one channel at a time. DirecTiVo users (combo users) with a dual dish, however, can do just that. DirecTiVo users can record one program, while recording another, *at the same time as they watch a third, previously recorded program*. They can also watch one program live while recording another. This is because DirecTiVos don't have *any* tuners; they grab already-encoded digital data straight from the satellite.

Watch Any Part of What's Already Recorded

Picture yourself driving home to watch your favorite TV show. It starts at 9:00 P.M., and your VCR is set up to record it. You get home at 9:15.

What do you do? You have three choices:

1. Start watching now, from 9:15 until the end, then rewind the tape to see the now-anti-climactic beginning of the show. Go to bed around 10:20.

2. Wait around twiddling your thumbs for 45 minutes, so you can see it all as it's supposed to be seen, rewind at 10:00, and watch it whole. Go to bed around 11:00 (rewinding might be offset if you fast-forward through commercials).

3. Give up, do something else, go to bed whenever, and watch it another day.

Those choices are pretty lousy, but that's all you get with a VCR. And if you pick number 3, the "something else" can't involve watching recorded shows, because your VCR is in use.

TiVo owners in this situation would take their time getting home, and at 9:15 would simply start watching the show, from the beginning. When a recording is under way, you can fast-forward and rewind anywhere you want within the recorded portion. The progress bar at the bottom of the screen shows how much of the show has been recorded, and where you currently are within the recording (see Figure 1-11).

In fact, when a show comes on at 9:00, I usually wait until around 9:15–9:20 to start watching it anyway (usually watching some other recorded show until 9:20). Why? Because then when I get to commercials, there is buffered TV ahead of me, so I can skip over them. That's the other benefit I didn't mention yet — the TiVo users getting home at 9:15 in the above example get to finish watching by 10:00, because they were able to skip commercials.

Another great example of this is watching the presidential debates. I set our TiVo up to record the debate, and we watched it live. At one point, I said, "did he really say that??" and we rewound to hear the last minute of video again. This is another great example of something that wouldn't be practical with a VCR; if you were taping the debate, and wanted to see what was just said, you'd have to either give up recording (hit stop, then rewind a few minutes, but completely miss seeing what's said while you're looking at the past minute), or wait until the entire debate was over and rewind to exactly that point, all to hear some sentence you missed, that you probably no longer care about.

Only Watch the Commercials You Want To

Most TiVo users give up watching live TV within a few weeks. The reason is that it's always good to be behind enough that you can skip commercials. What I've found is that there are some commercials I actually rewind to watch. Those commercials tend to get special treatment too if you think about it, because they have my complete attention. One can hope that this will raise the bar for what makes an effective ad; hopefully, they'll all be more interesting someday.

FIGURE 1-11: Progress bar during live recording.

Oh Yeah, You Can Pause and Rewind Live TV

When watching some random show on live TV, you can always hit pause. It will buffer up to 30 minutes. When you finally un-pause, you're now behind-live, which is great because it gives you buffer space to skip the next commercial. You can also rewind to see anything in the last 30 minutes of TV that has been on (the buffer is cleared when you change the channel though). So if you're walking through the room and see something interesting out of the corner of your eye, you can go back and see what it was.

In fact, if you hit Record while watching live TV, you can save the last 30 minutes of video (back to the beginning of the current show), as well as the rest of the show.

Delayed Gratification — Poor Man's Video-On-Demand

There is a very strange (and yet cool) sort of delayed gratification you can get from scheduling movies to be recorded, that almost acts like a poor man's video-on-demand.

Every once in a while, I'll try looking through what movies are coming up in the next two weeks. I do this by performing a search-by-title, under the category Movies, then entering "A" or "0" to get near the top of the list of movies. I'll walk down the list, looking for movies I want to see. I'll find a few, schedule them, maybe give some Thumbs-Ups to other movies I haven't rated yet, then I'm done and I go find something else to do.

A few days later, after I've completely forgotten scheduling anything, the recording shows up on my TiVo. I describe it as a small investment — I make the future me happy by scheduling things for him now.

Pay Channels Are Now Much More Valuable

Pay channels such as HBO used to be a bit of a chore. They used to have their own program guide that was mailed to your house each month, telling you what movies were on when. If you didn't glance at it (which I certainly didn't do a lot), there was this slight nagging feeling that you weren't watching it enough for it to be worth the money.

But now, there's a direct benefit. The more channels there are (especially from the same network, such as HBO4, HBO5, HBO6), the larger the base of movies that will be on in the next two weeks. More of these channels makes it an almost certainty that when someone tells me I have to see some movie, it'll be on sometime within the next two weeks.

With 24 hours in a day, there are plenty of movies that channels air within two weeks. You don't have to be up anymore, or commit a VCR (with an SP tape, precluding the recording of anything else), just to get some movies out of your pay-channel subscription. Just schedule some recordings. Or set up some WishLists. Or let TiVo find stuff for you on its own. The bottom line is, the source of content just became more worthwhile.

Keep Things around as Long as You Want

Having something important to you on videotape is okay, but how often do you actually bother to get up, walk across the room, pick up that old tape, dust it off, stoop down to put it in your

VCR, walk back across the room, sit down, and then watch it? (And don't give me that "at least it's exercise" bit—walking to get videotapes shouldn't be your only exercise.)

The answer is, not often. No one really bothers to do that. And even if you do, your friends probably don't, so if something comes up in conversation where you want to show them that quick moment from the tape—forget it. During the commotion/ordeal of finding the tape, inserting it, rewinding it, and getting everything ready, your friends will have either secretly snuck out, or they'll have been acting polite out of kindness while you've bored them to death.

Instead of keeping those moments on tape, keep them on your TiVo. Here's an example: my Mom was on TV (see Figure 1-12).

See? None of you put the book down. Ok, in fairness all I had to say was "see Figure 1-12", but compared to digging through a pile of videotapes etc, showing someone something stored on your TiVo is just as easy.

If you jump through a hoop or two, you can even store a copy of your own video (from a camcorder, for instance) on your TiVo. I talk about how to do that in Chapter 11. That's why my TiVo also has video of Laurie and me with our baby Emily on the day she was born (see Figure 1-13).

FIGURE 1-12: My mom on TV, easily accessible on my TiVo.

FIGURE 1-13: Emily Laryssa Keegan's first day, waiting for her on our TiVo.

See? Keep what you want to watch *readily accessible* — otherwise why have it at all?

Various Models

Originally, there were two different types of TiVo devices: Standalone TiVos, which accept RF, RCA audio/video, and S-Video inputs, and combo units (DirecTiVos), which are also DirecTV receivers, but can *only* accept input from the DirecTV dish.

The next distinction came when TiVo announced a new hardware platform for TiVo devices: TiVo Series2. (Older boxes were then referred to as Series1 standalones or Series1 combo units.) The new Series2 boxes also came in standalone and combo unit varieties.

All of the existing TiVo models currently fit into these four categories (Series1 standalone, Series1 combo, Series2 standalone, Series2 combo). A high-definition television (HDTV)-compatible TiVo is expected within a year. Rumors have it that this new HDTV TiVo will bridge the gap between the two types, by accepting DirecTV input as well as video input from an antenna.

Standalone versus Combo

There are a few important differences between standalone units and combo units. The first of those is video quality. Standalone units let the user choose from one of four video quality settings: basic, medium, high, and best. Combo unit owners don't get (or need) a choice — they're always in best quality.

The reason for this is that the quality setting in standalone units is a function of their internal video encoder. DirecTiVos don't have an encoder; the datastream received from the satellite dish is already digitally encoded. Furthermore, the encoding for DirecTV streams happens before uplink to the satellite, with much more expensive encoders than the cheap encoder in standalone TiVos. This allows the DirecTV stream to be much more highly compressed, with better video quality to boot. As a result, DirecTiVo users adding an 80-gig drive will add around 70 hours (of "best" quality), whereas standalone users adding an 80-gig drive will add only 28 hours of best quality (or 96 hours of basic quality).

Another big advantage for DirecTiVo users is that they have a fiber-optic Digital Audio Out jack, that outputs 5.1 surround sound.

Hacking-wise, one downside of the DirecTiVo units is that with later versions of the TiVo software, they have been locked down to a certain extent. The firmware on a DirecTiVo works in conjunction with the kernel to attempt to eliminate any user-added software hacks (although extra storage capacity is left alone). Software exists to flash the programmable read-only memory (PROM) to allow hacks to exist. I won't be describing that here (for legal reasons), but you should be able to find out something with a few searches at dealdatabase.com.

Series1 versus Series2

The second generation of TiVo devices (labeled Series2) were announced around the beginning of 2002 (at which point people started referring to the previous units as Series1). Series2 units are based on a MIPS processor (as opposed to the PPC — also known as PowerPC — processor in Series1 devices). The new units are faster, physically smaller, and have two USB (Universal Serial Bus) ports in the back.

They also are heavily locked down, hack-wise. Like all TiVos, you can add new drives (though with some units, you need a special mounting bracket and it's a tight squeeze), or expand existing drives. Unfortunately though, like the Series1 DirecTiVos with new software, the firmware works in conjunction with the kernel to make sure no new software (or config file changes) survive.

Even worse, the PROMs don't seem to be flashable, so Series2 units remain ineligible for most of the hacks in this book, without de-soldering the PROM and replacing it with a modified version. That also is certainly not something I'll describe here, but there are some interesting discussions at tivocommunity.com.

Existing Models

Here is a list of the existing models at the time I'm writing this. By the time this goes to press, there will probably be other units available as well. Do searches on tivocommunity.com for information about a model that isn't listed here.

To determine which is right for you, first look at whether or not you have DirecTV. If you have it, you'll want a DirecTiVo; if not, you'll need a standalone. Series2 units are newer, easier to find, and have some more features, but they're difficult to hack and won't work well with most of this book. Series1 units may be a bit slower but they're wide open and much easier to play around with. They're not made anymore, so you'll have to buy one someplace like eBay or elsewhere on the web.

Table 1-1 TiVo Models

Model# / SKU#	Description
HDR110 / R00100	Philips 14-hr Standalone (Series1)
(also known as PTV100)	"A" drive: 13.6 GB
HDR112 / R00100	Philips 14-hr Standalone (Series1)
(also known as PTV100)	"A" drive: 13.6 GB (or 13.7 GB)
HDR212 / R00200	Philips 20-hr Standalone (Series1)
(also known as PTV200)	"A" drive: 22 GB
HDR310 / R00300	Philips 30-hr Standalone (Series1)
(also known as PTV300)	"A" drive: 13.6 GB, "B" drive: 13.6 GB[1]
HDR312 / R00300	Philips 30-hr Standalone (Series1)
(also known as PTV300)	"A" drive: 13.6 GB, "B" drive: 13.6 GB
HDR312XX / R00300	Philips 30-hr Standalone (Series1)
(where XX is 01, 02, etc)	"A" drive: 30 GB
HDR612 / R00600	Philips 60-hr Standalone (Series1)
	"A" drive: 30 GB, "B" drive: 30 GB
	or
	"A" drive: 40 GB, "B" drive: 20 GB
DSR6000 / RC0300	Philips 35-hr DirecTiVo (Series1)
(with serial # <= 47039999)	"A" drive: 30 GB, "B" drive: 15 GB
DSR6000 / RC0300	Philips 35-hr DirecTiVo (Series1)
(with serial # >= 47040000)	"A" drive: 40 GB
SVR2000 / RS0300	Sony 30-hr Standalone (Series1)
	"A" drive: 30 GB (or 40 GB)
Sat-T60 / RSC300	Sony 35-hr DirecTiVo (Series1)
(with serial # <= 8009999)	"A" drive: 30 GB, "B" drive: 15 GB

Continued

Table 1-1 *(continued)*

Model# / SKU#	Description
Sat-T60 / RSC300 (with serial # >= 8010000)	Sony 35-hr DirecTiVo (Series1) "A" drive: 40 GB
GXCEBOT / RHC300	Hughes 35-hr DirecTiVo (Series1) "A" drive: 40 GB
PVR10UK / RTU400	Thompson 40-hr Standalone (Series1, UK-only) "A" drive: 30 GB, "B" drive: 15 GB or "A" drive: 40 GB
TCD130040 / R13040	AT&T 40-hr Standalone (Series2) "A" drive: 40 GB
TCD230040 / R23040	AT&T 40-hr Standalone (Series2) "A" drive: 40 GB Note: Made for one drive, needs special S2 bracket
TCD140060 / R14060	TiVo-branded 60-hr Standalone (Series2) "A" drive: 60 GB
TCD240040 / R24040	TiVo-branded 40-hr Standalone (Series2) "A" drive: 40 GB
TCD240080 / R24080	TiVo-branded 80-hr Standalone (Series2) "A" drive: 80 GB *Note: Made for one drive, needs special S2 bracket*
SVR-3000 / R11080	Sony 80-hr Standalone (Series2) "A" drive: 80 GB
HDVR2 / R15140	Hughes 35-hr DirecTiVo (Series2) "A" drive: 40 GB *Note: Made for one drive, needs special S2 bracket*

[1] This is a guess, because I can't find data on which sized drives shipped with this model.

Why Would I Want to Open It Up?

With such an incredible product, one might ask why is there any desire to open it up? Isn't it good enough? What's the point in messing with it?

There are many reasons why people hack their TiVos. The first reason, which applies to most TiVo owners, is to expand your TiVo's storage capacity. A 200-hour TiVo certainly has its appeal, when you consider the suggestions it records for you, the WishLists you might create to keep your TiVo full, and the favorite episodes that you want to keep around.

Then, there are the existing software projects that have been created to put on your TiVos. TivoWeb (which is discussed in Chapter 7) lets you control your TiVo from a web browser. Series2 users are able to pay for such a service as part of the Home Media Option (HMO), but TiVo hackers have had this ability for years, it's much more feature-rich, and it's an open platform that you can write your own modules for.

TiVo Control Station lets you display weather, sports, stock quotes, and eBay auctions (among other things) on your TV screen. It also is an open platform that allows you to write your own modules for it.

Other hacks let you display closed captioning, caller-ID info, and photos on screen as well.

But aside from the storage capacity upgrade, one of the best reasons to want to open up your TiVo is to have fun hacking around in it. It's a platform that happens to be connected up to your television, most likely the Internet, and your sound system. It's like writing software for your TV.

Simple Tricks (Before Voiding Your Warranty)

chapter

2

When you first buy a product like a home appliance, all of the features are originally somewhat new to you. They might be straightforward, but at that time you still don't "know" the product as a whole, so you take them all in at a different level. Over time as you become accustomed to it, these features slowly seep in, and you become used to them.

I don't think we're ever conscious of this effect, but it's there. You treat things differently over time; how you'd treat one of the 20 existing features of your new car is different from how you'd react to one new feature being added to a car you've owned for years.

That's what makes the hidden features in a TiVo seem so cool. It's not that they're terribly exciting features; it's just that they're extra things buried away inside that you didn't know about. If you've just bought your TiVo and you're still getting used to it, don't waste your time on this chapter yet — it will seem underwhelming. But if you're used to your TiVo, it can be fun seeing some of the extra things lying around.

TiVo's Backdoor mode turns on some experimental, debugging, and advanced features. Some of them are pretty so-so, but a few others are actually very useful. None of them were really meant for the public — or maybe they were. Either way, they are there, and people play around trying to look for more.

This is a good chapter for everyone, but especially for those who want to play around a bit more but haven't quite worked up the courage to take their beloved TiVo apart to do surgery on it.

Entering Backdoor Mode

The first step to using these backdoor codes is to get your TiVo into Backdoor mode. This mode allows most of the backdoor codes to function and causes more information to be displayed on the System Information and Program Details screens.

 Backdoor mode isn't a supported feature of the TiVo software. Some of the backdoor codes can disrupt your TiVo's normal behavior, and others can be downright dangerous. Enter Backdoor mode at your own risk! It's very possible that additional backdoor codes exist that aren't described here, and you may accidentally trigger them by being in backdoor mode and stumbling upon the right sequence of button presses during normal use. In that case, who knows what's happened to your TiVo. As I'll say many times in this book, you've been warned.

The code to enable backdoors is known for most versions of the TiVo software, but at the time of this writing it's not known for TiVo software versions 3.1, 3.2, or 4.0. If you are using any of these three versions, there's a description at the end of this chapter on how to change the backdoor code itself to one you actually know.

To determine what version of software your TiVo is running, go to the System Information screen (TiVo Central ➜ Messages & Setup ➜ System Information) and look for "Software Version" (Figure 2-1).

System Information

Manufacturer Brand:	Philips
Software Version:	3.0-01-1-000
TiVo Service Number:	
TiVo Account Status:	5: Product Lifetime Service
Recording Capacity:	53 hrs, 53 min (Best Quality)
	196 hrs, 6 min (Basic Quality)
Program Source:	Cable Box, IR
Source Input:	Composite Video, L/R Audio
Today's Date:	Monday, Mar 10, 2003, 3:20 pm
Program Guide Data To:	Saturday, Mar 22, 2003
Phone Call:	

FIGURE 2-1: Determining software version from the system information screen.

Once you know the version of software you're running,[1] check Table 2-1 to determine what the code is to enable backdoors for your TiVo. Note the locations of any spaces.

Table 2-1: Codes to Enable Backdoor Mode

TiVo Software Version	Code to Enter on Search By Title Screen
1.3	0V1T (zero V one T)
2.0	2 0 TCD (2 space zero space TCD)
2.5	B D 2 5 (B space D space 2 space 5)
3.0	3 0 BC (3 space zero space BC)
1.5.0 (UK TiVos)	
1.5.1 (UK TiVos)	0V1T (zero V one T)
1.5.2 (UK TiVos)	10J0M (one zero J zero M)
2.5.5 (UK TiVos)	B D 2 5 (B space D space 2 space 5)
2.5.2 (DirecTiVos)	B M U S 1 (B space M space U space S space one)

Once you've determined the code needed to enable backdoors, go to the Search By Title screen (TiVo Central ➜ Pick Programs To Record ➜ Search By Title). Choose "All Programs" from that screen, bringing you to the page with an on-screen keyboard. Use the keyboard to enter the code (see Figure 2-2).

(Note that when you enter the code, the cursor may move to the list on the right to select a recording with that name; if that happens, simply move the cursor back to the keyboard on the left.)

When the code has been entered, press the Thumbs-Up button. This should cause the words "Backdoors enabled!" to appear where you entered text (see Figure 2-3), and you should hear five dings. If you go back to the System Information screen, it should now contain a line that says "Backdoors: ENABLED!" (shown in Figure 2-4). Your TiVo will remain in Backdoor mode until you power down the machine.

[1] TiVo units upgrade to newer versions of software automatically, so unless you've deliberately done something to prevent yours from receiving an upgrade, your TiVo shouldn't have early versions such as 1.3. Different TiVos sometimes receive different software versions, however. For instance, at the time of this writing the most recent version of software downloaded to any Series1 TiVos is 3.0. TiVo Inc. has not officially declared whether Series1 units will ever receive another software update. So, if you were thinking, "Hey how do I get the latest software version?", realize that there isn't anything for you to do in this respect; you'll receive the latest version for your TiVo when it comes out.

FIGURE 2-2: Entering the code to enable backdoors.

FIGURE 2-3: After entering the code and pressing thumbs-up, backdoors are enabled.

FIGURE 2-4: System Information screen reporting that backdoors are enabled.

Backdoor Codes

All of the following codes that you are about to see were found by trial and error by countless people in the tivocommunity.com forum. There may be others that haven't been found yet, and some of these may not work for the version of software you are currently running. Some of these codes aren't completely understood — those are indicated with question marks (?).

Lists of these codes have been kept both in the Hacking the TiVo FAQ and in the Almost Complete Codes List thread on tivocommunity.com. The maintainer of the list moved elsewhere and hosted his copy on dbsforums.com, and a New Almost Complete Codes List thread was created on tivocommunity.com to keep the list current there as well. All of these versions (in the order listed above) are:

```
http://tivo.samba.org/index.cgi?req=show&file=faq04.025.htp
http://www.tivocommunity.com/tivo-vb/showthread.php?threadid=26530
http://www.dbsforums.com/ubb/ultimatebb.php?ubb=get_topic;f=14;t=003197
http://www.tivocommunity.com/tivo-vb/showthread.php?threadid=122090
```

Credit goes to Samuel "Otto" Wood (Otto on tivocommunity.com) for maintaining the list, and to many others for contributing codes as they found them. Searching through tivocommunity.com's Underground forum for "0V1T" yields an interesting historical read for those familiar with the codes today.

The list is broken down into groups based on the buttons used to enter the codes. Although some people have stated that they'd like to see the list organized by function instead, I feel they're coming at this from the wrong perspective: This is more a list of small things to play around with than a list of key, important features. For this reason I'll keep the list grouped in pretty much the same way, adding some detail and illustrating a few of the results.

For reference purposes, Table 2-2 gives a high-level map of most of the backdoor codes. After that I describe what the codes actually are and what they do.

Table 2-2: Known Backdoor Codes

Code[1]	Code to Enter on Search By Title Screen
S-P-S-3-0-S	30 Second (Commercial) Skip
S-P-S-9-S	Clock
S-P-S-IR-S	Status Line
S-P-S-Pause-S	Fast-Disappearing Play Bar
C-E-C-TU	TiVo Log Files
C-E-C-TD	Quit myworld
C-E-C-0	Transparent Clock
C-E-C-1	Opaque Clock
C-E-C-2	Scheduled Suggestions in To Do List
C-E-C-3	? Same as C-E-C-2 ?
C-E-C-4	Rebuild Suggestions
C-E-C-5	Overshoot Correction On/Off
C-E-C-6	Node Navigator
C-E-C-Slow	Dump myworld State to `/tmp/mwstate`
E-E-1	Change Fast-Forward Speed1 Value
E-E-2	Change Fast-Forward Speed2 Value
E-E-3	Change Fast-Forward Speed3 Value
E-E-4	? "Rate1" — unknown
E-E-5	? "Rate2" — unknown
E-E-6	? "Rate3" — unknown
E-E-7	Obsolete — Interstitial Interval
E-E-8	? "Open" — LongOpen Interval — unknown
E-E-9	Obsolete — Interstitials On/Off
E-E-TiVo	Set Clock

Code[1]	Code to Enter on Search By Title Screen
E-E-Rewind	Change Overshoot Correction "offset"
E-E-FF	Change Overshoot Correction "delay"
C-C-E-E-2	Debug Mode
C-C-E-E-3	Initiate (Special?) Call
C-C-E-E-7	Timestamp Problem in Log
C-C-E-E-8	Empty Channels-You-Watch Screen
C-C-E-E-0	Change Dial-in Configuration Code
TD-TD-TU-IR	Scheduled Suggestions in To Do List
Hidden Recordings in Now Playing	
TD-TU-TD-IR	Clips On Disk Menu
TD-TU-TD-Record	MenuItem Back Door
Hidden Showcases	
TD-TU-TD-Clear	Italic Font
TD-TU-TD-Enter	Dump Debug Messages to /var/log/tvlog
Slow-0-Record-TU	S.O.R.T. — Sort the Now Playing List

[1] Abbreviations used in this column: S=Select, P=play, IR=Instant-Replay, TU=Thumbs-Up, TD=Thumbs-Down, RW=Rewind, FF=Fast-Forward. -'s mean nothing, they are just a placeholder.

Codes that are probably of interest to the average reader have a star like this in front of their descriptions.

Select-Play-Select Codes

These are codes that start with Select-Play-Select. Since you don't want the button presses to correspond to any normal actions (like selecting menu items, changing the channel, and so on), you should start viewing a completed recording from the Now Playing list before entering these codes. You do *not* have to be in Backdoor mode to enter the Select-Play-Select codes.

30 Second (Commercial) Skip

```
Select-Play-Select-3-0-Select
```

This is probably the most popular TiVo backdoor known; it has even been covered by the press. Entering this code turns on (or off) 30-Second-Skip mode (which stays in effect until you reboot your TiVo). In this mode, the behavior of the skip-to-live button on your remote is changed: pressing it while watching video now causes an instant fast-forward of exactly 30 seconds. This means that you can press it four times when a commercial comes on and it will usually skip the commercial break completely, unlike normal fast-forwarding, where you have to watch to see where to stop.

The feature was originally introduced in version 1.3. It was removed for 2.0, and then it was put back in for versions 2.5, 3.0, and 4.0. The behavior was improved along the way; version 2.5 made the skip-to-live button *always* jump forward 30 seconds, even during fast-forward and rewind. Later versions now perform a 30-second skip during normal play, and a skip-to-tickmark during fast-forward/rewind.

Clock

```
Select-Play-Select-9-Select
```

The current time is displayed (in a constantly updating clock) in the lower-right side of the screen when this code is entered. Entering the code again turns off the clock, though it will stay on-screen unless you clear the screen (say via the TiVo Central menu).

In early versions, this clock also displayed the current time within the existing recording. This feature was removed from the 3.0 release but was reintroduced for 3.2 and 4.0.

Figure 2-5 shows the clock from 3.0, and Figure 2-6 shows the clock from 4.0 (with the time-within-recording feature reintroduced).

FIGURE 2-5: Clock in version 3.0.

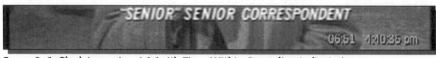

FIGURE 2-6: Clock in version 4.0 (with Time-Within-Recording indicator).

Versions prior to 2.5 let you set whether the clock had a black box drawn behind it or not with the C-E-C-0, C-E-C-1, C-E-C-2 and C-E-C-3 codes (see Clear-Enter-Clear Codes later in this chapter).

It should be noted that the clock is drawn so low on the screen that it's not visible on some televisions. The clock being on also interferes with the jpegwriter program, which is discussed in Chapter 9 and used by TiVo Control Station (TCS). TCS is discussed in Chapter 8.

Status Line

```
Select-Play-Select-InstantReplay-Select
```

This code causes a status line to be displayed in the lower-left side of the screen. It indicates such things as whether you're watching live TV or a recording, and what you're watching. When you're watching a live broadcast, the ID of the episode within the MFS database is displayed as well (we talk more about MFS in Chapter 13).

Entering the code again turns off the status line, though it will stay on-screen unless you clear the screen (say via the TiVo Central menu).

Figure 2-7 shows the status line displayed while watching a recorded program. Figure 2-8 shows the status line displayed while watching live TV.

Input 0: InputRecording 74 | | Mode: COMPLETED (PlayRecording)

FIGURE 2-7: Status line when viewing a recorded program.

Input 0: InputRecording* 74 FOCUS (1673822/80) | | Mode: RECORDING (WatchLive)

FIGURE 2-8: Status line when watching live TV.

As with the clock above, it should be noted that this status line is drawn so low on the screen that it's not visible on some televisions. The status line being on also interferes with the jpegwriter program, which is discussed in Chapter 9 and used by TCS. TCS is discussed in Chapter 8.

Fast-Disappearing Play Bar

`Select-Play-Select-Pause-Select`

This causes the play bar to disappear much faster than it normally would. Pressing play while TiVo is playing still makes the play bar appear for the normal 2–3 seconds, but other actions such as pausing, resuming, rewinding, fast-forwarding, pressing instant replay, pressing skip-to-tick, and pressing slow all cause the play bar to disappear almost instantaneously.

Entering the code again turns off the fast-disappearing-play-bar behavior.

Clear-Enter-Clear Codes

These are codes that start with Clear-Enter-Clear. Since you don't want the button presses to correspond to any normal actions (such as selecting menu items, changing the channel, and so on), you should start viewing a completed recording from the Now Playing list before entering these codes.

Entering these codes causes five dings to sound, indicating that you've successfully entered the code.

TiVo Log Files

`Clear-Enter-Clear-ThumbsUp`

This backdoor is impressive in that you actually get to see something dramatically different on-screen. Entering this code displays the TiVo log files in the `/var/log` directory. While a log is being displayed on-screen, you can page up and down within that log via Channel-Up/Channel-Down, move up and down one line at a time with the up and down arrows, and move to the next log file by pressing the right arrow. Thumbs-Up and Thumbs-Down bring you to the start and end of the currently displayed log.

Pressing left (or the TiVo button) will return you to the TiVo Central menu.

Figure 2-9 shows what it looks like to view log files with this backdoor.

Quit myworld

`Clear-Enter-Clear-ThumbsDown`

This causes the TiVo user interface (myworld) to quit gracefully (without rebooting the system). It leaves your TiVo completely unresponsive to the remote control. This only makes sense to do if you have telnet access into your TiVo (see Chapter 5) and for some reason want to play around with devices directly without competing with myworld.

Caution Quitting myworld will stop all recording and future scheduled recordings until the next reboot. There is no way to restart myworld from the remote control once it's quit—you'll have to reboot your TiVo. Unless you know what you're doing and have a good reason to quit myworld, avoid this code.

```
                          /var/log/Otclient
  May  8 11:01:47 (none) comm[181]: Finished HServerRqst in after Success, got 0x0
  May  8 11:01:47 (none) comm[181]: Finished HttpGet in after Success, got 0x0
  May  8 11:01:47 (none) comm[181]: checking for new software
  May  8 11:01:47 (none) comm[181]: NewSoftware: getting SwSystem name
  May  8 11:01:47 (none) comm[181]: NewSoftware: SwSystem 3.0-01-1-000 is already acti
  May  8 11:01:47 (none) comm[181]: Reverting private logs
  May  8 11:01:48 (none) avalPP[181]: Building "/Avalanche/Icebox/R1494472" from disk...
  May  8 11:01:48 (none) avalPP[181]: BuildFromDiskNoRetry: Open
  "/Avalanche/Icebox/R1494472"
  May  8 11:01:48 (none) avalPP[181]: FOUND 14 sections
  May  8 11:01:48 (none) avalPP[181]: Building "/Avalanche/Icebox/R1494472" from disk
  SUCCEEDED
  May  8 11:01:48 (none) tcphonehome[181]: CallService return status 0x0
  May  8 11:01:48 (none) tcphonehome[181]: GetPostalCodeVersion - /PostalCode/01844
  ServerVersion=96
  May  8 11:01:48 (none) tcphonehome[181]: debug: sumServerVersion=96
  May  8 11:01:48 (none) tcphonehome[181]: checking ServiceState
  May  8 11:01:48 (none) tcphonehome[181]: ReschedCall: reason = 0, secSinceLast = 0,
  numFails = 0
  May  8 11:01:48 (none) tcphonehome[181]: ReschedCall: reschedule after success
  May  8 11:01:48 (none) tcphonehome[181]: setting next attempt at 1052485968 (Fri May
  9 13:12:48 2003 )
```

FIGURE 2-9: Viewing log files with backdoor code.

Transparent Clock

`Clear-Enter-Clear-0`

In versions 2.0 and 2.5, this makes the clock (see Select-Play-Select-9-Select above) have a transparent background. This code also had a secondary purpose in 2.0: it turned off the display of "scheduled suggestions" in the To Do List (triggered by C-E-C-2 or C-E-C-3 as described later in this section).

Scheduled Suggestions are enabled differently in versions 3.0, 3.2, and 4.0 (see ThumbsDown-ThumbsDown-ThumbsUp-InstantReplay later in this chapter), and the clock never has a black bar in 3.0, 3.2, and 4.0, so this code is useless after version 2.5.

Opaque Clock

`Clear-Enter-Clear-1`

In versions 2.0 and 2.5, this makes the clock (see Select-Play-Select-9-Select above) have a black background. This code also had a secondary purpose in 2.0: it turned off the display of "scheduled suggestions" in the To Do List (triggered by C-E-C-2 or C-E-C-3 later in this section).

Scheduled Suggestions are enabled differently in versions 3.0, 3.2, and 4.0 (see ThumbsDown-ThumbsDown-ThumbsUp-InstantReplay later in this chapter), and the clock never has a black bar in 3.0, 3.2, and 4.0, so this code is useless after version 2.5.

Scheduled Suggestions in To Do List

Clear-Enter-Clear-2

 In versions 2.0 and 2.5, this turned on the display of "scheduled suggestions" in the To Do List (as well as making the clock from the Select-Play-Select-9-Select code above turn opaque, for some unknown reason). The To Do List normally only displays recordings you've scheduled via recordings, wishlists, and season passes; however, this code now causes it to also display suggestions that TiVo currently plans to record.

Scheduled Suggestions are enabled differently in versions 3.0, 3.2, and 4.0 (see ThumbsDown-ThumbsDown-ThumbsUp-InstantReplay later in this chapter), and the clock never has a black bar in 3.0, 3.2, and 4.0, so this code is useless after version 2.5.

See the ThumbsDown-ThumbsDown-ThumbsUp-InstantReplay code later in this chapter to see how this looks (see Figure 2-13).

? Same as Clear-Enter-Clear-2 ?

Clear-Enter-Clear-3

This seems to have done the exact same thing as the Clear-Enter-Clear-2 code above, including making the clock opaque. It isn't known if this had any other hidden differences from the Clear-Enter-Clear-2 code.

Rebuild Suggestions

Clear-Enter-Clear-4

Entering this code seems to causes the Suggestions list to be reevaluated based on the thumbs up/down ratings, though it doesn't always take effect immediately.

Overshoot Correction On/Off

Clear-Enter-Clear-5

 When you fast-forward at either 2× or 3× speed and then press Play, TiVo performs something called *overshoot correction*: it rewinds some number of seconds, trying to guess where you really meant to resume playing. The rationale here is that if you're fast-forwarding past a commercial and hit play when you see the show come back on, you probably really meant to resume a few seconds earlier so you wouldn't miss anything. Overshoot correction occurs when you rewind as well, in the opposite direction.

This code turns off overshoot correction altogether. It can look a little jittery sometimes.

It's also worth checking out Enter-Enter-FastForward, and Enter-Enter-Rewind later in this chapter; they modify overshoot parameters rather than disabling it entirely.

Node Navigator

Clear-Enter-Clear-6

 The Node Navigator screen lets you change many internal settings of your TiVo.

This is a very dangerous backdoor code that shouldn't be played around with much unless you have a backup of your hard drive and are prepared to deal with restoring it. The Node Navigator screen lets you change many internal settings, some of which can cause problems if you set them wrong. Since the mere act of selecting items from the node list can make changes, it's not safe to even view items. The common example given is what would happen if you found a node that allowed you to change your zip code, but then canceled before changing it; your zip code would be erased, causing the daily call to fail to grab necessary data, causing your TiVo to reboot every time you went to live TV.

There are, however, two nodes that are well known and incredibly useful for users of version 3.0, so I'll mention them here. Still, be careful!

Entering the Node Navigator code causes the Node Navigator screen to be displayed (see Figure 2-10).

The two entries of particular interest for users of 3.0 are node 1 (Overshoot Correction) and node 30 (Advanced WishLists). These were reported by Greg Leffler (gleffler on tivocommunity.com).

Overshoot Correction

Selecting node 1 from the Node Navigator screen brings you to the Set Over Shoot Value screen (Figure 2-11). Don't enter this screen if you're currently recording something, because it will cancel the recording. See the Clear-Enter-Clear-5 code previously described for a description of what Overshoot Correction is.

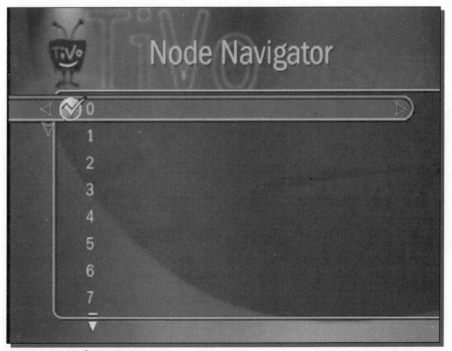

FIGURE 2-10: Node Navigator screen.

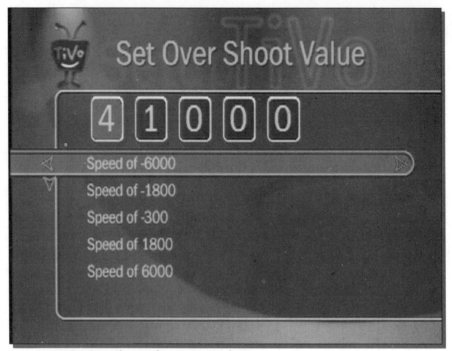

FIGURE **2-11: Set Over Shoot Value screen (Node 1).**

At this screen you can set the overshoot value for five fast-forward/rewind states. The -6000 speed corresponds to speed3 rewind (with three green left triangles in the playbar); -1800 corresponds to speed2 rewind, -300 corresponds to speed1 rewind, 1800 corresponds to speed2 fast-forward, and 6000 corresponds to speed3 fast-forward (there is no overshoot correction from speed1 fast-forward).

For each of those entries, you can set an overshoot value with the numeric keys on your remote. The -6000 default is 41000, -1800 is 14000, -300 is 01435, 1800 is 15226, and 6000 is 48000.

Note that changes you make here are permanent! They will survive after a reboot, and can only be changed by coming back into the Node Navigator and changing them back to their original values. Later in this section, there are two Enter-Enter codes related to overshoot correction for use on older versions of the TiVo software; *those* are reset after a reboot — these are not.

Advanced WishLists

Later in this chapter you'll read about advanced WishLists. In version 3.0, you can use the Node Navigator to permanently enable advanced WishLists (so they are enabled even after a reboot). Selecting node 30 brings up the WishList Options page, where you can enable advanced WishLists (see Figure 2-12).

FIGURE 2-12: WishList Options screen (Node 30).

Dump myworld State to /tmp/mwstate

`Clear-Enter-Clear-Slow`

This code causes the myworld process to dump internal state information into a file in the /tmp directory called `mwstate`. This file contains information such as what program is being watched, how far into that program you are, what menu text is on the screen, and so on. The information dumped is different depending on what you're currently doing (watching a recording, watching live TV, navigating through menus, and so on); however, you'll probably have trouble entering the code in places other than when watching a recording.

Another way to get this same behavior (even in places where it's difficult to trigger the backdoor with the remote) is by sending the dumpState key event (which you can create via "`SendKey dumpState`" in `tivosh`; `tivosh` is covered in Chapter 13).

Reboot

`Clear-Enter-Clear-FastForward`
`Clear-Enter-Clear-Rewind`

Either of these two codes causes your TiVo to reboot. It's not known if any other effect happens as well.

Boat Anchor Mode

`Clear-Enter-Clear-SkipToLive`

This code causes your TiVo to think it is out of guide data, thus putting it into "Boat Anchor mode." In my next book, I'll describe how to gouge your eyes out with a spoon.

Other Clear-Enter-Clear Codes

Two other Clear-Enter-Clear sequences cause the five dings to occur, but no one has figured out what (if anything) they do: Clear-Enter-Clear-Enter, and Clear-Enter-Clear-LiveTV.

Enter-Enter Codes

The Enter-Enter backdoor codes let you modify values used by your TiVo. You enter them all at the Search By Title screen. When you enter the code, the red recording light on the front of your TiVo will light up. Being careful to only press numbers, you then enter a numerical value (described for each code later in this section), followed by the original code again (for instance, Enter-Enter-1-3-0-0-Enter-Enter-1).

After entering the initial code, you'll see a prompt in the text field (such as Speed1: for the Enter-Enter-1 code in the next section). When you enter the numerical value, it appears after the prompt. Once you've entered the initial code again, the text field will clear and the red light will turn off.

Backdoors must be enabled for these to work (see above). These changes will last until the next time your TiVo reboots.

Change Fast-Forward Speed1 Value

`Enter-Enter-1`

⭐ When you use the fast-forward and rewind functions, there are three speeds of fast-forward/rewind. Normally, the first speed is 3 times as fast as normal play, the second is 20 times as fast, and the third is 60 times as fast. These three speeds are indicated by one, two, or three green triangles on the play-bar.

This code sets the value of the first speed. The prompt that will be displayed after the first code is Speed1:. The numerical value to enter is the multiple of the normal speed, times 100. Thus for speed1 the default value is 300 (3 × 100).

Note that this code only works on versions of software prior to 2.0, though the prompt still appears and the red light still lights up.

Change Fast-Forward Speed2 Value

`Enter-Enter-2`

⭐ This code lets you set the value for Speed2. See the description of the Enter-Enter-1 code above for a description.

The prompt that will be displayed after the first code is Speed2:. The default value is 2000.

Note that this code only works on versions of software prior to 2.0, though the prompt still appears and the red light still lights up.

Change Fast-Forward Speed3 Value

`Enter-Enter-3`

This code lets you set the value for Speed3. See the description of the Enter-Enter-1 code above for a description.

The prompt that will be displayed after the first code is `Speed3:`. The default value is 6000.

Note that this code only works on versions of software prior to 2.0, though the prompt still appears and the red light still lights up.

? Rate1 — unknown

`Enter-Enter-4`

It isn't known what this code does (if it still even does what it once did). The prompt that will be displayed after the first code is `Rate1:`.

? Rate2 — unknown

`Enter-Enter-5`

It isn't known what this code does (if it still even does what it once did). The prompt that will be displayed after the first code is `Rate2:`.

? Rate3 — unknown

`Enter-Enter-6`

It isn't known what this code does (if it still even does what it once did). The prompt that will be displayed after the first code is `Rate3:`.

Interstitial Interval

`Enter-Enter-7`

Very early on there were TiVo-guy animations that occurred between each of the menus (where he would juggle balls, kick them around, lasso them, and bounce them into the screen; the balls represented recordings). These were later taken out, and haven't been in the TiVo software for quite a while. This obsolete code related to these animations. Entering it gives you an `Inter:` prompt. Setting a value with this code is equivalent to setting the TIVO_ INTERSTITIAL_INTERVAL variable early on in the `/etc/rd.d/rc.sysinit` file on the hard drive. One can guess that it changed the timing of these clips, though it doesn't seem to do anything anymore.

? Open — LongOpen Interval — unknown

`Enter-Enter-8`

It isn't known what this code does (if it still even does what it once did). The prompt that will be displayed after the first code is `Open:`.

Interstitials On/Off

`Enter-Enter-9`

This obsolete code turned on and off the TiVo interstitial animations described in the Enter-Enter-7 description previously discussed. Each time you enter the code, the response alternates between `Int. disabled` and `Int. enabled`.

Set Clock

`Enter-Enter-TiVo`

When this worked, this set the current time and date on your TiVo. The prompt displayed after the code is entered is `Time:`. The date you enter is of the format:

`YYYYMMDDhhmmss`

(Where YYYY = year, MM = month, DD = day, hh = hour in military time — GMT based, mm = minutes, and ss = seconds.)

Before entering the code, you would have to be in "Debug mode" (see the Clear-Clear-Enter-Enter-2 code later in this chapter).

This no longer works in 3.0, though it's still possible via another method. To set the clock, from a bash prompt (obtained in Chapter 5) you can use the `settime` command:

```
=[tivo:root]-# settime 20030528100000
Time set to: Wed May 28 10:00:00 2003
Have a nice day.
=[tivo:root]-# settime -rtc
Time set to: Wed May 28 10:00:02 2003
Have a nice day.
=[tivo:root]-#
```

The first `settime` command sets the time in the normal clock, then the second command sets the time in the hardware real-time clock to the value of the normal clock.

Change Overshoot Correction offset

`Enter-Enter-Rewind`

See the Clear-Enter-Clear-5 code discussed previously for a description of what overshoot correction is.

Prior to version 3.0, the way to control overshoot correction was via this code and the Enter-Enter-FastForward code in the next section. These no longer work in 3.0; users of 3.0 should see the Clear-Enter-Clear-6 Node Navigator code discussed previously (be sure to read the warnings there before trying the code!).

The Enter-Enter-Rewind code displays the `Offset:` prompt, letting you enter an offset value for overshoot correction. The default value for this is 2000; to simulate the previous overshoot behavior in 1.3, use a value of 1000 (be sure to change the delay as well with Enter-Enter-FastForward in the next section).

Change Overshoot Correction delay

`Enter-Enter-FastForward`

See the previously discussed Clear-Enter-Clear-5 code for a description of what overshoot correction is.

Prior to version 3.0, the way to control overshoot correction was via this code and the Enter-Enter-Rewind code above. These no longer work in 3.0; users of 3.0 should see the Clear-Enter-Clear-6 Node Navigator code discussed previously (be sure to read the warnings there before trying the code!).

The Enter-Enter-FastForward code displays the `Delay:` prompt, letting you enter a delay value for overshoot correction. The default value for this is 957; to simulate the previous overshoot behavior in 1.3, use a value of 750 (be sure to change the offset as well with Enter-Enter-Rewind as described previously).

Clear-Clear-Enter-Enter Codes

The Clear-Clear-Enter-Enter codes are all entered on the System Information screen (under TiVo Central ➜ Messages & Setup ➜ System Information).

Debug Mode

`Clear-Clear-Enter-Enter-2`

Prior to 3.0, this code used to turn on Debug mode. After entering this code, you would hear one ding. Leaving the System Information screen and returning to the System Information screen, you would see "Special Mode: DEBUG" displayed, indicating that the code was active. This mode stayed on even after a reboot, only going away when the code was entered a second time.

In this mode, extra debugging information is written to the file `/var/log/tvdebuglog`. This mode was required for the Enter-Enter-TiVo (Set Clock) code to work.

Initiate (Special?) Call

`Clear-Clear-Enter-Enter-3`

Entering this code causes your TiVo to perform a call to TiVo Inc. It's not clear if this was meant to be a normal call or a special call that customer support would tell people to make when problems occurred.

Timestamp Problem in Log

`Clear-Clear-Enter-Enter-7`

This code causes the following line to be written to `/var/log/tverr`:

```
(none) SetupSystemInfoContext[199]: OnNumber: USER PROBLEM LOGSTAMP
```

Presumably this was a way for TiVo Inc. to have customers mark when a particular problem was occurring so the users logs could be analyzed.

Empty Channels You Watch Screen

`Clear-Clear-Enter-Enter-8`

This code used to bring you to the Channels You Watch screen, with *no* channels selected. People have reported problems continuing from this screen — this code should be avoided. It no longer does anything in 3.0.

Change Dial-in Configuration Code
`Clear-Clear-Enter-Enter-0`

This code lets you change the numeric portion of the Dial-in Configuration Code listed in the System Information screen. The default is 000. The value can be changed by scrolling down until you can see "Dial-in Configuration Code," pressing Clear-Clear-Enter-Enter-0, typing out a three-digit number, then pressing enter. Presumably this was used by customer support, telling a user to enter a specific number, causing specific pieces of code or data to be downloaded during the next call. This isn't something you should play with.

The Toll-Free-Authorization (TFA) code remains unaffected. This indicates whether your machine is allowed to call the 1-800 dial-in numbers or not.

Backdoor mode does not need to be enabled for this code to work.

Other Clear-Clear-Enter-Enter Codes
Four other Clear-Clear-Enter-Enter codes cause the single ding to occur, but no one has figured out what (if anything) they do: Clear-Clear-Enter-Enter-4, Clear-Clear-Enter-Enter-5, Clear-Clear-Enter-Enter-6, and Clear-Clear-Enter-Enter-9.

Thumbs Codes

The Thumbs codes (also known as the Triple Thumb codes) work in versions 2.5, 3.0, and 4.0 (they did nothing before then). Each has to be entered in a particular screen; some work in multiple screens, performing different tasks depending on which screen they were entered in (and they'll be listed here as separate codes).

Scheduled Suggestions in To Do List
`ThumbsDown-ThumbsDown-ThumbsUp-InstantReplay`

If entered while on the To Do List screen in version 3.0 or 4.0, this turns on the display of "scheduled suggestions". The To Do list normally only displays recordings you've scheduled via recordings, wishlists, and season passes; however, this code now also causes it to display suggestions that TiVo currently plans to record.

Scheduled Suggestions were enabled differently in versions 2.0, and 2.5 (see the previous description of Clear-Enter-Clear-2).

Figure 2-13 shows how the To Do List looks after the code has been entered (entering it again turns this behavior off). Note the entries without any yellow checkmarked circles next to them; those are scheduled suggestions.

Hidden Recordings in Now Playing
`ThumbsDown-ThumbsDown-ThumbsUp-InstantReplay`

When this code is entered on the Now Playing screen it makes the Hidden Teleworld Recordings visible. Teleworld recordings are programs that TiVo records around 4:00 A.M., once a week on the Discovery Channel. These recordings contain within them many small clips used for various promotions and showcase items. The Teleworld recordings visible via this code are the entire original recording.

FIGURE 2-13: Scheduled suggestions displayed in To Do List.

These recordings live in a reserved section of disk space, outside of your normal recording capacity (that is, if you have an 80-hour TiVo, these recordings don't take up any of your 80 hours). Figure 2-14 shows the hidden recordings, which occur on the bottom of the Now Playing list below recorded TiVo suggestions.

Clips On Disk Menu

ThumbsDown-ThumbsUp-ThumbsDown-InstantReplay

⭐ The Teleworld recordings mentioned in the previous code contain many short video clips intended to be separate. The TiVo software uses VBI information to determine where in a Teleworld recording what parts start and end where, and what to call them. A full recording is broken up into clips. In actuality the video remains as one big hidden recording, but clip objects are created to point within those recordings.

This code, when entered in the Now Playing screen, shows all of the clips that exist in the system. You can select one and it will play just that clip. In version 4.0 this screen is available via a Clip Lineup menu item on the TiVo Central screen that occurs whenever Backdoor mode is enabled. Figure 2-15 shows the Clips On Disk menu.

FIGURE 2-14: Hidden Recordings in Now Playing list.

FIGURE 2-15: Clips On Disk.

MenuItem Back Door

`ThumbsDown-ThumbsUp-ThumbsDown-Record`

This code (when is entered on the TiVo Central screen) causes the MenuItem Back Door screen to be displayed. This screen shows info about all of the custom menu items that exist (for example, those yellow-star promotional announcements that appear at the bottom of the TiVo Central screen from time to time). If no custom menu items exist the screen merely displays the current time in seconds (and the formatted equivalent of that as well). Figure 2-16 shows the MenuItem Back Door screen while a yellow-star promotional announcement is in effect, and Figure 2-17 shows that yellow-star item on the TiVo Central screen.

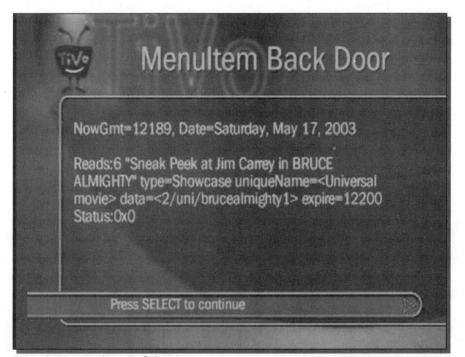

FIGURE 2-16: MenuItem Back Door.

Hidden Showcases

`ThumbsDown-ThumbsUp-ThumbsDown-Record`

Entering this code on the Showcases screen causes older expired showcases to appear as well (whereas normally they would be hidden).

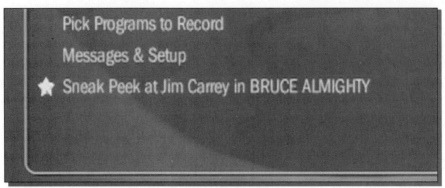

Pick Programs to Record

Messages & Setup

★ Sneak Peek at Jim Carrey in BRUCE ALMIGHTY

FIGURE 2-17: The yellow-star promotion described in Figure 2-16.

Italic Font

`ThumbsDown-ThumbsUp-ThumbsDown-Clear`

When this code is entered on the TiVo Central screen, all of the fonts on every page are rendered in italics. Entering the code again returns the fonts to normal. Figure 2-18 shows the TiVo Central screen rendered with an italic font.

FIGURE 2-18: Italic font enabled.

Dial Prefix Codes

In the Phone Dialing Options page (TiVo Central → Messages & Setup → Recorder & Phone Setup → Phone Connection → Change Dialing Options), there is an option that lets you change the dial prefix. In 3.0, there are now some special dial prefix codes you can enter that tell your TiVo to place its calls to home over either Ethernet or a PPP (Point-to-Point Protocol) connection on the serial line instead of with the built-in modem.

Decrease Modem Speed to 28.8 Kbps
`,#034`

When this code is entered on a DirecTiVo, the modem speed is decreased to 28.8 Kbps.

Decrease Modem Speed To 14.4 Kbps
`,#019`

When this code is entered on a DirecTiVo, the modem speed is decreased to about 14.4 Kbps.

PPP over Serial Line — Direct
`,#2xx`

`(xx: 96=9600, 38=38400, 57=57600, 11=115200)`

When this code is entered on a TiVo running 3.0, daily calls to home are made using PPP over the serial line at the specified (xx) speed.

PPP over Serial Line — With Modem Emulation
`,#3xx`

`(xx: 96=9600, 38=38400, 57=57600, 11=115200)`

When this code is entered on a TiVo running 3.0, daily calls to home are made using PPP over the serial line at the specified (xx) speed as with ",#2xx" described previously. At the beginning of the transmission, however, the TiVo first pretends it is talking to a modem with standard AT commands. Though there are only send and receive lines on TiVo's serial port (and thus hardware handshaking is out of the question), it is still technically possible to connect an external modem and have your daily calls go through it.

Ethernet via TiVoNet/TurboNET/USB
`,#401`

When this code is entered on a Series1 TiVo running 3.0 that has a TiVoNet or TurboNET card installed, or on a Series2 TiVo with a USB to Ethernet adapter, daily calls to home are made via Ethernet.

This functionality is now standard in version 4.0 — no dialing prefix code is required. On TiVo's site, there is a list of currently supported USB-to-Ethernet adapters at:

`http://customersupport.tivo.com/tivoknowbase/root/public/tv2006.htm`

That list relates to what is supported now in 4.0 though — fewer adapters were supported during 3.0 with this dialing prefix hack.

At the time of this writing, DirecTV has decided to not offer the Home Media Option (HMO) package as an option to its customers, and thus does not provide support for USB-to-Ethernet adapters.

Other Codes

Here are the remaining known codes, which don't fit into a convenient initial-button-press category like most of the codes previously described.

S.O.R.T. — Sort the Now Playing List

```
Slow-0-Record-ThumbsUp
```

Version 3.0 contains this backdoor that lets you sort items in the Now Playing list. While on the Now Playing page, pressing **Slow-0-Record-T**humbsUp causes a black box saying "Press DISPLAY for sort options" to appear at the bottom of the screen (which can be difficult to see on some televisions).

Once this mode is entered, pressing 1 sorts the items the traditional way (by record date), pressing 2 sorts the items by expiration date, and pressing 3 sorts the items alphabetically. Pressing Display or Enter brings up the Now Playing Options screen. Figure 2-19 shows the Now Playing list sorted alphabetically, and Figure 2-20 shows the Now Playing Options screen.

FIGURE 2-19: S.O.R.T. mode enabled, sorted alphabetically.

FIGURE 2-20: Now Playing Options screen.

Version 4.0 makes this an official feature (no backdoor code needed), but makes some changes as well. Sort by expiration is not an option; it's either alphabetical or by record date. The description on the bottom of the screen is transparent instead of black, and the Now Playing Options screen also contains information about the 4.0 folders feature.

Autotest Mode

`1-2-3-ChanDown`

Under software version 3.0, if you go to the Now Playing screen and select an item, then press 1-2-3-ChanDown, Autotest mode will be enabled.

When you're in Autotest mode, pressing 4 starts and stops the current test. Random buttons are triggered to test the user interface. Pressing 5 moves to the next test, while 7 and 8 change the length of the pause between button presses.

Autotest mode remains in effect until the next time your TiVo is rebooted.

TeachTiVo

It's not often that things get taken away, but when they do people get vocal about it. TeachTiVo was a hidden feature available only in version 2.0 of the software, and people are always asking for it to come back. It let you directly observe and affect TiVo's ratings of Actors, Directory, and Categories/Genres. If you don't want to be teased about something you can't have, skip ahead to the next section.

If you went to the TiVo's Suggestions screen, pressed 4, then caused Suggestions to be reevaluated (by giving something a thumbs up), a new item called Teach TiVo would be added to your TiVo's Suggestions screen (see Figure 2-21). Selecting that item would bring up the Teach TiVo screen (see Figure 2-22).

Pressing 1, 2, or 3 from the TiVo's Suggestions screen would take you straight to Teach Categories, Teach TiVo Actors, and Adjust Program Ratings.

You could "Teach" TiVo your preferences for individual categories (such as Movies/Sci-Fi), actors, or directors. Each screen would display explicit ratings you'd given it via Teach TiVo (with the normal Thumbs-Up/Thumbs-Down icons), as well as its own guesses (with different boxed-Thumbs-Up/Thumbs-Down icons). Figures 2-23, 2-24, and 2-25 show the Category, Actor, and Director pages.

FIGURE 2-21: Teach TiVo item present in TiVo's Suggestions screen.

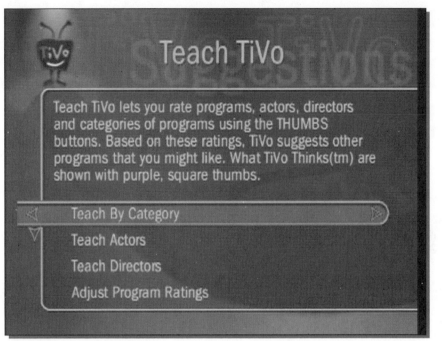

FIGURE 2-22: Teach TiVo screen.

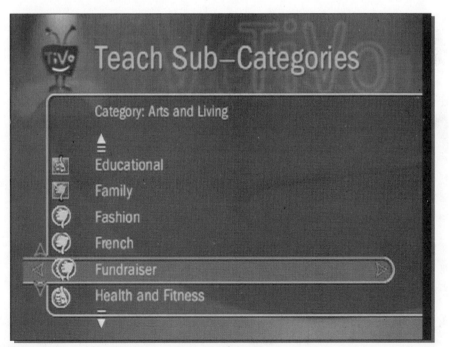

FIGURE 2-23: Teaching TiVo your category preferences.

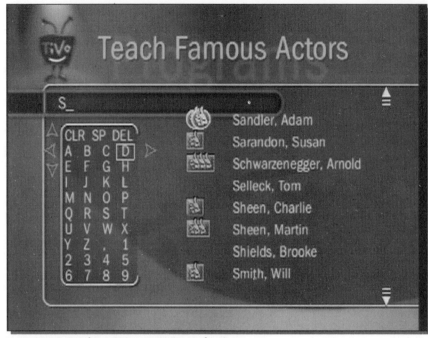

FIGURE 2-24: Teaching TiVo your actor preferences.

FIGURE 2-25: Teaching TiVo your director preferences.

You could also do another thing that's now impossible without using hacks such as TivoWeb (see Chapter 7): You could see the thumbs ratings you'd given to movies/programs that weren't airing within two weeks. In fact, you could change those ratings. Adjust Program Ratings (see Figure 2-26) let you see and change ratings for *all* movies/programs that you had rated, and all movies/programs within two weeks that TiVo had guessed you'd like.

There are definitely arguments to be made for *not* having Teach TiVo as an official feature: It could be confusing to new users, it might let you do more damage than good (do you *really* like that actor that much, or do you just think you do?), and its very existence could imply to a new-comer that it was necessary. But it certainly would be nice to eliminate a few genres that I know I never want to see.

Free Space

0-ThumbsUp

⭐ If you're running version 4.0, you can now get access to something people have been ask-ing for since the birth of TiVo: a free space indicator. Thanks go to Eric McDonald (MuscleNerd on tivocommunity.com) for finding it. With backdoors enabled, go to the Pick Programs to Record screen and press zero-ThumbsUp. You'll get the Disk Space Usage screen, which should look something like Figure 2-27.

FIGURE 2-26: Adjust Program Ratings screen.

FIGURE **2-27: Disk Space Usage screen in 4.0.**

Again, there are valid arguments for not including this as an official feature. Free space on a TiVo is a very difficult concept because it's actually two-dimensional, not just one. Saying that you currently have 10 hours of free space when you have an 8-hour scheduled recording occurring in 5 minutes doesn't really describe the picture accurately. You really should have a graph showing how much space will be occupied over the next two weeks with the currently scheduled recordings. That's obviously too much for the average user though. Most people use the number of recorded TiVo suggestions as a rough indication of how much "free" space they have; now, they have another way.

(It should also be noted that TivoWeb has a free space indicator. TivoWeb is described in Chapter 7.)

Advanced WishLists

If you're a fan of WishLists, you may have run into a few limitations of them. For example, there is no way to create a WishList for programs containing both one actor and another. You also can't create a single WishList that catches one of multiple actors. More complex ideas (such as combining genre with directors and actors, as in "Action&Adventure Movies directed by George Lucas starring Harrison Ford") cannot be done either.

Along come Advanced WishLists to the rescue. This extremely useful feature was available all the way back in 2.0 when WishLists first appeared.

You have one or two methods to enable Advanced WishLists, depending on what version of software you are running. If you're using 3.0 you can permanently enable Advanced WishLists using the Node Navigator discussed above (read about this dangerous option *before* trying the code: Clear-Enter-Clear-6). Doing this makes the Create WishList page have a hidden option, Advanced WishList, at the bottom (scroll down — it's below Title WishList). If you are using a version before 3.0 (or for that matter if you are using 3.0 or 4.0 and don't want to mess around with the Node Navigator), you can press "0" on the remote at the Create WishList page (provided that you are in Backdoor mode).

Creating a new Advanced Wishlist with either of those methods first brings you to the Create Wishlist screen (see Figure 2-28).

You can select a genre, but once you do you can't modify (or observe) it. You can add multiple actors, directory, and keywords as well. After adding items, Edit List appears on the Create WishList screen. Selecting it shows something similar to Figure 2-29.

FIGURE 2-28: Create (Advanced) WishList screen.

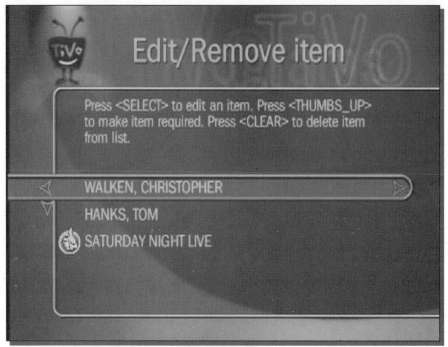

FIGURE 2-29: The item list page of Advanced WishLists.

The Advanced WishList in Figure 2-29 deserves some explanation. Walken,Christopher and Hanks,Tom are actor items, while Saturday Night Live is a keyword item. I pressed Thumbs Up next to Saturday Night Live, causing it to be *required*. All items with Thumbs Ups next to them *must* be present for a match, and *at least one of the remaining no-Thumbs-Up items must exist as well*. One could also describe that WishList as:

(Saturday Night Live AND (Walken,Christopher OR Hanks,Tom))

Upon completing the creation of an Advanced WishList, you see the Advanced WishList screen (see Figure 2-30), which isn't much different from the completed WishList screen for any type of WishList.

Another nice thing about Advanced WishLists is that you can rename them. "FavoriteSNLHosts sounds much better than a two-page long WishList title.

Getting back to the other examples at the beginning of this section, you could easily create an Advanced WishList with Jack Lemmon and Walter Matthau, both with Thumbs Ups next to their names. You could even put a category "Movies" with it, to select all movies containing both actors.

To create a WishList that finds only Action&Adventure Movies directed by George Lucas starring Harrison Ford, set the category to Movies/Action&Adventure, add a director of George Lucas, and add the actor Harrison Ford. Make sure that George Lucas and Harrison Ford have Thumbs Ups next to their names, and you're done.

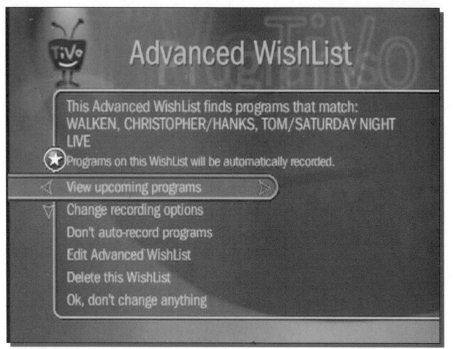

FIGURE 2-30: Advanced WishList completed.

DirecTiVo Satellite Data Status Messages

ThumbsUp

When on the DirecTiVo's Satellite Info screen ("Please wait while the Recorder acquires information from the satellite"), pressing Thumbs Up displays status messages at the bottom of the screen. One of the pieces of information available is which transponder is being used (TX:). You do not have to be in Backdoor mode for this code to work.

HMO "Advanced Troubleshooting" Screen

0-ThumbsDown

If you have a Series2 TiVo and have purchased the Home Media Option (HMO) package, then entering 0-ThumbsDown from the Now Playing list brings up an Advanced Troubleshooting screen. It seems to display information about existing HMO-enabled TiVos in your household with which video sharing might be enabled.

"IPreview Authoring Mode"

Clear-Play-Play-Clear-SkipToLive

When you are watching a recording and the iPreview icon pops up, enter the above code (you *do* need to be in Backdoor mode for this to work). Dings will sound, and you will enter IPreview Authoring mode. Some data related to the iPreview elements that are added into broadcast streams by TiVo partners will be displayed on-screen (see Figure 2-31). ID seems to correspond to the TmsId of the program that will be selected if you press Thumbs Up.

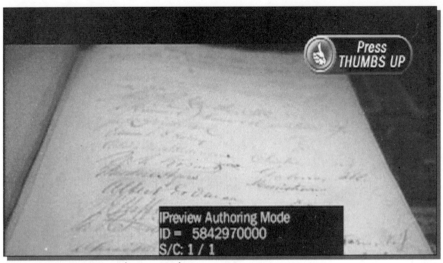

FIGURE **2-31: iPreview Authoring Mode.**

Unknown "789" Code

789

One other code I've found that I can't determine the effect of is entering "789" at the Now Playing screen in version 4.0 (which causes a single ding).

Shortcuts

There are a bunch of shortcuts that will bring you from TiVo Central to the most frequently used screens with a single press of a button. Although these aren't backdoors or secret in any way, enough people make it by without knowing them that I thought it worth mentioning them here.

Table 2-3 shows what screens you will jump to if you press various keys from the TiVo Central screen.

Table 2-3:	Shortcuts from the TiVo Central Screen
Button Press	**Screen You Are Taken To**
1	Season Pass Manager
	(Prior to version 2.5, this went to Now Playing.)
2	To Do List
3	Search Using WishLists
	(Prior to version 2.0, this did nothing.)

Button Press	Screen You Are Taken To
4	Search By Title
5	Browse By Channel
	(In version 2.0 this went to live TV, whereas in prior *and* later versions it goes to Browse By Channel.)
6	Browse By Time
7	Manually Record Time/Channel
8	TiVo's Suggestions
9	Showcases
0	Intro TiVo-guy Animation
	(Some DirecTiVo units lack this animation now.)
TiVo	Now Playing
	(Prior to version 2.0, this did nothing.)
Slow	TiVo Messages & Setup
	(Prior to version 4.0, this did nothing.)

Changing the Backdoor Code Under 3.1/3.2/4.0

The backdoor code for versions 3.1, 3.2, and 4.0 are not known at the time of this writing. It's entirely possible that there is no valid backdoor code that can be entered, however there *is* a Backdoor mode.

Using a hex editor, you can modify the hash for the backdoor code under 3.1/3.2/4.0 to be the hash of a known password (such as the hash for 3.0), so you can enter Backdoor mode on these machines.[2]

This process involves removing your TiVo's hard drive and connecting it to your computer. You may want to skip this section if you haven't read later chapters yet, and come back to it at a later time. Chapter 3 discusses removing the drives from your TiVo to make a backup, which should be considered a prerequisite to doing anything described here.

Caution

Just to be clear, I'll say that again. Make a backup of your TiVo's hard drive before attempting this procedure! If you modify the wrong thing, you can damage your TiVo and possibly render it useless. Chapter 3 describes making a backup.

[2] If there are any knowledgeable readers reading this that have already obtained access to a bash prompt on their 3.1/3.2/4.0 TiVos (by modifying their PROMs or via tricks like the two-kernel-monte trick that's out there), then there's another way for you to change the hash for the backdoor code. The hash is contained in ResourceItem 176 of the second ResourceGroup in the MFS object /SwSystem/ACTIVE. See Chapter 12 for more information on MFS and what this means and how to change it. One could easily write a TivoWeb Resource Editor addition to change this as well, but since this is something you'll only change once, it hardly seems worth it; still, the exercise is left to the reader should they wish to do it—see Chapter 7 for more info on TivoWeb.

Connect your A drive up to your computer as described in Chapter 3, and boot the accompanying CD, being sure to pick either "series1" or "series2," depending on what type of TiVo you have. The following instructions will assume that you have connected the drive to the secondary IDE bus as master (and that therefore the drive's device name will be /dev/hdc).

Once the CD has booted completely, you should get a =[HackingTiVoCD]-# prompt. Verify that you've connected the right drive by running the script checkdrivesetup as you did in Chapter 3 when creating your backup (you did create that backup, right?)

What we are going to do is search directly through the disk partition(s) that contain the MFS application region, looking for the hash of the 4.0 backdoor code. We'll replace it with the hash of a known previous backdoor code. In this example, we'll set it to be the hash for the 3.0 password "3 0 BC".

First, make sure you know which partition(s) hold the MFS application region (we talk about the partitions briefly in Chapter 4). To determine the correct partition(s), we use the pdisk command:

```
=[HackingTiVoCD]-# pdisk -l /dev/hdc

Partition map (with 512 byte blocks) on '/dev/hdc'
 #:                 type name                   length    base      ( size )
 1: Apple_partition_map Apple                       63 @ 1
 2:             Image Bootstrap 1                     1 @ 85965834
 3:             Image Kernel 1                     8192 @ 85965835 (  4.0M)
 4:              Ext2 Root 1                     262144 @ 85974027 (128.0M)
 5:             Image Bootstrap 2                     1 @ 86236171
 6:             Image Kernel 2                     8192 @ 86236172 (  4.0M)
 7:              Ext2 Root 2                     262144 @ 86244364 (128.0M)
 8:              Swap Linux swap                 131072 @ 86506508 ( 64.0M)
 9:              Ext2 /var                       262144 @ 86637580 (128.0M)
10:               MFS MFS application region     524288 @ 86899724 (256.0M)
11:               MFS MFS media region         68353188 @ 87948300 ( 32.6G)
12:               MFS MFS application region 2   524288 @ 87424012 (256.0M)
13:               MFS MFS media region 2       85965770 @ 64       ( 41.0G)
```

In this case, the partitions we need to check are /dev/hdc10 and /dev/hdc12. The program hexedit (which is on the accompanying CD) will let you edit individual bytes of a file; you can also use it directly on a raw disk partition.

To edit the first partition in this example, type hexedit /dev/hdc10.

You should see something that looks like Figure 2-32.

Now we want to search for the existing password hash that we want to replace. If your TiVo has version 3.1 or 3.2, the hash you are searching for is:

96F8B204FD99534759A6C11A181EEDDFEB2DF1D4

If your TiVo has version 4.0, the hash you are searching for is:

61508C7FC1C2250E1794624D8619B9ED760FFABA

(Those are ASCII strings, not hexadecimal values.)

FIGURE **2-32: Running hexedit on MFS Application Region partition.**

To search for this, press the Tab key (which should move the cursor to the right hand side of the screen), then press "/". You should see:

```
Ascii string to search: ()
```

in the center of the screen. If instead it says:

```
Hexa string to search: ()
```

then press return, TAB, and "/" again.

Carefully type out the entire hash string you're searching for, and press return. Searching may take up to a minute or two. If it fails to find the hash string and you have multiple MFS Application Regions, exit hexedit by typing Ctrl-C and try the next partition, which in our example would be done with "hexedit /dev/hdc12".

When it finds the hash string, with the cursor on the right over the first character (either 6 or 9, depending upon the hash for your version), you should *carefully* type the string for the replacement hash you're using. Table 2-4 shows some replacement hashes you can use and the backdoor codes that correspond to them.

Table 2-4: Some Replacement Backdoor Hashes

Backdoor Code	Hash for That Code
3 space zero space BC	5CA5D9DBE5338BAB8690C79C9A9310BCD3A8F23B
(empty — no code)	EEA339DA0D4B6B5EEFBF5532901860950907D8AF
T space one space V space zero	AC4C8366FE8AECBE054927D63F7D5F12AAE59E9A
AAAAAAA	9D86B2F92692CCE63FD890B939C85E80859CCC15
BACKDOOR	389DD8D6E5D37CCB8F532A989C59BAA782A5D794

For instance, to make your backdoor code be "3 space 0 space BC", you'd type:

```
5CA5D9DBE5338BAB8690C79C9A9310BCD3A8F23B
```

If you'd rather not remember "3 0 BC", you can use the "empty" hash from Table 2-4; if you use it, all you have to do to enable backdoors is to press Thumbs Up at an empty Search-By-Title screen.

Case matters — make sure those letters are all uppercase!

We now need to repeat the process (there will be multiple instances of the old hash, and they all need to be replaced with the same replacement string). Type "/", and it will ask you if you want to save your changes. Again, you made a backup of your drive, right? If you've entered the hash correctly (and you are sure you didn't type over anything else), press Y.

Now you'll have your search prompt again, but this time the search string you searched for previously is shown as the default. Hit return, and hexedit will search for the next occurrence of the original string. Replace this as well (the same way as above), and continue repeating this until there are no more occurrences of the original hash string left. When you are done (having seen "not found" on your last search), you can exit hexedit by pressing Ctrl-C.

If you had multiple MFS application region partitions (as reported by the pdisk command above), search through those other partitions as well, performing the same substitutions in the same way.

When you're done editing all of your MFS application regions, shutdown the machine by typing "shutdown", and place the hard drive back in your TiVo (as described in Chapter 3). Boot up the TiVo, go to Search By Name, and enter the appropriate backdoor code that you chose from Table 2-4. Press Thumbs Up; it should ding five times and say "Backdoors Enabled!" (see Figure 2-3).

Easter Eggs

Easter eggs are the little secret hidden messages that developers often throw in their products. When the TiVo backdoors were first discovered, many people were calling them Easter eggs, but that practice has since stopped; TiVo's backdoors are really hidden *features*, and there are quite a few of them (as you've seen). Still there are two remaining hidden-away things that do classify as Easter eggs. (There may be more — I hope there are — if so they're just not commonly known right now.)

Not wanting to spoil the first one, I won't give it a name or describe the joke behind it. Some of you will find it funny, others won't know the reference — search on Google (google.com). Enter Backdoor mode, go to the System Information screen, and page down about twenty times. At some point, you'll start hearing bongs — keep scrolling down.

The second one has a name: SHAGWELL. First turn on closed captions on your television. Then, go to the Search By Title screen and type out SHAGWELL on the on-screen keyboard, and press Thumbs Up.

Summing Up . . .

My personal opinion is that it's a good sign if a product has lots of hidden features and "Easter egg"-like things hidden away in it. It shows that the people working on it cared enough (and were enthusiastic enough) to put them in.

What's so particularly good in this case are that so many of the hidden features here are actually *useful*. Luckily, people organized to share the codes they found. If you think you've stumbled upon a new code that is clearly a backdoor, read through the New Almost Complete Codes List thread mentioned at the beginning of this chapter, and post it if it's not discussed anywhere within the thread.

Ok, enough observing from afar. It's time to open up your TiVo and make it better.

Diving In (Installing Existing Hacks)

O k, it's time to do some work on your TiVo. In Part II I describe many of the most popular and useful TiVo hacks out there today, and provide detailed instructions on how to install and use them yourself. You will increase your TiVo's capacity, get your TiVo transferring files over a network, set up a web server to remotely control your TiVo, enable it to display data from the web on-screen, extract recordings off of your TiVo, and more. This part will clearly be of interest to everyone who made it past the previous part, and can be done by anyone with enough familiarity with their PC to connect drives up to the IDE bus and boot a CD.

Chapters 3 through 6 should be considered prerequisites for the rest of the book. Chapter 3 discusses adding more storage to your TiVo, Chapter 4 describes how to install the software on the accompanying CD-ROM, Chapter 5 gets your TiVo on your network, and Chapter 6 sets up file transfer tools to get files to/from your PC.

Once that infrastructure is in place, the remaining chapters deal with specific hacks, what they do, and how you use them. Chapter 7 talks about a web interface for your TiVo called TivoWeb. Chapter 8 describes TiVo Control Station (TCS), which among other things lets you see sports scores and weather maps on-screen. Chapter 9 covers other hacks that display things on-screen, such as arbitrary text or graphics, closed captions, and caller-ID data. Chapter 10 lets you extract video from your TiVo to your PC, and Chapter 11 covers other miscellaneous hacks like Batch-Save-To-VCR.

Increasing Your Storage Capacity

I remember when my wife and I bought our first TiVo. It held 14 hours of recordings. When you looked closely though, you realized that it was 14 hours of "basic" quality — the quality on which even cartoons look bad. It was somewhere around 4 hours of "best" quality. Needless to say, we used basic for everything.

Prior to this, I had been one of those VCR owners that actually used his VCR to record things. Before I met Laurie, the living room of my apartment was filled with videotapes. So I really appreciated all of the features TiVo provided, such as jumping from show to show, skipping around within shows quickly, and guide data. All of it was incredibly cool.

But when I added an extra 80-gig drive to my TiVo, the change was profound. I realized that what used to be our 14-hour TiVo, and this new 110-hour TiVo that it had become, were *two fundamentally different products.*

At 14 hours, a TiVo could hold almost twice what a VCR with an 8-hour tape could hold. You didn't have to worry about rushing home to see your favorite shows. You could fast-forward quickly. If you were good about watching things on time, you might even find space to record a movie to watch later. It was way better than a VCR.

But our 110-hour TiVo was completely different. It changed things, in a big way. Now, our TiVo was recording things on its own that it imagined we'd like. Now, we were keeping shows around longer. Now, there was always something on.

Season Passes were now incredibly useful. There were always a few *Simpsons* and *Seinfeld* reruns lying around. We watched every episode of *The Practice* in reruns, without being glued to our TV each night. And we had entire seasons of *The Sopranos* at our fingertips.

All of a sudden, our subscription to pay channels like HBO made sense. Every once in a while, I'd do a search-by-name for movies, walk through the entire 2-week lineup, and schedule movies for us to see later.

Movies and shows would pile up, waiting to be watched or perhaps ignored. Occasionally a friend would say, "When are you going to find time to watch all that? Why do you need that much space?"

What they didn't get was that it was always better to have a TiVo full of shows I know I like than to have nothing and have to watch whatever happens to be on at the time. An empty TiVo is a bad, bad thing.

It didn't matter whether we watched it all or not. At first we felt compelled to watch everything we'd recorded, calling it "TiVo debt," but we got past that. We watch what we want, and ignore what we find ourselves not watching. Shows we thought we liked sat on our TiVo, unwatched, because we weren't forced to "watch or give up now" each week. It helped us watch less of the mediocre programming out there and more of the shows we really cared about.

The simple change from 14 hours to 110 was enough to completely change the product. It acted the same, but what it did for us was far more important. Somewhere between 14 and 110 hours, a threshold lies, where the machine metamorphoses into something significantly better.

Unfortunately, the desire to add space continues from there as well. Since that's 110 hours of basic quality (and only around 30 hours of best quality), even more storage is desirable.[1]

Ok, enough talk. Let's go ahead with the most important and basic hack in this book: upgrading the storage capacity of your TiVo.

Things You Need First

Before you start thinking that you will have an upgraded TiVo within hours, let's walk through the things you'll need. If you're adding a second drive, you may need a mounting bracket, which you will have to order through the mail. Set your expectations accordingly.

Mounting Bracket

Ok, let's talk about the mounting bracket. If you're going to be adding a second drive to your TiVo (as opposed to simply replacing the existing drive), then you might need a mounting bracket. Some models require one type, others another, and some don't need any at all.

If the model number of your TiVo is HDR110, HDR112, PTV100, HDR212, SVR2000, HDR31201, HDR31202, HDR31203, or HDR31204, you need to purchase a Series1 mounting bracket to add a second drive. They are available at:

`http://www.9thtee.com/tivoupgrades.htm#BRACKET`

("TiVo Mounting Bracket - Series 1" : TIVOBRACKET)

As I write this, the cost for Series1 mounting brackets is around $16.

[1] DirecTiVo owners may be a bit confused at this point, so let me explain. Standalone TiVos have four quality settings for recordings: basic, medium, high, and best. DirecTiVos don't get a choice, they're always in best mode. The reason for this is that the quality setting is a function of the encoder that exists in standalone TiVos. DirecTiVos don't have an encoder; the digital datastream received from the satellite dish is already encoded. Furthermore, the encoding for DirecTV streams happens before uplink to the satellite, with much more expensive encoders than the one in standalone TiVos. As a result, DirecTiVo users adding an 80-gig drive will add around 70 hours (of best quality, with 5.1 surround sound), but standalone users adding an 80-gig drive will add only 28 hours of best quality (or 96 hours of basic quality).

If the model number of your TiVo is HDR312 or HDR612, you should already have a second drive in your machine, meaning you have no need for an additional mounting bracket. The HDR312XX models above sometimes may come with a second drive inside, depending on where you get it, so it might make sense to open your TiVo up before ordering a bracket.

DirecTiVo Series1 models don't require mounting brackets, because the drive screws right into the unit.

Series2 users should generally open their machines to determine if they need a Series2 mounting bracket. The TiVo-branded 80-hour Series2 (TCD240080), the Tivo/ATT-branded 40-hour Series2 (TCD230040, not TCD130040), and the Hughes HDVR2 all require a Series2 mounting bracket to add a second drive. These are a bit more problematic to install, because these machines weren't designed for two drives, but mounting brackets exist nevertheless. They are available at:

`http://www.9thtee.com/tivoupgrades.htm#BRACKET`

("TiVo Mounting Bracket - Series 2, Including TCD230040, TCD240080 & Hughes HDVR2" : TIVOBRACKET-S2)

Another company, weaknees.com, sells a competing Series2 mounting bracket:

`http://www.weaknees.com/twinbreeze.php`

At the time of this writing, the cost for Series2 mounting brackets is around $13 at 9thtee.com, and from $30–50 from weaknees.com (depending on whether you get an additional fan and cables).

Series2 units TCD130040 and SVR3000 do not require mounting brackets to add additional drives.

Internal Cables

Some Series2 units require a power cable splitter (see Figure 3-15 at the end of this chapter). These sell for about $1.50, and can be purchased either at www.9thtee.com or most computer stores.

Another thing that some Series2 units need is a flexible IDE cable. For units where a custom mounting bracket is required, drives are back to back, so some IDE cables have to twist considerably to make them fit. Some people talk of "rounding" their own IDE cables by using a razor blade; good luck with that if you try. Round IDE cables exist as well, and are much more flexible.

Tools

There are several tools you'll need. If you don't have the following, make a quick trip to your local hardware store. You'll need:

1. A #10 Torx screwdriver. (You may need a #15 Torx screwdriver as well, depending on your TiVo.)

2. A Phillips-head screwdriver

3. To pry the case off of my Philips HDR112, I use a tack puller. It goes for about $5 at Home Depot, and is usually sold alongside the screwdrivers. Figure 3-1 shows what one looks like. If you can't find one, a flathead screwdriver may work, but not as well.

FIGURE 3-1: Tack puller.

4. An antistatic wrist strap. These go for about $6–7 at most computer stores. This is kind of like a seat belt — you'll never really appreciate it while using it, but you certainly will wish you had used one when you accidentally fry some component.

Computer

The backup and upgrade are done by pulling drives out of your TiVo and connecting them to a computer. There are several things you'll need to set up ahead of time.

First, you need a PC. The main tool we're going to use is called MFS Tools — it only runs on Linux (though the accompanying CD-ROM contains a mini-Linux OS on it that will boot up and let you run MFS Tools, so you don't need to have Linux installed). Although there are some other TiVo tools for MacOS X, they don't let you do everything we can do with MFS Tools. I strongly recommend trying to get your hands on a PC to use for a while. If you only have access to a Mac (and can't borrow a PC), then check out MacTiVo Blesser, written by Eric Wagner (Loki on tivocommunity.com), which is mirrored at:

```
http://www.weaknees.com/mactivo.html
```

If you do use MacTiVo Blesser, proceed with caution — there are many snags that can cause you to hose your TiVo. Read up a bit on it at this thread:

`http://www.tivocommunity.com/tivo-vb/showthread.php?threadid=79445`

Ok, so you've got a PC handy. You'll need to be able to connect IDE drives to it. Make sure the IDE cables you're using are long enough to reach where you're going to rest your TiVo drives while performing the backup. I open up my PC, and place the TiVo drives on the table to the side of the PC. If you have particularly short IDE cables, you might want to find some other IDE cables to use during the upgrade. I also recommend clearly marking the IDE cables to reflect which is the Primary IDE bus and which is the Secondary IDE bus.

You are going to need access to your computer's CD-ROM drive. Since you're going to need to boot a CD from it, it needs to be an IDE CD-ROM. The "Connecting the Drives" section in this chapter will instruct you on how you should set up your machine.

If you don't have a CD-ROM drive, you're obviously not going to be able to take advantage of the accompanying CD-ROM. You will have to use the floppy drive, and download the MFS Tools boot floppy from the web. Rather than cover floppy-only installation here, I'll redirect you to the popular Hinsdale How-To document at:

`http://www.newreleasesvideo.com/hinsdale-how-to/`

Hinsdale's How-To document is a good reference for upgrades. The MFS-tools boot floppy is available there at:

`http://www.newreleasesvideo.com/hinsdale-how-to/Mfstools2floppy.zip`

If you're only able to get access to a PC with a CD-ROM drive for a limited amount of time, you can create an MFS Tools boot floppy from the accompanying CD-ROM drive. Place the CD-ROM in any Windows machine, and under the directory `/floppy` you'll find a program called `rawrite`. Place a blank floppy in the drive, run `rawrite`, specify an image of "`floppy.img`", and tell it "`A:`" for the floppy drive. That will construct a boot floppy from which you can perform many of the tasks in this chapter.

Backup Drive

A key part of our upgrade procedure will be to make a backup of your TiVo's drive. Don't even think of skipping this part. This isn't some "you know, it's good to do backups" type of mantra — it's critically important in this case. If something goes wrong with your drive, you're out of luck; your TiVo has just become a boat anchor. It's not as if you can put a blank drive in the TiVo and have it just work; you can't. Software from TiVo exists on that drive, and without it, the TiVo is a useless hunk of metal and plastic. Do I seem like I've harped on this enough yet? You *must* make a backup of your drive.

Ok, so what do you need to make a backup of your drive? Well back in the old days, you needed an identically sized drive to store a backup on. People would go out and purchase either 15- or 30-gig drives, and use the dd utility to copy the entire disk onto the new drive. Typically, you'd put your original in a closet somewhere, and now boot off of your new "backup" drive.

This is luckily a thing of the past. Well, luck had nothing to do with it. We have Steven Lang (tiger on tivocommunity.com) to thank. Steven wrote MFS Tools, which lets you make a small backup that is often even small enough to fit on a CD-ROM.

So, back to the question of what you need. You need a drive to store the backup on. Your options are either a Linux ext2/ext3 drive, or a DOS/Windows FAT32 drive. NTFS drives are unfortunately not an option, since Linux can only mount NTFS partitions as read-only.

To be safe, the drive you use should have at least 700 MB of free space on it. Some of my backups are between 150–200 MB, though I have a few around 600 MB.

We'll discuss where to connect that drive in the "Connecting the Drives" section later in this chapter.

Expansion Drive(s)

The whole point of this is to increase the storage capacity of your TiVo. Your TiVo started out initially with either one or two drives. If your TiVo started out with only one drive, you can add a second drive (presumably with lots of space on it). Or, you could replace that single drive with a larger drive in its place. If your TiVo originally came with two drives, you can replace both of those with either a single large drive or two large drives.

These new large drives obviously need to be purchased before you can do your upgrade. When purchasing these drives, there are several issues to consider.

Storage Capacity

Adding an 80-GB drive will result in an increase of either 70 hours on a DirecTiVo, 96 hours of basic quality on a standalone TiVo, or 28 hours of best quality on a standalone TiVo. Actually those numbers are rough estimates, because different types of video are compressed differently on DirecTiVos, and the "save recording space" option on standalone TiVos skews the number as well.

Before you run out to buy a 160-GB drive though, there's a catch. The Linux kernel that TiVos use has a limitation whereby it will only recognize 137 GB of any particular drive. Hopefully this will change with the release of a new software update down the line, but as of the time of this writing this limitation still exists. As a result, many people purchase 120-GB drives, because 160-GB drives are currently significantly more expensive, and they'd rather not waste 23 GB per disk.

Kernel patches exist to provide lba48 support (an addressing scheme that allows the use of larger drives) for your TiVo, but those patches are dangerous considering the fact that newer software updates might not yet support larger drives, and since those updates would wipe out the custom kernel patch, you'd be left with a broken unit. Presumably you could reapply the patch after such an update, but who knows what problems might occur between the update and your reapplying the patch.

One of two things will happen here. Either TiVo will soon have to include a newer kernel distribution with their software updates, or they will stop supporting Series1 units. After either of those events happens, it will be safer to have larger drives, either because they'll be supported by the operating system, or because you'll safely be able to apply whatever kernel patches you want without fear of your TiVo downloading an update.

If you're really interested in having drives larger than 137 GB, and you're willing to lose everything if a software upgrade comes along down the road, do a search on the various forums (primarily dealdatabase.com and tivocommunity.com) for "lba48" for up-to-date information. Remember though, you have been warned.

Drive Speed

Drive speed is an issue people consider when purchasing new drives for their TiVos, but not for the reason you might expect. TiVos ship with 5,400-RPM drives. Having a drive that is faster than that (such as 7,200 RPM) turns out to not be of any benefit, due to the way TiVo writes data to the drive — video is written to disk constantly; 5,400 RPM is fast enough for that.

Disk caches don't generally help either, because they get flushed by all of the data being written to the drive. Remember, a TiVo is *always* recording video to disk, so the working set of the cache gets flushed.[2]

The reason people consider drive speed, then? Heat. Faster drives can cause more heat, and too much heat is a bad thing. It can cause drive failure, video skipping, and so on. As a result, people originally shied away from 7,200-RPM drives. But now with new technologies in newer drives, heat output might actually be less.

I'd give some advice here, but I'm sure it would be obsolete by the time this went to press. If you're concerned about the heat output of a particular drive, do some searches on tivocommunity.com to see what people are saying about particular drives. Do yourself and the community a favor though, and don't go posting questions without searching exhaustively for your answer first.

Voiding Your Warranty — Cracking the Case

To make a backup of your TiVo's drive(s), we need to take them out of your TiVo and connect them to your PC.

There are two big items of caution here. First, since the power supplies in TiVos are not shielded, you can electrocute yourself if you're not extremely careful (even when the unit is unplugged)!!! Second, opening your TiVo voids your warranty. Proceed at your own risk!

[2] Realizing that this problem existed, Nick Kelsey (jafa on tivocommunity.com) has designed and built a device called the CacheCard that sits between the TiVo and its hard drive. It has a slot where you place RAM (random access memory), and acts as a cache to increase the speed of TiVo database accesses. Menus can get pretty slow when you have a huge amount of recordings, and that slowness occurs because of database accesses, so this card has been eagerly awaited since it was announced. Specific areas of the disk are cached with a write-through cache, so that database reads are enormously fast (while still ensuring that all data is written accurately even during a power loss). Speed increases of somewhere between 2× and 6× have been observed through benchmark testing, depending upon the task. The CacheCard is discussed in Chapter 16, and is available for sale at http://www.9thtee.com/tivocachecard.htm .

If you're the kind of person to ignore text next to big icons like that, let me repeat it: BE CAREFUL. TiVos are not designed to be user serviceable, and you can electrocute yourself, EVEN IF THE UNIT IS UNPLUGGED. Also, your warranty will be voided as soon as you crack the case. Be sure you want to do this!

Still with me? Good. Unplug your TiVo and move it to where you're going to be working. First, you will need to remove the case. This varies from model to model. There should be three torx screws on the back of your TiVo (four on some units, but I'm talking about the large ones on the case, not smaller ones near the RCA jacks or modem port; see Figure 3-2). Remove these and store them in a safe place.

FIGURE 3-2: Torx screws to remove.

Depending on the model of your TiVo, you may notice a warranty sticker reading "Warranty void if this seal is broken." People used to talk about using a hairdryer to heat it up so it would-n't be destroyed when opening your unit. Forget it, your TiVo is opened, the warranty is voided.

Next, you need to pry off the case. This can be quite tricky, so take your time with it. The case slides back off of the TiVo exactly 1/2 inch, then swivels up. Getting the case to slide back is extremely difficult on a TiVo that hasn't been opened before. Here is where I use that tack puller to pry the case open. As an example of how to do it, Figures 3-3 and 3-4 show how to pry the case back from a Philips HDR112. Carefully get it under the cover, then twist and pry until it slowly comes loose. Other units are similar.

FIGURE 3-3: Getting the tack puller under the case.

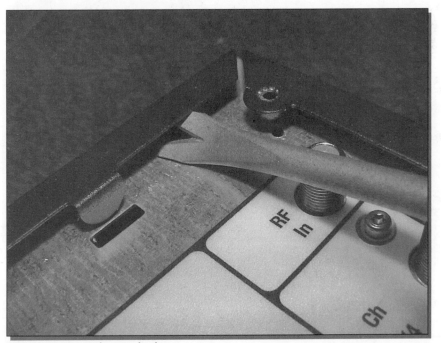

FIGURE 3-4: Prying the case back.

Figures 3-5 and 3-6 show what the case looks like when pulled back all the way, then Figure 3-7 shows how the case lifts off from the back.

Place the cover to the side. Again, be *very careful* about the power supply! Did I mention it was unshielded? That's your last warning. If you're not already wearing it, put on the antistatic wrist strap and connect it to ground (usually via the third prong on a three-prong outlet).

Next, you need to remove the hard drive(s) from your TiVo. If there are already two drives in your TiVo, you're going to want to make note of which is which — it's important. With the back of the TiVo facing you, the drive on the left is the "A" drive; its jumper settings are set to Master. The drive on the right is the "B" drive; its jumper settings are set to Slave.

Removal of the drives is different depending on the type of TiVo you're using. With TiVos that don't require a mounting bracket, you unscrew the drives directly from the frame. With TiVos that require a Series1 mounting bracket, you'll be removing the mounting bracket from the TiVo, with the drive attached. Series2 mounting brackets shouldn't matter here, since TiVos don't ship with them, but removing a drive from one is similar to removing it directly from the frame.

FIGURE 3-5: Case pulled back completely (as seen from back).

FIGURE 3-6: Case pulled back completely (as seen from side).

FIGURE 3-7: Case lifted up from back.

Figure 3-8 shows a single drive in a Philips HDR112 (which requires a Series1 mounting bracket). Remove the two torx screws at the top of the drive's mounting bracket in Figure 3-9, and store them in a safe place. Observe the tabs in Figure 3-10, and that the mounting bracket will slide off of these. Hold the drive by its sides and slide it towards you. Once it's off of the tabs, lift it carefully away from the power supply, as shown in Figure 3-11.

Figure 3-12 shows a single drive in a Hughes HDVR2. Remove the two torx screws at the top of the drive's mounting bracket in Figure 3-13, and store them in a safe place. Hold the drive by its sides, and lift it up off of the frame, as shown in Figure 3-14.

Remove the IDE connector and white power cable from the drive, freeing it from the TiVo. Carefully place the drive (with mounting bracket still attached) near your computer. If your TiVo had two drives inside, remove the second drive as well (similarly to the first), and place it near your computer (being sure to remember which drive it is).

If it turns out that you need to remove the mounting brackets from the drives to connect the drives to your PC, go ahead, but be careful not to lose any of the pieces. I leave my drives in the brackets until I *need* to remove them.

Note There are many models of TiVos, and some won't look like the ones I've described here. Some DirecTiVo models have a removable frame already in your TiVo that you need to remove to get the drives off of. The bottom line is, be careful, and try not to jostle or shock the drives (or yourself).

Move the rest of your TiVo to the side so nothing bad will happen to it.

FIGURE 3-8: Single mounted drive inside a Philips HDR112.

FIGURE 3-9: Two mounting bracket screws to remove.

FIGURE 3-10: Tabs on frame protruding through mounting bracket.

FIGURE 3-11: Pulling the drive and mounting bracket away, cables attached.

FIGURE 3-12: Single mounted drive inside a Hughes HDVR2.

FIGURE 3-13: Two mounting bracket screws to remove.

FIGURE 3-14: Pulling the drive and mounting bracket away, cables attached.

Connecting the Drives

For the sake of simplicity here, I'm going to tell you where to connect what drives, and all of these instructions will assume that configuration. If there is some reason why you absolutely cannot set up the drives as I'm recommending, then you'll have to adjust the instructions in the rest of this chapter accordingly.

There are either three or four drives that we care about at this point: your CD-ROM drive, the drive you'll be placing your backup on, and your TiVo drive(s). Don't worry about any larger disks you've purchased yet, first we're concentrating on making a backup of the drives that were in your TiVo.

Connect the drive that you'll be placing your backup onto (the drive containing either a Linux ext2 partition, or a DOS/Windows FAT32 partition) to your Primary IDE bus, as the Master drive. Be sure to set the jumpers on the drive such that it is the Master drive — don't use Cable Select.

Connect your IDE CD-ROM drive to your Primary IDE bus, as the Slave drive. Again, this may require changing jumper settings if your CD-ROM drive hadn't previously been connected as slave.

Now, connect your TiVo's A drive to your Secondary IDE bus. It already is set to Master. If your TiVo had a second (B) drive inside, connect that to the Secondary IDE bus also (it will already be set to Slave).

In Linux terms, this means the backup drive is /dev/hda, the CD-ROM drive is /dev/hdb, the TiVo A drive is /dev/hdc, and if there is a TiVo B drive, it's /dev/hdd.

If your PC won't boot off of a CD-ROM drive in the secondary slave position, you may have to put the CD-ROM somewhere else, and adjust all future instructions accordingly.

Backing Up Your TiVo

Be sure that you never boot Windows NT/2000/XP with your TiVo drives attached to your computer! Windows will write a signature that will damage the image on the drive. In the next few steps, if you're not entirely sure the device will boot (your CD-ROM, or a Windows installation), disconnect both TiVo drives and try it out first. If Windows writes a signature on your TiVo drive, and you don't have a backup yet, you're out of luck.

We're about to create a backup of your TiVo drive(s). This backup will contain only the software on the drives, your Season Passes, your WishLists, your thumbs preferences, and so on. It will *not* contain any recordings. Later we'll talk about what's needed to move everything *including* your recordings onto a larger drive, but even if that's the path you are taking you still want a backup of the software.

Booting the CD

To upgrade, we need to boot off of the accompanying CD for this book. First, you need to boot into your computer's BIOS (basic input/output system) and make sure that you've enabled booting from the CD-ROM drive. Also, make sure to tell your BIOS to try to boot your CD-ROM drive *before* trying other drives.

If the CD doesn't boot, you may have a particularly old machine that isn't capable of booting from many types of CDs. Every effort has been made to support old machines, but if yours is one of the few machines this doesn't work on, you may have to find a friend to borrow one from.

Upon booting the CD, you'll be presented with a menu asking you which type of TiVo you're upgrading. The reason this is necessary is because of how TiVo used to store data on disks. On Series1 machines, TiVo accesses its drives in byte-swapped mode. This is no longer done with Series2 TiVos. As a result, if you want to mount one of the ext2 partitions on a Series1 TiVo, you must instruct the kernel that that particular drive should be byte-swapped.

Two options are provided on the main page: `series1` (the default), and `series2`. Choosing `series1` (by typing "series1" or simply hitting return) will boot with drives hdb,hdc,hdd (the primary bus slave, secondary bus master, and secondary bus slave) byte-swapped, and DMA disabled. Choosing `series2` will boot with no byte-swapping, and DMA will be enabled. Unfortunately, DMA (direct memory access, which greatly increases drive speed when supported by the drive and BIOS) is currently incompatible with byte-swapping, so it's disabled by default for Series1 users to allow for drive mounting.

Select either `series1` or `series2`, and the disc will boot into Linux.

Eventually, you'll come to a command prompt that reads `=[HackingTiVoCD]-#`. At this prompt, you'll first want to run a little script I've written called `checkdrivesetup` that is on the accompanying CD-ROM. It will give you info about all IDE drives connected to your system, including whether byte-swapping is on for a particular drive. (See the next section, "Checking for 'Locked' TiVo Drives," if any of the TiVo drives are reported as only having 9–10 MB of storage). Make sure you hooked everything up as described above in the "Connecting the Drives" section and that the drives are listed as you expected. Remember, primary master is `/dev/hda`, primary slave is `/dev/hdb`, secondary master is `/dev/hdc`, and secondary slave is `/dev/hdd`. If you have drives connected up incorrectly, the instructions in this chapter may destroy all data on your original TiVo drive, or the drive you're putting the backup on. Be careful.

Checking for "Locked" TiVo Drives

Sometimes a Quantum or Maxtor drive that has been in a TiVo can become "locked." This was an early protection mechanism TiVo units used to do. There are various theories on why this was done. One such theory is that there was a fear early on that people would purchase TiVo units and gut them for their drives. Whatever the reason, drives sometimes become locked.

A locked TiVo drive, when inserted in another machine, reports as having a capacity of only 9–10 MB. There are three ways to get around this. The easiest (and most relevant) of these for our purposes is to use the accompanying CD for this book. Like the tivobootcd created by Silviu Tamasdan (kazymyr on tivocommunity.com), the kernels used on this CD contain the patch created by Mark Hatle (fray on tivocommunity.com) to "temporarily" unlock locked drives, using the same challenge/response mechanism that TiVos themselves use. Using this CD, you shouldn't encounter any locked drives.

The second way to get around this is to use a DOS program called DLGCHK.exe (a free utility from Western Digital, which you can find at:

```
http://support.wdc.com/download/dlg/dlgchk10.zip
```

if you really need it). You boot a DOS floppy containing the tool, run it, and press Enter at every prompt until the program exits. That enables LBA (logical block addressing) mode on the disk, which seems to get past the locking feature. You then remove the boot floppy, put in what you want to boot from (typically some boot floppy, since this was typically done before tivobootcd), then restart your computer via hitting Ctrl-Alt-Delete (you must not power down). Since the drive is still powered up, it stays unlocked, until you turn off the machine (hence the "temporary" nature of this unlocking).

The third way is a DOS program called qunlock.exe, written by Trevor Heartfield (TiVoMad on tivocommunity.com). *This should not be run anywhere near any Maxtor 120-GB drives!* In fact, to be safe, it shouldn't be used unless needed. What the program does is to modify the firmware on the drive to eliminate the locking mechanism. This therefore *permanently* unlocks the drive, so that it can always be mounted anywhere, without the need of something like DLGCHK.exe or a kernel modified with fray's patch.

Caution

Many people (myself included) have purchased Maxtor 120 GB drives that became permanently locked. Many people reported that these drives were becoming locked before going anywhere near a TiVo. Various theories floated around about what caused this behavior. qunlock.exe seems to be what causes this problem with these particular drives, though rumors are that the drives themselves were defective. The model number that I have personally seen fail is 6Y120L0. I've seen 6Y120L0 drives with firmware version YAR41VW0 and YAR41BW0 both fail. If this permanent locking occurs, these drives should be returned to Maxtor for replacement under warranty. Never subject one of these drives to qunlock.exe.

Other than the Maxtor anomaly, qunlock.exe was a great solution before boot CDs started coming out with fray's kernel patch. If you want to use an old TiVo (Quantum) drive somewhere else, it's still the only option in town. qunlock.exe can be downloaded at:

```
http://www.9thtee.com/qunlock.exe
```

Ok, as long as none of your drives are reporting as 9–10 MB (either during the booting of the CD, when using checkdrivesetup), continue on.

Mounting the Backup Drive

First, let's mount the drive that you're going to place the backup on. If you already have an existing ext2 or FAT32 partition you want to use, skip ahead to the "Mounting the Partition"

section. If, however, the drive you're going to place the backup on is a brand new drive, it may not have any partitions on it yet, and you should read "Creating a Partition on a Blank Drive" first.

Creating a Partition on a Blank Drive

If the drive you're going to place the backup on is a brand new drive, you need to create a partition table, create a new partition, and then make either an ext2 or FAT32 filesystem on that partition.

Format the disk connected as primary master at /dev/hda (*entirely wiping out all of its contents!!*), and create a single partition on it by typing:

```
fdisk /dev/hda
```

and then carefully type the following one-letter commands:

```
o    (that's a lowercase o)
n
p
1    (that's the number 1)
<enter>
<enter>
w
```

You should now have a drive with a single partition on it (/dev/hda1). Decide which type of filesystem you'd rather have on the partition, and follow one of the following two instructions:

1. To put a Linux ext2 filesystem on the partition, type:

   ```
   mke2fs -c /dev/hda1
   ```

 The -c option forces a check of the drive for bad blocks. It can be omitted, but it's a good idea to do it just to be safe.

2. To put a FAT32 filesystem on the partition, type:

   ```
   mkdosfs -F 32 -n TiVoBKUPFAT /dev/hda1
   ```

 The -n <name> option specifies a volume name that you will see later if you mount the FAT32 partition on a Windows machine. It can be up to 11 characters.

Your new drive is ready for the next section. You'll be placing your backup onto partition number 1 (/dev/hda1).

Mounting the Partition

Depending on whether your backup partition is ext2 or FAT32, follow one of these instructions:

1. If you're backing up onto a Linux ext2 partition, and the drive is connected as primary master (/dev/hda), type:

   ```
   mount /dev/hdaX /mnt/backupdrive
   ```

 (where X is the partition number of the ext2 partition you're using)

2. If you're backing up onto a FAT32 partition, and the drive is connected as primary master (`/dev/hda`), type:

```
mount -t vfat /dev/hdaX /mnt/backupdrive
```

(where *X* is the partition number of the FAT32 partition you're using)

If that doesn't work, you can try using `-t msdos` instead of `-t vfat`, but you'll be limited to 8.3 filenames.

If you have successfully mounted the partition, you should now be able to `cd` into the `/mnt/backupdrive` directory and look around with `ls`. If you've just created this partition, it will be empty, but if you've mounted an existing partition, you should see the files that live there.

Performing the Backup

Ok, now we're ready to back up the drive(s). If you're jumping straight to this section without reading the preceding sections, go back and read them. Make sure that everything is set up correctly, that the drive you'll be placing your backup image on is mounted, and that none of the drives are locked.

(A complete list of command-line options for all of the mfstool commands is provided at the end of this chapter.)

If you're using a Series1 TiVo, and have just one TiVo drive ("A", mounted on `/dev/hdc`), type the following:

```
mfstool backup -s6o /mnt/backupdrive/tivobkup /dev/hdc
```

(Technically, you can omit the `mfstool` at the beginning and start with "backup" for convenience, but my examples here will explicitly mention `mfstool`.)

If you're using a Series2 TiVo, and have just one TiVo drive ("A", mounted on `/dev/hdc`), type the following:

```
mfstool backup -f 4138 -s6o /mnt/backupdrive/tivobkup /dev/hdc
```

If you're using a Series1 TiVo, and have two TiVo drives ("A", mounted on `/dev/hdc`, and "B", mounted on `/dev/hdd`), type the following:

```
mfstool backup -s6o /mnt/backupdrive/tivobkup /dev/hdc /dev/hdd
```

If you're using a Series2 TiVo, and have two TiVo drives ("A", mounted on `/dev/hdc`, and "B", mounted on `/dev/hdd`), type the following:

```
mfstool backup -f 4138 -s6o /mnt/backupdrive/tivobkup /dev/hdc /dev/hdd
```

(None of the Series2 drives listed here ship with two drives, but if you're following these instructions again someday after having upgraded up on your own, those instructions will apply.)

Lastly, if you happen to have a UK TiVo, you also need -1 32 :

```
mfstool backup -l 32 -s6o /mnt/backupdrive/tivobkup /dev/hdc
```

After running any of these commands, you should eventually have a backup file in the top directory of your backup drive called `tivobkup`. If your backup drive is a FAT32 partition, you might want to give it a three-letter extension for aesthetic purposes. I name my backups with the date as well, such as `20030125_tivo1`.

Shutdown your PC by typing "shutdown" at the =[HackingTiVoCD]-# prompt.

If this is the first time you're backing up your TiVo, it's a *really* good idea to test this backup before modifying your original TiVo drives in any way. The best way to do this is to perform a restore onto a single drive, not worrying about preserving recordings, and see if it boots in your TiVo. The drive you restore onto will have to be at least as large as the original A drive that the TiVo *ever* shipped with. Once you've determined that the backup worked, you can reuse that drive as part of your actual restoration, which might preserve video or involve a second drive. Read the "Incorporating Your New TiVo Drive(s)" section, and follow the instructions for "I Don't Care about Preserving Recordings" for your first backup-validation pass, then reread it for how you actually want to proceed. You may want to omit the "x" option from the `mfstool restore` command during this test, to keep it from expanding the image to your larger drive size (so that you're testing one thing at a time).

Incorporating Your New TiVo Drive(s)

There are several options for what you're going to with your system. If you don't care about preserving recordings, the easiest methods involve taking the backup you just created and restoring it to one or two disks. This is very easy, takes very little time, and easily lets us increase swap space.[3] If you need to preserve recordings however, you encounter some tricky combinations. I'll break this section up into the various options that you have. Table 3-1 describes which section you should read, according to what drives you have in your TiVo and what new drives you're adding to the mix. The use of X and Y is just to make things more readable; we'll be using A and B to refer to the new drives throughout the chapter. Be sure to remember the 137-GB limit currently on all TiVo drives! For example, in the table entry that says A,B -> X,Y (where at least one of X or Y is larger than A + B)", if A was a 60-GB drive, and B was an 80-GB drive, then you're out of luck, even if X is a 160-GB drive, since only 137 GB of that is recognized (and 140 > 137).

[3] When upgrading, it is required that you increase the size of the swap partition if the combined size of the resulting drive(s) is 140 GB or larger. This is accomplished by passing the argument "s 127" to "mfstool restore", below. You need to add swap space because the repair program fsfix (which TiVo calls during errors) will run out of memory trying to rebuild things if the combined size is too large. Thus, you might be fine for a while, but then if your TiVo needs to run fsfix someday, you'll be stuck with a boat anchor. It is important to note that the documentation for "mfstool restore" is incorrect—it states that the value for the "-s" argument can be as large as 511. THIS IS INCORRECT. Any values above 127 will result in NO swap space being generated.

Table 3-1: Roadmap for Deciding Your Upgrade Path

Your Configuration	Section to Jump To
Restore from Backup Won't Preserve Recordings *Easiest Upgrade Method*	If you don't care about preserving recordings, go to "I Don't Care About Preserving Recordings", for *all* configurations. Again, this makes upgrading much easier. The rest of the choices in this table assume that you want to preserve recordings.
A → X	If you're going from an A drive to a new replacement A drive, go to "Simple Backup \| Restore."
A → A,X (where X is larger than A)*	If you're going from an A drive to that same A drive and a new B drive, and the new B drive is larger than the A drive*, then go to "Simple Backup \| Restore Plus mfsadd."
A → A,X (where X is the same size as A, or smaller)*	If you're going from an A drive to that same A drive and a new B drive, and the new B drive is the same size or smaller than the A drive, then you can't safely preserve recordings if the combined capacity of the two drives is larger than 140 GB (due to swap space issues). If the combined capacity of the two drives is larger than 140 GB, accept that you can't preserve recordings, and go to "I Don't Care about Preserving Recordings." If the combined capacity of the two drives is less than 140 GB, go to "Old/New-Fashioned Drive Blessing."
A → X,Y	If you're going from an A drive to a new replacement A drive and a new B drive, go to "Simple Backup \| Restore."
A,B → X	If you're going from an A and B drive to a single new replacement A drive, that new drive must be larger than the A and B drives combined for the upgrade to make sense (otherwise you'd be *reducing* your storage capacity). Assuming that the new replacement A drive is larger than the A and B drives combined*, go to "Simple Backup \| Restore."
A,B → A,X or A,B → X,B	If you're upgrading from an A and B drive by replacing just one of them and keeping the other, then the size of the new drive must be larger than the size of the original A and B drives combined (for you to preserve recordings)*. If this is the case, go to "Simple Backup \| Restore Plus mfsadd." If, however, the new drive is less than or equal to the size of the original A and B drives combined, then you can't preserve recordings. Accept that, and then go to "I Don't Care About Preserving Recordings."
A,B → X,Y (where at least one of X or Y is larger than A + B)*	If you're going from an A and B drive to a new replacement A drive and a new replacement B drive, and at least one of the new replacement drives is larger than the original A and B drives combined*, you have a choice. You can go to "Simple Backup \| Restore Plus mfsadd," which requires an extra step but can be done entirely from the CD-ROM, or you can go to "Floppy-Based Backup \| Restore" (which contains one less step, but requires creating a boot floppy).

Your Configuration	Section to Jump To	
A,B → X,Y (where neither X nor Y is larger than A + B) *	If you're going from an A and B drive to a new replacement A drive and a new replacement B drive, and neither of the new replacement drives is larger than the original A and B drives combined*, then go to "Floppy-Based Backup	Restore."

* Remembering that for the purposes of all comparisons here, drive sizes are truncated at 137 GB.

I Don't Care about Preserving Recordings

This is the most straightforward method of upgrading to your new drive(s). We take the backup image created in the "Backing Up Your TiVo" section and restore it onto either one or two drives. The TiVo's software, your season passes, your thumbs-up/down preferences, and so on will all be preserved, but your recordings will not be.

In the following instructions, we'll refer to the "A" drive and possible "B" drive that you're restoring onto. If you're simply adding a drive to a one-drived TiVo, the original A drive will be your new A drive, and your new drive will be the B drive. If you're replacing a single drive with a single larger drive, the larger drive will be your A drive. If you originally had an A drive and a B drive, and you've now purchased a larger drive to replace one of them (presumably the smaller one), then the unchanged drive would stay the same and the replacement drive would take the place of the drive it's replacing. Pretty straightforward, eh?

STEPS: Restoring from Backup

1. Making sure your machine is off, disconnect TiVo drive(s).

2. Connect what will be your A drive to the secondary IDE bus as Master. Be sure to check the jumpers on the drive, especially if this used to be a Slave. Do not use Cable Select (CS)!

3. If you will have a B drive in your configuration, connect it to the secondary IDE bus as Slave. Be sure to check the jumpers on the drive, especially if this used to be a Master. Again, explicitly set Slave, don't use Cable Select.

4. Leave the drive that your backup is located on connected to the primary IDE bus as Master (where it should still be, from the work you did in the "Backing Up Your TiVo" section), and leave your CD-ROM drive connected to the primary IDE bus as Slave.

5. Boot the CD, and choose either "series1" or "series2" from the boot prompt, as you did before when making the backup.

6. Check the drive setup to make sure that things are connected correctly via the `check-drivesetup` command. Remember, primary master is `/dev/hda`, primary slave is `/dev/hdb`, secondary master is `/dev/hdc`, and secondary slave is `/dev/hdd`.

7. Mount your backup partition by following the same instructions you used before, in the "Mounting the Partition" section.

8. If your new setup consists of only a TiVo A drive, on a Series1 TiVo, type (all on one line):

```
mfstool restore -s 127
        -xzpi /mnt/backupdrive/tivobkup /dev/hdc
```

If your new setup consists of only one TiVo A drive, on a Series2 TiVo, type (all on one line):

```
mfstool restore -s 127
        -bxzpi /mnt/backupdrive/tivobkup /dev/hdc
```

If your new setup consists of a TiVo A drive and a TiVo B drive, on a Series1 TiVo, type (all on one line):

```
mfstool restore -s 127
        -xzpi /mnt/backupdrive/tivobkup /dev/hdc /dev/hdd
```

If your new setup consists of a TiVo A drive and a TiVo B drive, on a Series2 TiVo, type (all on one line):

```
mfstool restore -s 127
        -bxzpi /mnt/backupdrive/tivobkup /dev/hdc /dev/hdd
```

(Obviously, substitute the appropriate filename for `tivobkup` in the preceding four commands.)

Note Though you may not notice it now, someday when you come back to these directions you might wonder what the deal is with the `-b` option for `mfstool restore`. We use it for Series2 units here (and it's the only difference between the Series1 and Series2 `restore` command), yet in other backup/restore options later in this chapter we don't use it. This isn't a typo. The `-B` and `-b` options to restore tell mfstools to disable its byte-swapping autodetection feature, and each specify whether to byte-swap or not, respectively. The reason we use it above is mainly as a convention for backward compatibility with older mfstools backup images (pre-mfstools-2.0). In the commands later in this chapter, because we're running the backup and restore at the same time, there's never a risk of encountering an old backup image.

When the restore is complete, you should see the `=[HackingTiVoCD]-#` prompt again. If the version of software you just restored was 2.0 or earlier, skip to "Old TiVo Software Versions: runideturbo=false." Otherwise, skip ahead to Putting Drives Back in TiVo.

Simple Backup | Restore

To preserve recordings, what we do is create a backup of the original drive(s), with a special flag that says to preserve recordings, then we *pipe* the output of that to a restore program that writes the result to one (or two) drives. This isn't the same as the backup we made earlier — it's much larger, because of all of the video data. This also causes it to take an extremely long time.

Since all of the drives (an original "A", possibly an original "B", a new "A", and possibly a new "B") need to be connected at the same time, you'll need to pay close attention to what drives are connected to what. You'll also want to try to make sure that what you're copying from and what you're copying to are on different IDE busses if possible, to increase performance.

For the next instructions, replace <OLDA>, <OLDB>, <NEWA>, and <NEWB> with the device names for where you've connected the old A, old B, new A, and new B drives, respectively.

As for where to connect them (remember to check Master/Slave jumpers!),

- If you're going from one A drive to a new replacement A drive, place the old A drive in /dev/hda (primary Master), and the new A drive in /dev/hdc (secondary Master).

- If you're going from one A drive to a new replacement A drive and a new B drive, place the old A drive in /dev/hda (primary Master), the new A drive in /dev/hdc (secondary Master), and the new B drive in /dev/hdd (secondary Slave).

- If you're going from an A and B drive to a new replacement A drive (and no B drive whatsoever), and the new replacement A drive is bigger than the old A and B drives combined, then place the old A drive in /dev/hdc (secondary Master), the old B drive in /dev/hdd (secondary Slave), and the new A drive in /dev/hda (primary Master). If the new A drive isn't bigger than the old A and B drives combined, then you won't be able to preserve recordings — go to "I Don't Care About Preserving Recordings."

Ok, here we go. Steps for doing a simple backup | restore:

STEPS: Backup | Restore

1. Making sure your machine is off, disconnect TiVo drive(s) and the drive you stored your backup image on (the one in the Primary Master slot).

2. Connect your drives as described in the preceding few paragraphs.

3. Leave your CD-ROM drive connected to the primary IDE bus as Slave.

4. Boot the CD, and enter "backup" at the boot prompt. Though this is appropriate for series1 and series2 users, it is equivalent to typing "series2"; it boots with DMA enabled and no byte-swapping. The label "backup" just seemed like a more platform-friendly name. Since we won't be mounting any TiVo partitions, and speed is of the essence with this costly data transfer, it makes sense to try to enable DMA. Technically there's nothing wrong with choosing "series1" if you want, it will just run much slower.

5. Check the drive setup to make sure things are connected correctly via the check-drivesetup command. Remember, primary master is /dev/hda, primary slave is /dev/hdb, secondary master is /dev/hdc, and secondary slave is /dev/hdd.

6. If you have one old drive and one new drive connected, type (all on one line):

```
mfstool backup -Tao - <OLDA>
        | mfstool restore -s 127 -xzpi - <NEWA>
```

If you have one old drive and two new drives connected, type (all on one line):

```
mfstool backup -Tao - <OLDA>
        | mfstool restore -s 127 -xzpi - <NEWA> <NEWB>
```

If you have two old drives and one new drive connected, type (all on one line):

```
mfstool backup -Tao - <OLDA> <OLDB>
        | mfstool restore -s 127 -xzpi - <NEWA>
```

When the transfer is complete, you should see the =[HackingTiVoCD]-# prompt again. If the version of software you just transferred was 2.0 or earlier, skip to "Old TiVo Software Versions: runideturbo=false." Otherwise, skip ahead to "Putting Drives Back in TiVo."

Simple Backup | Restore Plus mfsadd

There are four examples where we want to do exactly what we just described in the "Simple Backup | Restore" section, but then add yet another drive. (A tool called mfsadd, which is part of MFS Tools, does this adding of a second drive for us.[4]) In one case, we'd do the addition after-the-fact because we can't put four IDE drives in the machine at the same time without sacrificing our ability to use the CD-ROM drive. In another two, we want to copy over onto a new "A" drive, then reuse an original drive after the fact. In yet another, we also want to copy over onto a new A drive and reuse an original drive, but we'll copy the drive first just to add swap space.

Rather than duplicate the instructions given in the "Simple Backup | Restore" section, I'll set up the specifics for these cases, then redirect you to the "Simple Backup | Restore" section for part of your work. You'll come back here afterward, and add the next drive with mfsadd.

Info For Simple Backup | Restore Section

If you are originally starting with one drive, and you're adding another, and the combined storage capacity of both drives exceeds 140 GB, then you'll need to copy your old A drive onto your new A drive, then add the old "A" drive afterwards as a "B" drive with mfsadd (making sure to switch the jumper setting from Master to Slave). Place your old A drive in /dev/hdc (secondary Master), and your new A drive in /dev/hda (primary Master). Use these as your values for <OLDA> and <NEWA>, and go follow the instructions in "Simple Backup | Restore." Then, proceed to the "mfsadd" section below, remembering that your old A drive will now be the new B disk during the mfsadd step.

If you are originally starting with two drives, and you're replacing them both with two new replacement drives, and you don't want to create a boot floppy, then you'll have to copy your old A and B drives onto your new A drive, then add the new B drive afterward with mfsadd. Place your old A drive in /dev/hdc (secondary Master), your old B drive in /dev/hdd (secondary Slave), and your new A drive in /dev/hda (primary Master). If only one of your two new drives is larger than your old A and B drives combined, then that large drive must be your new A drive (so that there is space to do this first transfer). Use these as your values for <OLDA>, <OLDB>, and <NEWA>, and go follow the instructions in the "Simple Backup | Restore" section. Then, proceed to the "mfsadd" section below, remembering that the as-of-yet-unused new B disk will be the disk added during the mfsadd step.

If you are originally starting with two drives, and you're replacing only one of them with a replacement drive (but keeping the other), then you'll be copying your old A and B drives onto the new A drive, then adding whichever of the two original drives that you're keeping as a B drive. If the drive you're keeping is the old A drive, be sure to change the jumper settings from Slave to Master at that point. Place your old A drive in /dev/hdc (secondary Master), your old B drive in /dev/hdd (secondary Slave), and your new A drive in /dev/hda (primary Master). Use these as your values for <OLDA>, <OLDB>, and <NEWA>, and go follow the instructions in the "Simple Backup | Restore" section. Then, proceed to the "mfsadd" section below, remembering that whichever of the old drives that you've decided to keep will be the drive added during the mfsadd step.

[4] Technically, mfsadd lets you add new MFS partition pairs to the existing set of MFS partitions. It will also create the partitions for you if instructed to do so, as we will be telling it to do via the -x option.

mfsadd

If you're at this point, then you should have just followed instructions for doing a Simple Backup | Restore of one or two original drives onto a new A drive, and that new A drive should be connected as /dev/hda (primary Master). If what will be your new B drive isn't currently connected, then shutdown your machine (using the "shutdown" command), leave the new A drive and CD-ROM drive connected to the primary IDE bus, and connect the new B drive (you should remember which that is, see above if you've forgotten) to /dev/hdc (secondary Master). Unfortunately this will be a bit inconvenient because you need to set the jumpers on this drive as Master to connect it to /dev/hdc, but when we're done you'll have to switch it to Slave for it to be a valid B drive. Boot the CD again, typing "series1" or "series2" at the boot prompt.

We're about to use mfsadd to create partitions on a second drive and add them to the set of existing MFS pairs. If you've jumped around these instructions (or skimmed and might have missed something), *be sure that you are supposed to be here*. Specifically, the A drive had better already have had a larger swap partition put on it; otherwise, you should *not* run mfsadd (unless the size of both drives combined is less than 140 GB). The previous instructions leading up to this step all had an "mfstool restore -s 127 ..." occurring to this drive first, putting a large swap partition on it, which is why it's safe to add another drive to the mix. You can end up hosing your TiVo, with a "wed" but otherwise empty B drive and a TiVo that constantly reboots. Be careful!

With the A drive in /dev/hda and the B drive in either /dev/hdc or /dev/hdd, at the =[HackingTiVoCD]-# prompt type:

mfsadd -x /dev/hda <NEWB>

(where <NEWB> should be either /dev/hdc or /dev/hdd)

This marries the B drive to the A drive, as the old BlessTiVo tool by Mike Hill (Belboz on tivocommunity.com) used to do.[5]

Each time you use mfsadd (or restore with the -x option) to add partitions, you are increasing the number of pairs in the set of existing MFS pairs. MFS itself is limited in that it can only use six pairs of MFS Application/Media partitions (12 partitions in all). For example, if you had a 15-gig A drive then added a 15-gig B drive, you'd go from 1 to 2 pairs. If you did a backup | restore onto a 45-gig drive preserving video (using restore's -x to expand, but not using backup's -s option to shrink), then that 45-gig drive would have three pairs. Adding another drive with mfsadd would bring it to four pairs, and so on. Once you hit six, you're done — the only way to increase storage is to shrink the volume set with -s, losing all recordings in the process. Plan those upgrades carefully — it might not be worth adding that 15-gig drive you have lying around today because the 120-gig drive hasn't arrived in the mail yet. Each upgrade brings you one notch closer to having to erase all of your video.

[5] Back then, you'd use Dylan's Boot Disk, "bless" a drive, put it in your TiVo, the TiVo would boot, and suddenly the drives would be wed (unlike using mfsadd, where the drives are wed right there in your PC immediately). From that point on, there was no way to divorce them. Today, however, divorcing drives is easy. The -s option in mfstool backup not only divorces drives, but it eliminates video streams, allowing for small, compact backups.

If the version of software you just transferred was 2.0 or earlier, skip to "Old TiVo Software Versions: runideturbo=false." Otherwise, skip ahead to "Putting Drives Back In TiVo."

Floppy-Based Backup | Restore

Because you can only fit four IDE devices on most PCs, and the CD-ROM drive usually has to be IDE to be bootable, you're prevented from using the accompanying CD to perform backups where four drives need to be connected at the same time.

So, to perform such a backup, I've included a boot floppy image on the CD. Insert the CD into a Windows machine, and get to a command prompt. Go to the /floppy directory on the CD, and you'll find a program called rawrite.exe. Insert a blank floppy in the drive, then run rawrite.exe. It will ask you for an image; enter "floppy.img". Then it will ask a drive; enter "A". This should create a boot floppy.

Put the boot floppy in the machine you're upgrading the TiVos with. Connect the old TiVo "A" drive to the primary IDE bus as Master. Connect the old TiVo "B" drive to the primary IDE bus as Slave. Connect the new TiVo A drive to the secondary IDE bus as Master. Connect the new TiVo B drive to the secondary bus as Slave. Power-on the machine, booting from the floppy. (If that fails, check to see if your BIOS is set up to boot floppies by default.)

Start the transfer by typing:

```
mfstool backup -Tao - <OLDA> <OLDB>
        | mfstool restore -s 127 -xzpi - <NEWA> <NEWB>
```

This may take a very, very long time. Think several hours, then double that. Well, then double that too. I had one large copy go on for around 32 hours once — it depends on how much video you are copying.

 Note This seems hardly worth mentioning, but if it helps one person out there it's worth it. During one long video copy I kept running into a problem where mfstool would crash with a segmentation fault after making it through a random percentage of the copy. It was a new PC so I tried using other IDE cables, putting an extra fan in front of the drives, and so on. In the end, it turned out that the PC had shipped with bad memory, and the manufacturer had turned off the BIOS memory check. The bottom line is that once the copy has started, it should run from start to finish reliably (unless there isn't enough disk space). If you're getting random errors like this one, you've got something else wrong with your computer.

Anyway, when it's finally done you should have a new A and a new B drive, ready to put into your TiVo. If the version of software you just transferred was 2.0 or earlier, skip to "Old TiVo Software Versions: runideturbo=false." Otherwise, skip ahead to "Putting Drives Back in TiVo."

Old/New-Fashioned Drive Blessing

If you're starting out with a single-drive TiVo, you want to add a second drive, and the combined capacity of the two doesn't exceed 140 GB, then you can just bless the new drive and add it to your TiVo.

You used to "bless" a new "B" drive with BlessTiVo, by Mike Hill (Belboz on tivocommunity.com), as I mentioned just above. When that drive was placed in a TiVo, the TiVo would detect a blessed drive, and marry it to the "A" drive, after which point the A drive would no longer operate individually.

In fact, you can still do that if you want; BlessTiVo is on the accompanying CD.

That old style of blessing a drive would erase the first few sectors, write a valid bootpage to the first sector, partition the drive, and mark the third sector with TiVo's ID.

Now, however, mfsadd (part of mfstools) is the tool of choice. mfsadd not only allows you to bless a new drive, but it can expand an existing drive as well. For instance, if you copied an existing 15-GB image onto an 80-GB drive with the Unix utility dd, you could use mfsadd to create more TiVo partitions on that same drive, utilizing the remaining 65 GB of space. The utility used to perform this before mfsadd was TiVoMad, by Trevor Heartfield (TiVoMad on tivocommunity.com). Ok, enough history, let's just add the drive.

Connect your TiVo's existing A drive to the secondary IDE bus as Master. Connect your new B drive to the secondary IDE bus as Slave (be sure about the jumper settings on the drive).

Boot the CD-ROM, type "series1" or "series2" at the boot prompt, and at the =[HackingTiVoCD]-# prompt type:

```
mfsadd -x /dev/hdc /dev/hdd
```

Shutdown your PC by typing "shutdown" at the =[HackingTiVoCD]-# prompt, and skip ahead to "Putting Drives Back in TiVo."

Old TiVo Software Versions: runideturbo=false

A few places in this chapter I've said, "If the version of software you just restored was 2.0 or earlier" Just for clarification, subscribed TiVos download new software automatically, so you usually don't have to worry about what software version you have.

But, if you happen to have a backup from an old TiVo, or if you've modified scripts in the /etc directory to prevent upgrading for some reason, then you might have TiVo software version 2.0 or earlier. If so, and you just replaced your A drive with a non-Quantum drive, then you have one more step to do (otherwise, skip ahead to "Putting Drives Back in TiVo").

Connect your new A drive to your computer, and boot the CD (remember to reconnect the CD-ROM if you've disconnected it above!). When you get to the =[HackingTiVoCD]-# prompt, type the following:

```
/tivomad/edit_bootparms hdX -I
```

(replacing hdX with hda if the drive is connected as primary Master, hdb if connected as Primary Slave, hdc if connected as secondary Master, or hdd if connected as Secondary Slave)

Putting Drives Back in TiVo

Now that your upgrade is done, it's time to put your new drives into your TiVo, right? Well, yes, but you might not want to bolt it all down just yet (though you *do* need to at least reboot

the PC now via "cd / ; umount -a ; reboot" if your TiVo is a Series1 TiVo and you typed anything other than "series11" at the boot prompt, such as "series2" or "backup"; otherwise, you won't be able to mount disk partitions in the next chapter because byte-swapping will be off).

The next two chapters will all involve opening up your TiVo again. But certainly you want to see some results from having just upgraded, and you probably want to see those results right now.

At least move any mounting brackets (if applicable) from old TiVo drives onto the new ones, to rest them in the TiVo (without screwing them in). If you have a small portable TV, consider bringing it down to where you're working on your TiVo, connecting it up, connecting the drives, putting on the case, and powering up your TiVo (being careful not to electrocute yourself!). That way at least you can see it boot up, and you can go to the System Information screen to see your increased recording capacity. Expect to feel the desire to do more after a few minutes of that, and move on to the next chapter soon. Do *not* move your TiVo at all without everything screwed in tight though. If the nearest TV is more than a few feet away, just accept that you'll be disassembling and reassembling your TiVo a few times.

Ok. First, you need to remove the mounting bracket from any old drives, and move it to your new ones. I recommend doing this with great care; you certainly don't want to lose a small piece and be unable to install your drive.

There are excellent directions for installing Series1 and Series2 mounting brackets at www.9thtee.com, where they can be purchased. The Series1 mounting bracket instructions are at:

http://www.9thtee.com/TiVoMtgBracket.htm

and the Series2 mounting bracket instructions are at:

http://www.9thtee.com/TiVoMtgBracket-s2.htm

If I haven't said it enough times in this chapter, be sure you have the jumper settings correct on your drives; the A drive should be set to Master, and the B drive should be set to Slave.

On Series1 TiVos, pay particular attention to where you place the mounting bracket for the A drive (on the left). There are two holes in the mounting bracket that you can slide over the protruding tab from the frame, as seen in Figure 3-10. That figure shows the mounting bracket on the frame the way it ships; more towards the center. For two drives to fit on the frame, the bracket needs to be moved to the left one notch, such that the tabs instead come out of the holes to the right of where they are in Figure 3-10. This will also mean that when you screw the mounting bracket down, the screws will go in different holes than they were in Figure 3-9; they will instead go through the holes to the left of those in the picture.

To connect the white power cables to the drives, a few things may be necessary. Philips TiVos sometimes have a white pull-tie holding the power cable together, that needs to be cut without hurting the wires. Some Series2 units won't even have a second power adapter, and will require a power cable splitter, as seen in Figure 3-15. These can also be purchased from www.9thtee.com, as well as many computer stores, for about $1.50.

FIGURE 3-15: Power Y-cable.

Once your TiVo drives are mounted, the IDE cables connected, and the power cables attached, you can put the case back on, screw it all together, and you're done (for now).

Power up your TiVo. It may reboot once, but should soon come up as usual. Go to the System Information screen, and check out the Recording Capacity, to witness the result of your work. Congratulations!

Reference — mfstool Command Line Options

The instructions above are all you *need* to do the upgrades described, but I wanted to include the command line options for the MFS Tools commands here as well, at the very least as a good reference.[6]

There are five subcommands of mfstool: backup, restore, mfsadd, mls, and mfsinfo. On the accompanying CD-ROM, all five have symlinks letting you enter just the subcommand name (for example, "backup" instead of "mfstool backup"), though I'll still use mfstool with backup and restore below.

[6] You may also want to read the MFS Tools README file, which has more details. The README file is included on the accompanying CD-ROM at /cdrom/doc/mfstools-2.0/README.

mfstool backup

The usage string for mfstool backup is:

```
mfstool backup [options] /dev/hdX [/dev/hdY]
```

(where /dev/hdX is the device name of your "A" drive, and /dev/hdY is the device name of your B drive — if it exists).

The valid options are listed in Table 3-2.

Table 3-2: Command Line Options for "mfstool backup"

Option	Description
-o file	Specify a file to dump the backup to, instead of standard output. "-o -" is the same as not specifying the "-o" option — output goes to standard output.
-1 .. -9	Compress the backup, ranging from 1 (quick, least compression) to 9 (slow, most compression). Recommended value is 6.
-v	Don't back up the /var partition. This makes the backup smaller, but if you are storing hacks in /var you'll lose them when you restore.
-s	Shrink the MFS partition set as small as possible, effectively "divorcing" wed drives.
-q	Quiet. Don't display progress.
-qq	Really quiet. Don't display anything except errors.
Advanced Options	
-f N	Back up all video streams whose fsid is below N.
-l N	Back up all video streams smaller than N megs in size.
-t	Cause space calculations for "-l" (above) be done on the total space allocated, instead of space used.
	Doesn't work with mfstool restore's "-i" option.
-T	Cause space calculations for "-l" (above) be done on the total space allocated, instead of space used. Unlike "-t", this will also actually backup the entire stream (instead of just the part of it that is used).
	Does work with restore's "-i" option.
-a	Backup *all* streams. This allows you to preserve video.

mfstool restore

The usage string for "mfstool restore" is:

```
mfstool restore [options] /dev/hdX [/dev/hdY]
```

(where `/dev/hdX` is the device name of your A drive, and `/dev/hdY` is the device name of your B drive — if it exists).

The valid options are listed in Table 3-3.

Table 3-3: Command Line Options for "mfstool restore"

Option	Description
`-i file`	Specify a file to read the backup from, instead of standard input. "`-i -`" is the same as not specifying the "`-i`" option — input comes from standard output.
`-x`	Extend the existing set of MFS pairs by creating new partitions on all available drives to utilize all of the space on them. Those partitions are then added to the MFS pairs set similar to "mfsadd -x".
	This option may cause restore to fail if there isn't enough disk space on the destination drive to create new partitions.
`-s size`	Recreate swap partition of specified size. The value for size is in MB.
	WARNING: Do not put a value greater than 127, or you will end up with no swap space at all! The README file for mfstools does not mention this, but it's crucial. This can render your TiVo unusable. Always just use "`-s 127`" during restores if the combined drive size is greater than 140 GB.
`-z`	When recreating partitions, zero out any partitions that weren't backed up.
`-p`	Rearrange the partition layout intelligently. Partitions are placed on the drive such that database data is kept near the center of the drive (minimizing seeks), while video is moved to the outer edge of the drive.
`-b`	Prevent any byte-swapping from occurring during restore. This disables the default behavior of auto-detecting whether the backup has come from a byte-swapped version or not. This is necessary when restoring a Series2 backup that was made with an earlier version of MFS Tools.
`-B`	Force byte-swapping to occur during restore. This disables the default behavior of auto-detecting whether the backup has come from a byte-swapped version or not.
`-q`	Quiet. Don't display progress.
`-qq`	Really quiet. Don't display anything except errors.
`-v size`	Create `var` partition of specified size. The value for size is in MB.
`-r scale`	Increase block size for storage that is allocated with the `-x` option above. `scale` can be a value from 0–4, for 1, 2, 4, 8, or 16 MB per block. Larger blocks mean a bit more wasted storage, but decreased RAM usage. Small values can cause serious problems on some large full TiVos. As the author himself says, "best to leave this option alone."
`-l`	Leave at least two partitions free (that is, don't fill up the partition table). This will (try to) leave room on the drives(s) to add another MFS pair later (but only relates to the partition table, not disk space).

mfsadd

The two usage patterns for "mfsadd" are:

```
mfsadd [options] /dev/hdX [/dev/hdY] -x
```

and

```
mfsadd [options] /dev/hdX APPPARTITION MEDIAPARTITION
```

(where `/dev/hdX` is the device name of your A drive, `/dev/hdY` is the device name of your B drive if it exists, and `APPPARTITION`/`MEDIAPARTITION` are two existing partitions you've created with `pdisk` that you want to add to the MFS pair set.)

The first syntax is used when you want mfsadd to create new partitions for you and add them to the MFS pair set (destroying any existing data on any newly added B drive). The second syntax is used when you have data you wish to keep; you create the new MFS Application/Media partitions yourself, then tell mfsadd to add them to the MFS pair set.

The valid options are listed in Table 3-4.

Table 3-4: Command Line Options for mfsadd

Option	Description
-x	Extend MFS to take up all of every connected drive, by creating new partitions and adding them to the MFS pair set.
-X drive	Extend MFS to take up just the specified drive, by creating new partitions on it and adding them to the MFS pair set.
-r scale	Increase block size for storage that is allocated with the -x option above. scale can be a value from 0–4, for 1, 2, 4, 8, or 16 MB per block. Larger blocks mean a bit more wasted storage, but decreased RAM usage. Small values can cause serious problems on some large full TiVos. As the author himself says, "best to leave this option alone."
App Media	When you specify an MFS Application partition and an MFS Media partition, mfsadd adds them to the MFS pair set (without modifying the partitions themselves). This is the second usage pattern described above. You must have created both partitions already (using pdisk), and their type must be "MFS". When you specify the partitions, use their full device names (for example, /dev/hdb4 and /dev/hdb5).

mls

The usage string for "mls" is:

```
mls [mfsdirectory]
```

This command will fail if you don't set the environment variable MFS_HDA (and MFS_HDB, if there is a B drive) to the device name for your A (and B) drive. This command mimics (and

improves upon) the `tivosh` subcommand `mls`, described in Chapter 13. The `mls` subcommand of `mfstool` has the same syntax and behavior as the `mls.tivo` executable described in that chapter.

Here's a sample of what the failure looks like if you forget to set MFS_HDA (and MFS_HDB, if you have a second drive), followed by a sample of what it looks like when it works.

```
=[HackingTiVoCD]-# mls /MessageItem/MessageBoard/
/dev/hda10: Success
mfs_load_volume_header: mfsvol_read_data: Input/output error
mfs_init: Failed.  Bailing.
=[HackingTiVoCD]-# export MFS_HDA=/dev/hdc
=[HackingTiVoCD]-# mls /MessageItem/MessageBoard/
    Name                    Type      FsId      Date   Time    Size
    ----                    ----      ----      ----   ----    ----
    12024~33942~1399195     tyDb      1399195   03/09/03 15:45   288
    12112~70307~1568719     tyDb      1568719   05/13/03 14:08   896
    12199~70700~1733909     tyDb      1733909   05/27/03 19:41   708
=[HackingTiVoCD]-#
```

mfsinfo

The usage string for "mfsinfo" is:

```
mfsinfo /dev/hdX [/dev/hdY]
```

(where `/dev/hdX` is the device name of your A drive, and `/dev/hdY` is the device name of your B drive — if it exists).

`mfsinfo` returns information about the existing set of MFS pairs in use by MFS. This is useful in keeping track of how many more times you can add partitions (preserving video) before you have to erase video and start from scratch (as described in the Note in the "mfsadd" section earlier in this chapter).

Here's sample output from `mfsinfo` run on a 15GB "A" drive:

```
=[HackingTiVoCD]-# mfsinfo /dev/hdc
MFS volume set for /dev/hdc
The MFS volume set contains 2 partitions
  /dev/hdc10
    MFS Partition Size: 512MiB
  /dev/hdc11
    MFS Partition Size: 12098MiB
Total MFS volume size: 12610MiB
Estimated hours in a standalone TiVo: 15
This MFS volume may be expanded 5 more times
=[HackingTiVoCD]-#
```

It's All Worth the Effort

Adding storage can be nerve-wracking — the stakes are high if you're trying to preserve all of your recorded video. As you have seen, there are many different paths you can take, depending

on the slightest of differences (such as what size drives you have in there already). The reward is definitely worth it though — now you can stop worrying about what to delete (for a while at least).

If something didn't work, you have your backup. A good place to go to see if others are having the same problem you are is the TiVo Upgrade Center section of tivocommunity.com. Search for your question on the forum first, several times. Chances are, someone has already asked your question, and it has been answered. And it's an absolute certainty that if you ask something that's asked often, and you didn't search for it, that you'll end up irritating others and getting little help.

Enjoy the extra space. Now, on to the rest of the book.

Installing Software All at Once

"Give a man a fish, and you feed him for a day. Teach him how to fish, and you feed him for a lifetime." — Unknown

You would think that that one phrase would keep me from shipping a full software distribution with this CD. I've certainly considered it enough when writing this book. By giving readers an easy way to install *all* of the software, isn't it taking some of the fun out of adding these things in the first place?

When considering this, my mind kept drifting back to the example of Linux distributions. I kept wondering how much patience I would have for Linux if every time I installed it, I separately had to go download the vi text editor, the ls command, and tcsh. What if awk or sed weren't included? For those of you who aren't familiar with Unix, what if Windows didn't ship with Notepad or Wordpad? Or what if MacOS didn't have Simpletext?

I use that example to remind myself why I like the idea of software distributions. Downloading things from all over, and making them fit together, is interesting maybe once or twice. But after a while, it's no longer a productive way to spend one's time.

Then there's the other issue here — these are all hacks. There is no TiVo Freeware Distribution being funded by anyone. The software discussed in this book was written by people for the fun of it, and shared with others for the fun of it. There is no standards group to say "there shall be a /var/hack/bin directory, and people shall keep common executables there." And worse, some software assumes that a given tool lives in one place, while other software assumes that it lives somewhere else. Working out those inconsistencies certainly isn't fun, and it's probably something most people would just rather have addressed for them ahead of time.

So here's what I decided. I put together a distribution of all of the software in this book, modifying config files as needed to point to the correct locations of various tools. I put it on the CD, in such a way that people could install it all at once. And in each chapter, I try to describe installation both in terms of it already having been installed via this chapter, and also via describing the necessary install steps for installing each component by hand.

I resolved my concerns about giving people fish, like this: If you've purchased this book, you most likely are interested in seeing how everything works. You *want* to fish. Plus, it's not like we're building a time machine out of our TiVo here — we're just adding some cool hacks, that are more worth it for the fun of playing with them than they are for raw functionality. I think of this more like teaching someone to fish in a pond that we know has some fish, so they can get the hang of it.

So, here's how to put a bunch of this software on your TiVo for easy access when reading later chapters. Do it all at once here, or individually in each chapter there — it's your decision. I'm hoping that for some of you, the fun will come from creating something new, rather than just installing what's here.

These Instructions Cover Series1 Standalones

Series1 standalone users can skip right ahead to the "Mounting the Drives" section. Series1 DirecTiVo owners need to either first flash the PROM on their TiVo (and fix the initrd on the kernel they're booting from), or they need to take a different approach to booting their machine (see:

http://www.tivocommunity.com/tivo-vb/showthread.php?threadid=80754

or just search for "persistent hacks" on the forums listed in Appendix A).

If you purchase a TurboNET card for Ethernet access for your Series1 DirecTiVo (which you'll want to do anyway; TurboNET is described in Chapter 5), then you will have met the terms of service for the nic_install software installation CD located on the TurboNET site at:

http://www.silicondust.com/turbonet/install_software.html

(which lets you use tivoflash to flash the PROM of your Series1 DirecTiVo, and fix the initrd on the kernel). There are other methods as well — dealdatabase.com's DirecTiVo Hacking forum has many such instructions.

Series2 users are another matter. I can't describe to you how to obtain bash access, which is necessary to get most of the hacks in this book working on a Series2 TiVo; there are various approaches discussed on the forums (searching for "monte" yields interesting discussions), but I won't be describing how to do them here.

All that having been said, any Series1 DirecTiVo or Series2 owners that have bash access on their own can install the hacks described in this book by continuing on.

Mounting the Drives

Remove the A drive from your TiVo, and connect it to your PC. For the sake of simplicity, let's assume you connect it to the secondary IDE bus as Master (/dev/hdc). You can connect it anywhere else if you want (except primary Master for Series1 users), but you'll have to modify these instructions accordingly.

Boot the accompanying CD, entering either "series1" or "series2"[1] at the boot prompt. While for *other* purposes Series1 users can actually sometimes enter "series2" to get DMA enabled; in

this case, Series1 users really do need to enter "series1" to enable byte-swapping, since we're going to mount the TiVo drive.

Upon reaching the =[HackingTiVoCD]-# prompt, run checkdrivesetup to make sure that you have connected the drives correctly. Again, if the TiVo drive came from a series1 TiVo, you'll want to make sure that the drive is mounted as byte-swapped. If it isn't, then either you didn't enter "series1" at the boot prompt, or you connected the drive to the primary IDE bus as Master.

We will soon be modifying the TiVo A drive. For an idea of what it looks like, see Listing 4-1 for a list of partitions.

Listing 4-1: Partitions on a Typical "A" Drive

```
=[HackingTiVoCD]-# pdisk -l /dev/hdc

Partition map (with 512 byte blocks) on '/dev/hdc'
 #:                type name              length    base      ( size )
 1: Apple_partition_map Apple                 63 @ 1
 2:               Image Bootstrap 1         4096 @ 64        (  2.0M)
 3:               Image Kernel 1            4096 @ 4160      (  2.0M)
 4:                Ext2 Root 1            262144 @ 8256      (128.0M)
 5:               Image Bootstrap 2         4096 @ 270400    (  2.0M)
 6:               Image Kernel 2            4096 @ 274496    (  2.0M)
 7:                Ext2 Root 2            262144 @ 278592    (128.0M)
 8:                Swap Linux swap        131072 @ 540736    ( 64.0M)
 9:                Ext2 /var             262144 @ 671808    (128.0M)
10:                 MFS MFS application region 1048576 @ 933952    (512.0M)
11:                 MFS MFS media region  24777728 @ 1982528   ( 11.8G)
```

Before we go mounting things, here's a brief description of what we're going to be mounting. The /var partition on a TiVo drive is kept on partition 9. This is the only partition that the TiVo mounts as read-write, and it isn't replaced during a software update, so it's where many people place their hack directory for all of their software. That's what we'll be doing as well. Some people create their own partition to keep their hacks on, because if the /var partition becomes too full, the unit will erase it completely and rebuild it upon reboot. I've decided not to cover that here. For our purposes, /var is where we'll keep our hacks. It's up to you to use something like rsync (see Chapter 6) to maintain a backup of your hacks, in case the partition ever fills up and gets wiped out.

[1] As described above, it's important to note here that Series2 users are currently not able to install software on their machines. Expanding drive space is ok, but not adding software. TiVo Inc. has cracked down on these machines with firmware that detects and eliminates any software modifications at boot time, preventing you from even getting a bash prompt on Series2 units. There are many interesting discussions about this on tivocommunity.com. Also, since the architecture is MIPS-based (and not PPC-based, like the Series1 units), many of the executables on this CD are incompatible. For this (and other) reasons, I won't be describing any attempts to install the software hacks in this book on Series2 units. I do, however, still describe the kernel option "series2", to fully explain what the CD does and how booting works, should you obtain access on your own.

Kernel Options When Booting Accompanying CD

Though the CD contains easy-to-use labels to boot with (for example, "series1", "series2", etc), I think it's worth describing how things are actually working here for those of you who are curious. It's perfectly safe to skip this and move on.

At the boot prompt, you typically specify the kernel to boot with, and any options you'd like to pass along to that kernel. Labels can be created for convenience; they specify a kernel and options to pass along to it. The labels I've provided[2] on the CD include `series1`, `series2`, `series1dma`, `series2nodma`, `swap`, `dma`, `dmaswap`, `nodma`, and `backup` (where `swap` is a synonym for `series1`, `dma` is a synonym for `series2`, `dmaswap` is a synonym for `series1dma`, `nodma` is a synonym for `series2nodma`, and `backup` is a synonym for `series2`). These synonyms are just for people who might be more familiar with them from earlier TiVo boot CDs.

There are two kernels that ship on this CD: `vmlinuz` and `vmlnodma`. `vmlinuz` has DMA mode enabled, and `vmlnodma` has DMA disabled.

Byte-swapping is done by passing in an argument for each drive that is to be byte-swapped. So for example, the label "series1" is defined as using `vmlnodma`, passing it the arguments `hdb=bswap hdc=bswap hdd=bswap`. That is why primary Master (`/dev/hda`) isn't byte-swapped by default with the `series1` label. If you had some bizarre setup where you really wanted only `/dev/hdb` and `/dev/hdd` byte-swapped, at the boot prompt you could type:

```
vmlnodma hdb=bswap hdd=bswap
```

(Note that CD-ROM drives are immune from byte-swapping, no matter what arguments are passed to the kernel.)

The `vmlinuz` kernel doesn't allow DMA access and byte-swapping at the same time, but there is something you can do. The `series1dma` label uses `vmlinuz`, and passes in arguments of `hdb=bswap hdc=bswap hdd=bswap`. While DMA is enabled, byte-swapping will *not* be enabled, but you can disable DMA at runtime on a drive with the `hdparm` command. If you've booted with the `series1dma` label and wish to disable DMA on a drive (to enable byte-swapping), type:

```
hdparm -d0 /dev/hdX
```

(where `hdX` should be `hdb`, `hdc`, or `hdd`, depending on which drive you wish to disable DMA access for. Since `series1dma` doesn't specify `hda=bswap`, it wouldn't make sense to disable DMA on `hda`).

To re-enable DMA on a drive after doing this, type:

```
hdparm -d1 /dev/hdX
```

(again substituting for `hdX`)

[2] For those who are really curious about how these labels were created, you can view the config file from the Linux prompt. It's available at `/cdrom/isolinux/isolinux.cfg`. Just be aware that you're going off on a tangent!

This feature is rather bizarre and really only for advanced users who would otherwise be rebooting constantly to go from mounting drives to doing lots of disk access, etc. It's not for everyone, but I figured I'd describe it here.

Note

Experienced users who would create their own hacks partition can still do so, but I won't be adjusting examples to reflect changes you would need to make (for instance, some configuration files specify the location of the program newtext2osd as /var/hack/bin/newtext2osd. There are even methods that would allow hacks to persist across a software upgrade, that involve creating a new partition (see http://www.tivocommunity.com/tivo-vb/ showthread.php?threadid=80754 or just search for "persistent hacks" on the forums listed in Appendix A). Series1 DirecTiVo owners will need to either follow those instructions or flash their PROM to be able to run code on their machines. If you purchase a TurboNET card for Ethernet access for your Series1 DirecTiVo (described in Chapter 5), then you will have met the terms of service for the software installation CD located on the TurboNET site at: http://www.silicondust.com/turbonet/install_software.html (which lets you flash the PROM of your Series1 DirecTiVo). There are other methods as well—dealdatabase.com's DirecTiVo Hacking forum has many such instructions.

Next, TiVo has two partitions that can act as the root partition ("/"). Partition 4 and partition 7 are used for this. The reason there are two root partitions has to do with how TiVo does software updates.

When the TiVo boots up, it checks the first several bytes of the first sector of the A drive (the bootpage) for a string. This string usually contains either root=/dev/hda4 or root=/dev/hda7. That string tells TiVo which partition (4 or 7) that it will mount as its root ("/") directory. When a new software update comes from TiVo via a nightly phone call, the device sets up the new root partition in the opposite partition from what it's currently using, then modifies the bootpage info to switch root to the other partition.[3]

What this boils down to is that there are two places that the current root partition could be on your TiVo drive: /dev/hda4, or /dev/hda7.

Run the following command to determine which partition your TiVo is currently using as root:

```
/tivomad/edit_bootparms hdc -r
```

(replacing hdc with hdb or hdd if you've got the TiVo drive mounted elsewhere).

This should return either "root=/dev/hda4" or "root=/dev/hda7".

[3] Actually, it's not just the root partition that alternates. If you look at Listing 4-1, you'll see that partition 2, 3, and 4 are the bootstrap, kernel, and root for "root=/dev/hda4", and partition 5, 6, and 7 are the bootstrap, kernel, and root for "root='/dev/hda7". Software updates modify the bootstrap and kernel partitions as well. Running "/sbin/bootpage -b /dev/hda" (*on your TiVo*) will return the kernel partition to be used (which will be either 3 or 6), and running /sbin/bootpage -a /dev/hda will return the alternate kernel partition (again, 3 or 6). /sbin/bootpage -B <n> /dev/hda will actually let you change which kernel partition is used. None of this really matters much to us here though, which is why it's easiest to think of just the root partitions alone as being the alternating piece.

Now let's mount the drives. First, let's mount the /var partition (partition 9) as /mnt/9:

```
mount /dev/hdc9 /mnt/tivovar
```

And now, mount the current root partition. If your TiVo is currently using partiton 4 as root, then type:

```
mount /dev/hdc4 /mnt/tivoroot
```

Or, if your TiVo is using partiton 7 as root, type:

```
mount /dev/hdc7 /mnt/tivoroot
```

If you've mounted your TiVo drive somewhere other than /dev/hdc, change the above mount commands appropriately.

If you get the following error message:

```
/dev/hdc4: Success
mount: you must specify the filesystem type
```

then you probably don't have byte-swapping on when you need it, or you have byte-swapping on when you don't need it.

Some people like to make the changes to both partitions 4 and 7 just to be sure that they're changing files on the correct root partition. It's easier to make sure that you're correctly reading the output of edit_bootparms, mount the correct root partition, and make any changes once instead of twice.

Installing It All

 These instructions assume that you don't already have a /var/hack directory on your TiVo from previous hacking you may have done. If you have a pre-existing /var/hack directory that you care about preserving, rename it to something else before following these instructions. These instructions also modify some bash initialization files in /, and /etc/dhclient.conf.

Ok, now that everything is mounted, let's copy the software over. Perform the following steps to install the software distribution onto your TiVo's drive.

STEPS: Installing Software onto TiVo Drive

1. Go into the /var partition on your TiVo drive by typing:

```
cd /mnt/tivovar
```

2. Copy the software onto the /var partition:

```
tar xfp /cdrom/putInTiVoVar.tar
```

3. Go into the /root partition on your TiVo drive by typing:

```
cd /mnt/tivoroot
```

4. Copy miscellaneous config files onto the root (/) partition by typing:

```
tar xfp /cdrom/putInTiVoRoot.tar
```

This will install the various hacks discussed in this book; however most of them are initially disabled. See the "Enabling the Various Pieces" section later in this chapter to see how to enable them.

hacks_callfromrc.sysinit

You also need to make one change to the file /etc/rc.d/rc.sysinit so that every time the TiVo reboots, rc.sysinit will call a script of your own, where you can launch various hacks that you want enabled. Many people like naming their script /etc/rc.d/ rc.sysinit.author, since rc.sysinit already tries to execute a script of that exact name if it exists, in which case you wouldn't have to modify rc.sysinit at all. However, I find it's better to have your own script in your own location, since you can put it on a partition that is typically mounted as read-write (unlike the root partition "/"). One can then argue, "well why not have rc.sysinit.author call your own script, rather than modifying rc.sysinit to do it?" While you can certainly do this, I prefer modifying rc.sysinit directly because I don't trust that rc.sysinit will always execute rc.sysinit.author in future releases of the TiVo software. That means after every new release you'll be checking rc.sysinit anyway to see if it still calls rc.sysinit.author, and now you've got another file you're keeping track of. It's easier to just modify rc.sysinit directly.

Follow these steps to modify rc.sysinit:

STEPS: Setting up rc.sysinit

1. Move to the TiVo's /etc/rc.d directory by typing:

    ```
    cd /mnt/tivoroot/etc/rc.d
    ```

2. Make a backup copy of rc.sysinit via:

    ```
    cp rc.sysinit rc.sysinit.ORIG
    ```

3. Add these 3 lines (exactly as shown) to the end of the file rc.sysinit:

    ```
    if [ -f /var/hack/etc/hacks_callfromrc.sysinit ]; then
      . /var/hack/etc/hacks_callfromrc.sysinit
    fi
    ```

 You can do this with vi or joe, which are both text editors. For your convenience (and to reduce typos), I've included a text file with the previous three lines on the CD. So, if you want, you can add the above three lines to the end of rc.sysinit by carefully typing (note the TWO ">"s!!):

    ```
    cat /cdrom/addtorc.sysinit >> rc.sysinit
    ```

 Verify that you've added the lines correctly by viewing the file (type "more rc.sysinit"). At the end of the file you should see the three lines above. If you make a mistake, you can restore your backup copy via "cp rc.sysinit.ORIG rc.sysinit").

Note that you may have to come back and perform "Setting up rc.sysinit" (and steps 3 and 4 of "Installing Software onto TiVo Drive") after your TiVo receives new software updates in the future.

Enabling the Various Pieces

Ok, so everything is installed, but most of it is disabled. The change we just made to rc.sysinit causes a file of ours, /var/hack/etc/hacks_callfromrc.sysinit, to be launched when the TiVo starts up. That file is the launching pad where we start the many hacks in this book.

Consider leaving these disabled until you get to each hack while reading through the book. For instance, you might not want to enable TiVo Control Station before reading about it, to learn what modules should be enabled and disabled due to performance issues, and so on. Enabling all of the hacks in this book right now may not be the best idea, and it will certainly be more interesting for you to experience them all one at a time.

So, you may come back to this section often throughout the book. The first time you read this, you should have your TiVo drive installed in your PC, which has booted from the accompanying CD, and you'll edit the file via the mounted partition on /var/tivovar. Other times, you may be telnetting into a running TiVo via Ethernet or a serial-line PPP connection.

Edit the file hacks_callfromrc.sysinit with a text editor (again, vi and joe are available, both on the boot CD and the TiVo itself, thanks to the install we did above). If you've booted the CD and mounted the drives in a PC, this file is located at /mnt/tivovar/hack/etc/hacks_callfromrc.sysinit. If you've telnetted into your TiVo to make the change, then the file is located at /var/hack/etc/ hacks_callfromrc.sysinit.

Listing 4-2 shows the initial contents of the hacks_callfromrc.sysinit script. Lines beginning with a "#" are commented out. I could have written this such that you change one variable and it enables or disables a particular hack; I decided against this because it's better for you to see how we're actually running the hacks, and to feel comfortable making multiple changes to the file.

Listing 4-2: /var/hack/etc/hacks_callfromrc.sysinit

```
#!/bin/bash
#
# hacks_callfromrc.sysinit
# Jeff Keegan
#
# Call this from /etc/rc.d/rc.sysinit .. Place all the things that you
# want to start up in this file.  That way, the changes to
# /etc/rc.d/rc.sysinit are minimal (the call to this script), and
# reenabling them after a software upgrade will be as simple as
# re-inserting the one line to call this into the new /etc/rc.d/rc.sysinit
#

if test -f /var/hack/kernelmods/nfs-tivo25.o
then
  insmod /var/hack/kernelmods/nfs-tivo25.o
fi
```

```
# You want one of the two following sections of code uncommented, depending
# on whether this is going on a standalone TiVo or a DirecTiVo.
#
# Uncomment this section if going on a standalone TiVo - otherwise comment
if test -f /var/hack/kernelmods/tvbi.o
then
  echo 'Ignore next "Device or resource busy" error message, it is normal.'
  insmod /var/hack/kernelmods/tvbi.o
fi
# Uncomment this section if going on a DirecTiVo - otherwise comment
#if test -f /var/hack/kernelmods/tvbi-dtv.o
#then
#  echo 'Ignore next "Device or resource busy" error message, it is normal'
#  insmod /var/hack/kernelmods/tvbi-dtv.o
#fi

# If your TiVo is running slowly, consider uncommenting the next line
# to set the priority of all hacks to a low priority level.
/var/hack/bin/setpri fifo 1 $$

tnlited 23 /bin/bash -login &

# Uncomment next section to enable a bash prompt over the serial line
#if test -x /var/hack/etc/spawnbash
#then
#  /var/hack/etc/spawnbash &
#fi

# Uncomment next section to start a PPP connection over the serial line
# (NOTE: This is only for TiVo software version 2.5 and earlier.. Users
#        running 3.0 and later should see the Dial Prefix backdoor codes
#        discussed in Chapter 2 of Hacking TiVo (isbn: 0764543369))
#if test -x /var/hack/etc/startpppd
#then
#  /var/hack/etc/startpppd &
#fi

# Uncomment next section to enable tivoftpd
if test -x /var/hack/bin/tivoftpd
then
  /var/hack/bin/tivoftpd
fi

sleep 120

# Uncomment next section to enable TivoWeb
#if test -x /var/hack/tivoweb-tcl/tivoweb
#then
#  /var/hack/tivoweb-tcl/tivoweb
#fi

# Uncomment next section to enable TiVo Control Station
```

Continued

Listing 4-2 *(continued)*

```
#if test -x /var/hack/tcs/starttcs
#then
#   /var/hack/tcs/starttcs
#fi

# Uncomment next section to enable cron
if test -x /var/hack/bin/cron
then
  /var/hack/bin/cron
fi

# Uncomment next section to enable yac
#if test -x /var/hack/bin/yac
#then
#   /var/hack/bin/yac &
#fi

# Uncomment next section to enable elseed
#if test -x /var/hack/bin/elseed_forever.sh
#then
#   /var/hack/bin/elseed_forever.sh -c /var/hack/etc/elseed.conf &
#fi

# Uncomment next section to enable tivocid
#if test -x /var/hack/bin/tivocid
#then
#   /var/hack/bin/tivocid 192.168.1.2 &
#fi

# Uncomment next line to enable tivo_messenger, if you're using gaim2tivo
#if test -x /var/hack/bin/tivo_messenger
#then
#   /var/hack/bin/tivo_messenger > /dev/null 2> /dev/null &
#fi

# I can't get samba to work with my particular setup. Maybe you can
# with yours. If you want to try, uncomment the next line and
# play around with /var/hack/bin/smbmount.
#
# insmod -f /var/hack/kernelmods/smbfs-2.0.1.o

echo "hacks_callfromrc.sysinit is complete"
```

For example, to enable TivoWeb, uncomment the line

```
# /var/hack/tivoweb-tcl/tivoweb
```

by removing the #.

If you're installing this on a DirecTiVo, be sure to comment out the section on `tvbi.o` and to uncomment the section on `tvbi-dtv.o`. Those are the kernel modules for `tivovbi`, discussed later in Chapter 9.

If you've telnetted into your TiVo to make these changes, reboot the TiVo for your changes to take effect.

Moving Along to the Next Chapter

While you have your TiVo's "A" drive connected to your PC, you probably want to move on to the next chapter, "Getting Access to Your TiVo," before putting it all back together (if not, unmount the drives with "`cd /; umount -a`" before shutting down with "`shutdown`"). When you're done with the next chapter, you'll have access to your TiVo without having to disassemble your TiVo and connect its drive(s) to a PC. Once done with that, you can skip back to "Putting Drives Back in TiVo" in Chapter 3.

Getting Access to Your TiVo

I t's hard to remember what it was like to be satisfied working on a computer that wasn't connected to other computers. Back in the old days, computers stood alone, possibly talking to each other via floppy disk — you had to take a disk out of one computer and put it in the other. Some people even remember when a floppy disk seemed like luxury — on my Vic-20 and ZX-80, I stored my programs on audio tape, connected via two mono headphone cables. (I have a friend, Aron Insinga, who always trumps me at this point with PDP-11 stories from before my day. "We were lucky to have memory." "We had no electricity." "We had to spin the electrons by hand," etc.)

But nowadays when the net connection goes down, it sometimes almost feels like the power has gone out. We're growing accustomed to communication with other computers, with other people, and with other sources of information. We extend control through that growth as well: we control remote machines via command-line interfaces (e.g., telnet) and full-blown windowing systems (X-Windows, VNC, etc.)

Now that even appliances have become computers, it's growing more and more common to want to control them remotely as well. It's at the point where it's almost crazy to ask *why* you'd want to connect an appliance up, because our experience is showing us it will inevitably be beneficial.

In the case of TiVo units, you don't need to think too hard to figure out good reasons why you would want your TiVo accessible via a network. Being able to schedule recordings remotely, being able to display external data on your TV, being able to display TiVo video from another appliance, and simply being able to telnet in to a command-prompt are all justifications in and of themselves.

Here we talk about getting your TiVo online, so it is accessible via a network. By the end of this chapter, you'll be able to telnet into your TiVo and get a bash prompt, which is a prerequisite for many of the hacks throughout the rest of this book.

Caution

One word of warning: what we are setting up here is not secure by any means. It is decidedly insecure. When trying to connect to a TiVo via the serial line or telnet, you get a straight bash prompt (running as root), without having to enter any password. It's a very bad idea to put your TiVo on a network you don't trust.

in this chapter

☑ Your Connection Options

☑ Controlling IP Addresses

☑ Making Daily Calls via the Net (Instead of the Modem)

Your Connection Options

There are various methods through which you can set up access to your TiVo. I'll describe each a bit here, then describe them all in detail in the following sections. You'll want to pick one and follow those steps, after which you can proceed to "Making Daily Calls via the Net (Instead of the Modem)." Quick tip — the last few methods are the easiest.

Back when TiVo hacking was young, the first goal was just to get a bash prompt.[1] Using a terminal program on your computer, you could then connect into your TiVo and issue commands, *while it was running*. This certainly was a satisfying accomplishment back then, and I imagine it still is now for someone doing it for the first time. The feeling is almost like being a kid in a toy store — ooh, let's look around.

However, I describe how to set up a simple serial connection (and start a bash prompt on the serial line) more for those who want the experience than for those wanting practical use out of their TiVo hacking experience. Although you can issue commands, look around, and tinker with a few things, having only one channel into the machine becomes tedious real quick. File transfer is cumbersome (anyone remember zmodem?), job control is an issue, you get only one command prompt, and you don't have TCP/IP access. Again, it's fun at first, but it might be more fun to skip this and go straight to one of the other methods for more direct access. (All of the rest of the chapters in this book assume that you have TCP/IP access — a simple bash prompt on the serial line won't do that for you.)

The next approach is to still use the serial line, but to set up PPP access over it. This requires a host computer for your TiVo to be connected to, which will constantly route IP traffic to your TiVo via PPP. By enabling IP-Masquerading and IP-Forwarding, you will give your TiVo an IP address in your local subnet, and you will be able to telnet into your TiVo (as well as set up other servers in later chapters, such as a web or FTP server).

Then the easiest approach for Series1 users: add an Ethernet card to your TiVo. This puts your TiVo on your network without relying on a host computer. I talk about the two current options as well as the original for a historical perspective.

Finally, we have Series2 users. TiVo has made it more difficult to gain *shell* access to a Series2 TiVo, while making it extremely trivial to get Ethernet access for other (official) uses. Actually, they've made it more difficult for Series1 DirecTiVo owners as well, but it doesn't pose a problem for installing the Ethernet cards mentioned above. The current methods of gaining shell access to your Series2 TiVo involve either soldering a new PROM onto your motherboard, or using two-kernel-monte tricks to use holes in older kernels to gain access. I won't be describing those methods here. Take a look around the tivocommunity.com or dealdatabase.com web sites for such discussions.

Aside from the hurdles Series2 owners face, there is a benefit that makes Ethernet access itself trivial — the USB ports. Series2 TiVos all have two USB ports. (On some earlier models they were USB 1.1, but later models are USB 2.0, though at the time of this writing, even units with USB 2.0 are limited to 1.1 speeds.) Using USB Ethernet adapters, Series2 TiVo owners can get Ethernet access by just plugging in.

[1] For those of you unfamiliar with Unix, bash is a command-line interface — a shell (like a DOS prompt, but much more elegant).

Ok, those are the choices. You only need pick one, then go do it. I recommend starting from last to first — it's much easier for Series1 users to install one of the discussed Ethernet cards than to set up PPP. Then again, I've been at each stage, so maybe I'm just used to it.

Simple bash Prompt Directly over Serial Line

If you've jumped to this section without reading the preceding text, go back and read it now. Setting up a simple bash prompt directly over the serial line is interesting from a historical (and getting-your-feet-wet) perspective, but it's not going be good enough for many of the hacks described in later chapters.

Still here? Sure? Ok, let's get started. Setting up a bash prompt on the serial line is pretty straightforward (for Series1 standalone users at least). We need to make a change to your hard drive to enable a bash prompt on the serial line, connect your TiVo to your computer, and finally use a terminal program to log in.

Setting Up bash over Serial

To be able to use the serial line to get a bash prompt, you need to modify the boot-up scripts on your TiVo's hard drive to continually re-spawn a bash shell on the serial port. Since you have no access to your TiVo yet (that's why you're here!), you need to remove your TiVo's hard drive and connect it to your PC. Possibly you just finished Chapter 4 and still have your TiVo drive connected to your PC (and, hopefully, you also made a backup of your TiVo's hard drive in Chapter 3). If not, go back and read the following sections: in Chapter 3 read "Voiding Your Warranty — Cracking the Case," and in Chapter 4 read "Mounting the Drives" and "Setting up rc.sysinit." Upon returning from that you should have your TiVo's /var and /root partitions mounted, on /mnt/tivovar and /mnt/tivoroot, respectively. You should also now have the file /var/hack/etc/hacks_callfromrc.sysinit set up to be executed from /etc/rc.d/rc.sysinit.

Ok, let's add the command that continually re-spawns a bash prompt on the serial line for us. Edit /mnt/tivovar/hack/etc/hacks_callfromrc.sysinit (with vi or joe) to make sure the following lines are present and uncommented:

```
if test -x /var/hack/etc/spawnbash
then
  /var/hack/etc/spawnbash &
fi
```

If you installed the software distribution on the accompanying CD-ROM in Chapter 4, then spawnbash is already installed. If not, use a text editor to create a new file called /mnt/tivovar/hack/etc/spawnbash with the contents shown in Listing 5-1.

Listing 5-1: /mnt/tivovar/hack/etc/spawnbash

```
#!/bin/bash

echo "spawnbash: looping to spawn bash prompts on /dev/ttyS3"
export HOME=/var/hack/root
exec 0<>/dev/ttyS3 1>&0 2>&1
```

Continued

Listing 5-1 *(continued)*

```
set -m
stty sane 115200 ixon ixoff
while true
do
  bash
  echo "spawnbash: respawning new bash prompt.."
done
```

Make sure it's executable via:

```
chmod 755 /mnt/tivovar/hack/etc/spawnbash
```

Note the `stty` line in Listing 5-1where we specify a baud rate of 115200. If you want to use another baud rate (such as 9600), modify `spawnbash` to reflect that. If you're familiar with the `stty` command, then you'll notice that we've also turned on software flow control; the serial cable we're using only has three leads — TD, TR, and GND — which means that hardware flow control is not an option.

Once you've made these changes, it's time to shut down your PC. Unmount the partitions you've mounted with:

```
cd / ; umount -a
```

then shut the machine down with "`shutdown`". If you're not familiar with placing drives back into your TiVo yet, then go read "Putting Drives Back in TiVo" in Chapter 3.

Wiring Your TiVo to Your Computer

Next, you need to connect your TiVo to your computer. You have two options here. The first is to use the serial cable that shipped with your TiVo in combination with a null modem and gender bender, and the second is to construct your own cable. Figure 5-1 shows the standard TiVo serial cable, with a DB-9 null-modem and DB-9 female gender bender.

You can also construct your own cable with a female DB-9 connector, and with pins 2 and 3 switched. That eliminates the need for both the gender bender and the null modem. See the "Serial Port" section of Chapter 14 for a pinout diagram (Figure 14-3). If you don't feel like making a cable, 9thtee.com sells a completed custom cable:

```
http://www.9thtee.com/tivoupgrades.htm#COMMKIT
```

Plug the headphone-plug end of the cable into the back of your TiVo (into the jack labeled Serial), and plug the other side into your computer's serial port (including the null modem and gender bender if you aren't using a custom switching cable).

FIGURE 5-1: TiVo serial cable with DB-9 null modem and female gender bender.

Connecting with a Terminal Program

Fire up your favorite terminal program (Linux users might want to consider minicom, while Windows users probably have HyperTerminal on their machines already). Set the connections for 115200 baud, N-8-1. Turn on software flow control (xon/xoff). If you set a different baud rate than 115200 in the spawnbash program described previously, then use that baud rate instead.

Start the connection, and you should get a bash prompt! Congratulations. If you're familiar with Linux, go ahead and play around, see what's in what directory, etc. If you're not familiar with Linux, check out Appendix C for a quick intro to some of the basics.

If all you have is a serial connection, the rest of this chapter doesn't really apply to you. Some of the hacks in the book work just fine over a serial line, though getting them on there is a bit of a pain. Basically, play around for a while (since you've chosen this path), but eventually you're going to want to come back here and set up either PPP or one of the Ethernet cards described below.

PPP Access over Serial Line

This next approach is better because you finally get TCP/IP access onto and off of your TiVo, but there are still limitations: It's slower than Ethernet, it needs your PC to be up most of the time, and it takes effort to set up. Then again, it doesn't require much hardware if you already have some serial adapters lying around. For a while, this was all we had, which is why it was huge at the time.

Heads up — later when I describe the PC side of things, I only describe Linux. Users of other operating systems might want to either look elsewhere for documentation on setting up a PPP daemon first, or decide (as I suggest) that it's just easier to go buy a TurboNET card (see "TiVoNet / TurboNET / AirNET" later in this chapter).

Setting Up PPP over Serial

Back before version 3.0 of the TiVo software, setting up a PPP connection over the serial line required work. You had to create configuration files and modify boot-up scripts to start a PPP connection over the serial line. These days it's much easier, as TiVo has added PPP support as an "unsupported feature." I'll go over both approaches here — if you have version 3.0 or later, skip right ahead to "3.0-and-Later PPP Setup (via Dial Prefix Backdoor Codes) on TiVo" — don't bother trying to attempt the old setup.

If for some reason you've ever modified your boot parameters, make sure that you don't have a variable called shondss set to 1. In older software versions, specifying shondss=1 would cause a line in rc.sysinit to spawn a shell on the serial port (*SHell-ON-DSS*-port); this would interfere with the PPP connection we're trying to run there. Since shondss=1 no longer works in later versions of the TiVo software, I've decided not to mention it, except here where it might interfere with what we are trying to do.

Pre-3.0 PPP Setup on TiVo

Frank Pineau (Scutter on tivocommunity.com) deserves credit for writing a very good list of instructions for setting up PPP to do daily calls:

```
http://www.pineaus.com/HOWTO/Tivo-DSL-HOWTO.html
```

It's a bit outdated these days (since as I described above, this functionality is now included in TiVos already), but if you're using a version of software prior to 3.0 this is still a good reference worth mentioning, especially since according to my own notes, they were the instructions I followed back when first setting up PPP myself years ago. In that sense, the following is inspired by Frank's instructions.

Note In the following instructions we're going to talk about modifications that need to occur on your TiVo's hard drive. If you don't have your TiVo drives connected to your PC already (from having just finished Chapter 4, for instance) *and* your TiVo is running version 3.0 or later, *and* you have previously installed the software distribution on the accompanying CD-ROM, then don't take apart your TiVo just yet; you may only need to enter the backdoor code in Chapter 2 referred to in the instructions below, since the work you did in Chapter 4 should have set up tnlited already (you'll understand what that means soon).

To set up a PPP connection over the serial line, there are several things you need to do on your TiVo's hard drive. Since you have no access to your TiVo yet (that's why you're here!), you need to remove your TiVo's hard drive and connect it to your PC. Possibly you just finished Chapter 4 and still have your TiVo drive connected to your PC (and hopefully you also made a backup of your TiVo's hard drive in Chapter 3). If not, go back and read the following sections: in Chapter 3 read "Voiding Your Warranty — Cracking the Case," and in Chapter 4 read "Mounting the Drives" and "Setting up rc.sysinit." Upon returning from that, you should have your TiVo's `/var` and `/root` partitions mounted on `/mnt/tivovar` and `/mnt/tivoroot`, respectively. You should also now have the file `/var/hack/etc/hacks_callfromrc.sysinit` set up to be executed from `/etc/rc.d/rc.sysinit`.

Here are the steps you need to perform now that your TiVo drive is mounted.

STEPS: Setting Up PPP

1. You need to make your own copy of the `pppd` daemon that already exists on your TiVo. Unfortunately, a problem was introduced with the `pppd` that shipped with version 2.5 of the TiVo software, so you'll need a copy of the version that shipped with 2.0. If you installed the software distribution from the accompanying CD-ROM in Chapter 4, then there is already a copy of that file called `custpppd20` in `/var/hack/bin` on your TiVo and you don't have to do anything. If you didn't and you're running 2.0 or earlier, you can copy it from your own TiVo via (all on one line):

   ```
   cp /mnt/tivoroot/sbin/pppd
           /mnt/tivovar/hack/bin/custpppd20
   ```

 If not, you can copy it from the CD-ROM by hand (again, all on one line):

   ```
   cp /cdrom/misc/custpppd20
           /mnt/tivovar/hack/bin/custpppd20
   ```

2. Make sure it's executable via:

   ```
   chmod 555 /mnt/tivovar/hack/bin/custpppd20
   ```

3. Create a cuaX-style device entry for the serial line:

   ```
   mknod /dev/cua3 c 5 67
   ```

4. The `pppd` daemon will use a configuration file called `ppp-options.cua3` for setting up a PPP connection over the serial line. If you already installed the software distribution on the accompanying CD-ROM in Chapter 4, then it's already installed on your TiVo at `/var/hack/etc/ppp-options.cua3` (you may feel free to skim/skip-over steps 5 and 6 as well). If you didn't install the distribution, then either copy it onto your TiVo's hard drive from the accompanying CD-ROM by typing:

   ```
   cp /cdrom/misc/ppp-options.cua3 /mnt/tivovar/hack/etc/
   ```

 or create the file `/mnt/tivoroot/etc/ppp-options.cua3` by hand, whose contents are:

   ```
   /dev/cua3
   115200
   nocrtscts
   ```

```
lcp-restart 1
ipcp-restart 1
local
noauth
passive
persist
nodetach
asyncmap 0
proxyarp
defaultroute
netmask 255.255.255.0
```

Note the second line of ppp-options.cua3 where we specify a baud rate of 115200. If you want to use another baud rate, modify ppp-options.cua3 to reflect that. You may also note that we've disabled RTS and CTS hardware handshaking; the serial cable we're using only has three leads — TD, TR, and GND — which means that hardware flow control is not an option.

Note If you're not going to follow the instructions to modify your TiVo to perform its daily calls home over this PPP connection, then replace the line "defaultroute" in your ppp-options.cua3 file with "nodefaultroute".

5. We need a simple script that we can call from hacks_callfromrc.sysinit to start up PPP (or a bash prompt if PPP failed to launch for some reason). Again, if you installed the software distribution on the accompanying CD-ROM, you're all set. If not, either copy the file startpppd onto your TiVo's hard drive from the accompanying CD-ROM by typing:

```
cp /cdrom/misc/startpppd /mnt/tivovar/hack/etc/
```

or create the file /mnt/tivovar/hack/etc/startpppd by hand, whose contents are:

```
#!/bin/sh
/var/hack/bin/custpppd20
if /var/hack/bin/custpppd20 file \
    /var/hack/etc/ppp-options.cua3 passive \
    nodetach nocrtscts noauth persist
then
  echo "pppd started on /dev/cua3"
else
  echo "pppd failed on /dev/cua3, running spawnbash"
  /var/hack/etc/spawnbash &
fi
```

If you're curious about the two separate calls to custpppd20, it's a workaround for an intermittent problem — in other words, it's a hack (in the less-cool meaning of the word; think "kludge").

Make sure it is executable via:

```
chmod 555 /var/hack/etc/startpppd
```

6. If PPP fails to launch for some reason, `startpppd` spawns a bash prompt on the serial line (so at least you have some access into the machine). It does this by running a script called `spawnbash`; if you haven't installed the software distribution on the accompanying CD-ROM as described in Chapter 4, then create the file `/var/hack/etc/spawnbash` either by hand or by copying it from the CD-ROM, as described in the "Setting Up bash over Serial" section above.

7. Finally, we need the `startpppd` script from step 5 to actually be called from `hacks_callfromrc.sysinit` (and we need a daemon listening on the telnet port, 23, as well). Edit the file `/mnt/tivovar/hack/etc/hacks_callfromrc.sysinit`, and make sure that the following lines are present and uncommented:

```
if test -x /var/hack/etc/startpppd
then
    /var/hack/etc/startpppd &
fi
```

Make sure that the `tnlited` entry is uncommented as well:

```
tnlited 23 /bin/bash -login &
```

Once you've made these changes, it's time to shut down your PC. Unmount the partitions you've mounted with:

```
cd / ; umount -a
```

then shut the machine down with "`shutdown`". If you're not familiar with placing drives back into your TiVo yet, then go read "Putting Drives Back in TiVo" in Chapter 3.

Now skip ahead to "Wiring Your TiVo to Your Computer."

3.0-and-Later PPP Setup (via Dial Prefix Backdoor Codes) on TiVo

There are two things you need to do to set up PPP access on machines with newer TiVo software releases. Well, technically there is only one thing to do if all you want is for your TiVo to use PPP to dial home, but we'll also want to be able to telnet into the machine.

Let's deal with that item first — we need to run a daemon that listens on the telnet port (port 23) for incoming TCP connections, and starts a bash shell for all connections received. The program we'll use for this is called tnlited (which is sort of a telnetd-lite). It's already on your TiVo (it's a part of TiVo's software distribution), and all we need to do is start it. Make sure the following line is present (and uncommented) in `/mnt/tivovar/hack/etc/hacks_callfromrc.sysinit`:

```
tnlited 23 /bin/bash -login &
```

At this point, you're done making modifications to your TiVo's hard drive, and it's time to shut down your PC. Unmount the partitions you've mounted with:

```
cd / ; umount -a
```

then shut the machine down with "`shutdown`". If you're not familiar with placing drives back into your TiVo yet, then go read "Putting Drives Back in TiVo" in Chapter 3.

Next, you need to tell your TiVo that you'd like it to use the serial port for a PPP connection. This is done with the ", #2xx" or ", #3xx" Dial Prefix codes, described in the Dial Prefix Codes section of Chapter 2. Go read the "PPP over Serial Line — Direct" and "PPP over Serial Line — With Modem Emulation" sections of Chapter 2, and follow the instructions to enter the appropriate code (most likely you'll use ", #211"). Reboot your TiVo, then proceed on to "Wiring Your TiVo to Your Computer."

Wiring Your TiVo to Your Computer

See the previous section also titled "Wiring Your TiVo to Your Computer" to see how to connect your TiVo to your computer via a serial line. We'll just be using that serial line for a PPP connection instead of just one single channel of text.

Setting Up PPP on Your Computer

On the other end of the serial line there needs to be a computer for your TiVo to start a PPP connection with. I'll briefly discuss the setup for Linux here, but any computer will do — if you don't have a Linux box, find documentation on setting up a PPP daemon on your computer, and you'll be all set.

Setting up PPP on RedHat Linux

Note The following instructions set up your TiVo so it can see the entire network it is connected to. If you don't want that to occur (for instance, if you only wanted specific manual routes to individual outgoing connections, and wanted your TiVo to still use the phone line for its normal daily call), then ignore the following instruction about ip-forwarding, omit the `proxyarp` command from the pppd line, and replace `defaultroute` with `nodefaultroute` in `ppp-options.cua3`.

To start with, check to see if your kernel has `ip_forwarding` turned on by typing:

```
cat /proc/sys/net/ipv4/ip_forward
```

If you see "0", type:

```
echo "1" > /proc/sys/net/ipv4/ip_forward
```

Now let's start a PPP connection by hand first to try it out and make sure that everything works. Run the following command as root (substituting your PC's IP address for 192.168.1.2, the new IP address you are giving your TiVo for 192.168.1.101, the serial port you're actually using for cua0, and the actual baud rate you're using for 115200 (all on one line):

```
/usr/sbin/pppd cua0 115200 proxyarp noauth local
   nocrtscts 192.168.1.2:192.168.1.101
```

Wait about 20–30 seconds for the connection to have a chance to occur. If the command was successful, then typing "telnet 192.168.1.101" (obviously substituting in the new IP address you're giving your TiVo for 192.168.1.101) should get you a bash prompt on your TiVo.

If this doesn't work, first try "telnet 192.168.1.101 23" (explicitly specifying the port number for telnet). There have been reports that the tnlited shipped with the TiVo software is

buggy and that this sometimes solves the problem. There are also other versions of tnlited out there that you can find if you're affected, but it's not likely that this is your problem if you're stuck here. Check the serial cable, make sure that you have the null-modem in place, etc. You may want to try using a terminal program on your Linux box to test the serial connection.

Assuming that it did work (and that you were able to telnet into a bash prompt), add the pppd command that you just typed to your Linux box's /etc/rc.d/rc.sysinit or /etc/rc.d/rc.local file. You probably also want to add an entry to /etc/hosts, similar to:

```
192.168.1.101 tivo
```

so you can type "telnet tivo" instead of using an IP address.

Telnetting in to a bash Prompt

From this point it's pretty simple. Connect to your TiVo via "telnet 192.168.1.101" (substituting in the IP address for your TiVo), and you're done (see Listing 5-2).

Listing 5-2: telnetting in to a bash Prompt

```
# telnet 192.168.1.101
Trying 192.168.1.101...
Connected to 192.168.1.101.
Escape character is '^]'.
Welcome to your TiVo

=[tivo:root]-#
```

Again, if you get problems, you might want to try "telnet 192.168.1.2 23" instead, or try downloading an alternate version of tnlited from the various TiVo forums. If so, be sure to change hacks_callfromrc.sysinit to point to the location of your version of tnlited.

TiVoNet / TurboNET / AirNET

Before I say anything else, let me say this up front: by far the easiest option for getting your Series1 TiVo online these days is a TurboNET or AirNET card. You can purchase them at:

```
http://www.9thtee.com/turbonet.htm
http://www.9thtee.com/tivoairnet.htm
```

Now that you've placed your order online and are waiting for a few days for it to arrive, you have time to read a bit of history.

Originally, there was the TiVoNet card. It was developed by Andrew Tridgell and its specs were released on the web for anyone to use. 9thtee.com started selling it either pre-assembled, or as a kit (for those with steady hands who didn't mind soldering surface-mount chips). It plugged on the edge connector of Series1 TiVos and had an ISA (Industry Standard Architecture) slot

where you plugged in an Ethernet card. Figure 5-2 shows an assembled TiVoNet card with an Ethernet card plugged into the ISA slot. When installed in a TiVo, the Ethernet card would hang over the motherboard.

FIGURE 5-2: TiVoNet ISA Adapter with Ethernet card plugged in.

The TiVoNet card is now obsolete because of the availability of two new cards: the TurboNET card and the AirNET card. The TurboNET card is a self-contained Ethernet card also made for your Series1 TiVo's edge connector (see Figure 5-3), while the AirNET card allows the use of a wireless 802.11b card in your TiVo for the same purpose.

When using one of these cards in a TiVo that is running old (pre-3.0) software, it was necessary to install drivers. Installation instructions for those drivers are available from the same page on 9thtee.com where you purchase them. Users of TiVoNet or TurboNET cards no longer need worry about this however — TiVo introduced "unsupported" support for those two cards in version 3.0 of its software (through the use of the ", #401" Dial Prefix code, as described in Chapter 2). AirNET cards still require software installation.

How you run CAT-5 cable out of your TiVo is up to you. Some people cut fancy holes in the back of their TiVo to mount jacks. I run cable from the TurboNET card across the inside of the TiVo, then out through a hole in the bottom of my Philips HDR112 near the fan (see Figure 5-4). You can either make a cable long enough to reach where you want it to go (crimp the connectors on after running it through the hole!), or make it just long enough to reach the outside of your TiVo and connect it to a CAT-5 barrel connector that you affix to the outside of your TiVo.

FIGURE 5-3: Installed TurboNET card.

FIGURE 5-4: Running CAT-5 cable through a hole in the bottom of your TiVo.

Series2 USB Ethernet

Series2 TiVos all come with two USB ports, and support now exists to use USB Ethernet adapters to connect your TiVo to your network. In version 3.0 you could obtain this access via the "unsupported" support for Ethernet that the ", #401" Dial Prefix code provided (see Chapter 2). In version 4.0, support is official (and can be used for daily calls as well as the optional Home Media Option package).

At the time of this writing, DirecTV has decided not to offer the HMO package, and support (even "un-support") for the USB Ethernet adapters does not exist for Series2 DirecTiVos.

Various USB Ethernet adapters are reported to work. From TiVo's own web site, here are the models people have reported success with (see Table 5-1).

Table 5-1 USB Ethernet Adapters for Series2 TiVos

Compatible TiVos	USB Ethernet Adapter Make/Model
Wireless Adapters	
All Series2 Units	■ Linksys WUSB11 ver. 2.6 ■ NetGear MA101 V.B ■ D-Link DWL-120 V.E ■ SMC 2662W V.2 ■ Belkin F5D6050
Series2 Units with service numbers starting with 110, 130, and 140	■ NetGear MA101 V.A ■ D-Link DWL-120 V.A
Series2 Units with service numbers starting with 230, 240	■ D-Link DWL-120 V.D ■ Linksys WUSB12 ■ Hawking WU250 ■ Microsoft MN-510
Wired Adapters	
All Series2 Units	■ Linksys USB100TX ■ Linksys USB100M ■ Linksys USB200M ■ NETGEAR FA101 ■ NETGEAR FA120 ■ Belkin F5D5050 ■ 3Com 3C460B ■ Microsoft MN-110 ■ Hawking UF200 ■ Hawking UF100 ■ D-Link DSB-650TX ■ D-Link DUB-E100 ■ Siemens SS1001 ■ SMC SMC2208

If you were curious, there is no Series2 equivalent to the edge connector inside Series1 TiVos, so there is no TiVoNet/TurboNET/AirNET equivalent other than the USB Ethernet adapters.

Though I've stated it elsewhere, it bears repeating again. Gaining access into a Series2 TiVo (such as being able to telnet in, being able to run custom code on the machine, etc.) is relatively new and requires extra effort, since Series2 units check for modified/damaged files on the hard drive at boot time and replace them. Some people have obtained access via modifying their PROM, whereas others have made use of a two-kernel-monte hack in conjunction with earlier versions of the software. Search around on the various forums for more info. Series1 DirecTiVo owners have similar restrictions; obtaining access is now pretty easy.

Controlling IP Addresses

In the pre-3.0 PPP method described earlier, you clearly specify which IP address your TiVo should be given in the pppd running on your PC, and Series2 owners running 4.0 can specify an IP address in TiVo's own user interface. But what of users of the "unsupported" Dial Prefix codes; are they doomed to always get assigned a random IP address from their home network's DHCP server?

You have several options. First, if your DHCP server supports DHCP reservations, you might be able to specify the MAC address of your TiVo's Ethernet card and have the DHCP server always give it the same dynamic address, essentially making it static. If your DHCP server displays machine names, you can make your TiVo easy to recognize as well by having a /etc/dhclient.conf file on your TiVo that contains something like:

```
interface "eth0" { send host-name "bedroomtivo"; }
```

(If you try to create this file while telnetting in, remember that you need to first remount the root directory writable via "mount -o remount,rw /", then afterward mount it read-only again with "mount -o remount,ro /".)

A more direct approach is to just force your TiVo to use a specific static IP address. To do this you want to modify the file /etc/rc.arch (make a backup first). As described in the last paragraph, you'll need to remount the root ("/") directory as read-write first. Look for the two lines that say:

```
export DYNAMIC_NET_DEV=eth0
```

Before each, add the following two lines (thus adding four lines to the file in total), substituting your desired IP address, netmask, and gateway:

```
ifconfig eth0 192.168.1.101 netmask 255.255.255.0 up ;
route add default gw 192.168.1.1 ;
```

From now on when your TiVo connects (via the ",#401" Dial Prefix code), it will assume the IP address 192.168.1.101, a netmask of 255.255.255.0, and a gateway of 192.168.1.1 (in this example).

Making Daily Calls via the Net (Instead of the Modem)

In the pre-3.0 days, you made a slight change to /tvlib/tcl/tv/TClient-lib.itcl to make your TiVo's daily calls happen via your new Internet connection. With version 3.0 this changed, because the daily call is no longer controlled by a Tcl script but rather by compiled internal code. In place of the old Tclient_lib.itcl script is now a notice informing users about the Dial Prefix backdoor codes discussed in Chapter 2. These codes do the entire TiVo side of the PPP / TiVoNET / TurboNET setup, as well as routing all daily calls through that connection. So if you're using 3.0 or later, this is all done for you if you're using the Dial Prefix codes.

Just in case you happen to be running an old pre-3.0 version of the software, here was the change that you would make. In /tvlib/tcl/tv/TClient-lib.itcl, there were two lines that read:

```
if [file exists /var/tmp/pppaddr] {
if {[connectPPP $phone $pppUser $pppPass] != 0} {
```

Right before those two lines you would add:

```
catch {file delete /var/tmp/pppaddr}
```

This kept TClient-lib.itcl from disconnecting the existing connection and starting a new one.

Almost Done with the Boring Stuff

So far, the most impressive thing you've done in this part of the book is to have expanded the storage capacity of your TiVo (if you did that). In Chapter 4, you installed software but didn't do much with it, and here you've set up basic communication abilities. These have been useful, but not terribly exciting. There's just one more chapter like this: Chapter 6 deals with getting file transfer utilities in place. Stick with it!

Setting Up rsync, ftpd, or NFS

Before you start diving in installing things and playing with them, do yourself a favor and set up some tools for doing file transfer. No one wants to waste time struggling to get files onto their TiVo, when the real fun is working on that next cool feature they just read about. In this section we'll get that problem out of the way, so that moving files to and from your TiVo won't be a burden when you'd rather be having fun playing.

The three main methods of file transfer we'll discuss here are rsync, ftpd, and NFS. These all require net access to/from your TiVo, so you'll want to take a look at Chapter 5, "Getting Access to Your TiVo," before continuing. I really want to de-emphasize zmodem and samba, so I'll cover them last.

On a procedural note, I'll mention that this chapter will be a bit more forgiving than most with regard to editing files on your TiVo. Whereas other chapters will assume that you have a text editor like vi or joe installed, this chapter will hold your hand a bit, since the results of this chapter make it easier to get editors on the TiVo in the first place. Of course, if you've installed the distribution on the accompanying CD, you should already have those editors on your TiVo.

in this chapter

- ☑ rsync
- ☑ ftpd
- ☑ NFS
- ☑ Other File Transfer Tools

Caution

As with any file protocol, all of the following have their security risks, even if set up correctly. The goal of this chapter is to get you up and running with easy access into and out of your TiVo. It is not the author's intention to cover these tools fully. Consult the documentation for these tools to learn more. It's safest to assume that these servers open up your TiVo entirely, so keep them on a private network unless you know what you're doing.

rsync

rsync is a fast file transfer program that allows you to keep files and directories on multiple machines in sync. It was originally written by Andrew Tridgell, and has since grown with the help of others.

What makes rsync quick is how it handles file transfers. The first time you send a file with rsync, it's just as fast as any file transfer utility. But the next time you send the same file, rsync uses various algorithms to determine just the portion of the file that has changed, and then sends over just the changes. That makes it especially attractive for those using PPP for their net connection, because it reduces the bandwidth needed for subsequent transfers.

rsync also allows you to sync entire directory hierarchies, meaning that you can keep a synced copy of your TiVo's hack directory on your PC. It's common for one to set up a cron job (see Chapter 12) to keep directories synced up every 5 minutes or so, completely automating the process. This ease of use (combined with the bandwidth benefit for PPP users) is why I'm covering rsync first.

Though I refer here to an rsync *client* and an rsync *server*, they're actually the same executable: rsync. You'll need to install the rsync client on your TiVo, and also an rsync server on the machine you wish to sync up with. rsync was originally written on Unix, though Windows versions do now exist. Mac OS X, being Unix, runs rsync quite well.

Installing rsync Client on TiVo

On the CD If you've installed the distribution I've included on the accompanying CD as described in Chapter 4, then the rsync client is already on your TiVo, and you can skip ahead to Installing rsync Server.

First, download a copy of rsync compiled for your TiVo at:

```
http://tivo.samba.org/download/tridge/rsync
```

Now we want to put that executable on your TiVo, in the directory `/var/hack/bin/`. Since we don't yet have `rsync` set up, we are limited to two options: copying it directly to the hard drive or fetching it with a command called `http_get`.

Copying rsync to the hard drive directly involves copying rsync to a floppy, shutting down the TiVo, taking out the "A" drive, connecting it to a PC's IDE bus, booting the tivoboot CD or an appropriate TiVo boot floppy, mounting the A drive, mounting the floppy holding rsync, copying rsync onto the A drive, and doing a `chmod 555 rsync` on it. If you're going to go this route, you might want to consider just installing all of the software as described in Chapter 4.

The second option (`http_get`) works well if you have a spare web server lying around. Place the rsync executable somewhere on your web server, where you know how to access it via a URL. Find out the IP address of the web server; TiVo isn't set up to do hostname resolution. Then, follow these steps:

STEPS: Using http_get to Fetch rsync Client

1. Telnet into your TiVo (see Chapter 5 if that's not set up yet).

2. Make sure that the `/var/hack/bin` directory exists, via:

```
mkdir -p /var/hack/bin
```

3. Move to the `/var/hack/bin` directory by typing:

```
cd /var/hack/bin
```

4. Fetch the file via the TiVo internal command called `http_get`. The usage string for `http_get` is:

```
Usage: http_get [-sd] -U <url> -D <dest_dir> -T <tcd_id>
                -C <call_id> [-H <host_ip>] [-P <port>]
                [-r <rate> -t <timeout>]
```

The URLs it takes are particular in that they must have an IP address in place of a host-name, and they must specify a port (even if it's the default of 80). So for example, if your URL is originally:

```
http://192.168.1.5/~jkeegan/rsync
```

then the `http_get` command you type should be:

```
http_get -T 0 -C 0 -D /var/hack/bin \
        -U http://192.168.1.5:80/~jkeegan/rsync
```

(You don't have to type the "\" — just type the entire command on one line.)

Don't bother playing around with the other options, just make sure you specify "`-T 0`", "`-C 0`", a destination directory with `-D`, and a source URL with `-U`.

5. Set the permissions on the file to executable via:

```
chmod 555 /var/hack/bin/rsync
```

At this point, rsync should reside in `/var/hack/bin/rsync`, and should be executable.

Installing rsync Server

Next, you have to install rsync on the machine you want to sync up with. This will obviously vary from system to system. I'll cover a few here, and then deal with configuration afterwards.

Caution

Do not use rsync version 2.4.6, it has significant bugs that keep rsync from working at all. On my Red Hat 7.2 system, rsync version 2.4.6 was installed by default, and I had to upgrade to 2.5.5. It's ok to use version 2.4.4 on the TiVo itself, but the machine you sync up with should use at least version 2.5.5.

Red Hat Linux

Download the latest RPM for rsync, if it's not already installed. You can see what version is installed (or if it's installed at all) by typing:

```
rpm -qa | grep rsync
```

Binaries of rsync for various platforms are available at:

```
http://samba.anu.edu.au/ftp/rsync/binaries/
```

and RPMs can always be found at:

```
http://www.rpmfind.net/
```

The latest version at the time of this publication is `rsync-2.5.5-1.i386.rpm`. Become root (either by logging in as root, or by running the command `su`), then install the rsync package via

```
rpm -I rsync-2.5.5-1.i386.rpm
```

Now you have rsync installed, but we still want to set it up to run in daemon mode each time you start up your PC. To do this, you first need to become root, and then edit the file `/etc/xinetd.d/rsync`. The file should look something like Listing 6-1.

Listing 6-1: A Typical /etc/xinetd.d/rsync File

```
# default: off
# description: The rsync server is a good addition to \
# an ftp server, as it allows crc checksumming etc.
service rsync
{
        disable = yes
        socket_type      = stream
        wait             = no
        user             = root
        server           = /usr/bin/rsync
        server_args      = --daemon
        log_on_failure   += USERID
}
```

Change `disable = yes` to `disable = no`. Save the file, and proceed to the "Configuring rsync Server" section.

Windows NT/2000

Installing rsync on Windows is a bit trickier, though it's easier now than it was in the past. To install rsync on your Windows machine, you'll need to install Cygwin, which is a Unix environment for Windows developed by Red Hat. `www.cygwin.com` is the web site for Cygwin, but the easiest way to install it is to just enter this URL into your browser on your Windows machine:

```
http://www.cygwin.com/setup.exe
```

There's no need to save a copy of the file that is downloaded, you can just open it directly. The URL downloads a small program that runs and lets you decide which components of Cygwin to install; it then downloads and installs all selected components.

On the first screen, choose Install from Internet. On the second, be sure to choose Unix as the Default Text File Type. Then, proceed through the next two screens until you come to Choose a Download Site. Pick one of the available mirrors. Clicking Next from this screen will bring up the Select Packages screen, which should look something like Figure 6-1.

FIGURE 6-1: Initial Cygwin Setup window.

Click on the + next to Net, and make sure that rsync is enabled as in Figure 6-2.

FIGURE 6-2: Selecting rsync for installation.

Proceed with the rest of the installation, and now you'll have Cygwin installed, including rsync. To bring up a Cygwin window, from the Start menu, choose:

Start → Programs → Cygwin → Cygwin Bash Shell

From the Cygwin command line, you can start rsync in daemon mode (as a server) by typing rsync -daemon (though don't do that yet — read the "Configuring rsync Server" section first). This method requires that you restart rsync by hand every time you reboot or log in. You can also install rsync as a service that will run whether someone is logged in or not. If you're interested in doing this, proceed on to "Windows NT/2000 as a Service"; otherwise, skip ahead to "Configuring rsync Server."

Windows NT/2000 as a Service

If you want to have your rsync daemon running even when no one is logged in, then you'll want to set it up as a service as well. To set up rsync as a service, first perform the steps in the previous "Windows NT/2000" section, then read on. Otherwise, skip ahead to "Configuring rsync Server."

First, we need to make sure that the mounted drives in the Cygwin environment are available to the System account used for running services. In a Cygwin window, type:

```
mount -m
```

This should output something like Listing 6-2.

Listing 6-2: Output of mount -m

```
mount -fsb "C:/cygwin/usr/X11R6/lib/X11/fonts" "/usr/X11R6/lib/X11/fonts"
mount -f -s -b "C:/cygwin/bin" "/usr/bin"
mount -f -s -b "C:/cygwin/lib" "/usr/lib"
mount -f -s -b "C:/cygwin" "/"
mount -s -b --change-cygdrive-prefix "/cygdrive"
```

One at a time, copy then paste each of these lines into a Cygwin window. What this does is to remount each of the existing mounts, but ensure that they're mounted as system-wide mount points that are accessible to the System account. If you didn't do this, you'd get errors trying to start up the service later.

Now we're able to create our new NT service to run rsync. In a Cygwin window, enter the following command (all on one line):

```
cygrunsrv -I "rsyncd" -d "RSYNC Daemon" --path /usr/bin/rsync
        -args '--config=/etc/rsyncd.conf --no-detach --daemon'
        -e CYGWIN='binmode tty ntsec'
```

That should create a new service to run rsync. If you want, you can check to see that it was installed by bringing up the Services window via Start → Programs → Administrative Tools → Services, and scrolling down to RSYNC Daemon (see Figure 6-3).

FIGURE 6-3: Our new NT service for rsync.

Don't start the service until after setting up /etc/rsyncd.conf it in the "Configuring rsync Server" section.

Mac OS X

Mac OS X version 10.2 has the rsync executable installed already, but it's not set up yet to be a server. Here I'll describe the steps needed to set up rsync as a server. To perform these tasks you'll need to be root, so start up the Terminal application to get a command prompt, and type sudo tcsh to get a root shell.

There is no /etc/rsyncd.conf file by default in Mac OS X, and rsync needs it, so we need to create it. I'll leave the description of that file until the "Configuring rsync Server" section , but be aware that you'll be creating the file where one didn't exist before.

Then, we need to create an xinetd entry for rsync, so it will run every time the machine is restarted. In the /etc/xinetd.d directory, create a file called rsync, and enter the contents of the file in Listing 6-3.

Listing 6-3: Contents of Our /etc/xinetd.d/rsync File

```
# default: off
#
# Created this by hand... Didn't come with Mac OSX
#
service rsync
{
        disable = no
        socket_type      = stream
        wait             = no
        user             = root
        server           = /usr/bin/rsync
        server_args      = --daemon
        log_on_failure  += USERID
        groups           = yes
}
```

Do yourself a favor right now and triple-check that you haven't made any typos.

Now xinetd knows about rsync, but we still have to add rsync to /etc/services so it's listed as a service for its port number of 873. Edit the file /etc/services and add the following two lines:

```
rsync            873/tcp                        # rsync
rsync            873/udp                        # rsync
```

That's all that's needed to fully enable rsync as a daemon. Don't try telling xinetd to reload its configuration (via kill -HUP <xinetd's-pid>) until you've created /etc/rsyncd.conf in the next section.

Configuring rsync Server

For rsync to work in daemon mode as a server, it needs a configuration file. By default, rsync looks in `/etc/rsyncd.conf` .[1] If you don't currently have a `/etc/rsyncd.conf` file, create one; otherwise edit the existing one (make a backup first!).

`rsyncd.conf` lets you specify named directories to share via rsync. Each named directory can have its own configuration options. For the purposes of this book, I'll only cover the few that are needed here. Consult rsync's documentation (its man-page) for more information.

Let's start with an example file, and then we'll dissect it so you can see which pieces you'll need. Listing 6-4 shows a sample `/etc/rsyncd.conf` file.

Listing 6-4: Sample /etc/rsyncd.conf file

```
# sample /etc/rsyncd.conf file

###########################
# Global Config Settings #
###########################
# For NT/2000, be sure "use chroot" is false
use chroot = false

# For NT/2000, be sure "strict modes" is false
strict modes = false

# If you want to restrict access, place hostnames
# or IP-addresses in the "hosts allow" field, or * for all.
hosts allow = *

###########################
# Module Config Settings #
###########################
[tivo]
path = /home/jkeegan/tivo
uid = root
read only = no

[scratch]
path = /home/jkeegan/tmp/scratch
uid = root
read only = no
```

[1] If you're using BSD, rsync's config file lives in `/usr/local/etc/rsyncd.conf`, not `/etc/rsyncd.conf`. If you are using Windows NT/2000, the file is still `/etc/rsyncd.conf`. In a cygwin window, you can cd to `/etc` and create the `rsync.conf` file with a text editor such as `vi`. You can also access the file via its Windows location (for example, `c:\cygwin\etc\rsyncd.conf` if you installed cygwin in `c:\cygwin`), but be aware that the text editor you use has to save its files in Unix format. Textpad (shareware, www.textpad.com) works well.

At the beginning of the file we have some global[2] configuration settings.

```
use chroot = false
```

If this value were set to true, then rsync would be a bit more security conscious by using a system command called `chroot` to limit its own file access to just within the specified directories. Unfortunately, this option doesn't work correctly on Windows, so Windows users need to specify this as false.

```
strict modes = false
```

A file known as the secrets file will have its permissions checked to make sure it's not world-readable if this value is set to true. Again, this doesn't work correctly on Windows, so Windows users need to specify this as false.

```
hosts allow = *
```

This is the mechanism which allows you to limit which machines can access a given share. Since we're not spending too much time on security here, we'll just specify *, meaning all machines can have access.

After the global configuration settings, the rest of the file contains a list of *modules* and module-specific settings. A module is like a share — it specifies a named access point with which someone can access your machine. We've defined two modules in our example; one named `tivo`, and another named `scratch`.

```
path = /home/jkeegan/tivo
```

`path` specifies the directory to share for this named module.

```
uid = root
```

When files are accessed or modified, it will be with the access rights of the user specified by the `uid` parameter for that module. Specifying `uid = root` means the files will be accessed by the superuser account.

```
read only = no
```

You can specify read-only access to a particular module by specifying `read only = yes`. Here we probably want to be able to write to the share on the PC however, so we have `read only = no`.

You can create as many modules/shares as you want. Let's try a local test on the server. For this test (and for the examples in the next section), we'll assume that you have a module called `tivo` with parameters similar to the example above. A simple `rsync` command to run on the server to test your setup is:

```
rsync -PavzH /etc/passwd localhost::tivo/
```

If this is successful, the directory you specified in the `path` setting in the `tivo` module in `rsyncd.conf` should now contain a copy of the `/etc/passwd` file.

[2] Actually, the three configuration settings listed here aren't technically global parameters, but are actually *module* parameters. Since these are listed at the top of the file, they override the default module parameter values so that all modules inherit these, so calling them global parameters is close enough for our purposes.

Using rsync

Some of the arguments that `rsync` takes are listed in Table 6-1.

Table 6-1 Common rsync Arguments

Argument	Description
-P	Keep partially transferred files, and show progress during transfer.
-a	Turns on various archiving options such as indicating that directories should be recursively copied, and to preserve permissions, times, owner, and group on copied files/directories.
-v	Increase verbosity.
-q	Decrease verbosity.
-z	Compress files during transfer.
-H	Preserve hard links.
--numeric-ids	Don't use actual usernames and groupnames when preserving owner/group, but instead use the numeric uid/gid. This option is necessary when rsyncing to a Windows NT/2000 machine.
--exclude=PATTERN	Exclude any files matching PATTERN. See the rsync man-page for a detailed list of acceptable forms for PATTERN.
--include=PATTERN	Don't exclude any files matching PATTERN. This is used in conjunction with an exclude rule, to limit what it excludes. See the rsync man-page for a detailed list of acceptable forms for PATTERN.
--exclude-from=FILE	Like --exclude, but one or more exclude patterns are read from a file.
--include-from=FILE	Like --include, but one or more include patterns are read from a file.
--delete	Delete files that don't exist on the sending side. *This is obviously a very dangerous command.* Before using this, try the command out with the -n option to perform a dry run.
--delete-excluded	Delete any files on the receiving side that were excluded via --exclude or --exclude-from above. *This is obviously a very dangerous command.* Before using this, try the command out with the -n option to perform a dry run.
-n	Perform a "dry run," displaying what would have been transferred and/or deleted without actually doing so. This is a good idea when specifying complex commands, and should always be used before using --delete or --delete-excluded.

Here are some examples that illustrate how to use rsync to move files from your PC to your TiVo via rsync (and vice versa). In the following examples, we'll use 192.168.1.2 for the IP address of your PC, and we'll assume you've specified a read-write module called tivo in the previous section. All of the following commands are run on the TiVo itself.

Note If the machine you are rsyncing with is running Windows NT/2000, always include the `--numeric-ids` argument in your rsync command.

```
rsync -PavzH 192.168.1.2::tivo/file.txt file.txt
```

This copies a file called `file.txt` from the `tivo` share on the PC to the current directory on the TiVo.

Note that when you run this command for the first time, you may see the error "chown file.txt : Function not implemented". This is because the -a (archive) option actually expands to `-rlptogD` , where -o says to preserve file owners and -g says to preserve groups. Since TiVo's Linux is limited in its handling of permissions, this causes a problem. One solution is to use `-rlptD` in place of -a, but this can be a pain, especially if you're used to rsync. The other solution is to ignore the error, or pipe the result of rsync to grep, to eliminate the error message, as in the next example.

```
rsync -PavzH 192.168.1.2::tivo/file.txt file.txt
      2>&1 | grep -v "Function not implemented"
```

This does the same thing as the last command, but filters out the error message. If you create a script to perform your common rsync commands, you can choose whether to use this method or whether to use `-rlptD` instead of -a.

```
rsync -PavzH 192.168.1.2::tivo/foo/bar.txt blah.txt
```

This copies a file called `bar.txt` from within the `foo` directory inside the `tivo` share on the PC to the current directory on the TiVo, naming it `blah.txt`.

```
rsync -PavzH 192.168.1.2::tivo/images/. /var/hack/images
```

This recursively copies the entire directory named `images` inside the `tivo` share on the PC onto the directory `/var/hack/images` on the TiVo. If a `/var/hack/images` directory doesn't exist, it will be created. If a `/var/hack/images` directory does exist and contains files also in the PC's version of the directory, then those files will be overridden with the new copies from the PC. If a `/var/hack/images` directory does exist and contains extra files not in the PC's version of the directory, those will be left alone (since we didn't specify the very dangerous `--delete` option).

```
rsync -PavzH --numeric-ids --delete --exclude=displayfiles
      --exclude=apsrunning.sh /var/hack/.
      192.168.1.2::tivo/backupofvarhack/.
```

This is the command I use to back up my TiVo's `/var/hack` directory (see Chapter 12 for an example of how to run this command periodically via cron). The two exclude patterns ensure that files named `displayfiles` or `apsrunning.sh` will not be copied. The `--delete` argument specifies that any old files in my `backupofvarhack` directory that aren't still on my TiVo will be deleted. I've included the `--numeric-ids` argument here as well to show an example of it for those using Windows NT/2000 as their rsync server.

You can learn more about rsync at `http://samba.anu.edu.au/rsync/` as well as from the man-pages for rsync, rsyncd, and rsyncd.conf.

ftpd

FTP (File Transfer Protocol) has been around since 1985, so it's a very familiar way to transfer files. All of the major operating systems ship with FTP clients, and web browsers will act as FTP clients as well. You can install an FTP server on your TiVo, allowing you to FTP into the machine from other machines on the network to send or receive files.

The ftpd client for the TiVo is tivoftpd, by Dan Stagner (sorphin on tivocommunity.com). The 0.0.2 version fixes important bugs that were present in the 0.0.1 version, so save yourself some headaches and make sure that you get the right version.

Installing tivoftpd

If you've installed the distribution I've included on the accompanying CD as described in Chapter 4, then the tivoftpd server is already on your TiVo, and you can skip ahead to Using tivoftpd.

First, download a copy of ftpd compiled for your TiVo (`tivoftpd-0.0.2.zip`) from:

`http://www.tivocommunity.com/tivo-vb/attachment.php?postid=559541`

The thread it was posted on is:

`http://www.tivocommunity.com/tivo-vb/showthread.php?threadid=63942`

The zip file contains two files; `tivoftpd.ppc` and `tivoftpd.mips`. The first version is for Series1 TiVos, which are PowerPC-based. The second version is for the newer Series2 TiVos. The two versions are also mirrored separately at:

`http://prdownloads.sourceforge.net/tivoutils/tivoftpd.ppc.gz`
`http://prdownloads.sourceforge.net/tivoutils/tivoftpd.mips.gz`
`http://tivoutils.sourceforge.net/`

Now we want to put one of those two executables on your TiVo, in the directory `/var/hack/bin/`. As with rsync, we still have the chicken-and-egg problem of how to get the file onto the TiVo without having any file transfer mechanism already set up.

If you have already set up rsync, you can use it to move tivoftpd onto the TiVo. If not, you have the same options you had with the rsync executable above: copy it directly to the hard drive, or fetch it with `http_get`. See the Installing rsync Client On TiVo section above for help getting `tivoftpd` onto your TiVo.

Once on your TiVo, place the file in the `/var/hack/bin/` directory, and call it `tivoftpd` (remove the `.ppc` or `.mips` extension). Remember to set the permissions on the file to executable via:

`chmod 555 /var/hack/bin/tivoftpd`

Now the executable is installed, but it would be nice if the TiVo started tivoftpd each time the machine rebooted. If you're reading this, chances are you didn't install the distribution on the accompanying CD as described in Chapter 4, so you have some changes to make.

First, you need to modify /etc/rc.d/rc.sysinit to launch what you want after a reboot. Rather than hardcoding tivoftpd here, I find it's better to have rc.sysinit launch a script of ours that we can easily change later. In Chapter 4 I described how to do this if your TiVo's drives were connected to your PC. I'll give similar instructions here from the point of view of someone telnetting in, just to keep from bouncing you around the book or muddying up the instructions in Chapter 4. (If you're interested in a justification for why I suggest an external script, see the "hacks_callfromrc.sysinit" section in Chapter 4.)

Follow these steps to set up rc.sysinit via telnet:

STEPS: Setting up rc.sysinit via telnet

1. Telnet into your TiVo (see Chapter 5 if that's not set up yet). This assumes that you've already made changes to rc.sysinit to allow access via telnet, which might seem bizarre because we're about to describe changing it again. Presumably, since you're reading these steps and haven't installed the distribution in Chapter 4, you're installing things at your own pace. If you already have rc.sysinit calling /var/hack/etc/hacks_callfromrc.sysinit, you can skip these six steps.

2. Type the following command to remount the root partition as read-write:

   ```
   mount -o remount,rw /
   ```

 Between now and the time that you remount it as read-only below, be careful not to unplug the machine. The main reason that the root filesystem can handle abrupt power disconnects is because it's mounted as read-only.

3. Move to the /etc/rc.d directory by typing

   ```
   cd /etc/rc.d
   ```

4. Make a backup copy of rc.sysinit via:

   ```
   cp rc.sysinit rc.sysinit.ORIG
   ```

5. Add these three lines (exactly as shown) to the end of the file rc.sysinit:

   ```
   if [ -f /var/hack/etc/hacks_callfromrc.sysinit ]; then
     . /var/hack/etc/hacks_callfromrc.sysinit
   fi
   ```

 If you installed the distribution on the accompanying CD in Chapter 4, you should have the text editor vi installed and you can use it to add the lines. If you didn't, you can add these lines by carefully using cat. First put the lines in a temporary file via:

   ```
   cat > /var/tmp/rctmp
   if [ -f /var/hack/etc/hacks_callfromrc.sysinit ]; then
     . /var/hack/etc/hacks_callfromrc.sysinit
   fi
   « Ctrl-D »
   ```

Verify that the file contains these three lines via:

```
cat /var/tmp/rctmp
```

If you entered it correctly, then type the following, *being extremely careful to type two >'s, not just one*:

```
cat /var/tmp/rctmp >> /etc/rc.d/rc.sysinit
```

6. Verify that the three lines were correctly added to the end of the file, by viewing the file with `cat`, paying attention only to the end:

```
cat /etc/rc.d/rc.sysinit
```

7. Remount the root partition as read-only again:

```
mount -o remount,ro /
```

Now you have rc.sysinit executing `/var/hack/etc/hacks_callfromrc.sysinit`, so you can launch tivoftpd from there. If you haven't created a file called `/var/hack/etc/hacks_callfromrc.sysinit` (either on your own or in Chapter 4), then follow these steps:

STEPS: Creating /var/hack/etc/hacks_callfromrc.sysinit

1. Make sure the `/var/hack/etc` directory exists, via:

```
mkdir -p /var/hack/etc
```

2. Move to the `/var/hack/etc` directory by typing:

```
cd /var/hack/etc
```

3. Check to make sure that the file doesn't already exist, by typing:

```
/bin/ls -la
```

and looking at the directory listing.

4. If you're sure that it doesn't exist yet, create it by typing:

```
echo "#!/bin/sh" > hacks_callfromrc.sysinit
```

Now add the line to `hacks_callfromrc.sysinit`, that launches tivoftpd, again being sure to use *two* >'s, not just one:

```
echo "/var/hack/bin/tivoftpd" >> hacks_callfromrc.sysinit
```

tivoftpd should now be set up to run after every reboot. Either restart your TiVo to test this now, or just run tivoftpd by hand now via

```
/var/hack/bin/tivoftpd
```

and test whether it's started on reboot later.

Using tivoftpd

Once tivoftpd is set up on your TiVo and is running, using it is the same as using any other FTP server. Listing 6-5 shows a sample FTP session.

Listing 6-5: Sample FTP Session

```
# ls
filetomovetotivo.txt
# ftp 192.168.1.101
Connected to 192.168.1.101 (192.168.1.101).
220 You are in TiVo Mode.
220 Login isn't necessary.
220 Please hit ENTER at the login/password prompts.
Name (192.168.1.101:jkeegan):
331 No Auth required for TiVo Mode.
Password:
230 Running in TiVo Mode.
Remote system type is UNIX.
ftp> cd /var/hack/root
250 Directory change successful.
ftp> dir
227 Entering Passive Mode (192,168,1,101,4,1).
150 Opening ASCII mode data connection for file list.
total 0
-rw-r--r--    1 0    0    34 Jan 30 08:02 filetogetfromtivo.txt
226 Transfer complete.
ftp> type binary
200 Type set to I.
ftp> get filetogetfromtivo.txt
local: filetogetfromtivo.txt remote: filetogetfromtivo.txt
227 Entering Passive Mode (192,168,1,101,4,2).
150 About to open data connection.
226 File transfer complete.
34 bytes received in 0.00014 secs (2.4e+02 Kbytes/sec)
ftp> put filetomovetotivo.txt
local: filetomovetotivo.txt remote: filetomovetotivo.txt
227 Entering Passive Mode (192,168,1,101,4,3).
150 Opening BINARY mode data connection for filetomovetotivo.txt.
226 File transfer complete.
44 bytes sent in 0.000107 secs (4e+02 Kbytes/sec)
ftp> dir
227 Entering Passive Mode (192,168,1,101,4,4).
150 Opening ASCII mode data connection for file list.
total 0
-rw-r--r--    1 0    0    34 Jan 30 08:02 filetogetfromtivo.txt
-rw-r--r--    1 0    0    44 Jan 30 08:05 filetomovetotivo.txt
226 Transfer complete.
ftp> quit
221 Service closing control connection.
#
```

There is no username or password required when FTPing into tivoftpd. Once in, you have access to the entire filesystem.

If you're unfamiliar with FTP, consult the man-page for a more detailed description of available commands. A few of the basic FTP commands are listed in Table 6-2.

Table 6-2 Basic FTP Commands

Command	Description
cd <dir>	Change the working directory of the remote machine to <dir>. This is the remote directory that will be used for get, put, and dir/ls commands.
lcd [<dir>]	Change the working directory of the local machine to <dir>. This is the local directory that will be used for get, put, and dir/ls commands. If <dir> is omitted, the user's home directory is used.
dir <dir>	Print a listing of the contents of a directory on the remote machine. If <dir> is omitted, the current remote working directory is used.
ls <dir>	Same as dir.
get <remotefile> [<localfile>]	Fetch a file from the remote machine and deposit it on the local machine. If <localfile> is omitted, the file is stored in the current local working directory, with the same name as <remotefile>.
put <localfile> [<remotefile>]	Deposit a file from the local machine onto the remote machine. If <remotefile> is omitted, the file is stored in the current remote working directory, with the same name as <localfile>.
mget <remotefile> ...	Fetch multiple files from the remote machine and deposit them on the local machine. Filenames are expanded, so you can say mget foo*.txt to fetch all files starting with foo and ending with .txt on the remote machine's working directory.
mput <localfile> ...	Deposit multiple files from the local machine onto the remote machine. Filenames are expanded, so you can say mput foo*.txt to send all files starting with foo and ending with .txt from the local machine's working directory.
mkdir <dirname>	Create a directory called <dirname> on the remote machine.
prompt	Toggle whether or not to prompt the user for each filename selected by an mput or mget.
type <ascii \| binary>	Specify whether file transfers should translate text formats, or leave files as they are. type ascii will translate text, whereas type binary must be used to send executables, images, etc. It's a very good habit to enter type binary when starting any FTP session.

Command	Description
! <localcommand>	Run a command locally. For example, !ls will print the contents of the current local working directory, and !mkdir /tmp/foo will create the directory /tmp/foo on the local machine. Note that you can't use "!cd", since that would change directories only in a subshell and then immediately return, doing nothing. Use lcd (above) instead.
bye	Close the connection to the tivoftpd server and quit.
quit	Same as bye

NFS

Network File System (NFS) certainly provides the most seamless file transfer of all of these options. NFS lets you mount a remote hard drive as if it were a normal, local drive. Changes made on one side are reflected immediately on the other. Since it acts just like a normal drive, you can choose to mount it anywhere in the file system hierarchy that you want.

There are various things to consider when deciding whether to use NFS. Users connecting to their TiVo via a serial-line PPP connection can still use NFS, although it will be considerably slower than via Ethernet. NFS doesn't do the clever things rsync does to reduce bandwidth, which is an important consideration when using the serial line.

Ethernet users still have NFS issues to weigh as well. NFS doesn't always react well to servers going down. This could cause problems when rebooting your server. Files on an NFS share aren't cached locally either; when accessing a file on an NFS share, you're always using the network.

Still, if these issues are understood, NFS is an extremely convenient way to share files, especially if you have multiple TiVos you'd like to share data with.

Installing NFS Client *on* TiVo

On the CD

If you've installed the distribution I've included on the accompanying CD as described in Chapter 4, then the software needed to mount NFS shares is already on your TiVo, and you can skip ahead to "Installing NFS Server."

For your TiVo to be able to mount NFS shares, you must load an NFS kernel module. For TiVos using software version 2.5 or later, the file is nfs-tivo25.o. For TiVos using software version 2.0, that module is a file called nfs-2.0.1.o. For even older TiVos using software version 1.3, that module is a file called nfs.o.

Download the appropriate file, based on the version of TiVo software that you are running. Most likely you'll be using the `nfs-tivo25.o` module. Download that from:

`ftp://ftp.alt.org/pub/tivo/dtype/nfs-kernelmod_TiVo25-1.tar.gz`

Since this is a `.tar.gz` file, you'll need to expand the archive to get the `nfs-tivo25.o` file out. Extract the contents of the archive via:

`tar xfvz nfs-kernelmod_TiVo25-1.tar.gz`

and obtain the `nfs-tivo25.o` file from the `nfs-kernelmod_TiVo25-1` directory.

If you're using version 2.01 of the software, download the older NFS module from:

`http://www.9thtee.com/nfs-2.0.1.o`

If for some reason you're actually running version 1.3 of the TiVo software, download the oldest NFS module:

`http://www.9thtee.com/nfs.o`

If you are using version 1.3 and downloaded `nfs.o`, it's not a bad idea to rename it `nfs-1.3.o` to avoid confusion later. These instructions will assume you do so.

Now that module must be placed somewhere on your TiVo. I recommend creating a directory called `/var/hack/kernelmods` and placing it there.

As with rsync and tivoftpd, we once again have the chicken-and-egg problem of how to get the file onto the TiVo without having any file transfer mechanism already set up. Just think, once you're done installing one of the methods in this chapter, you won't have to worry about that ever again.

If you have already set up rsync or tivoftpd, you can use it to move your nfs module onto the TiVo. If not, you have the same options you had with the rsync executable above: copy it directly to the hard drive, or fetch it with `http_get`. See the "Installing rsync Client on TiVo" section earlier in this chapter for help getting your nfs module onto your TiVo.

Make sure that `/var/hack/kernelmods` exists on your TiVo, via:

`mkdir -p /var/hack/kernelmods`

Then, place either `nfs-tivo25.o`, `nfs-2.0.1.o`, or `nfs-1.3.o` in your TiVo's `/var/hack/kernelmods` directory.

For the TiVo to be able to use this kernel module, it must be loaded with a command called `insmod`. This command only takes affect until the TiVo is rebooted, so we need to set up the TiVo to run it after every reboot.

As with tivoftpd above, we want to change `/etc/rc.d/rc.sysinit` to execute a script of our own, and then run the `insmod` command from that script. Follow the steps entitled "Setting up rc.sysinit" and "Creating /var/hack/etc/hacks_callfromrc.sysinit" under "Installing tivoftpd" earlier in this chapter. After completing those steps, make sure that you're in the `/var/hack/etc` directory by typing:

`cd /var/hack/etc`

Now run one of the following three commands on your TiVo to add the `insmod` call to our script:

If you're using `nfs-tivo25.o`, then being sure to use two >'s, type:

```
echo "insmod /var/hack/kernelmods/nfs-tivo25.o" >> hacks_callfromrc.sysinit
```

If you're using `nfs-2.0.1.o`, then being sure to use two >'s, type:

```
echo "insmod /var/hack/kernelmods/nfs-2.0.1.o" >> hacks_callfromrc.sysinit
```

If you're using `nfs-1.3.o`, then being sure to use two >'s, type:

```
echo "insmod /var/hack/kernelmods/nfs-1.3.o" >> hacks_callfromrc.sysinit
```

The `hacks_callfromrc.sysinit` script should now be set up to load the nfs module after every reboot. Either restart your TiVo to test this now, or just run the `insmod` command now via:

```
insmod /var/hack/kernelmods/nfs-tivo25.o
```

or

```
insmod /var/hack/kernelmods/nfs-2.0.1.o
```

or

```
insmod /var/hack/kernelmods/nfs-1.3.o
```

Installing NFS Server

As with the rsync server above, installing an NFS server will vary greatly from system to system. Again, I'll cover a few here, then deal with configuration afterwards.

> **Note**
> If you already have an NFS server set up somewhere and are familiar with its operation, feel free to skip ahead to the "Using NFS" section. Before you do, though, create a "tivo" directory somewhere on your machine. Either export the "tivo" directory itself, or export a directory above it, if your NFS server allows you to mount subdirectories of exported directories.

Red Hat Linux

Become root, then type "setup" and press return. Use the up and down arrow keys to scroll down to System services, as shown in Figure 6-4.

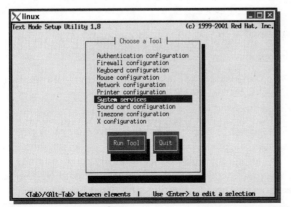

FIGURE **6-4: Setup utility.**

Hit return, and you'll be shown a list of services. Use the up and down arrow keys to scroll down to nfs. Use the space key to select nfs and nfslock so that both have a "[*]" next to them, as in Figure 6-5.

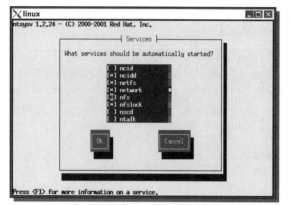

FIGURE 6-5: Selecting "nfs" and "nfslock" services.

Press the tab key until OK is selected, then press return. This will bring you back to the screen in Figure 6-4. Press the tab key until Quit is selected, then press return again. The NFS server that ships with Red Hat Linux should now be enabled upon startup.

To start the NFS server, either reboot your Linux machine or start it now via:

```
/etc/rc.d/init.d/nfslock start
/etc/rc.d/init.d/nfs start
```

Windows NT/2000

Windows is trickier than other OSs because there is little NFS server support, and almost none of it is free. Having not used any of these solutions, I won't be discussing them in any detail, but I'll list a few that I've heard about.

Microsoft previously released something called Microsoft Services for Unix, which shipped with MSDN. It's available for purchase for $99.

ProNFS, for about $40, can be purchased at http://www.labtam-inc.com/.

Omni-NFS Server, for $99, can be purchased at http://www.xlink.com/.

There was a freeware NFS daemon called War NFS Daemon, but it has been discontinued. Doing a search for "WAR NFS DAEMON" on google.com may still yield results, as well as doing searches on www.tivocommunity.com.

In searching for a free Windows NFS server to talk about in the book, I did find one free NFS server. It's written in, of all things, Lisp. It seemed to work pretty well, so I'm mentioning it here. Allegro NFSd is downloadable from http://opensource.franz.com/nfs/. The configuration file for Allegro NFSd is considerably different from any standard NFS server (it's in Lisp), so be aware of that when ignoring the "Configuring NFS Server" section later in this chapter.

Mac OS X

Mac OS X also has NFS already installed, but not set up. If using Mac OS X 10.2 (Jaguar) or later, follow the instructions in the "Configuring NFS Server" section below to modify /etc/exports. If you're using an earlier version of Mac OS X, you'll need to modify the /exports entry in the NetInfo database instead.

Reboot the machine. Jaguar is smart enough to start the NFS daemon automatically if there are any entries in /etc/exports or the NetInfo database.

Configuring NFS Server

To configure an NFS server, you basically tell it which directories you want to share with other machines, and who will have what access to those directories. Unfortunately, the methods of configuring your NFS server vary as much as the methods of installing it. The concepts are generally the same, but there are enough differences that I'll describe each configuration separately.

Red Hat Linux

Linux uses a configuration file called /etc/exports to specify which directories should be shared via NFS. Be aware that the format of /etc/exports file is *not* the same on every operating system.

Listing 6-6 contains a sample /etc/exports file for Red Hat Linux:

Listing 6-6: Sample Red Hat Linux /etc/exports

```
#
# Sample Red Hat Linux /etc/exports File
#
/home 192.168.1.0/255.255.255.0(rw,insecure,no_subtree_check)
/usr/tivo 192.168.1.0/24(rw,insecure,all_squash,anonuid=555,anongid=666)
/usr/tivo2 192.168.1.50(rw,insecure,no_root_squash,no_subtree_check) \
           192.168.1.89(ro,insecure,no_root_squash,no_subtree_check)
/mnt/cdrom 192.168.1.104/255.255.255.252 (ro,insecure,no_root_squash)
```

The first line specifies that the /home directory should be shared out to all machines whose IP address starts with 192.168.1. The address of an incoming NFS request is bit-wise AND'ed with the mask (255.255.255.0), then the result is compared to the address (192.168.1.0) to determine if access is allowed. Options are specified in parentheses. See Table 6-3 for a list of some relevant Red Hat Linux export options and what they mean.

In the second line, /usr/tivo is shared out to the same machines that /home was shared to — machines whose IP address starts with 192.168.1.192/168.1.0/24 is another way of writing 192.168.1.0/255.255.255.255; the 24 corresponds to the number of bits in the mask. (255.255.255.0 in binary is 11111111.11111111.11111111.00000000, which has 24 1's in it). This line also specifies that all file read/write requests from anyone should come in as if the requesting user had a user-id of 555 and a group-id of 666.

The third and fourth lines illustrate that a directory entry can have multiple machine designations associated with it, by either placing them on the same line, or continuing that line with "\". Two specific machines are listed, both having full access to all files as root, and the first having write access as well.

The last line introduces nothing new, but illustrates the masking feature more clearly. The /mnt/cdrom directory is shared, read-only, with four machines: 192.168.1.104, 192.168.1.105, 192.168.1.106, and 192.168.1.107.

Table 6-3 Red Hat Linux /etc/export Options

Option	Description
rw	Specifies both read and write permissions.
ro	Specifies read permissions only; write are disallowed. This is the default.
secure	Requires that NFS requests have originated from a port number below 1024. This is the default.
insecure	Opposite of secure.
subtree_check	This is a security option that carries with it some overhead. When subtree_check is specified, a shared directory that isn't the root of its filesystem will have extra checks performed to make sure that requested files are actually within that subdirectory and not somewhere above it. This is the default. For our purposes this is hardly worth it, so I recommend specifying no_subtree_check.
no_subtree_check	Opposite of subtree_check. I recommend this option for what we're doing.
sync	Causes all writes to be written to disk before returning from the write request, in case of a server crash. This carries a performance hit.
async	Causes writes to occur whenever the server is ready to write them. Opposite of sync. This is the default.
root_squash	If the user root (uid=0) on the NFS client tries reading or writing files on this NFS share, cause their uid/gid to be morphed to either -2, or to the values specified by anonuid/anongid below. Since the only user that will ever be on a TiVo is root, it is a particularly relevant choice for us whether to use this or not. It really depends on your preference. On one hand, this limits the TiVo's ability to see files on the NFS share that aren't accessible to the user with a uid/gid of -2, which can be inconvenient. On the other hand, using the opposite (no_root_squash) means that processes on the TiVo have root access on your NFS machine. On my home machine, I use no_root_squash below. The choice is yours.

Option	Description
no_root_squash	Opposite of root_squash. See root_squash for the pros/cons of each.
all_squash	Like root_squash, except *all* uid/gids will be morphed, not just root. As with root_squash, the resulting uid/gid is either -2, or the value specified by anonuid/anongid below.
anonuid / anongid	When using root_squash or all_squash, use this userid or groupid instead of -2. Values are provided after an =, as in anonuid=123 or anongid=42.

Create a tivo directory somewhere on your machine, for use in the "Using NFS" section below. Either export the "tivo" directory itself, or export a directory above it.

Windows NT/2000

The various NFS server solutions listed under the Windows NT/2000 section of Installing NFS Server above each have their own formats, as far as I know. Configuration of those servers won't be covered here. See the earlier "Red Hat Linux" section for ideas about some options that may or may not map to what your Windows NT/2000 NFS server provides.

If you decide that NFS is still the way you want to go, and you get an NFS server configured, create and export a tivo directory somewhere on your machine for use in the "Using NFS" section later in this chapter. Either export the tivo directory itself, or export a directory above it, if your NFS server allows you to mount subdirectories of exported directories.

Mac OS X 10.2 (Jaguar)

Mac OS X 10.2, unlike earlier versions, will look at the /etc/exports file to determine what directories to share via NFS. If you're using an earlier version of Mac OS X and don't want to upgrade, skip to the "Mac OS X 10.1 and Earlier" section.

The /etc/exports file in Mac OS X has a different format than Red Hat Linux. Listing 6-7 contains a sample /etc/exports file for Mac OS X:

Listing 6-7: Sample Mac OS X 10.2 /etc/exports

```
#
# Sample Mac OS X 10.2 /etc/exports File
#
/Users -network 192.168.1 -mask 255.255.255.0
/Users -alldirs -maproot=0:0 192.168.2.48
/Volumes/FireWireDrive1/tivo -mapall=555:666 192.168.1.51 192.168.1.90
/Volumes/FireWireDrive2 -ro -maproot=0:0 192.168.1.101
```

The first line specifies that the /Users directory will be shared out to all machines whose IP address starts with 192.168.1. Those machines aren't allowed to mount /Users/jkeegan, only /Users. If the user on the NFS client side is root, all read and write requests will be done with a user-id of -2 and a group-id of -2.

The second line specifies that the /Users directory (and any of its subdirectories, such as /Users/jkeegan) will be shared out to the machine 192.168.2.48. If the -alldirs option were omitted, only the /Users directory itself could be mounted. If the user on the NFS client side is root, all read and write requests will be done with a user-id of 0 and a group-id of 0. -maproot=0:0 is equivalent to no_root_squash in Red Hat Linux's /etc/exports format.

A host may only be specified once for each local filesystem, so if /foo was a directory in the "/" filesystem, you couldn't have:

```
/foo 192.168.2.48
```

That's illegal because the second line of the above example already exported /Users (which also lives in the "/" filesystem) to 192.168.2.48.

The third line shares the /Volumes/FireWireDrive1/tivo directory with two machines: 192.168.1.51, and 192.168.1.90. All read and write requests from anyone will be done with a user-id of 555, and a group-id of 666.

Finally, the fourth line shares the /Volumes/FireWireDrive2 directory, read-only, with the machine whose IP address is 192.168.1.101.

These options are described in Table 6-4.

Table 6-4 Mac OS X 10.2 /etc/export Options

Option	Description
-maproot=x:y	If the user root (uid=0) on the NFS client tries reading or writing files on this NFS share, cause the user's uid to be morphed to x, and their gid to be morphed to y.
-mapall=x:y	Like -maproot, except *all* uid/gids will be morphed, not just root.
-ro	Specifies read permissions only; writes are disallowed.
-alldirs	Allows NFS clients to mount the specified share as well as any subdirectories beneath it. Without this option, only the exact directory specified can be mounted.

Create a tivo directory somewhere on your Mac, for use in the "Using NFS section" later in this chapter. Either export the tivo directory itself, or export a directory above it, making sure to specify -alldirs.

Mac OS X 10.1 and Earlier

Versions of Mac OS X before 10.2 require you to use the NetInfo Manager to specify directories to be shared via NFS. More accurately, you need to edit the `/exports` directory in the NetInfo database. The values you'll enter are the same as in Mac OS X 10.2's `/etc/exports` file, so go back and read that section first.

Back? Ok, I'll walk you through entering the NetInfo equivalent of the first line of Listing 6-7:

```
/Users -network 192.168.1 -mask 255.255.255.0
```

Again, see the Mac OS X 10.2 (Jaguar) section to understand what that line means. Here we'll be looking more at the particulars of using the NetInfo Manager.

Follow these steps to enter the above example:

STEPS: Modifying /exports in NetInfo Database

1. Find the NetInfo Manager application under `/Applications/Utilities` and launch it.

2. Click the lock at the bottom of the window. This will provide you with an authentication window where you can provide an administrator's username and password. Provide one, then click OK.

3. If the center column doesn't contain an entry called `exports`, you'll need to create one:

 - Click on the `/` in the left column.

 - From the Directory menu, choose "New Subdirectory". A new directory will be created with the name `new_directory`.

 - Double click the value `new_directory` in the bottom half of the window, and replace it with `exports`.

 - Save your changes, via the Save Changes item in the Domain menu.

4. Select `exports` in the center column. The window should now look like Figure 6-6.

5. Choose New Subdirectory from the Directory menu. You'll see the columns at the top of the window scroll left, with "`new_directory`" now in the center column.

6. Double-click the value `new_directory` in the bottom half of the window, and replace it with `/Users` (from our example).

7. Save your changes, via the Save Changes item in the Domain menu.

8. Select `/Users` in the upper-right column, then choose New Property from the Directory menu. You'll see a new property/value pair appear in the bottom part of the window. See Figure 6-7.

FIGURE 6-6: NetInfo Manager tool.

FIGURE 6-7: New property under /Users.

Replace new_property with clients, and replace new_value with an empty string. This property is where you would put one or more hosts if you were sharing via specific IP addresses. Since we're using a network and mask in our example, the value for clients should be empty.

9. Choose New Property from the Directory menu again. Give this property a name of opts, and a value of network=192.168.1. Note that the hyphen before network isn't present, and that we've placed an = between network and its value of 192.168.1.

10. Click on the opts row you just created, then choose "New Value" from the Directory menu. Your window should look like Figure 6-8.

FIGURE 6-8: New value under "opts".

Replace new_value with mask=255.255.255.0.

11. Save your changes, via the Save Changes item in the Domain menu.

Not quite as easy as just editing /etc/exports, is it? Still, it works, and it came with the OS. Now that you've added an entry to NetInfo's /exports directory, you should be able to add entries that are meaningful to you.

Just in case you haven't guessed, if we were doing the next share in our example:

```
/Volumes/FireWireDrive1/tivo -mapall=555:666 192.168.1.51 192.168.1.90
```

you would create a subdirectory of /exports named /Volumes/FireWireDrive1/tivo. You'd create a property named opts within it, with a value of mapall=555:666. You'd create another property called clients, which would have two values, the first being 192.168.1.51 and the second 192.168.1.90. It would look like Figure 6-7.

FIGURE **6-9**: NetInfo /exports example with multiple clients.

If you don't want to share /Users, don't forget to remove the entry you just created by clicking on /Users under /exports, then choosing Delete from the Edit menu.

Create a tivo directory somewhere on your Mac, for use in the Using NFS section below. Either export the tivo directory itself, or export a directory above it, specifying alldirs under opts.

Using NFS

Assuming you just read through one of the previous sections, you should now have an installed, configured NFS server, and a TiVo with the necessary code on it as well. You should also have either rebooted your TiVo, or run the appropriate insmod command by hand, as described in "Installing NFS Client on TiVo."

Hopefully, you've also created and exported a directory called "tivo". If not, go back and try that now, restarting the machine your NFS server resides on if necessary.

To mount that share on your TiVo, you first need a place to mount it:

```
mkdir -p /var/hack/mnt/tivo
```

That certainly isn't the friendliest of mount directories; its path name takes up a whole 18 characters. If you wanted to create a mount point in the root directory, you could do so via:

```
mount -o remount,rw /
mkdir /t
mount -o remount,ro /
```

The mount commands are necessary to change the read-only status of "/" to read-write, so you can create the /t directory. It's important that the second mount command be done right afterward, because a power failure might damage "/".

Ok, so if your NFS server had a directory called /tivo, and the machine had an IP address of 192.168.1.2, you could mount that directory on your TiVo with:

```
mount -t nfs -o rsize=8192,wsize=8192 192.168.1.2:/tivo /var/hack/mnt/tivo
```

Actually, the -t nfs isn't really necessary; mount will figure out on its own that you're talking about an NFS share. The rsize and wsize arguments specify block sizes for reading and writing. Specifying 8192 will help performance when using Ethernet, as it writes out more data per block.

If your NFS server had a directory called /home shared, and your tivo directory lived in /home/jkeegan/shared/tivo, then you could mount that directory on your TiVo by typing this (all on one line):

```
mount -o rsize=8192,wsize=8192
       192.168.1.2:/home/jkeegan/shared/tivo /var/hack/mnt/tivo
```

To see what directories you have mounted, type mount on the TiVo. If you had previously entered:

```
mount -o rw 192.168.1.2:/home/jkeegn /mnt
```

then the output from mount would look something like Listing 6-8.

Listing 6-8: Sample Output of mount on TiVo

```
/dev/hda4 on / type ext2 (rw)
/dev/hda9 on /var type ext2 (rw)
/proc on /proc type proc (rw)
192.168.1.2:/home/jkeegan/tivo on /mnt type nfs (rw,addr=192.168.1.2)
```

The last line is obviously key here — it shows that in this example, /mnt is actually the directory /home/jkeegan/tivo from the machine whose IP address is 192.168.1.2.

Now you can cd into /mnt, look around, and see the files from your NFS server as if they were local to your TiVo. Later, you can un-mount the directory via:

```
umount /mnt
```

(Note: that's umount; there is no "n")

Congratulations, you just set up NFS.

Other File Transfer Tools

While I strongly believe that rsync, ftpd, and NFS are the best tools to use for getting files to/from your TiVo, this chapter wouldn't be complete without at least mentioning three others.

zmodem (rz/sz)

If you're connecting to your TiVo using a terminal program and a straight bash prompt on the serial line, zmodem is your only option (short of removing the drive and copying the files over directly). If you're using PPP over a serial line, or connecting via ethernet or USB, ignore zmodem completely.

zmodem is an old file transfer protocol built into several terminal programs. The whole idea goes something like this: while using the terminal program to access a bash prompt on your TiVo, you run a command (rz or sz) that sends a special signature over the serial line. The terminal program recognizes this as a zmodem instruction, and proceeds to either download or upload a given file over the serial line connection.

I won't be discussing any terminal programs or how they handle zmodem. I *will* say that rz and sz are already installed on your TiVo, in the /bin directory. To move a file to your TiVo, at your TiVo bash prompt you'd type:

```
/bin/rz
```

and your terminal program would prompt you for which file to send. A transfer would commence, and eventually the rz program would terminate, with the new file located in the current directory on the TiVo.

To move a file from your TiVo to your PC, you'd type:

```
/bin/sz <file-to-send>
```

Your terminal program will start receiving the file, and what it does after that is implementation-specific. The bottom line is, it will successfully send the file.

Since most of the hacks in this book assume your TiVo has IP connectivity, this isn't a good long-term solution for file transfer, but it might help you early on if you're just tinkering around with a straight bash prompt on the serial line.

http_get

TiVo has an executable installed on it already called http_get. It basically fetches a file from a given web server. There are many drawbacks to this tool:

- It only allows file transfer *to* the TiVo, not from it.

- You must have access to a web server.

- It wasn't intended for use by everyone. It has various required arguments that don't apply to normal file transfers. It requires specification of a port number even if the port number is 80.

Still, it does come preinstalled on your TiVo, and can help out in a pinch. Its usage is described earlier in this chapter under the "Installing rsync Client on TiVo" section.

Samba

Samba allows Unix machines to mount Windows file shares. In that sense it's closer to NFS than any of the other file transfer methods described in this chapter, since there's just one copy of the file, and both machines can access it at any time.

Andrew Tridgell, the author of Samba, is well known in the world of TiVo hacking. So you'd think the version of Samba that's been ported to the TiVo would work pretty well. Unfortunately, you would be wrong, but it's not his fault. It's also not the fault of Chris Worley, who compiled Samba for the TiVo.

The problem lies with the fact that the Linux kernel in TiVos is pretty old, and has a very, very old version of Samba. This has resulted in two problems. The first problem is that you won't be able to mount any Windows 2000 shares, since this old version of Samba doesn't contain changes needed to support Windows 2000. The second problem is that since it's such an old version, it's a bit rusty.

Here's how it's supposed to work. These are the steps required to mount a Windows share with Samba (if you're lucky enough to have the right configuration).

STEPS: Mounting a Windows Share with Samba

1. Fetch the files `smbfs-2.0.1.o` and `smbmount` compiled for TiVo from

   ```
   http://www.9thtee.com/smbfs-2.0.1.o
   http://www.9thtee.com/smbmount
   ```

 I've included them on the CD. If you installed the distribution on the CD in Chapter 4, then skip ahead to step 3.

2. Put smbmount in `/var/hack/bin/` , and put smbfs-2.0.1.o in `/var/hack/kernelmods/` .

3. At TiVo's bash prompt, enter:

   ```
   insmod -f /var/hack/kernelmods/smbfs-2.0.1.o
   ```

 (You will see an error stating "`Warning: kernel-module version mismatch`". Ignore this error.)

4. Use the smbmount program to mount your Windows share. An example of the syntax used is:

   ```
   smbmount //192.168.1.14/sharename /mnt -I 192.168.1.14
   ```

Some people have reported that the above command works for them (replacing `192.168.1.14` with the IP address of your Windows machine, and `/mnt` with the directory you wish to mount onto).

Not having a Windows 95/98 machine to try, I set up my Mac OS X 10.2 machine to share out a directory via Samba. I could in fact mount *that* Samba share. Sometimes. Some of the time, it would connect, and I could `cd` into the directory and successfully do an `ls`, but as soon as I started trying to access files it would hang. Both of my TiVos rebooted more than a few

times when I was preparing this section. And in my attempts to verify claims that this old Samba installation wouldn't work with Windows 2000, I never did successfully mount any Windows shares from my TiVo (despite the fact that I could mount those Windows shares via Samba from my Red Hat system).

But even if you're one of the lucky few who have the right setup, beware, because it's not consistent. One user reported that it works well as long as he performed the mount immediately after booting his TiVo, but not after that. Another reported it only working if the share he was connecting to had a password. And then there was the disturbing claim that once you've entered a failing smbmount command, you had to reboot to get another chance before it would work again.

Bottom line, it's not the best way to go.

TivoWeb

There is a story that I tell people when I talk about hacking my TiVo.

My Dad, my wife, and I were sitting at a Patriots football game in Foxboro Stadium. It was 2001, the season where we'd go on to win the Super Bowl, and we had finally become season ticket holders after years of waiting.

My Dad went off to get some food, and missed several really incredible plays. I told him he should find a payphone and call my Mom, and have her TiVo the 11 o'clock news so he could watch the highlights later. (They also have a TiVo, which my wife and I had given them as a gift.)

I got a bit upset for a second, saying, "Damn, Laurie and I can't do that, because we're both here!" Laurie turned to me and asked, "Don't you have your Palm Pilot . . . ?"

My hand slowly reached down to my pocket, and pulled out my Palm VIIx. I flipped up the antenna, went to the TivoWeb page of one of my TiVos, and scheduled a recording of the 11 o'clock news on channel 7. When we got home, sure enough, it had recorded it for us, and we got to watch those incredible plays all over again.

Lacking any better sing-able TiVo theme music, the Beatles song they played in those Philips commercials ran through my head for the rest of the night. *Got to admit it's getting better . . . it's getting better all the time.*

Often people think about what it would be like to show new technology to a caveman and have him not understand it at all. Well forget the caveman; if I went back *twenty years* I'd have trouble describing this to someone. "You see, I had my wireless organizer in my pocket, which had Internet access. I had a palm query app I'd written to visit any URL I wanted, so I went the web page of one of my two TiVos, where I scheduled the recording of . . ."

It's not even as if what I did was *incredibly* useful. It was just incredibly cool.

TivoWeb (the Tivo Web Project) is one of the coolest hacks to be written for TiVo so far. It's such a good idea that TiVo Inc. rolled out their own official equivalent[1] of TivoWeb for Series2 users in the HMO (Home Media Option) package.

TivoWeb is composed of a Tcl-based web server, and various modules that ship with it. These modules interact with TiVo's internal MFS database to provide much of the functionality of the real TiVo interface, via a web interface. Additionally, there are many things that TivoWeb lets you do that you can't even do with the regular TiVo interface.

The list of contributors to the TivoWeb project is long. As of version 1.9.4, they include (alphabetically): Courtney Bailey, Mike Baker (embeem), Dave Boodman, Jake Bordens (The Jake), Mike Byrne (Turbo), Dan Campbell (Angra), Luan Dang, Philip Edelbrock, Dale Engle, Josha Foust (Lightn), Mike Henry (mrtickle), myself (Jeff Keegan, jkeegan), Mike Langley, John Paglierani (Jpags), Stephen Rothwell, Aaron Schrab, Jon Squire, Dan Stagner (sorphin), and Benjamin Tompkins (Juppers). The list continues to grow, as more and more modules are written. The original Tcl-based webserver (`httpd.tcl`) was written by Stephen Rothwell.

TivoWeb is a great platform for implementing TiVo hacks, because it gives you the ability to provide your hacks a familiar user interface: HTML, forms, etc.

Installing TivoWeb

On the CD If you've installed the distribution I've included on the accompanying CD as described in Chapter 4, then TivoWeb is already on your TiVo. If this is the case, make sure it's enabled in `hacks_call fromrc.sysinit` as described in "Enabling the Various Pieces" in Chapter 4, then make sure you've gained telnet access to your TiVo as described in Chapter 5, and finally skip ahead to "Using TivoWeb."

Before you read any further, make sure that you've gained telnet access to your TiVo as described in Chapter 5, either via a serial-line PPP connection, a TiVoNet card, a TurboNET card, or an AirNET card.

The TivoWeb project is written and maintained by Joshua Foust (Lightn). Download the latest version from his web site at:

`http://tivo.lightn.org/`

The version I'm describing here (and that's on the accompanying CD) is 1.9.4:

`http://tivo.lightn.org/tivoweb-tcl-1.9.4.tar.gz`

[1] Let's be clear though, it's not as if the remote programming in the HMO package is the same as TivoWeb. They are different, and each has its advantages. The Remote Scheduling feature in the HMO package requires no effort to set up for external access, whereas TivoWeb requires setting up a home firewall to allow ports through, increasing security risks, etc. However, Remote Scheduling's conflict handling is less effective than TivoWeb's conflict handling (since you get direct access to data In realtime with TivoWeb, whereas with the HMO scheduling there's a 1-hour period of time required to guarantee scheduling). Plus, remote scheduling is only a part of what TivoWeb does — with all of the modules it currently has, TivoWeb is more like a small development platform than a remote scheduling mechanism.

Download this version, and then move it over to your TiVo with one of the file transfer mechanisms described in Chapter 6. Place it at the top of the TiVo's /var directory for now.

Then, follow these steps to install and enable TivoWeb.

STEPS: Installing and Enabling TivoWeb

1. Telnet into your TiVo (again, see Chapter 5 if that's not set up yet).

2. Make sure the /var/hack directory exists, via:

   ```
   mkdir -p /var/hack
   ```

3. Move to the /var/hack directory by typing:

   ```
   cd /var/hack
   ```

4. Move the downloaded file into /var/hack by typing:

   ```
   mv /var/tivoweb-tcl-1.9.4.tar.gz /var/hack
   ```

5. If you have a previously installed earlier version of TivoWeb, shut it down, then rename the directory (we'll delete it later) with:

   ```
   mv /var/hack/tivoweb-tcl /var/hack/DELETEMEtivoweb-tcl
   ```

 (substituting the directory location if it had been installed elsewhere).

6. Decompress the file, via:

   ```
   gzip -d tivoweb-tcl-1.9.4.tar.gz
   ```

7. To unpack the file, we'd normally use tar, but if you're reading this you didn't do the full software install in Chapter 4 so you probably don't have tar on your TiVo yet. Unpack the file with cpio, by typing:

   ```
   cpio -H tar -i < tivoweb-tcl-1.9.4.tar
   ```

8. If you don't have a /var/hack/etc/hacks_callfromrc.sysinit file, you can copy one from the root directory of the accompanying CD-ROM, and then modify rc.sysinit to call it (see "Setting up rc.sysinit" under "Installing It All" in Chapter 4). To start TivoWeb after each reboot, the file must contain the line:

   ```
   /var/hack/tivoweb-tcl/tivoweb
   ```

9. Make sure that the "/var/hack/tivoweb-tcl/tivoweb" line in your /var/hack/etc/hacks_callfromrc.sysinit file is uncommented (that is, that there is no "#" on the left).

10. Either reboot your TiVo, or run TivoWeb by hand (with the above line).

TivoWeb should now be installed. The installation on the CD contains a few of the optional modules, the keegan.org TivoWeb theme used in the following figures, and a necessary patch for the ui.itcl module posted here:

http://tivocommunity.com/tivo-vb/showthread.php?postid=973653#post973653

If the version of TivoWeb you just fetched and installed was 1.9.4, apply that patch.

The keegan.org TivoWeb theme is also available at:

```
http://keegan.org/jeff/tivo/downloads/keegan_org_tivowebtheme_1.0.tar.gz
```

You can start TivoWeb either by rebooting (since we set it up to start at boot time above), or by typing:

```
/var/hack/tivoweb-tcl/tivoweb
```

Note Don't ever try to kill TivoWeb with the Unix command `kill`; that will cause your TiVo to reboot. Instead, access the TivoWeb interface with a web browser, choose Restart, and then choose Quit.

To change what port TivoWeb will run on (it defaults to port 80, like all web servers), modify the file `/var/hack/tivoweb-tcl/tivoweb.cfg`. Once you've run TivoWeb in the next section, if you feel confident you don't want any old installation anymore, remove any old installation via:

```
rm -rf /var/hack/DELETEMEtivoweb-tcl
```

Using TivoWeb

Caution Despite the introduction to this chapter, it is a very bad idea to put your TiVo directly on the Internet with access from the outside world (including just opening up a port for TivoWeb). Any denial of service attacks that get to the TiVo will crash it easily. But if you do decide to set up traffic into your TiVo, `tivoweb.cfg` has username/password fields for authentication. You can also read the TivoWeb README file (in the `tivoweb-tcl` directory) for a description of how to set up Apache as an authenticating proxy server.

Pull up a web browser, and go to `http://192.168.1.101` (replacing `192.168.1.101` with the IP address of your TiVo, and appending ":" and a port number if you changed the default to be something other than 80). The main page looks like Figure 7-1. The choices displayed on the Main Menu (and at the top of each screen) are from modules that have been installed. For instance, if you installed the DisplayText module described later in this chapter, then it would be visible at the top of each page. The screenshots in this section will reflect the modules installed with the default installation for TivoWeb 1.9.4.

FIGURE 7-1: TivoWeb Main Menu.

I'll discuss the modules one at a time. Rather than trying to discuss them in order of importance and jumping all over, I'll describe them alphabetically (which is how they're ordered on the Main Menu). Some of these screens can be multiple pages, so when needed I'll break the screenshots into parts.

Info

The Info module was written by Jon Squire, with additional changes made later by Benjamin Tompkins (Juppers). It displays various pieces of general info about your TiVo. Figure 7-2 shows the first half of sample output from the Info screen.

FIGURE 7-2: Info Screen (Part 1).

The Current Channel data specified what's currently on Live TV (whether you're watching it or not). The rest of the info in this figure should be self-explanatory. Figure 7-3 shows the second half of the page:

Here you see the current memory usage on the system, and more importantly, the *disk* usage. This shows the amount of free space currently on your TiVo. This isn't as straightforward as it sounds, since there are many possible definitions of "free" here. Remember, TiVo Suggestions will never cause any recordings (even expired recordings) to be deleted. The "Total" line you see is the total of all recordings *plus* expired items, *plus* suggestions! Yet another consideration is that this is the space used *right now*; if you have a really full TiVo and a save-until-I-delete 2-hour movie at best quality scheduled for a 6 hours from now, then you might see from the Info screen that you have free space, but you won't be able to schedule a recording right now that lasts for more than those 6 hours. Because of scheduling, "free space" is really a two-dimensional issue. Still, it's better to have this info than not.

```
Info Page - Mozilla                                                    _ □ ×
File  Edit  View  Go  Bookmarks  Tools  Window  Help

  Back    Forward    Reload    Stop      http://192.168.1.101/inf  ▼   Go   Search
```

MEMORY INFORMATION						

```
Memory Statistics:
          total:     used:       free:  shared: buffers:  cached:
Mem:   14278656 14102528      176128 1415507968    61440  3518464
Swap: 133820416  9789440 124030976
MemTotal:       13944 kB
MemFree:          172 kB
MemShared:    1382332 kB
Buffers:           60 kB
Cached:          3436 kB
SwapTotal:     130684 kB
SwapFree:      121124 kB
```

SPACE USED - 143616 MB				
Expired Wishlist	1	730 MB	0.5%	1:00:02
Expired Season Pass	23	13957 MB	9.7%	18:30:24
Expired Single	12	14851 MB	10.3%	18:14:38
Single	58	63869 MB	44.5%	62:05:44
Season Pass	66	46432 MB	32.3%	63:17:20
Suggestion	1	368 MB	0.3%	0:30:02
Live Cache	1	1428 MB	1.0%	0:33:30
Total	162	141635 MB	98.6%	164:11:40
Free Space - Basic	-	1981 MB	1.4%	2:42:39
Deleted	2	1459 MB	1.0%	2:00:01

FIGURE 7-3: Info Screen (Part 2).

Logos

The Logos module was written by Jake Bordens (The Jake on tivocommunity.com), with import code added later by Joshua Foust (Lightn). It lets you change what logos are displayed for a given channel in the normal TiVo interface. Channels can have two images associated with them: an image for use in the on-screen display, and an image for use in the Now Playing[2] screen (see Figures 1-11 and 1-4 from Chapter 1 for examples of these). Often (as in the case of those two figures), the same (or a very similar) image is used for both.

[2] The Now Playing screen in the TiVo Interface used to be called Now Showing; the Logos module still uses the old name.

Figure 7-4 shows the initial page of the Logos module, which displays channels and their associated icons. In the rightmost column of each row is a Change link, which leads to the Choose a Logo page (see Figure 7-5). Here, the user can select any of the logo icons present in the TiVo, and associate them with the channel whose Change link was clicked.

NO.	CALL SIGN	NAME	CHANNEL	NOW SHOWING	CHANGE
2	WGBH	WGBH	(none)	(none)	Change
3	ATT3	AT&T/Manchester (Med1)	(none)	(none)	Change
4	WBZ	WBZ	(none)	(none)	Change
5	WCVB	WCVB	(none)	(none)	Change
6	NEWSENG	New England Cable News	(none)	(none)	Change
7	WHDH	WHDH			Change
8	LOOR008	Local Origination	(none)	(none)	Change

FIGURE 7-4: Initial Logos page.

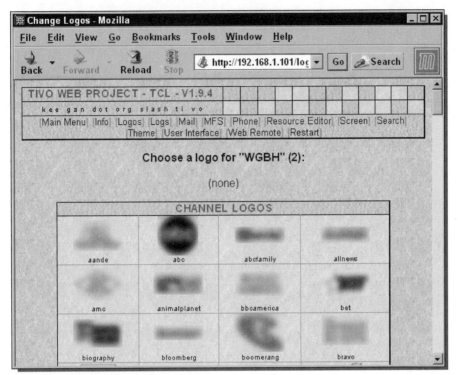

FIGURE 7-5: Choose a Logo page.

This is useful for times when logos are present in your TiVo (perhaps from other channel line-ups) that for some reason haven't been associated with a channel. The Automatically Associate Logos link in Figure 7-4 (which brings you to the Associate Logos screen in Figure 7-6) lets you make many such assignments, based on guesses made automatically for you.

FIGURE 7-6: Associate Logos screen.

What's much more useful however is the ability to import your own logos for channels that don't have any suitable icons in the TiVo already. When you click the Import Logo link in Figure 7-4, you're brought to the Import Logo screen (see Figure 7-7). Clicking the Browse button brings up a standard file dialog box, letting you select your own PNG file. The dimensions of this file need to be either 65×55 (for the on-screen display image) or 100×35 (for the Now Showing image). It also needs to be of exactly the same format of the existing icons (non-interlaced PNG file, using LZ77 compression), and using the same color palette. To get the same color palette, I saved one of the existing logos to disk, renamed it, opened it in an image program, pasted my image onto it, and saved it. Clicking Import should bring you to a result page (mine looked like Figure 7-8).

FIGURE 7-7: Import Logo screen.

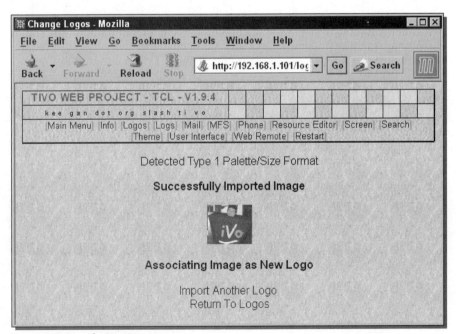

FIGURE 7-8: Sample Success page.

If you're going to import both types of logo, be sure both original files have the same name (keep them in different folders). This way, the Logos module will know to associate the two images together. Once an image is uploaded, you can associate it like any other logo (that is, your image will show up in the listing displayed in Figure 7-5). If you've imported a new logo (instead of just associating an existing one), you now have to reboot your TiVo for the changes to take effect.

Logs

The Logs module was the second TivoWeb module that I wrote. It lets you view the log files on your TiVo. The initial page of the Logs module (see Figure 7-9) displays all logs residing in /var/log. You can click on a log's name to view the log itself (see Figure 7-10).

FIGURE 7-9: Logs module.

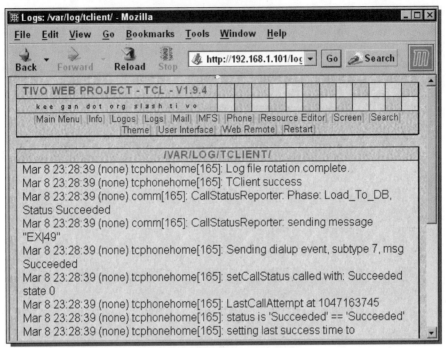

FIGURE 7-10: Viewing /var/log/tclient with the Logs module.

Mail

The Mail module was the first TivoWeb module that I wrote.

Every once in a while, TiVo Inc. sends informational messages to its subscribers' TiVos via the TiVo Messages feature. When a new message arrives via a nightly call (or is triggered by some internal condition in the unit), a mail icon appears next to the "Messages & Setup" item on the TiVo Central screen (shown in Figure 7-11). By choosing TiVo Messages from the Messages & Setup screen, users can read and delete these notifications from TiVo Inc. (see Figures 7-14 and 7-15 as well).

The Mail module allows to you to create *your own* messages for display on the TiVo, view the messages already on your TiVo (from TiVo Inc. or from you), and delete them.

FIGURE 7-11: New Mail icon on TiVo Central screen.

From the initial screen of the Mail module (see Figure 7-12), choose Create New Mail to create a new message. There you can enter the text of a message to create, as well as set an expiration time for the message. For the Destination field, choose Message Board for a normal TiVo Message. Click Send Mail, and a new message will be created as if it had come from TiVo Inc. See Figure 7-13 to see the message creation page, and Figures 7-14 and 7-15 to see how it appears on an actual TiVo.

FIGURE 7-12: Mail module initial screen.

FIGURE 7-13: Mail module's message creation screen.

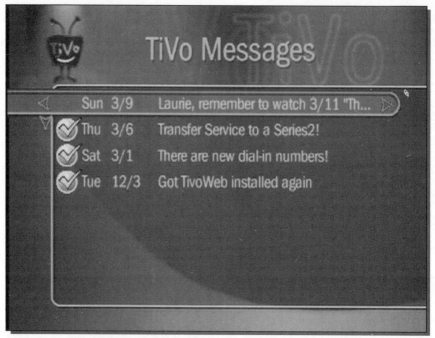

FIGURE 7-14: TiVo Messages screen listing newly created message.

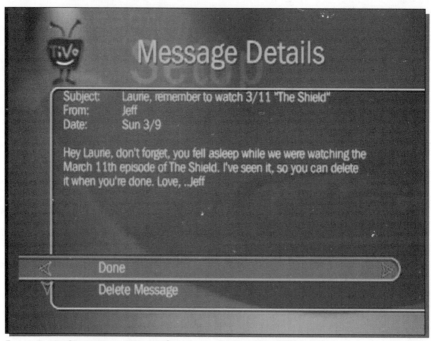

FIGURE 7-15: Our custom TiVo mail message displayed on TV.

There is another kind of message you can create as well—a "Pre-TiVo Central" message. After a Pre-TiVo-Central message is created, the next time a user presses the TiVo button on the remote control, this message will be displayed immediately, before going to the TiVo Central screen (hence, the name Pre-TiVo Central). It will beep and display, waiting for a key press. Some people find these very intrusive, and TiVo tries to reduce the number of times they use this feature. To create a Pre-TiVo Central message, choose Pre-TiVo Central for the destination instead of Message Board. When it displays on the TiVo screen, it looks like Figure 7-16. Actually, what TiVo Inc. usually does when issuing Pre-TiVo Central messages is to actually create two messages: a Pre-TiVo Central message making the announcement, and a Message Board message to sit around in the "mailbox." The Pre-TiVo Central message often describes how to get to the TiVo Messages screen.

FIGURE 7-16: Pre-TiVo Central message appearing when TiVo button is pressed.

Be aware that the expiration date on a Pre-TiVo Central message is pretty important; if you don't have it set to expire soon, it may repeat.

Lastly, you can also view (and delete) messages from TivoWeb, just like you can in the TiVo interface shown in Figures 7-14 and 7-15. From the Mail module's initial screen, choose View/Delete Existing Mail to get a list of all TiVo Messages (see Figure 7-17), and click on one to read/delete it (see Figure 7-18).

FIGURE 7-17: List TiVo Mail screen.

MFS

The MFS module has its origin in the original `httpd.tcl`, written by Stephen Rothwell. The MFS module is an invaluable tool for the TiVo hacker. It lets you browse through the MFS database via a simple click of the mouse.

MFS stands for Media File System. It's TiVo's proprietary, internal database of video, audio, and metadata. We'll talk more about MFS in Chapter 13, but for now, a screenshot or two should give you an idea of the interface for the TivoWeb MFS module. If you don't follow what's going on here, come back to this section later when you've made it to Chapter 13 and want to start browsing through MFS. Figure 7-19 shows the top of the MFS tree, Figure 7-20 shows a "directory listing" within the tree, and Figure 7-21 shows the MFS object representing the TiVo Message we created in the Mail example above.

FIGURE 7-18: View TiVo Mail screen.

FIGURE 7-19: Top of MFS database, viewed with MFS module.

FIGURE 7-20: "Directory" listing of /MessageItem/MessageBoard node in MFS.

FIGURE 7-21: Viewing leaf node MFS object created in mail example above.

Phone

The Phone module was written by Courtney Bailey. Simply put, the Phone module allows you to initiate a test call (or an actual daily call) via the web. There's only one screen (see Figure 7-22), which updates dynamically via JavaScript to indicate progress.

FIGURE 7-22: Phone module screen.

Resource Editor

The Resource Editor module was written by Mike Bryne (Turbo). It was later modified with new definition updates for version 2.5 of the Tivo software by Dan Stagner (sorphin).

The Resource Editor module allows tweaking of several particular resources in MFS that TiVo software uses internally. The resources that it lets you edit by default are not values you want to go mucking with without an idea of what you're changing. Examples of some of the resources listed include variables for the various recording quality levels, recording resolutions, and the number of seconds to wait when on a menu before switching automatically to live TV.

It is possible to enhance the Resource Editor module. The resource module reads a file (either tvres-2.0.res, tvres-2.5.res, or tvres-3.0.res, depending on what version of TiVo software you are running) from the modules directory to decide what resources to let you edit. Each line of the file specifies another resource, indicating:

- The submenu it should be displayed beneath by the Resource Editor module
- The name to be given to the resource
- The zero-based offset of the ResourceGroup within the /SwSystem/ACTIVE MFS object
- The zero-based offset of the ResourceItem within that ResourceGroup

(If any of that confuses you, don't worry, you'll know more after reading Chapter 13, then you can come back here and re-read this.)

One example is from Chapter 13. My wife and I have multiple TiVos, and we wanted to be able to easily tell which TiVo display we're looking at. What I do is to change the Now Playing and TiVo Central titles to reflect which TiVo we're on ("Now Playing - TiVo1(main)" and "TiVo Central - TiVo1(main)"). Whereas I used to make that change through Tcl calls in tivosh (see Chapter 13), I now have the resources listed in the Resource Editor's tvres-3.0.res file. The resource that originally contains the text "Now Playing" is the sixth ResourceItem in the second ResourceGroup of the /SwSystem/ACTIVE MFS object. Remembering that the offsets in the tvres-x.x.res files are *zero-based* (meaning that sixth becomes 5 and second becomes 1), I added this line to tvres-3.0.res:

```
MenuTitles NowPlayingTitle 1 5
```

The very next ResourceItem contains the text "TiVo Central", so I also added:

```
MenuTitles TiVoCentralTitle 1 6
```

Now when I go to the Resource Editor module, I see a new menu called MenuTitles (I could have called it anything, but MenuTitles made sense). Clicking on it shows the current values for the title for the Now Playing screen as well as the TiVo Central screen, both of which can be changed.

Chapter 11 contains another useful example of resources to add, under the section titled "Negative Padding."

Note Unfortunately the resource editor isn't quite as elegant with submenus as I've described here. Each ResourceGroup can have only one submenu; so for instance you couldn't create the MenuTitles example above (specifying the 2nd ResourceGroup with "1") and then create another submenu for other related items in the 2nd ResourceGroup. If you add new submenus, make sure there isn't already a submenu for that ResourceGroup—use it instead.

And obviously, be careful with any resources that you edit.

Screen

The Screen module was written by Mike Baker (embeem). The Screen module lets you see the text that is currently being shown on the real TiVo UI at that very moment, but on a web page. It also renders menu items as links that you can click on; clicking a link results in a sequence of simulated remote control key presses, like such as page-down page-down scroll-up select. This means that unlike the user interface module (described below), the Screen module can affect what is being seen by whoever is watching the TV screen, since it is actively changing its state.

It's extremely good about screens where there are multiple pages worth of items; while the TiVo UI on the TV screen displays only a page of items at a time, the Screen module will display all of the items on the web page at the same time. If you select an item that would be 10 pages down, the TiVo issues several simulated page-down remote control key presses, then adjusts with page-up/down until it's on the right item. This saves a lot of time when you're searching for something on a list and don't want to scroll down repeatedly on your own.

Here are a few examples of TiVo screenshots and Screen module screenshots side by side (see Figures 7-23 through 7-29). Notice in 7-24 and 7-26 that the Screen module displays more items than the TiVo UI does, and that some screens in the TiVo UI don't render in the screen module (see Figure 7-29).

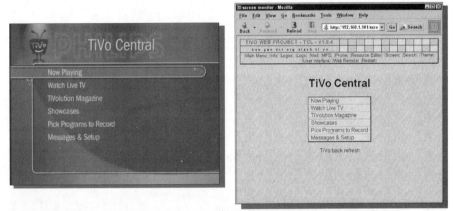

FIGURE 7-23: Side by side TiVo / Screen-module: TiVo Central.

FIGURE 7-24: Side by side TiVo / Screen-module: Now Playing.

FIGURE 7-25: Side by side TiVo / Screen-module: Program Description.

FIGURE 7-26: Side by side TiVo / Screen-module: TiVo Suggestions.

FIGURE 7-27: Side by side TiVo / Screen-module: Live TV Guide.

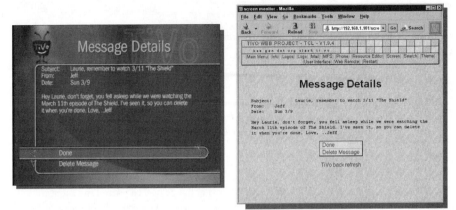

FIGURE 7-28: Side by side TiVo / Screen-module: Viewing a TiVo message.

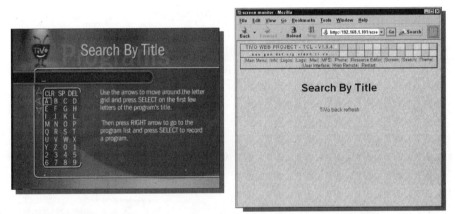

FIGURE 7-29: Side by side TiVo / Screen-module: Search By Title not rendered.

When using the Screen module, don't use the remote control. The screen module keeps track internally of which item on the screen is selected; if you change which item is selected (or what screen the TiVo is on) with the remote, then click a link, the remote key sequences issued won't do what they were intended to. You could end up inadvertently selecting the wrong menu, possibly doing very bad things like deleting recordings. Use the TiVo and back links on the Screen module pages, and click the refresh link if the screen module's rendition becomes out of sync with the TiVo UI.

Search

The Search module lets you do a search by title, title keyword, keyword, actor, or director.

What I didn't mention in the Palm Pilot story at the beginning of the chapter is that the Search module didn't exist at the time. What I actually had to do was use the User Interface module, select the Channel Guide sub-module, pick a channel and click on it, and then click View Upcoming Listings. This showed me a list of programs for the rest of the day, one of which was the news, and I could schedule it from there.

That lack of a search-by-name feature in TivoWeb was a large motivator for me to write the Search module (which is the third TivoWeb module I've written). I also didn't like having to create a WishList just to search for an actor, keyword, or episode title.

Joshua Foust (Lightn) and Mike Baker (embeem) collaborated to write (and later enhance) a compiled executable called bsearch to increase performance, and eventually most of the User Interface sub-modules were modified to render many fields as links to the search module for specific searches on those fields.

Figure 7-30 shows the initial page of the Search module.

FIGURE 7-30: Initial Search module page.

The Category and SubCategory drop-downs let you filter results by category and subcategory. The Include Channels You Don't Watch checkbox allows you to search for channels you

haven't enabled, and the "Display Empty (No Upcoming Episodes) Hits" checkbox allows a series with no upcoming episodes to match a query and still be displayed.

- Title searches will only match a series or movie title, not an episode title.

- Title Keyword searches will match any word of any title, including episode titles. See in Figure 7-31 how vanilla matches both a movie title and an episode title with a Title Keyword search.

- Actor searches first come back with a list of matching actors for your search term (enter that term in the form last name, first name). When the correct actor/actress is selected, the results for just that actor are displayed. See Figures 7-32 and 7-33.

- Director searches are the same as Actor searches; first a list of matching directors for your search term are returned, then after you choose the right director you get a list of the films he/she directed.

- Keyword searches will search program descriptions, actors' names, directors' names, etc.

FIGURE 7-31: Title Keyword search matches episode title too.

FIGURE 7-32: First pass of Actor search.

You can click on the links in the search results to see more info. Sometimes that results in a second search. Other times it goes to sub-modules of the User Interface module to display upcoming showings, etc.

Theme

TivoWeb is themeable, thanks to Mike Baker (embeem). Using stylesheets, you can change the look of the entire interface. The Theme module lets you switch from theme to theme; it selects from files named `*.css` in the `tivoweb-tcl` directory (`/var/hack/tivoweb-tcl`). In fact, all of the screenshots in this chapter were done with my own theme `keegan_org.css`, which I've included and set as the default on the accompanying CD.

Search - Mozilla

File Edit View Go Bookmarks Tools Window Help

Back Forward Reload Stop http://192.168.1.101/se Go Search

SEARCH	
Search By:	Actor
Category	All
SubCategory	Don't specify a sub-category
Search For:	Stewart, Jon
☐ Include Channels You Don't Watch	
☐ Display Empty (No Upcoming Episodes) Hits	

Search

Search Results for "Stewart, Jon"

		EPISODE	NUM	ORIG.AIR DATE	CHANNEL	DATE		TIME
	Spin City							
		Wall Street	322	5/11/1999	WSBK	Sat	3/15	12:00 am
✔	**The Larry Sanders Show**							
✔		Another List	78	3/15/1998	BRAVO	Thu	3/20	2:30 am

FIGURE 7-33: Second pass of Actor search.

Note Many of the themes appear differently in different web browsers. I've done most of the screen-shots in Mozilla to show how they're supposed to look. Adams, blue, sortof, technophobe, tivo-forum, and keegan_org look just about the same in both (with a few exceptions). Daynight2, daynight, and jwhowa look bad in Internet Explorer (IE). Tivocomm looks better in IE than in Mozilla (the colors are wrong). Technophobe2 looks great under Mozilla, but just like techno-phobe(1) under IE, because it uses features that IE doesn't support.

The Theme module itself looks like Figure 7-34. Choosing a new theme will change what theme TivoWeb outputs until the server itself quits; the state is kept on the server. You can change the default theme by modifying `/var/hack/tivoweb-tcl/tivoweb.cfg`.

FIGURE **7-34: Themes module.**

Here are what a few of the themes look like (see Figures 7-35 through 7-37).

FIGURE 7-35: Daynight2 theme.

FIGURE 7-36: Technophobe2 theme.

FIGURE 7-37: Tivocomm theme, shown in Internet Explorer.

User Interface

The User Interface module makes up most of what people usually think of TivoWeb as doing; it allows you access to your season passes, the Now Showing list, the To Do List, TiVo Suggestions, WishLists, and so on. Unlike the screen module, everything you do with the User Interface module can be done without interrupting someone else who is watching TiVo.

Joshus Foust (Lightn), who is the primary author of TivoWeb, wrote the User Interface module, and adds new features/tweaks regularly. Since this is a core feature of TivoWeb itself, many people have contributed changes to the User Interface module that have made it into the codebase. John Paglierani (Jpags) provided the program title/description editing routine. Dale Engle provided enhancements to the Edit Program, Now Showing, To Do, and Series screens. Dave Boodman implemented the multi-delete feature, and wrote the original description-hover feature. Dan Campbell (Angra) wrote the TmsId index lookup code. And Aaron Schrab wrote the recording history feature.

The User Interface module is broken down into sub-modules (see Figure 7-38). Many of the screens that make up the User Interface are accessed from many of these, so I'll make reference to them throughout the section.

FIGURE 7-38: Initial User Interface screen.

Season Pass

The Season Pass screen (see Figure 7-39) displays all of the season passes on your TiVo, all on one screen. The leftmost column contains an icon indicating whether it's a normal season pass (the double checkmark), or an auto-record WishList (the star in a circle). The "KAM" title (Keep-At-Most) indicates how many episodes of this season pass should be kept around (1–5, or All). The Show Type column displays whether the season pass should record reruns as well, or only first-run episodes.

FIGURE 7-39: Season Pass screen.

Clicking on the icon in the left column will let you edit the season pass data, such as how many episodes to keep at most, how long to keep the recording around, etc. (see Figure 7-40).

Clicking on the title of a season pass brings up the Series page, which is a list of all episodes (showings) for that season pass that are currently recorded on your TiVo, as well as upcoming

showings that may or may not be recorded (see Figure 7-41). A double checkmark in the left-hand column of *this* screen indicates that the showing is scheduled for recording. Conveniently, the episode number and original air date for each showing are shown here as well.

Clicking on a channel name will bring up the Channel page, described later under "Channel Guide."

FIGURE 7-40: Edit Season Pass screen.

FIGURE 7-41: Series screen.

Unfortunately, there isn't yet a way (in TivoWeb 1.9.4) to re-prioritize season passes.

Now Showing

The Now Showing screen (see Figure 7-42) lists all recordings currently on your TiVo, just like the Now Showing screen in the TiVo UI. You have the option of viewing them sorted the usual way (by the date on which they were recorded), by expiration date, or alphabetically (similar to the S.O.R.T. backdoor in Chapter 2). What's nice is that the entire list gets displayed; when you have over a hundred recordings, it's much easier to scroll down a web page to find an item than to use the real TiVo UI's small pages.

FIGURE 7-42: Now Showing screen.

Clicking on the Program name will bring you to the Series page (described previously) for that particular show, displaying existing recordings on your TiVo as well as upcoming episodes that may or may not be recorded (see Figure 7-41).

The Episode column displays the name of the episode (if the show is episodic), or "Not an Episode" if it isn't, such as a movie or special. Clicking this name (or Not an Episode) brings you to the Showing page (see Figures 7-43 and 7-44), which displays a program description of the recording. The Showing page renders Actors' names as links to the Search module, searching for that actor. From this page, you can delete the recording, get/edit a season pass for the show, and even edit the program description (see Figure 7-45). There is an alternate version of this page for future recordings, which also lets you schedule a recording (see Figure 7-46).

FIGURE 7-43: Showing screen (Part 1).

Actors	Karnes, Catherine Dent, Walton Goggins, Michael Jace, Kenneth Johnson
Exec Producers	Shawn Ryan, Scott Brazil
Genres	Crime Drama
Bits	CC
Type	Series
Channel	69 FX
Showing Date	2/11 10:00 pm
Expiration Date	
Deletion Date	
Cancel Date	
Cancel Reason	
Quality	Basic
Time Watched	0:50:03
Num Visits	1
Selection Type	Season Pass
State	Now Showing
Size	729 MB

ACTIONS
Edit Program
Delete Recording
Edit Season Pass

FIGURE 7-44: Showing screen (Part 2).

FIGURE 7-45: Edit Program screen.

Note the different actions on a Showing page for an item that
hasn't been recorded (or scheduled) yet.

FIGURE 7-46: Showing screen from future unscheduled item.

If you move the mouse over the link in the Episode column of the Now Showing screen, a
small Tool-Tip-style popup window will appear describing that episode (or the showing itself if
it's not episodic). In Mozilla it's one line at most, while Internet Explorer allows for multi-line
descriptions (see Figure 7-47). Modifying tivoweb.cfg can disable both this "Description
Hover" feature and the multi-delete feature.

FIGURE 7-47: Comparison of hover text in Mozilla and Internet Explorer.

The Now Showing screen also lets you do something that's extremely tiresome and painful in the real TiVo UI: delete multiple recordings. The rightmost column in Figure 7-42 shows checkboxes for each item, as well as a checkbox on the header at the top. Clicking the top checkbox will check or uncheck all of the checkboxes below it. Select which items you want to delete, then click the Delete Shows button at the bottom. It's not often that you need to delete a lot of shows, but for the few times that you do, this is *much* better than the tedious and dull chore of doing so with the remote. Dave Boodman, my right thumb thanks you.

To Do

The To Do screen displays programs that are scheduled to be recorded as a result of season passes, auto-record WishLists, individual recordings, and manual recordings. Figure 7-48 shows an example of the To Do list screen.

FIGURE 7-48: To Do List screen.

Like the Now Showing screen, clicking the Program or Episode name brings you to the Series or Showing screens, and moving the mouse over the episode link displays the episode description in a Tool-Tip-style pop-up window. Also like the Now Showing screen, there are checkboxes and a Delete Shows button; this allows you to delete multiple scheduled shows from the To Do List, so they won't be recorded.

Scheduled Suggestions

Mix the To Do List with the Suggestions screen, and you get the Scheduled Suggestions screen (Figure 7-49). This screen displays programs that are scheduled to be recorded as a result of TiVo deciding to record them for you from the TiVo Suggestions list.

FIGURE 7-49: Scheduled Suggestions screen.

There's an extra column here that the To Do List doesn't have: Score. Score is some description of how much your TiVo thinks you like this show, made up of three fields. The first field describes how it got this score; it can be either Explicit (set by you via Thumbs-Up/Thumbs-Down settings) or Predicted. The second field indicates the actual or predicted thumbs rating. The last field indicates TiVo's confidence level in this score.

Suggestions

The Suggestions screen lists all of the recordings that TiVo has predicted you might like. It's exactly like the Scheduled Suggestions screen above, except that there's no Delete button since these suggestions aren't necessarily scheduled.

Deleted Shows

Ever accidentally deleted a recording before you wanted to? From now on when that happens, you'll have a chance of getting it back. The Deleted Shows screen displays a list of deleted shows that can still be recovered, since they haven't been overwritten by something else yet. Figure 7-50 shows an example of the Deleted Shows page. Click on the recycle icon in the left-most column, and you should be able to recover the show. It will show up on your Now Showing list again, good as new.

FIGURE 7-50: Deleted Shows screen.

Preferences

The Preferences screen lets you see what TiVo thinks you like. I'm not talking about which shows it's recommending for you, I'm talking about the raw data like what your score is for a given actor, director, series, etc. This data is obtained both through Thumbs-Up/Thumbs-Down ratings you've provided, and by predictions it makes based upon those ratings.

There are five types of preferences data, as shown in Figure 7-51: Genre, Series, Actor, Director, and Writer. Series items are shows or movies, some of which have been explicitly set by you, and some of which were implied; for example, when you record a show, an implied 1-Thumbs-Up is given to the recording. Genre, Actor, Director, and Writer preferences are all implied; when you give a Thumbs-Up to Back to the Future, the actors Michael J. Fox and Christopher Lloyd are given weight, as well as the director Robert Zemeckis and the Science Fiction genre.

What I find particularly cool is to be able to have a list of all of the movies I've seen, with their ratings. I've been rating movies on my TiVos for about a year and a half, so now I have a pretty comprehensive list of what movies I've seen and like. Figure 7-52 shows what the Series Preferences screen looks like.

FIGURE 7-51: Preferences screen.

The Actor, Director, and Writer screens have so much data that they are each divided up into 26 screens (A–Z).

Channel Guide

When the Channel screen first comes up you choose whether you want to see a listing of All channels, just channels you Watch, or just your Favorite channels. After selecting one of the choices, you're shown a list of all channels that match that criterion. Figure 7-53 shows the beginning of a list of All of my channels, and shows the sample logo I associated with it above with the Logos module.

FIGURE 7-52: Series Preferences screen.

FIGURE 7-53: Channel Guide screen.

Clicking on the channel name here (as well as any other place in the User Interface module) brings up the Channel Screen (see Figure 7-54). The first page lists the season passes associated with that channel, and provides a link to the Listings screen (see Figure 7-55), where you can view *all* upcoming shows on that channel.

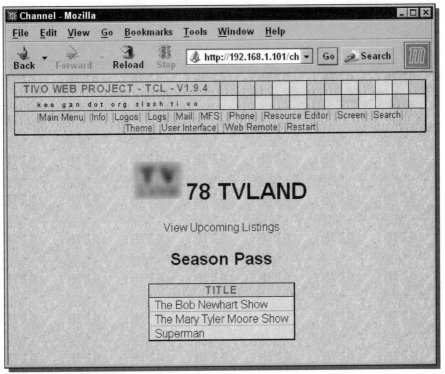

FIGURE 7-54: Channel screen.

FIGURE 7-55: Listings screen.

WishLists

The WishLists screen shows you all of the WishLists that are on your TiVo. Unfortunately, as of version 1.9.4 of TivoWeb, you still can't modify the WishList directly. What you can do is click the star-in-a-circle on any auto-record WishLists (see Figure 7-56), and edit the season pass aspect of the WishList, like how long to keep recordings around, etc.

FIGURE 7-56: WishLists screen.

Recording History

The Recording History screen lets you see what is normally found under the To Do List's "View Recording History" option in the real TiVo UI. It also displays the reason for any conflicts right there on the same screen.

The initial Recording History screen lets you choose whether you want to see just five days of the past, all of the past, just five days of the future, all of the future, or all of the future and the past. Figure 7-57 shows an example of the future, and Figure 7-58 shows an example of the past.

FIGURE 7-57: Recording History screen displaying "future".

I show both of these specifically because of the Reason column. Figure 7-57 shows reasons such as "no longer in program guide," "not enough space," and "conflict," rather than the general "Won't Record" that would be displayed in the TiVo UI; there, you'd have to dig down an extra screen to find this info. Also, one entry shows a conflict, and mentions that an alternate has been scheduled; this indicates that the episode that couldn't be recorded due to this conflict has been scheduled for a different time, so there's nothing to worry about. Figure 7-58 shows similar examples of increased specificity in reasons, such as "expired," "deleted," and "MaxRecordingsNowShowing," instead of the TiVo UI's general "Deleted" catchall, and "duplicate" and "conflict" instead of TiVo's "Not Recorded."

Clicking on "duplicate" or "conflict" on these screens will show exactly what the conflict was with. Figure 7-59 shows the result of clicking on the "Conflict (alternate scheduled)" link in Figure 7-57.

FIGURE 7-58: Recording History screen displaying "past".

FIGURE 7-59: Conflict Explanation screen in Recording History.

Web Remote

The Web Remote module displays a remote control in your web browser. When you click buttons on it, it's just as if your TiVo had received those button presses via an actual remote control.

The first remote control was written by TivoTechie, as a modification to the "SFR" Tcl web server httpd.tcl written by Stephen Rothwell. It was text-based. Then, for TivoWeb, the Web Remote module was written by Mike Baker (embeem), which now includes a graphical remote and lets you choose between the two.

Figure 7-60 shows the graphical version of the Web Remote module.

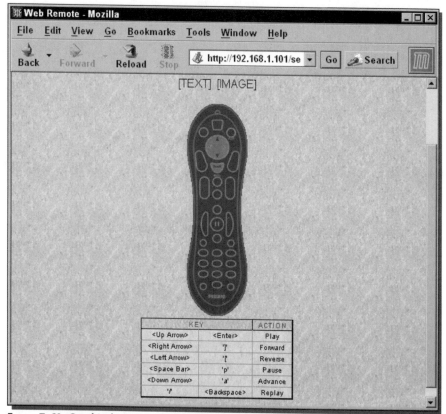

FIGURE 7-60: Graphical version of Web Remote.

Later, Luan Dang submitted a modification that allowed key presses in a web browser to be trapped, such that when you're on the Web Remote screen, you can hit the up arrow or enter for Play, the right arrow or "]" for forward, etc (see the bottom of Figure 7-60 for the keystrokes allowed). I myself find it to respond much faster than the actual remote control, despite the fact that it's an HTTP submit to a web server running on a TiVo.

Another modification was made by Mike Langley to allow you to specify multiple remote button presses to occur in a row, from the same request. For instance, if you go to the following URL:

```
http://192.168.1.101/sendkey/livetv/wait/tivo/4/right
```

you should be brought to the Search By Title page on your TiVo. First the `livetv` key is issued, then `wait` causes a three-quarter-second delay. This should anchor you from most locations in the TiVo UI. After the delay, `tivo` is issued bringing you to TiVo Central, 4 is issued (which is the shortcut for the Search By Title page), and then `right` chooses All Programs to search through all categories. Again, be careful here, if you forget a key or the context of a page wasn't what you expected, you might end up selecting some action you didn't want to do (like deleting things, etc).

Additional Modules

I wanted to mention two other modules as well. These don't ship with TivoWeb 1.9.4, but they're listed on TivoWeb's web site.

- DisplayText, by Gary Davis (gardavis on tivocommunity.com). This module lets you enter a string of text to be displayed on the screen. I talk about this more in Chapter 9.

    ```
    http://www.webguild.com/tivo/
    ```

- What's On, by LJ. This displays a list of shows on at a given time (something like the Browse By Time feature in TiVo's UI).

    ```
    http://tivo.lightn.org/whatsonpackage.zip
    http://www.ljay.org.uk/tivoweb/
    ```

- ChannelGrid, by Christopher Wingert (cwingert on tivocommunity.com). This module lets you see a single channel's programming data for the week, arranged in the familiar lineup grid that we were used to before TiVos.

    ```
    http://tivocommunity.com/tivo-vb/showthread.php?threadid=116879
    ```

- ChannelMap, by Glenn R. Souther (Zirak on tivocommunity.com). This module lets you re-map channel numbers for a given station.

    ```
    http://tivocommunity.com/tivo-vb/showthread.php?threadid=61830
    http://tivo.lightn.org/channelmap.itcl.gz
    ```

- Movie Search, by Brian Wagener (CptanPanic on tivocommunity.com), lets you browse upcoming movies.

    ```
    http://tivo.lightn.org/moviesearch_0.8.tgz
    ```

- Manual Record, by Christopher Wingert (cwingert on tivocommunity.com). This module allows you to set up a manual recording.

    ```
    http://tivocommunity.com/tivo-vb/showthread.php?threadid=117985
    ```

- Showcase, by LJ. This module displays Showcases in your web browser.

    ```
    http://www.ljay.org.uk/tivoweb/
    ```

There are many other useful modules out there, I just haven't used them all. More can be found on the TivoWeb site at `http://tivo.lightn.org/`.

Writing Your Own

In Chapter 15 I talk about writing your own hacks, and have a section dedicated to writing TiVo modules. Be sure to check it out. If you have an idea, mock it up, write a quick prototype. Before you know it, you could be releasing it to the public and adding to the functionality of TiVos everywhere.

TiVo Control Station

About 6 months ago my wife and I finally got hooked on *The West Wing*. Friends of ours had pushed it for a long time, and we were sure it was great, but we just hadn't gotten around to watching it; there was always some conflict, we didn't know the back story, etc. But we finally came around, and now we love it.

The thing is, I'm one of those people who wants to hear every line in a show, every half-utterance, every under-the-breath snide remark, and every fast-paced exchange. *The West Wing* is extremely fast paced, which is how I like it. The downside is that sometimes they're talking so fast that the slightest external noise in the shot can make a phrase inaudible, even after rewinding. If it's obscure enough (which again, I like), then you won't even be able to get it through context.

So, one of the hacks I use quite a bit is tivovbi, by Mike Baker (embeem). It displays closed caption information right on the screen. Since I made the switch to TiVo years ago, I don't even know where my TV remote control is, and I have no desire to try to find it; I don't want a second remote control just to turn on my TV's closed captioning. Plus, tivovbi does a better job at keeping up with the fast-paced nature of rewinding on a TiVo; normal closed captioning decoders always seem a bit too slow.

That's great and all, but then came the question of how to start and stop it. When it first came out, I remember he had a simple script that watched for keystroke events. The thing was, you could tell that would be a problem someday when the next hack came along that also needed to trap remote codes. Even if there weren't technical limitations from having two competing IR listeners, there would still be the question of what button presses would be reserved for what. What we really needed was some daemon that managed these hacks and could arbitrate such problems.

Enter TiVo Control Station (TCS). TCS lets you start your own commands with the remote control, as well as via a simple socket connection. Your commands are then free to do whatever they want, including outputting graphics or text right onto your TV screen.

My tivovbi example above is a valid enough reason for installing TCS, but it's not actually why I installed it. Part of what makes it fun to crack open one's TiVo is the idea that you'll be able to make it do something that it normally can't do. It's even better if it's something new you've developed yourself. But for TiVo to be a fun platform on which to write hacks, you really need a way to either modify the interface, or at least be able to *do* things while sitting on the couch. That's the whole fun of hacking something connected to your TV, right?

TCS is the closest we've come to that so far. While it doesn't let you create full-blown menus like TiVo's own UI, it turns out it that it doesn't need to, to be useful. One of the default commands (9-0-clear) displays a text file on-screen, with a list of other commands. It's close enough to a UI that it'll spark the creative juices of hobbyists who wouldn't otherwise have invested months writing a full-blown harness for their own simple hack idea.

And, of course, we also get to benefit from the existing hacks that have been written for TCS. Modules that ship with the default TCS distribution allow you to display stock quotes, sports scores, caller-ID logs, and weather maps on your screen. An eBay module watches auctions you're bidding on or tracking, and displays a warning on screen when the auction is about to end. And you can easily start and stop other hacks like TivoWeb, tivoftpd, and of course, tivovbi.

Installing TiVo Control Station

 On the CD

If you've installed the distribution I've included on the accompanying CD as described in Chapter 4, then TiVo Control Station is already on your TiVo. If this is the case, make sure it's enabled in `hacks_callfromrc.sysinit` as described in "Enabling the Various Pieces" in Chapter 4, then make sure you've gained telnet access to your TiVo as described in Chapter 5. Skim through the following text (since you need to supply the IP address of your DNS (Domain Name System) server, modify the `prefs` file, and learn about enabling/disabling modules), and then finally skip ahead to Using TiVo Control Station.

Before you read any further, make sure you've gained telnet access to your TiVo as described in Chapter 5, either via a serial-line PPP connection, a TiVoNet card, a TurboNET card, or an AirNET card.

TiVo Control Station is written and maintained by Glenn R. Souther (Zirak on tivocommunity.com). Download the latest version from his web site at:

`http://www.zirakzigil.net/tivo/TCSdownload.html`

The version I'm describing here (and that's on the accompanying CD) is TCS Release Version 1.0.1:

`http://www.zirakzigil.net/download/TCS_1.0.1.tar.gz`

Download this version, and then move it over to your TiVo with one of the file transfer mechanisms described in Chapter 6. Place it at the top of the TiVo's `/var` directory for now.

You'll also need to install newtext2osd-1.4, jpegwriter, and probably tivovbi. Either reconsider going back to Chapter 4 to install it all, or instead go to Chapters 9 and follow instructions there.

Then, follow these steps to install and enable TiVo Control Station:

STEPS: Installing and Enabling TCS

1. Telnet into your TiVo (again, see Chapter 5 if that's not set up yet).

2. Make sure the `/var/hack` directory exists, via:

   ```
   mkdir -p /var/hack
   ```

3. Move to the `/var/hack` directory by typing:

   ```
   cd /var/hack
   ```

4. Move the downloaded file into `/var/hack` by typing:

   ```
   mv /var/TCS_1.0.1.tar.gz /var/hack
   ```

5. If you have a previously installed earlier version of TiVo Control Station, shut it down, then rename the directory (we'll delete it later) with:

   ```
   mv /var/hack/tcs /var/hack/DELETEMEtcs
   ```

 (substituting the correct directory location if it had been installed elsewhere).

6. Decompress the file, via:

   ```
   gzip -d TCS_1.0.1.tar.gz
   ```

7. To unpack the file, we'd normally use `tar`, but if you're reading this, you didn't do the full software install in Chapter 4, so you probably don't have `tar` on your TiVo yet. Unpack the file with `cpio`, by typing:

   ```
   cpio -H tar -i < TCS_1.0.1.tar
   ```

8. If you don't have a `/var/hack/etc/hacks_callfromrc.sysinit` file, you can copy one from the root directory of the accompanying CD-ROM, and then modify `rc.sysinit` to call it (see "Setting up rc.sysinit" under "Installing It All" in Chapter 4). To start TCS after each reboot, the file must contain the line:

   ```
   /var/hack/tcs/starttcs
   ```

 This way of starting TCS will keep a log file in `/var/log/tcs`. Alternately, you can use:

   ```
   /var/hack/tcs/starttcs console
   ```

 to write the output to the console, or

   ```
   /var/hack/tcs/starttcs console
   ```

 to ignore the output by writing it to `/dev/null`.

9. Make sure that the "`/var/hack/tcs/starttcs`" line in your `/var/hack/etc/hacks_callfromrc.sysinit` file is uncommented (that is, that there is no "#" on the left).

Caution

I don't have a better place in the chapter to insert this, so I'll say it here. Be aware of the log file that TCS creates in /var/log/tcs. It doesn't get deleted, so over time it can grow, and might someday fill up your /var partition, causing your TiVo to delete the entire partition (including all of your hacks) and restart. This isn't a huge concern (and it's certainly not unique to TCS), but it is worth mentioning.

TiVo Control Station should now be installed, but you still have some important configuration to do, which if left undone may cause your TiVo to occasionally reboot.

First, you need to supply the IP addresses of the nameservers you use in your network. Determine the IP address of your DNS servers (your router may have obtained this via DHCP (Dynamic Host Configuration Protocol), or you can try "ipconfig/all" on Windows 2000/NT or look in /etc/resolv.conf on Linux). Then, edit the file /var/hack/tcs/config/IPAddresses and specify as many nameservers as you have, in the first three lines (replace "xxx.xxx.xxx.xxx" with the first address, and so on).

Next, you need to modify the preferences file. Edit the file /var/hack/tcs/config/prefs, and make sure the locations of the various hacks are correct. For instance, you probably will need to change:

```
ftp FtpCommand /tivo-bin/tivoftpd
```

to

```
ftp FtpCommand /var/hack/bin/tivoftpd
```

Important: DNS Server Must Support TCP Requests

Since the modified version of Linux that TiVo ships with doesn't support name resolution, TCS needs to use a Tcl-based DNS library to lookup hostnames. Since Tcl doesn't provide support for UDP, the DNS library is limited to communicating with DNS servers only via TCP (Transmission Control Protocol), not through UDP (User Datagram Protocol). What this means is that if the domain server (which is most likely from your ISP) that you are using doesn't support TCP requests, then the DNS library (and by extension, TCS) won't work.

An easy way to test whether your DNS server supports TCP requests is to go to a Linux box and use the command dig. dig lets you perform a DNS lookup using either TCP or UDP. If when you run this:

```
dig +tcp @yourdnsserversipaddress www.tivo.com
```

it hangs for about 20 seconds then returns "no servers could be reached", and this:

```
dig +notcp @yourdnsserversipaddress www.tivo.com
```

returns immediately and gives you info, then your DNS server only responds to UDP requests. Complain to your ISP that their DNS server isn't handling TCP-based DNS queries, and give them both of the dig commands above with their outputs. In the meantime, you might be able to find a public DNS server you can use (try searching around with Google). If neither command worked, you have some other problem going on, and if both worked, you're good to go.

There are two more options you want to learn about before continuing: `tcsautoupdate` (TCSAutoUpdate), and `getnewmodules` (TCSInstallNew). If `tcsautoupdate` is set to 1, new versions of modules will be downloaded from the TCS web page periodically. If `getnewmodules` is set to 1, then new modules (that you don't yet have) will be downloaded from the TCS web page when present. Be aware of these options and what they mean.

Once you're satisfied with the values in `/var/hack/tcs/config/prefs`, save the file.

Modules in TCS are enabled if they are present in the `/var/hack/tcs/modules` directory. There is another directory *below* that, `/var/hack/tcs/modules/modules`, which typically contains *all* modules. When you decide you want to disable a module, you delete the module from `/var/hack/tcs/modules`. If you want to re-enable it, you create a hard link of the file in `/var/hack/tcs/modules/modules` into `/var/hack/tcs/modules`.

For example, when the football season is over, you can delete `/var/hack/tcs/modules/NFL.tcl`. Then in August when you want to re-enable it, telnet in and type:

```
ln /var/hack/tcs/modules/modules/NFL.tcl /var/hack/tcs/modules/NFL.tcl
```

If a module is present in both directories, it will be eligible for auto-update if `tcsautoupdate` is enabled. If it is absent from both directories, it is eligible for autodownload if `getnewmodules` is set to 1.

Caution Sometimes TCS can behave strangely when a network connection isn't present. There is a bug in TiVo internal software known as the "Event bug" that also causes problems with TCS from time to time. Bottom line, TCS may do things to your TiVo like causing it to slow down unexpectedly, or occasionally reboot. This is not typical, but you should be aware of the possibility before you go diving in. (It can always be disabled later by commenting out the line in `hacks_call-fromrc.sysinit` that starts TCS.) You may also want to consider which modules you have turned on, and which ones you really use.

Start TCS either by rebooting or by typing `/var/hack/tcs/starttcs`.

Using TiVo Control Station

Once TCS is started up, grab your remote control and head over to your TV. Go to live TV (or start watching a recording), and while on that screen press 9-0-clear on your remote control. Within a few seconds, you should see a menu of commands displayed on the screen, that looks like Figure 8-1. If you press "down" on the directional pad, the screen should clear briefly, then display the next page of commands, shown in Figure 8-2.

For the sake of readability, I've also included the text of those two screens in Listing 8-1, as well as entries for MLB, NFL, and NCAA scores (which happened to be disabled in Figure 8-1 and 8-2).

Remote	Net	Function
0 0 clr	----	Caller-ID History
0 1 clr	----	eBay
0 2 clr	----	ResetEBayTimers
0 8 clr	----	Caller-ID Phonebook
1 1 clr	KTEL	KillTelnet
2 2 clr	KFTP	KillFtp
3 3 clr	KWEB	KillTivoWeb
5 5 clr	KVBI	KillTivovbi
6 0 clr	----	SportsCommands
6 4 clr	----	NHL
6 5 clr	----	NBA
7 1 clr	----	Interest Rates
8 1 clr	----	GetWeatherZipFromRe
8 2 clr	----	LocalRadar
8 3 clr	----	NationalRadar
9 0 clr	----	ShowCommands
9 1 clr	DOOR	EnableBackdoors
9 2 clr	SORT	EnableSortNowPlayin
9 3 clr	CLCK	ToggleClock
9 4 clr	SSUG	ShowSuggestions

--- more ---

FIGURE 8-1: First page of command list (9-0-clear).

Remote	Net	Function
9 5 clr	SKIP	SkipThirty
9 6 clr	----	ModuleVersions
9 7 clr	----	ListTimers
9 8 clr	----	ResetAllTimers
9 9 clr	QUIT	Terminate
clr 0 clr	----	Applications
clr 1 clr	RTEL	RestartTelnet
clr 2 clr	RFTP	RestartFtp
clr 3 clr	RWEB	RestartTivoweb
clr 4 clr	RSER	StartSerialBash
clr 5 clr	RVBI	RestartTivovbi
clr 7 clr	----	Quotes
clr 8 clr	----	Weather
mute mute clr	----	ToggleGreedy
-------------	DISP	Network OSD
-------------	MEAN	Greedy
-------------	NICE	NoGreedy
-------------	RTES	RestartEventServer

Figure 8-2: Second page of command list (9-0-clear, then down).

Listing 8-1: Default TCS Remote Commands

```
Remote            Net    Function
=======           ====   ========
0 0 clr           ----   Caller-ID_History
0 1 clr           ----   eBay
0 2 clr           ----   ResetEBayTimers
0 8 clr           ----   Caller-ID_Phonebook
1 1 clr           KTEL   KillTelnet
2 2 clr           KFTP   KillFtp
3 3 clr           KWEB   KillTivoWeb
5 5 clr           KVBI   KillTivovbi
6 0 clr           ----   SportsCommands
6 1 clr           ----   MLB
6 2 clr           ----   NFL_Scores
6 3 clr           ----   NCAA_Football_Scores
6 4 clr           ----   NHL
6 5 clr           ----   NBA
7 1 clr           ----   Interest_Rates
8 1 clr           ----   GetWeatherZipFromRemote
8 2 clr           ----   LocalRadar
8 3 clr           ----   NationalRadar
9 0 clr           ----   ShowCommands
9 1 clr           DOOR   EnableBackdoors

              --- more ---

Remote            Net    Function
=======           ====   ========
9 2 clr           SORT   EnableSortNowPlaying
9 3 clr           CLCK   ToggleClock
9 4 clr           SSUG   ShowSuggestions
9 5 clr           SKIP   SkipThirty
9 6 clr           ----   ModuleVersions
9 7 clr           ----   ListTimers
9 8 clr           ----   ResetAllTimers
9 9 clr           QUIT   Terminate
clr 0 clr         ----   Applications
clr 1 clr         RTEL   RestartTelnet
clr 2 clr         RFTP   RestartFtp
clr 3 clr         RWEB   RestartTivoweb
clr 4 clr         RSER   StartSerialBash
clr 5 clr         RVBI   RestartTivovbi
clr 7 clr         ----   Quotes
clr 8 clr         ----   Weather
mute mute clr     ----   ToggleGreedy
--------------    DISP   Network OSD
--------------    MEAN   Greedy
--------------    NICE   NoGreedy

              --- more ---

--------------    RTES   RestartEventServer
```

Typing the commands on your remote will trigger the appropriate behavior.

You can also telnet into your TiVo on port 8762 and issue the four-letter commands to cause those actions to be performed.

Note The first time you run TCS it might seem a little sluggish at first, while it downloads the latest versions of modules and data to display.

I'll walk through a few examples here, but most of this should be pretty easy to figure out by experimentation.

Weather

First, try getting a text-based weather forecast. Press clear-8-clear to display the weather forecast on-screen. Pressing down or up will move from screen to screen, and clear (as well as just about anything else) will make the text go away. See Figure 8-3 for an example of what it should look like.

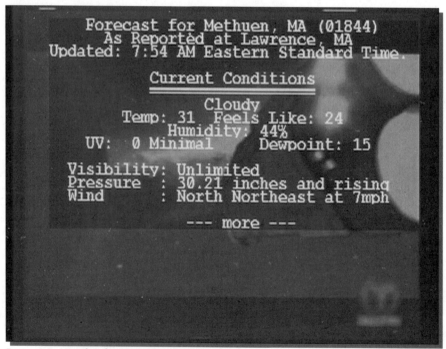

FIGURE 8-3: Weather forecast (clear-8-clear).

Next, let's pull up a weather map. Press 8-2-clear for a local weather map, or 8-3-clear for a national weather map. Again, pressing clear afterwards will clear the screen. Figures 8-4 and 8-5 show sample weather maps. If the image is off to the right, the reason is the utility jpeg-writer that the weather module is using to display the image.

FIGURE 8-4: Local weather map (8-2-clear).

Stock Quotes

Press clear-7-clear to get current stock quotes on all symbols listed in /var/hack/tcs/config/tickers (see Figure 8-6).

FIGURE 8-5: National weather map (8-3-clear).

FIGURE 8-6: Stock quotes (clear-7-clear).

Enable Backdoors

This one's worth doing just for how cool it looks when it's being done. When I first saw that there was a TCS command to enable backdoors, I figured someone had determined what bit to set in memory somewhere (or some MFS entry) to turn on backdoors. Nope. Choosing the backdoors sequence (9-1-clear) causes a long set of sendkey commands to happen, simulating remote-control button presses. It brings you into the Search By Name page and enters the backdoor code for your system. Definitely cool. Chapter 2 has more on backdoors.

tivovbi

If you want to view close captioning, try turning on tivovbi by pressing clear-5-clear. To turn it off, press 5-5-clear. Make sure you're on a program that has closed captioning, otherwise you might not see anything. I discuss tivovbi much more in Chapter 9.

eBay

Mark Pulver (mpulver on tivocommunity.com) wrote the eBay module for TiVo Control station. If you've ever bid on eBay auctions, you'll love this: not only does it show you info about auctions you're bidding on or tracking at the touch of a button, but it will also display information about one of those auctions when it's about to close, *without you pressing anything*. Maybe you had bid on that The Incredible Hulk lunchbox on Monday and forgot about it by Friday, when the auction closes. Why let bixbyfan78 get it instead of you, just because you forgot? Now, your TiVo will remind you.

Log into eBay with a web browser (not just visiting the page, but actually logging by clicking "sign in" in the upper-right section of the page). Once you're logged in, click on "my eBay" in the upper-right section of the page. When the page finishes loading, look at the URL of the page you're on (it may help to copy the entire thing then paste it into a text editor). Somewhere in the URL you will see &userid=johndoe&pass=YYYYYYY& , where johndoe is your username and YYYYYYY looks like gibberish. Copy the YYYYYYY portion entirely (everything after "pass=" and before the next "&"). Now telnet into your TiVo, and edit the file /var/hack/tcs/config/ebayitems. Add a line like:

```
USER=johndoe YYYYYYYY
```

This should let your TiVo log into eBay as you, so if you're not the trusting type, this might not be your cup of tea. You technically don't *have* to put this here, you can instead list each auction item that you're watching by hand, but that's hardly making your life easier.

Once you've done this, type 0-1-clear on the remote, and it should show you a list of the items you're bidding on or watching (see Figure 8-7).

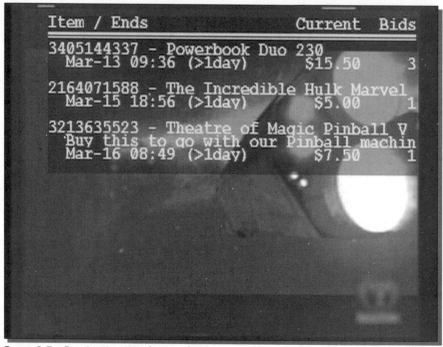

FIGURE 8-7: eBay Auction Watch (0-1-clear).

Have patience trying to get this to work. Every once in a while I have problems showing it to friends, and I haven't been able to figure out what the problem is since it's intermittent; but it *does* work. At the very least, placing item numbers by hand into ebayitems works great.

Note Just before the book went to press, the eBay module was removed from the latest release of TCS because it stopped working. Hopefully the module will be fixed by the time you read this, and will auto-download when you run TCS for the first time.

ElseedHistory

The ElseedHistory module was written by Chris Nims (cdn). It allows you to view a list of people who called you, via caller-ID info gathered with the Elseed program, which is talked about in Chapter 9. To view this history, press 0-0-clear.

Issue Commands via Socket

Try telnetting to your TiVo at port 8762, and entering:

```
DISP Testing 1, 2, 3!
```

This should draw text to the screen. Any of the four-letter commands visible in the command menu (Listing 8-1) can be entered.

Writing Your Own

In Chapter 15, I talk about writing your own hacks, and have a section with it dedicated to writing TiVo Control Station modules. Be sure to check it out. If you have an idea, mock it up, write a quick prototype. Before you know it, you could be releasing it to the public and adding to the functionality of TiVos everywhere.

Displaying Things On-Screen

No one can deny that increasing the storage space on your TiVo is probably the most useful hack around, nor that being able to schedule recordings while not at home with TivoWeb is a close second. However most of our experience when using a TiVo occurs while sitting down on the couch, watching TV. That's where the valuable real estate is — your TV screen. What you really want to be able to do is display whatever you want, on your TV.

Wouldn't you rather display your digital photo album on a big screen (which is probably in front of a couch or two) rather than having everyone cram around a small computer monitor? Which idea seems more appealing: sitting at your computer waiting for a lengthy task to be completed, or relaxing for a while watching some TV until you're told on-screen that it's done?

TiVo Control Station (see Chapter 8) let you display some things on-screen. It did that with the help of the tools in this chapter. Here we talk about a few basic tools that let you view pictures and text, then some more advanced ones displaying specific data — such as closed caption text, caller-ID information, and AOL Instant Messenger messages.

When you get to the later chapters in this book and start writing hacks of your own, you'll find these are valuable tools that you can call from your own code.

Displaying Images on the Screen

On a Series1 TiVo, the MPEG decoder chip is how the on-screen display (OSD) is rendered. The chip allows for separate video and OSD layers, which can both be turned on and off with commands called ioctls (more on that in Chapter 14). This mechanism is how all of the TiVo's menus and on-screen descriptions are drawn.

There are a few ways to write images to the OSD layer.

osdwriter

There is a program in your TiVo called `osdwriter`, that writes image files to the OSD layer. That's actually how the "Almost there. A few more seconds please . . ." boot message gets rendered, as well as many of the severe error messages. It's located in `/tvbin/osdwriter`, alongside those same images. They made a *huge* change in the version that shipped with TiVo software version 3.0, so I'll describe them separately.

osdwriter, Pre-3.0

Prior to version 3.0 of the software, `osdwriter` took a strangely formatted image file as input, apparently specific to the IBM CS22 MPEG decoder chip itself.

Mike Hill (belboz on tivocommunity.com) wrote a program called `osdmngr` that let you convert Targa files (`.tga`) into uncompressed CS22 files suitable for viewing with TiVos' `osdwriter` executable. The `.tga` files needed to be exactly 720×480 pixels (the left 80 pixels of which was just padding), and there needed to be a color palette. `osdmngr` also let you convert the compressed CS22 files from your TiVo into `.tga` files, so you could view them on your computer.

So, if you had a 640×480 pixel JPEG image on a Red Hat Linux box that you wanted to display on your TiVo, you had to use the ppm/pnm image tool package to do something like:

```
jpegtopnm doismellpopcorn.jpg | pnmpad -180 | \
  ppmquant 256 | ppmtotga -cmap > doismellpopcorn.tga
```

then

```
osdmngr doismellpopcorn.tga
```

You could then send the resulting `doismellpopcorn.tiv` file (`.tiv` was Mike Hill's file extension for an uncompressed cs22 file) to your TiVo for viewing with `osdwriter` (via "osdwriter doismellpopcorn.tiv"). It wasn't the easiest of procedures, but it was quick enough that if you smelled popcorn coming from downstairs you could jump onto Google, grab a few popcorn images, and have something like Figure 9-1 up on the screen for your spouse/roommate to see while watching TV. There's no justification for actually including that image here, other than it's my book and I get to decide what to put in. In lieu of a smiley face, picture someone happily eating popcorn here.

If for some reason you're running an old version of the TiVo software and want to try `osdmngr`, it's included on the accompanying CD-ROM under `/cdrom/nonTiVoFiles/osdmngr-1.7.tar.gz`. That file contains the source code and a compiled binary for Red Hat Linux. It can also be downloaded from:

```
http://tivo.samba.org/download/belboz/osdmngr-1.7.tar.gz
```

osdwriter, 3.0 and Later

When version 3.0 of TiVo's software came out, people discovered that `osdwriter` no longer accepted the same type of file as input. The new version of `osdwriter` accepts industry-standard PNG files, eliminating the entire `osdmngr` step above.

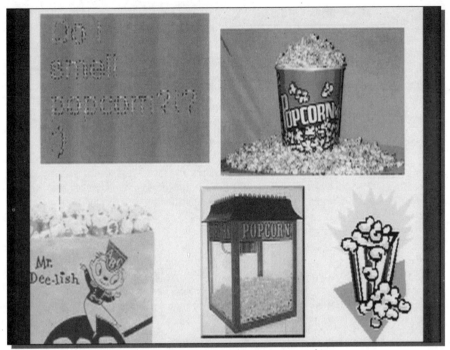

FIGURE 9-1: Actual popcorn request screen I used (proven to work).

There are still some gotchas. The image still needs to have an 8-bit color palette. If it's smaller than 640 × 480, it will be centered vertically but will be aligned with the bottom of the screen. Sometimes images will come across with the wrong color palette, and you'll definitely run into problems if you try rendering images larger than 640 × 480. But it's better to have the images in a well-known format than an obscure one that requires a custom hack to get to.

So to display a 640 × 480 JPEG image from a Red Hat Linux box on your TiVo, you'd now do something more like:

```
jpegtopnm doismellpopcorn.jpg | ppmquant 256 | \
  ppmtopng > doismellpopcorn.png
```

Once you move the .png file to the TiVo, you display it the same way as with the old syntax: "osdwriter doismellpopcorn.png".

jpegwriter

Jake Bordens (The Jake on tivocommunity.com) created jpegwriter, which is a TiVo executable to display JPEG files directly (without requiring you to convert them to anything first). It has its plusses and minuses over osdwriter, but the minuses can be overcome with a few of the image tools used above.

If you installed the software distribution on the accompanying CD-ROM as described in Chapter 4, then `jpegwriter` is already on your TiVo in `/var/hack/bin/jpegwriter`. If not, you can download it from:

`http://www.allaboutjake.com/tivo/jpegwriter.html`

Move the `jpegwriter` executable to `/var/hack/bin/jpegwriter`, and make it executable via "`chmod 555 /var/hack/bin/jpegwriter`".

Note The version of jpegwriter that people have been using for quite a while is 1.0a. Jake has since also released version 1.0b which he'd worked on but never previously released. Version 1.0b has the benefit of an additional option, -dc, that tells jpegwriter to enter "direct color" mode. In this mode, images are drawn with more than 256 colors and look great, but the downside is that 1.0b crashes with some types of JPEG files. As a result, I'm including both versions on the accompanying CD-ROM. Version 1.0a is the version that installed by default when using Chapter 4's instructions, since it is extremely stable. Version 1.0b is located on the accompanying CD-ROM at /cdrom/doc/jpegwriter-1.0b.

The first benefit of `jpegwriter` is obviously that it accepts JPEG files. The second is that it handles colors much better — images displayed with `jpegwriter` look closer to what they're supposed to look like than images reduced to 256 colors with `ppmquant`. A third benefit (if you're aware of it, otherwise it becomes a burden) is that it scales images to fit on the screen — though it only does so by powers of 2 — 1/2, 1/4, 1/8, and so on.

One downside though is that if your image is even one pixel too tall or wide, the entire image gets shrunk practically in half (because of the scaling method used by the libjpeg library). As a result, you want to be very careful about your image sizes. What makes things worse is the second downside — that `jpegwriter` renders all of its images off to the right of where they are supposed to be. That means that your image may be scaled way down in size, and then thrown to the right of the screen.

Figure 9-2 shows how `jpegwriter` drew the original JPEG version of the popcorn image from Figure 9-1. The image is 640 × 480, and was scaled down (since it's taller than 460 pixels as discussed below). Note how it's off-center as well. In this case with the scaled image being smaller than the screen, the fact that it is off-center is only a nuisance; if, however, the image had been wide (but not wide enough to scale), some of the image might actually be hidden off-screen.

Luckily, there are ways around this. Through trial and error it can be observed that 700 × 460 is the largest image allowed by `jpegwriter` before resizing happens to shrink the image; any image wider than 700 or taller than 460 causes the image to be rendered smaller. However, if you create a grid and display it on-screen, you'll notice that `jpegwriter` really only gives you a visible area of about 560 × 460 pixels. Unlike the `osdmngr/pre-3.0-osdwriter` solution above, the content to the *right* isn't being seen (instead of the content on the left). This means that we should create an image of size 560 × 460, and then throw 140 pixels of padding to the right of it.

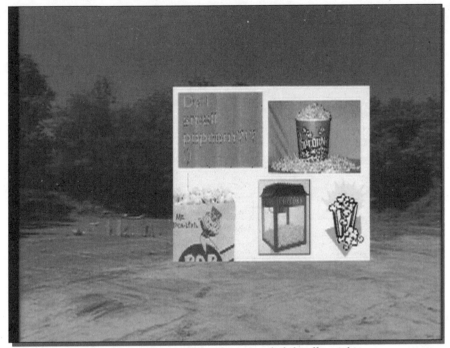

FIGURE 9-2: jpegwriter scales down 640 × 480 image, slightly off to right.

The ppm/pnm tools on Red Hat Linux again let us solve this problem, at least if the image to be displayed can be processed on the external Linux box before being viewed by jpegwriter on the TiVo. To convert an existing 560 × 460 pixel JPEG image into a 700 × 460 JPEG image (with padding on the left), you can use a command similar to:

```
jpegtopnm my560x460img.jpg | pnmpad -black -r140 | \
  pnmtojpeg > my700x460paddedtivoimg.jpg
```

It's not likely that you'll have a 560 × 460 image lying around, and even our osdwriter examples above were a bit awkward, requiring 640 × 480 images. Two extra commands, ppmmake and pnmcomp will help. The following code will take any arbitrary jpeg image, resize it (maintaining the aspect ratio of the image) to a bounding box of 560 × 460, center that image on a black background, pad the right side with 140 pixels of black, and save it as a new jpeg:

```
ppmmake black 560 460 > tmpbackdropimg.ppm
jpegtopnm myimg.jpg | pnmscale -xysize 560 460 | \
  pnmcomp -invert -align=center -valign=middle \
  - tmpbackdropimg.ppm | pnmpad -black -r140 | \
  pnmtojpeg > my700x460tivoimg.jpg
rm tmpbackdropimg.ppm
```

If you still see video to the left of the image, you can black that out by temporarily turning off the video layer with the `displayctl` command mentioned in Chapter 14.

Note The Clock and Status Line backdoor codes described in Chapter 2 both cause jpegwriter to behave incorrectly (causing no harm but interfering with its ability to display images). Avoid playing with those backdoor codes when you plan to be using jpegwriter to view something.

One last item about `jpegwriter` to mention: Shawn Aruch (kronos80 on tivocommunity.com) wrote a simple, quick and dirty, barebones TivoWeb module to display a directory of jpeg files as links and draw them on-screen with `jpegwriter` when clicked. If you have installed both TivoWeb and `jpegwriter` and want to try it, it can be found in this thread:

http://tivocommunity.com/tivo-vb/showthread.php?postid=317759#post317759

HMO

Series2 owners have the option of purchasing an option called the Home Media Option (HMO). This buys them several features, one of which is the ability to view photos on your TiVo.

Luckily the Series2 machines are much faster, and can view JPEGs rather well. The software used to render photos is particularly good about colors, and the images just look incredible. Pictures are scaled correctly; the only complaint one could make is that the image rotate feature seems to distort the image a bit.

With the ability to browse nested folders of thumbnails, it really is a great way to watch a family album. The pieces are there for Series1 owners (although not quite as pretty) — it's just that no one has put it all together yet. I'd say that it's a definite that it will happen, except that if the people who would write it see how nice the HMO slideshow looks, they may just go buy a Series2 and the HMO option instead.

Figure 9-3 shows the thumbnail view of the HMO View Photos feature.

Another thing that the HMO's photo viewing is good for is to give some avenue of hacking to Series2 owners who are hesitant to whip out a soldering iron. Since Series2 owners have a more difficult time getting a bash prompt on their machine, any data in is good. Chapter 11 briefly mentions some examples of custom HMO servers that return images to you that were created on the fly, to display whatever information you want.

Slide Shows

The next logical step after viewing individual images is viewing a whole collection of them. The HMO View Photos option above lets you create slideshows as well, displaying one image for a set amount of time before moving on to the next. There are some options for Series1 folks as well though.

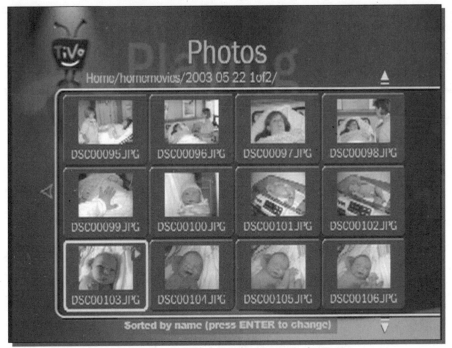

FIGURE 9-3: Viewing thumbnails of photos with the Home Media Option.

slideshow

For a brief while (during version 2.5) there was a solution called slideshow, by Jake Bordens (The Jake on tivocommunity.com). You would put your TiVo into standby mode, and it would display a directory of JPEG images for you. It listened to the remote for commands you could use to skip to the next image, pause, resume, and exit.

I haven't bothered including it on the accompanying CD-ROM because it doesn't work anymore; anyone running 2.5 who wants to try it can find it at:

```
http://www.allaboutjake.com/tivo/slideshow.html
```

Simple Script Replacing slideshow

Of course, you can always write your own slideshow script. Here's a simple script that took two minutes to throw together that does much of what slideshow, described in the previous section, did. It requires jpegwriter and a program called displayctl (which is talked about briefly in Chapter 14, and used here to turn the video display back on when a user is in standby mode). This is more of an example than a working script; it should really monitor the remote control, sleep more intelligently (so it can skip to the next image when told to), and detect

when the user has hit TiVo and that it's time to exit. But again, it took two minutes; I'm merely illustrating that you have all of the pieces at your disposal already.

```
#!/bin/sh
#################
# simpleslideshow
#
# Quick replacement for Jake's slideshow executable

if test "$#" -lt 1 -o "$#" -gt 2
then
  echo "Usage: $0 <jpegs directory> [delay in seconds]"
  echo "(Go into standby mode then run this)"
  exit 1
fi

cd "$1"

delay="$2"
if test "$delay" = ""
then
  delay=5
fi

displayctl -d on > /dev/null
displayctl -v off > /dev/null

for f in *.[jJ][pP]*[gG]
do
  jpegwriter "$f" > /dev/null
  sleep "$delay"
done
```

slides

John N. Kemeny (jnk27 on tivocommunity.com) put together a script to let people view their slides; it runs on cygwin (cygwin installation instructions are in Chapter 6). The thread describing it is:

```
http://www.tivocommunity.com/tivo-vb/showthread.php?threadid=72981
```

Displaying Text on the Screen

At a low level, displaying text on the screen is done through the same mechanism as displaying images — the MPEG decoder chip's OSD (see the earlier description). The difference here is that the tools simply draw text instead of arbitrary images.

There are a few ways to write text to the OSD layer.

text2osd

There is a program in your TiVo called text2osd, that writes text to the OSD layer. It's not the best looking text in the world, but it certainly works. text2osd reads data either from a file or standard input, then blacks out the display and draws the text all at once. On most televisions, text2osd can display 40×25 characters. Figure 9-4 shows text2osd rendering a test-grid text file to demonstrate that resolution.

FIGURE 9-4: Test-grid text file drawn with text2osd.

The text2osd program is located at /tvbin/text2osd.

newtext2osd

Christopher Wingert (cwingert on tivocommunity.com) wrote an open-source replacement to TiVo's text2osd program, called newtext2osd. It provides more functionality, has different command-line arguments, looks slightly different, and is used by several other hacks.

If you installed the software distribution on the accompanying CD-ROM as described in Chapter 4, then newtext2osd is already installed on your TiVo in /var/hack/bin/newtext2osd. If not, you can download it at:

http://www.geocities.com/wyngnut2k/newtext2osd-1.4.tar.gz

Unpack it and place the newtext2osd executable in /var/hack/bin/newtext2osd. Make it executable via "chmod 555 /var/hack/bin/newtext2osd".

Listing 9-1 shows the command-line arguments for newtext2osd.

Listing 9-1: Command-Line Arguments for newtext2osd

```
=[tivo:root]-# newtext2osd -h
Display a File
newtext2osd -s seconds -w file -f color -b color -d file
Display a Text String
newtext2osd -s seconds -f color -b color -x xpos -y ypos -t "text"
 Wait for Options:
  -z    wait forever (must be killed)
  -s    wait for specified seconds
  -m    wait for specified microseconds
  -w    wait for a file to be removed
  -e    exit without clearing the screen
 Display Options:
  -f    Foreground color (numeric)
  -b    Background color (numeric)
  --fg  Foreground color (string, see below)
  --bg  Background color (string, see below)
  -d    File to Display (stdin, if not specified)
  -r    Pick a random x and y location
  -x    X Offset
  -y    Y Offset
  -t    Text String

  -c    Clear Screen

  Defaults to a (very compact) 40 x 24 Screen Size
  --zirak   - Use Zirak's Screen Size
  --gardavis - Use GarDavis's Screen Size

        Specifying -m less than 40000 is probably not very interesting
        (ie TOO subliminal)

Possible Colors : transparent1, grey, white1, white2, white3, transparent2,
red1, green, red2, orange, turquoise, red3, yellow, black1, transparent3,
black2,
=[tivo:root]-#
```

As you can see, newtext2osd provides such features as letting you specify how long the text should remain on-screen, and what colors it should be drawn in. You can have small chunks of text displayed at a given position on screen, or have them placed randomly. Text can also have a transparent background color, allowing video from beneath to be seen.

Figure 9-5 shows how newtext2osd renders the test-grid text file when using the default settings. Note that the resolution here is 40 × 24 (as opposed to the 40 × 25 resolution of text2osd described earlier).

FIGURE 9-5: Test-grid text file drawn with newtext2osd.

Enhancements were made after version 1.3 by other people, and those were incorporated into the official 1.4 version of newtext2osd. Specifying the --zirak option implements the behavior of a patch made by Glenn R. Souther (Zirak on tivocommunity.com), which preserved the default resolution of 40 × 24 but spaced out the lines a bit more to evenly spread them across the screen (see Figure 9-6).

FIGURE 9-6: Test-grid text file drawn with newtext2osd --zirak.

The --gardavis option implements the behavior of another patch by Gary Davis (gardavis on tivocommunity.com). In this patch, the characters displayed are much bigger, and are spaced out both horizontally and vertically. This makes small amounts of text look much nicer, but does also reduce the resolution from 40 × 24 to 37 × 17. The patch also rendered descending characters such as g, j, p, q, and y better, not chopping off the bottoms as the other two newtext2osd methods do.

Figure 9-7 shows a portion of the test-grid rendered with the --gardavis option. Figure 9-8 shows how descending characters are rendered by text2osd (described previously) and the three newtext2osd methods.

FIGURE 9-7: Test-grid text file drawn with newtext2osd --gardavis.

FIGURE 9-8: Comparison of descending characters using various methods.

Other Methods

In general, Series2 users don't get to do many of these hacks, because without modifying your PROM it's very difficult to get your own executables running there. Series2 users who have purchased the Home Media Option (HMO) package still have the ability to display text, although not in the same way as described here. You can write text to your own JPEG files on your PC, and view them via the HMO's photo viewing option. Chapter 11's "Reading Email via HMO" section gives an example of someone doing just that.

Another item worth mentioning here is the DisplayText module for TivoWeb. That module lets you enter text in a web page, which then is rendered on-screen. It uses the `newtext2osd` command (with the `--gardavis` option) to do so. Figure 9-9 shows what the DisplayText module looks like, and Figure 9-10 shows the resulting text on-screen.

FIGURE 9-9: The DisplayText TivoWeb module, which uses newtext2osd.

If you installed the software distribution on the accompanying CD-ROM, then the DisplayText module is already installed. If not, you can download it from:

`http://www.webguild.com/tivo`

Obviously, first install TivoWeb as described in Chapter 7, then place `displaytext.itcl` in TivoWeb's modules directory. Restart TivoWeb, and you're done.

Finally, TCS (see Chapter 8) also has an interface that lets you write text to the screen. If you telnet in to port 8762 on a TiVo running TCS, you can issue the "DISP" command, to display text on-screen via newtext2osd. The text can contain "\n" to indicate a new line. Listing 9-2 shows an example how to display a text message on-screen in this way.

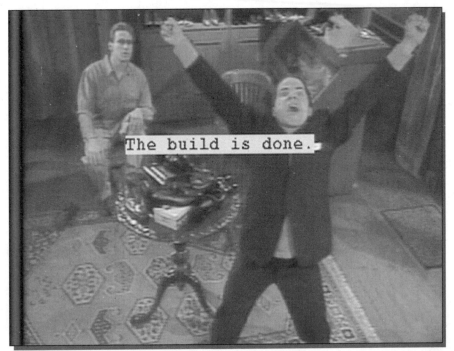

FIGURE 9-10: Results of clicking "Display Text" in Figure 9-9.

Listing 9-2: Drawing Text On-Screen Via TCS's "DISP"

```
# telnet 192.168.1.101 8762
Trying 192.168.1.101...
Connected to 192.168.1.101.
Escape character is '^]'.
DISP Message via telnet:\n\n\n\n  The build is done!\n\n

Connection closed by foreign host.
   #
```

Closed Captioning Hack

I started Chapter 8 with a song of praise for the ability to turn on closed captioning with your remote control. TCS (described in that chapter) is the part that's listening to the remote control commands to turn it on and off. The real hero of that story though is tivovbi.

tivovbi[1] is a program written by Mike Baker that displays the closed captioning text of a recording on-screen. Rather than using the closed captioning facilities that your TV might have, it renders the text itself directly onto the video image. This has two huge advantages: it works on *all* TVs, and it can handle the speed at which TiVo fast-forwards and rewinds. You can also instruct tivovbi to print the closed caption text to standard output.

When video comes into a TiVo, it removes the closed caption information and stores it separately. When playing back video, it reintroduces it into the video stream to be output. This is how tivovbi is able to handle fast-forwards and rewinds better than your television — it has access to the separate "clean" data just before it is re-encoded for output (whereas a television would have to decode the signal, at fast speeds no less).

Installing tivovbi

If you installed the software distribution on the accompanying CD-ROM in Chapter 4, then you already have tivovbi (and the required kernel module that accompanies it) installed. Modify /var/hack/etc/hacks_callfromrc.sysinit to make sure that the correct kernel module is loaded (only load tvbi.o on standalone TiVos, and tvbi-dtv.o on DirecTiVos) If you didn't install that distribution, you can download tivovbi from:

http://tivo.samba.org/download/mbm/tivovbi-1.03.zip

and one of the following kernel modules (depending on whether you're using it on a standalone or a DirecTiVo, respectively) from:

http://tivo.samba.org/download/mbm/bin/tvbi.o
http://tivo.samba.org/download/mbm/bin/tvbi-dtv.o

The tivovbi-1.03.zip file contains the tivovbi executable as well as the source code. Many existing hacks are based on this code.[2]

Place the tivovbi executable in the /var/hack/bin directory, and the kernel modules in the /var/hack/kernelmods directory. Add one of the following two lines to either your /etc/rc.d/rc.sysinit file, or to a file that it calls (such as /var/hack/etc/hacks_callfromrc.sysinit if you have set that up):

insmod /var/hack/kernelmods/tvbi.o
insmod /var/hack/kernelmods/tvbi-dtv.o

[1] The "vbi" in tivovbi refers to the vertical blanking interval, which is a portion of the television signal where closed caption text is encoded between frames of video. As it turns out, there are other pieces of info there as well, such as TiVo's iPreview icons that sometimes occur during commercials (allowing you to press Thumbs-Up to record a show).

[2] There is another piece of code out there that demonstrates writing to the OSD layer as well: osdtxt, written by Mike Hill (belboz on tivocommunity.com). osdtxt was a Hello World application, really only useful as example code. It's included on the accompanying CD-ROM in /cdrom/doc/osdtxt. It is available on the web at: http://tivo.samba.org/download/belboz/osdtxt.tar.gz.

Once the `insmod` command has been run, the kernel module will be loaded and `tivovbi` can function. The kernel modules are only necessary for version 3.0 and later of the TiVo software.

Using tivovbi

Listing 9-3 shows the command line arguments for `tivovbi`.

Listing 9-3: Command-Line Arguments for tivovbi

```
=[tivo:root]-# tivovbi
tivovbi [ -t | -o ] [ -c ] [ -x ]
 DISPLAY MODE:
  -t     text output
  -o     OSD display       (requires -c)
 DECODE:
  -x     XDS data          (requires -t)
  -T     set clock         (requires -x)
  -c1    CC1 data
  -c2    CC2 data
  -d     DEBUG MODE        (requires -t)
  =[tivo:root]-#
```

To start displaying closed captioning on-screen, you can run tivovbi directly from the command line with "`tivovbi -o -c1`"; it will fork off another process to run in the background, and you'll be told the process-id of that process so you can kill it when you're done. The "`-c1`" selects the normal closed captioning channel of information, and "`-o`" says to draw it on-screen (see Figure 9-11).

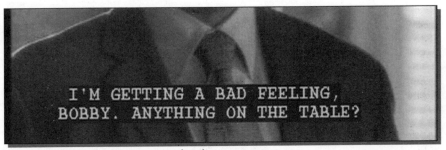

FIGURE 9-11: Closed caption text rendered on-screen.

You can also have `tivovbi` print the closed caption text to standard output as well, with or without simultaneous display on-screen. When using the "`-t`" option to do this, `tivovbi` will stay in the foreground. Listing 9-4 shows a sample run, displaying standard closed captioning text.

Listing 9-4: Sending Closed Caption Text to a Terminal

```
=[tivo:root]-# tivovbi -t -c1
      THOUGH TECHNICALLY
 THE BURDEN IS ON THE STATE,
        MOST EXPERTS FEEL
 THAT BURDEN HAS REALLY SHIFTED
 TO THE DEFENSE IN THIS CASE.
 I'M GETTING A BAD FEELING,
 BOBBY. ANYTHING ON THE TABLE?
 NO, WE HAVEN'T EVEN PUT IN
 OUR CASE YET.
      OUR CASE? WELL,
    A BIG PART OF IT IS
« Ctrl-C »
===== tivovbi 1.03 =====
programmed by mbm@linux.com
  =[tivo:root]-#
```

When displaying text on-screen, italics are used when the closed caption text dictates that they are supposed to be. ANSI color codes are output with terminal output as well — when I ran tivovbi for Listing 9-4, the first five lines of output were rendered in blue.

The "–x" option displays extended data services (XDS) data, which is supposed to carry information like what channel you're watching, what the program is, its duration, its air date, and so on. The "–d" option allows you to see extra debugging information within tivovbi (and can be given up to four times to increase the debugging level). An interesting thing to try is to combine these and watch one of the TiVo "Teleworld Paid Program" recordings on the Discovery channel (see Listing 9-5).

Listing 9-5: Teleworld Paid Programming tivovbi Data

```
=[tivo:root]-# tivovbi -c1xdt
% CURRENT    TITLE: PAID PROGRAMMING
% CURRENT    GENRE: 00 00
% CURRENT DURATION: 1:54:00 of 6:00:00
% CHANNEL  NETWORK: The Discovery Channel
% CHANNEL CALLSIGN: DSC
% CURRENT   RATING: (NOT RATED)
% CURRENT DURATION: 1:55:00 of 6:00:00
 (debug) Tt:C`5[H^3k0Z[xm]kf4xUd !#V-,
% CURRENT DURATION: 1:56:00 of 6:00:00
(debug) Tt*A  `   %8YT
```

```
(debug) Tt4CR5[H^3k0Uq`$'' 8.!@
(debug) Tt*A   p  %>#H
(debug) Tt<Cb5[H^3j0]o8gqXNW`Taj$P LSB\
% CURRENT DURATION: 1:57:00 of 6:00:00
(debug) Tt*A   ! %.C$
(debug) Tt<Cb5[HUS^'2IJF;V;00^ajb`J8/L
(debug) Tt5dep01:9  8C(?]_?@ V/@
(debug) Tt5dep01:9  8C(?]_?@ V/@
« Ctrl-C »
===== tivovbi 1.03 =====
programmed by mbm@linux.com
  =[tivo:root]-#
```

There you can see the hidden data that TiVo uses to break those Teleworld Paid Programs up into video clips. If you want to try it yourself, either try using tivovbi around 4:00 A.M. when it's recording, or instead see the "Hidden Recordings in Now Playing" section of Chapter 2 to make the hidden recordings on your TiVo visible. You can also see TiVo's iPreview data this way (which causes the "Press Thumbs-Up To Record" message that you sometimes see between HBO, NBC, and PBS broadcasts).

Starting/Stopping tivovbi

Aside from running tivovbi by hand as we just did, there are two other ways to start and stop it (both using your remote control). The more recent method is via TCS (see Chapter 8), which lets you start tivovbi by pressing "clear-5-clear" and stop it by pressing "5-5-clear". Since TCS lets you control multiple hacks, it's clearly the preferred method now (so that you don't have multiple programs trying to monitor remote control codes).

However, before there was TCS there was cctoggle, which is still an option for those not wanting to install all of TCS just to start/stop closed captioning. cctoggle was written by Josh Harding (TheAmigo on tivocommunity.com). If you installed the distribution from the accompanying CD-ROM as described in Chapter 4, cctoggle.tcl is already installed in /var/hack/bin/cctoggle.tcl. If not, you can download cctoggle_1.1.zip from this thread:

http://www.tivocommunity.com/tivo-vb/showthread.php?threadid=38739

Note that if you download it you'll need to edit it slightly to define the location of certain executables.

Once you've started cctoggle.tcl, it listens for remote-control codes pressed while you're watching a recorded program or live TV. Pressing Select will toggle whether tivovbi is running or not. Pressing Up toggles whether tivovbi is running with the -c1 or -c2 option. Finally, pressing Down toggles whether tivovbi uses a translucent background or a solid black background.

Caller-ID

This next hack is an example of something that sounds cool when you hear about it, but it's even cooler when it's working later on and you had forgotten about it. The idea is, use the caller-ID information that modems are able to receive, and display it on-screen. It sounds really cool, but that's nothing compared to the effect it actually has when you're watching a show, the phone rings, you look around for the phone, and then the name of the caller appears on your TV. Ignoring telemarketers just became a lot easier.

There are a few different flavors of this. DirecTiVo owners are lucky because the internal modems in DirecTiVos can actually support caller-ID. Software called elseed will run on a DirecTiVo and do the whole thing for you. Standalone users either have to try hooking up an external modem, or more easily can use software on their PC to use the PC's modem to fetch the data.[3] I'll describe that second option first because it applies to more users.

Note I shouldn't have to say this, but be aware that you need to subscribe to the caller-ID service from your phone company to get any caller-ID data. Furthermore, you have to have a modem that supports caller-ID—many "WinModems" do not.

YAC

YAC (which stands for Yet Another Caller-ID program) is a Windows-based server written by Jensen Harris (josquin on tivocommunity.com) that uses the modem in your PC to broadcast caller-ID info to listeners on your network. Thus, there are two components you need to install to use YAC: the server on your PC and a YAC listener on your TiVo.

If you installed the software distribution from the accompanying CD-ROM in Chapter 4, the yac listener is already installed on your TiVo as /var/hack/bin/yac. The YAC server is located on the CD-ROM under /cdrom/nonTiVoFiles/yac-0.16-win32.zip. Or, you can download the components from:

```
http://www.sunflowerhead.com/software/yac/yac-0.15-tivo.tar.gz
http://www.sunflowerhead.com/software/yac/yac-0.16-win32.zip
```

[3] Ok, actually there's a third option for brave standalone users with a steady hand, a soldering iron, and loved-ones considerate enough not to kill them if they screw something up. T. McNerney (ElectricLegs on tivocommunity.com) figured out that many of the chips actually do support caller-ID functionality, but that a few pins need to be jumpered and a resistor must be added to enable it. Two posts describing the instructions are:

```
http://www.tivocommunity.com/tivo-vb/showthread.php?postid=488985#post488985
http://www.tivocommunity.com/tivo-vb/showthread.php?postid=500155#post500155
```

Source code is available as well in the `/cdrom/doc/yac` directory, or from:

```
http://www.sunflowerhead.com/software/yac/yac-0.15-src-tivo.tar.gz
http://www.sunflowerhead.com/software/yac/yac-0.16-src-win32.zip
```

(The URL for the project is `http://www.sunflowerhead.com/software/yac` .)

The TiVo listener should be placed in `/var/hack/bin/yac` (and made executable via "`chmod 555 /var/hack/bin/yac`"). You probably want to start it after every reboot — either uncomment the `yac` entry in `/var/hack/etc/hacks_callfromrc.sysinit`, or add the line

```
/var/hack/bin/yac &
```

directly to `/etc/rc.d/rc.sysinit`.

That's the easy part. I won't go into installing your modem on Windows. If you're having problems, it might be better to go with an internal modem that's recognizable and has supported drivers. I went through two cheap modems that didn't work well before I just bought a U.S. Robotics Pro Modem for around $80, which installed pretty easily after I managed to uninstall the half-installed drivers from the other failed modem attempts.

Once you've installed your modem on your Windows machine, unpack the YAC server (`yac-0.16-win32.zip` from above) and run `setup.exe`. Walk through the various screens to install YAC server.

Then, start YAC by selecting Start ➜ Programs ➜ YAC ➜ YAC. In the taskbar's tray you should see a little cell-phone-like icon. The first time you start, you should get a dialog box that lets you select the modem to use. Click on the phone icon in the taskbar tray, and select Listeners from the resulting pop-up menu. Enter the IP address of your TiVo as one of the listeners. Be aware that the `yac-0.16-win32.zip` file installs the Windows YAC *listener* as well, so if you wanted to install YAC on another PC in your house you could add its IP address as well to send it caller-ID info.

From this window, you should be able to send a test message with the Test Listeners button (which simulates a fake call). Upon receiving calls, on your PC you should see something like Figure 9-12, and on your TiVo you should see something like Figure 9-13.

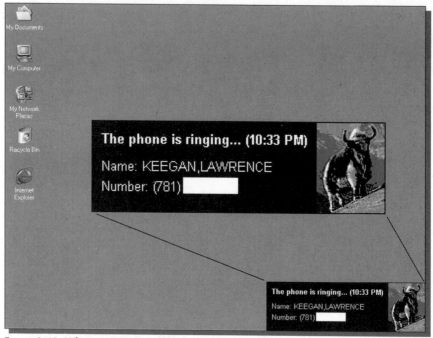

FIGURE **9-12:** What receiving a call looks like on your PC.

FIGURE **9-13:** What receiving a call looks like on your TiVo.

Congratulations, YAC server and listener are installed.

If you'd like to change the colors that YAC uses to display its info, you can specify them as arguments to the YAC listener when you call it. You can also specify for how long the text should remain on-screen. For instance, if you wanted a bright yellow background with black text, and liked 45 seconds instead of the default 20, you could have the call to yac be:

```
yac -f 13 -b 9 -t 45
```

The full usage string is shown in Listing 9-6.

Listing 9-6: Command-Line Arguments for yac Listener

```
=[tivo:root]-# yac -h
YAC 0.15: Yet Another Caller ID Program
Copyright (C) 2002 by Jensen Harris (jensen@sunflowerhead.com)
http://www.sunflowerhead.com/

Usage: yac [options]
Options:
    -f N    set foreground color to N [default 4]
    -b N    set background color to N [default 13]
    -t S    set time CID info is on screen [default 20 seconds]
    -p P    set port for yac to listen on [default 10629]
    -D      run yac in debug mode
    -h      show this help
=[tivo:root]-#
```

You can also set up Name Substitutions by clicking the phone icon then choosing . . . wait for it . . . Name Substitutions. This lets you map phone numbers to text names to use instead of what the phone company tells you. My wife's cell phone always comes back as KEEGAN, but I'd much rather see Laurie!!.

elsee*d*

As I mentioned earlier, DirecTiVo users have it easier than standalone users when it comes to caller-ID hacks: the built-in modem supports caller-ID. The caller-ID software that runs on a DirecTiVo is called elseed, by Greg Gardner (gregggreg on tivocommunity.com). With the 0.6.0 version, elseed can now even be set up to double as a YAC server, so that you can receive call notifications on your PC using a YAC client as well (see "YAC" earlier in this chapter).

Note

Some people have reported that elseed doesn't work for them, even though they have a DirecTiVo. Apparently, different modem chips may have been used in different instances of the same model TiVo. There's not much more to say on that subject than good luck, and if it doesn't work for you, you can always try YAC (see the previous "YAC" section).

If you installed the software distribution from the accompanying CD-ROM as described in Chapter 4, the files needed for `elseed` are already installed on your TiVo. If not, you can download `elseed-0.6.0-tar.gz` from:

`http://www.bah.org/~greg/tivo/elseed/elseed-0.6.0.tar.gz`

Unpack it and place `elseed` in `/var/hack/bin/elseed`, `elseed_forever.sh` in `/var/hack/bin/elseed_forever.sh`, and `elseed.conf.sample` in `/var/hack/etc/elseed.conf` (get rid of the ".sample").

You probably want to start it after every reboot. There are two ways to set up `elseed` to run: run it once by hand from some boot script (like `/var/hack/etc/hacks_callfromrc.sysinit` if you have that set up, or directly from `/etc/rc.d/rc.sysinit`), or instead start a shell script in its place that calls `elseed` repeatedly (with an `-e` flag causing it to exit after each phone call). Some people reported problems with only the first phone call working, so the `-e` option was thrown in as a quick fix until the problem can be solved. The installation in Chapter 4 set it up with the latter method (although you still need to go uncomment the line from `hacks_callfromrc.sysinit` that calls `elseed_forever.sh`). If you just downloaded `elseed`, either add:

`/var/hack/bin/elseed -c /var/hack/etc/elseed.conf &`

or

`/var/hack/bin/elseed_forever.sh -c /var/hack/etc/elseed.conf &`

Next, you need to edit `elseed`'s config file. The default contents of `/var/hack/etc/elseed.conf` are:

```
Map 4155551212 INFORMATION SERVICES
#YacClient 10.0.0.21
#YacClient 10.0.0.22:1024
```

(The second two lines are commented out with a '#', but kept for illustration purposes.)

Using lines similar to the first one, you can map phone numbers to text names to use instead of what the phone company tells you, just like using the Name Substitutions option in YAC above.

The lines below that are examples of how you can cause `elseed` to act as a YAC server — on each line you specify the IP address of a machine that's running a YAC listener. When a call comes in, `elseed` will send a message out to each of the YAC listeners listed there.

The resulting display of `elseed` looks similar to Figure 9-13. If you set up a YAC listener on your PC as well, it will obviously look like Figure 9-12.

Like the TiVo yac client discussed previously, `elseed` also lets you set the colors used and the amount of time the message is displayed on-screen. It also however lets you specify *where* on the screen to draw the message, which is particularly useful when you're looking at a small TV that chops off the top of the screen. The full usage string for `elseed` is shown in Listing 9-7.

Listing 9-7: Command-Line Arguments for elseed

```
=[tivo:root]-# elseed -h
elseed version 0.6.0 by Greg Gardner
Usage: elseed [options]
Options:
    -x N    set x coordinate to N [default 0]
    -y N    set y coordinate to N [default 1]
    -f N    set foreground color to N [default 4]
    -b N    set background color to N [default 13]
    -d S    set modem device to S [default '/dev/cua1']
    -i S    set modem init string to S [default 'AT+VCID=1']
    -l S    set log file to S [default '/var/log/elseed.log']
    -c S    set conf file to S [default '/etc/elseed.conf']
    -t S    set time CID info is on screen in secs [default 10 seconds]
    -v S    set delay for reading from modem in tenths of a sec [default 5]
    -z S    set YAC connect timeout in milliseconds [default 150]
    -e      exit after displaying caller-id info [default is off]
    -n      tells elseed not to look for the caller's name [default is off]
    -M      turn off modem sharing [default is on]
    -D      put elseed in debug mode
    -h      show this help
=[tivo:root]-#
```

One last item: You *can* connect an external modem (that supports caller-ID) to your standalone TiVo and use the -d option to use that modem instead of the internal one. This lets you run elseed without requiring that a computer be running. I came this close (holding fingers really close together) to going out to buy an external modem to try this with, but alas, I did not — YAC works really well, and I always have a computer running. If you try this, you need to make sure you're not using the serial port for anything else (like a bash prompt or PPP connection), and that you've adjusted your modem init string appropriately for your modem with "-i".

ncid

Linux users who own standalone TiVos might seem a bit exasperated by now. Fear not, everything is ok, there is a solution.[4]

[4] Technically, the tool we're about to talk about is supposed to work on MacOS X as well. Unfortunately, you have to compile it yourself, and it doesn't compile cleanly. MacOS X users are on their own, but you're welcome along for the ride, because if you do feel like getting the compile and install to work, all of the rest of the steps should be similar. I figured I'd rather give you the heads up that it's supposed to be supported than leave you in the cold, but don't let me lead you on — it's not as trivial as it should be.

Network Caller ID (ncid) is a package containing a server for your Linux box (ncidd), and a TiVo client (called tivocid, although it's just a symbolic link to an executable called ncid). It was written by John L. Chmielewski (jlc on tivocommunity.com). This has been around for a while, but it still works. There are Tcl-based versions of the client program "ncid" for Linux/Windows/MacOS that let you see the caller-ID messages from your computer as well, but I'm going to focus on just getting ncidd and tivocid/ncid installed here.

You might still get a bit exasperated if you choose to download it yourself. I did, enough that I'm breaking this up into sections so you can skip stuff.

Downloading the ncid Components

If you *do* want to download it yourself (it *is* on the CD-ROM you know), read on. Otherwise skip ahead to the "Installing tivocid" section.

Still here? The page you start at is:

```
http://ncid.sourceforge.net
```

that leads you to

```
http://sourceforge.net/projects/ncid/
```

which leads you to

```
http://sourceforge.net/project/showfiles.php?group_id=80586
```

From here, there are three important files available for download:

```
http://prdownloads.sourceforge.net/ncid/out2osd-0.6.tivo.tgz?download
http://prdownloads.sourceforge.net/ncid/ncid-0.12.tivo.tgz?download
http://prdownloads.sourceforge.net/ncid/ncid-0.12-1.i386.rpm?download
```

You want to download the first two, and you want the third one as well if you're running Red Hat Linux. If you're running MacOS X and want to try getting ncidd to compile, then you'll need to grab the source code instead and build it. That code is located at:

```
http://prdownloads.sourceforge.net/ncid/ncid-0.12.tar.gz?download
```

If you felt you haven't spent enough time downloading things, you can grab the source code to out2osd at:

```
http://prdownloads.sourceforge.net/ncid/out2osd-0.6.tar.gz?download
```

and a Windows client at:

```
http://prdownloads.sourceforge.net/ncid/ncid-0.12.zip?download
```

It's not going to get any less tedious, sorry.

Installing tivocid

Good news for those who did the installation of the software distribution that's on the accompanying CD-ROM as described in Chapter 4 — you already have tivocid installed. You're welcome. Ok, for the rest of you, here we go.

Unpack `ncid-0.12.tivo.tgz`. You'll find a `hack` directory with a bunch of subdirectories in it. Move the contents of `hack/bin` into `/var/hack/bin` on your TiVo. Move the contents of `hack/etc` into `/var/hack/etc` on your TiVo. Move the contents of `hack/sbin` into `/var/hack/bin` on your TiVo. And move the contents of `hack/var` into `/var/hack/log` on your TiVo. There is documentation under `hack/doc` (that the lucky CD-ROM users have located under `/cdrom/doc/ncid/ncid-0.12.tivo`).

Run the following commands to make sure that the executables are executable:

```
chmod 555 /var/hack/bin/cidalias
chmod 555 /var/hack/bin/cidlog
chmod 555 /var/hack/bin/cidlogupd
chmod 555 /var/hack/bin/ncid
chmod 555 /var/hack/bin/ndidd
```

Create a symbolic link called `tivocid` that points at `ncid`, with:

```
cd /var/hack/bin; ln -s ncid tivocid
```

One big step down, two to go.

Installing out2osd

Next we install the program called `out2osd`, which draws text on the screen. Yep, another draw-text-on-screen program — this one supports a resolution of 33×16. It lets you use a configuration file to determine what colors to use, where on the screen to draw the text, and how long to draw it; you can still specify these things via command-line arguments as well.

Once again, if you did Chapter 4, you have out2osd already installed and maybe just want to edit the config file as described below. Otherwise skip ahead to "Installing ncidd on Your Computer."

Unpack `out2osd-0.6.tivo.tgz`. Once again you'll find a `hack` directory with a bunch of subdirectories in it. Move the contents of `hack/bin` into `/var/hack/bin` on your TiVo. Move the contents of `hack/etc` into `/var/hack/etc` on your TiVo. There is documentation under `hack/doc` that exists on the CD-ROM under `/cdrom/doc/ncid/out2osd-0.6`.

Make sure out2osd is executable via: "`chmod 555 /var/hack/bin/out2osd`".

If you'd like to change where text will be displayed on screen (or what color it will be, or for how long it will be displayed), edit `/var/hack/etc/out2osd.conf`.

Installing ncidd on Your Computer

If you're using Red Hat Linux, you can install `ncidd` (and an `ncid` client) with one line. Become root and type:

```
rpm -i ncid-0.12-1.i386.rpm
```

Then all you need to do is edit `/etc/ncidd.conf` to reflect the device of your modem. For instance, in my case I added the line:

```
set modem = /dev/ttyS4
```

If you don't know the device of your modem, there is a lot of documentation out there on how to set up your modem on Linux — I won't be covering that here. I will throw a few scraps at you though: Since my internal modem was a PCI card, I ran "lspci -vv" (as instructed in the MODEM HOWTO document, which is easily found with any search engine) to determine the IRQ setting for my U.S. Robotics modem — in my case, it was IRQ 10. I looked through the output of the "dmesg" command (to see text that was printed when the machine booted up), and found the line "ttyS4 at port 0xe800 (irq = 10) is a 16550A", from which I figured out that my modem is /dev/ttyS4. I could also have done a "set serial -g /dev/ttyS*" to figure out the same thing.

While you're editing that file, you can also add aliases (similar to name substitutions above) such as:

```
alias NAME KEEGAN = "Laurie!!!"
alias NMBR "9785551212" = "7815551213"
```

The second line is a bizarre feature that also lets you substitute the *phone number* displayed with another number or string. (Don't get any ideas about using this to hide an affair. TiVo couples are supposed to be happy people. Stay together!)

Anyway, once that's set up, you can start ncidd either by rebooting your machine, or by becoming root and running /etc/init.d/ncidd restart.

MacOS X users, again, sorry but you're on your own. If you succeed, post it on the forums so others can benefit from your completed work.

Using tivocid / ncidd

To test that you have the tivocid (ncid) listener client and the ncidd server both set up correctly, start ncidd (as described above), and then run the tivocid executable with the -v (verbose) argument. Listing 9-8 shows an example of what this should look like — substitute in the IP address of the machine your ncidd server is running on. If you see the "Network CallerID Client Version 0.12" string then the connection between client and server worked. Try calling yourself (from a cell phone, or have a friend call you); those calls should then appear in the output (as shown here), as well as on your TV screen.

Listing 9-8: Running tivocid with "-V" to Verify the Connection

```
=[tivo:root]-# tivocid -V 192.168.1.2
Connecting to 192.168.1.2:3333
Network CallerID Client Version 0.12
Network CallerID Server Version 0.12
06/20/2003 17:57 (978)XXX-XXXX KEEGAN
06/20/2003 17:57 OUT-OF-AREA OUT-OF-AREA

« Ctrl-C »
  =[tivo:root]-#
```

You always need to specify the IP address of your `ncidd` server, but you usually won't use the verbose option. Put the following lines in whatever boot-up script you use, whether it be `/var/hack/etc/hacks_callfromrc.sysinit` or `/etc/rc.d/rc.sysinit` itself:

```
if test -x /var/hack/bin/tivocid
then
   /var/hack/bin/tivocid 192.168.1.2 &
fi
```

(Again, substitute the IP address of *your* `ncidd` server for the one in my example.)

Even More about ncid

Though I'm not crazy about how much setup is necessary for it to work (especially compared to other solutions), `ncid` *does* do its job. Plus, if the only machine you leave on 24 hours a day is your Linux box, then it's the only game in town. It's also worth mentioning that an `ncidd` daemon compiled for your TiVo is part of what we just installed too — in theory you can take an external modem, connect it to your TiVo, and run the `ncidd` daemon directly on your TiVo (as you can with `elseed`). Have fun.

GAIM

IM (Instant Messaging) allows two or more people to do at least two things: see who is "online", and send text messages back and forth to each other immediately. From a usage point of view, IM is to email as a phone call is to a written letter; the former are informal and quick, while the latter are more "weighty" and usually demand more justification. There is a huge benefit to being able to send a quick meaningless greeting/thought/jab that would otherwise seem not worth a full email message.

The other main benefit though is that you know the other person is seeing what you type, *as you type it*, because they are online right then. Well, that's how it was for a while anyway — you used to be able to tell if someone was there. These days, many of us leave our computers on 24 hours a day, and often leave ourselves logged in to our IM clients constantly as well. Now seeing "who's on" isn't as clear cut — you usually have to ask first ("there?"). This is good and bad; good in the sense that we can still send quick messages that aren't deserving of a full-blown email message, and bad in that the whole idea of knowing that someone is actually there has been blurred.

Well, that part has just gotten blurrier. Here we discuss a plug-in to the GAIM Instant Messenger client that sends instant messages you receive (as well as "Laurie has logged on!" notifications) to your television set. This might lead to the IM equivalent of people screaming "Hey, pick up!" into phone answering machines, expecting that the person on the other end might just be watching TV but still able to see. But there still is a benefit to the user of the plug-in — we've all ignored our answering machines from time to time, but it's still nice to know who is calling when we do. And for the person on the other end of that IM, it's still just as satisfying, even if he'll be seeing that on his TV instead of his computer.

Enough waxing philosophical about whether it will be useful and/or alter your relationships with the people in your lives for the better or worse; let's get on to the details!

The GAIM Instant Messaging client lets you log in to multiple IM networks simultaneously; you can be logged in to your AOL Instant Messenger, ICQ, Yahoo! Messenger, MSN Messenger, Jabber, and IRC accounts all at the same time. First you should install GAIM, log in, and make sure it's working. Then, work on installing the gaim2tivo plug-in to send those messages to your TV as well.

Installing GAIM and gaim2tivo

Getting this all working involves installing software in two places — on your PC and on your TiVo. You install GAIM on your PC (there are Linux and Windows versions available, but don't get your hopes up Windows users — read on). Then you install the gaim2tivo plug-in, which is actually made up of two pieces as well: tivo_messenger (yet another text-drawing program that goes on your TiVo), and the gaim2tivo plug-in itself, which goes on your PC along with GAIM. The Windows version of the gaim2tivo plug-in is described as being in the "alpha" stage — it didn't work for me at all, and sadly I won't be describing it here. Perhaps a Windows version of the plug-in that works is out there by the time you are reading this. For more info, check out the gaim2tivo thread on dealdatabase.com:

```
http://dealdatabase.com/forum/showthread.php?threadid=14453
```

and the plugins page for Gaim:

```
http://sourceforge.net/tracker/?atid=390395&group_id=235&func=browse
```

At the time of this writing, even the Linux version of the gaim2tivo plug-in is pretty finicky about which version of GAIM it will work with. I'll describe the installation procedures for GAIM and gaim2tivo, but be aware that the specific versions I mention were the only ones I was able to get to work together.

Version 0.3.1 of gaim2tivo was originally advertised as only working on an *alpha* version of GAIM 0.60. As it turns out, gaim2tivo 0.3.1 doesn't even work with the release version. Another user on tivocommunity.com later posted changes to gaim2tivo.c (and a compiled gaim2tivo.so) that lets it work with the final release of GAIM 0.60. I also tried both versions of the plug-in with GAIM 0.64, and they did *not* work. Perhaps by the time you're reading this there will be a newer version that works great — until then, I've included the versions of GAIM (and of gaim2tivo) that *do* work together, both on the accompanying CD-ROM and in the form of URLs below.

For people who want to download pieces on their own, there are files you need to download:

```
gaim2tivo-0.3.1.tar.zip:
   http://dealdatabase.com/forum/attachment.php?postid=67006
```

Fixed versions of gaim2tivo.c and gaim2tivo.so:

```
   http://www.geekandproud.net/stuff/gaim2tivo.c
   http://www.geekandproud.net/stuff/gaim2tivo.so
```

GAIM 0.60 rpm for Red Hat Linux:

```
   http://prdownloads.sourceforge.net/gaim/gaim-0.60-3.i386.rpm?download
```

GAIM 0.60 source code rpm for Red Hat Linux (optional):

```
   http://prdownloads.sourceforge.net/gaim/gaim-0.60-3.src.rpm?download
```

`gtkspell-2.0.4-fr1.i386.rpm` (which you might need). All on one line:

```
ftp://rpmfind.net/linux/freshrpms/redhat/8.0/
   gtkspell/gtkspell-2.0.4-fr1.i386.rpm
```

First we'll install GAIM. Users wanting to use the files on the accompanying CD-ROM can find the GAIM rpm at:

```
/cdrom/nonTiVoFiles/gaim-0.60-3.i386.rpm
```

Become root, and then install GAIM via:

```
rpm -i gaim-0.60-3.i386.rpm
```

If you have an older version of GAIM installed already, you'll have to upgrade instead:

```
rpm -U gaim-0.60-3.i386.rpm
```

If you have a newer version of GAIM installed, and really want to get `gaim2tivo` to work, you can either go research and experiment on your own to see if there are newer versions that are compatible, or you can downgrade your current GAIM installation with:

```
rpm -U --oldpackage gaim-0.60-3.i386.rpm
```

If you run into an error saying you need `gtkspell` installed, you can install that as well the same way—a copy of `gtkspell-2.0.4-fr1.i386.rpm` is on the CD-ROM at:

```
/cdrom/nonTiVoFiles/gtkspell-2.0.4-fr1.i386.rpm
```

Once GAIM is installed, you should be able to test out the basic installation by typing "`gaim`" (make sure your DISPLAY environment variable is set to a valid X Server, since `gaim` is an X Windows client). You should get a window that looks like Figure 9-14. Try logging in with one of your existing IM accounts, and make sure that it works. Once you've got GAIM installed, quit the application—it's time to install the `gaim2tivo` plug-in.

FIGURE 9-14: GAIM Login window (Linux).

Users who decided to download gaim2tivo-0.3.1.tar.zip should unpack it, find the file tivo_messenger within it, and put that on their TiVo as /var/hack/bin/tivo_messenger (make sure that it's executable with the command "chmod 555 /var/hack/bin/tivo_messenger"). If you did the installation in Chapter 4, then it's already there on your TiVo.

Make sure tivo_messenger is set to start up after every reboot. If you did the installation described in Chapter 4, then just make sure the lines in /var/hack/etc/hacks_callfromrc.sysinit that start tivo_messenger are not commented out. If not, add the following lines to whatever boot-up script you use:

```
if test -x /var/hack/bin/tivo_messenger
then
  /var/hack/bin/tivo_messenger > /dev/null 2> /dev/null &
fi
```

Either start tivo_messenger now by hand, or reboot your TiVo.

Now, you need to put gaim2tivo.so in /usr/lib/gaim/gaim2tivo.so on your Linux box; however, remember that as I described above, the version that came in gaim2tivo-0.3.1.tar.zip actually doesn't work. So, instead copy either the "fixed version" you downloaded from the URL above, or the fixed version from the accompanying CD-ROM at

/cdrom/doc/gaim2tivo-0.3.1/FIXEDSRC/gaim2tivo.so

to your Linux box's /usr/lib/gaim directory.

Start GAIM again (type "gaim" on your Linux box), and click the Preferences button on the login window (it's also available once you've logged in via a menu option). A preferences window should come up looking like Figure 9-15. If it doesn't have "Gaim2Tivo Message Relayer" as one of the plug-ins on the right (as in Figure 9-14), then go back and double-check that you used the right version of GAIM and of gaim2tivo.so.

FIGURE 9-15: GAIM's Plugins section in the Preferences window (Linux).

Click the checkbox next to "Gaim2Tivo Message Relayer" to enable it. On the gaim2tivo plug-in page (see Figure 9-16), enter the IP address of your TiVo, then click Save. Other useful options on this page include the ability to truncate screennames to two characters (to save precious screen real estate for the messages themselves), and the ability to limit which users' text get sent to your TiVo.

FIGURE 9-16: gaim2tivo's plugin preference page (Linux).

Close the Preferences window, then log in.

Using GAIM and gaim2tivo

When someone sends you a message, you should receive a chat window for the user as usual (see Figure 9-17), but the message should also appear on your TV screen (see Figure 9-18). When users log on and off, notifications such as "GAIM: foobar555 just departed!" and "GAIM: foobar555 just arrived!" are displayed as well.

 Caution While you have the plug-in enabled, all IM chats you're having will be displayed on your television set. If you're one of the alluded-to-in-this-chapter people who cheat on your significant other and you've skated by this far, don't trip up here. Then again, go get caught, you're giving the rest of us TiVo owners a bad name: stop cheating!

FIGURE 9-17: GAIM Chat window — message received (Linux).

FIGURE 9-18: Display on-screen: GAIM message received.

Video Extraction (and Insertion)

When you made the switch over to TiVo you gave something up: removable storage. Almost everyone brings this up as their first concern, and after a few minutes of hearing about what TiVo can actually do, the benefits of what TiVo gives you far outweigh that loss. Our concern over being able to archive shows is quelled by a two-pronged argument: first, you can save recordings to videotape via the Save-to-VCR feature, and second, you won't want to save recordings to tape anymore anyway.

While these are both true, let's be fair and admit that there's a new problem that gets introduced: we become spoiled! TiVo's navigation (fast-forward/ rewind at three speeds each, instant replay, skip-to-live, and skip-to-tick, combined with the play-bar and overshoot correction) is *so* much better than using a VCR that most of us laugh or cringe when forced to actually use a VCR again. TiVo's fast-forwarding/rewind speed and slickness makes VCR operation seem like doing brain surgery while wearing mittens. It doesn't take long for you to realize that when you move something to tape, you've basically excluded that video from the wonderful world of TiVo that you've just bought into. If you do dump something to tape, it's to give to a friend, or because it's something you *really* don't want to lose.

And that's where the problem gets worse. The things that we care about the most either:

➤ Eat up precious space on our TiVo's hard drive forever

➤ Get saved to videotape, where we'll never watch them because using a VCR is now painfully slow and clumsy

➤ Do both: take up precious space for easy access, and get saved to VCR in case they're accidentally deleted or your TiVo's hard drive dies someday

As if all that wasn't enough, if you want to save an hour-long show to videotape, *you can't watch TiVo for an hour*. The device that has us blown away with the ability to record one show while watching another recorded show doesn't let us watch anything while dumping to tape, because it can't. Even if they had gone to the trouble to design it such that it could (with an extra MPEG decoder, another pair of audio and video encoders, and special audio/video output jacks just for the VCR), the feature would *still* go relatively unused because it involves inserting a video tape, choosing Save to VCR, pressing Record on the VCR at the right time, and then coming back an hour later to press Stop and take the tape out.

All that having been said, going back to using a VCR simply isn't an option. Anyone who has owned a TiVo will violently object to that idea — it's absurd. So we accept not needing to archive recordings that often. One solution is to add more space to your TiVo so it can hold more, as we did in Chapter 3. That way, you still have everything at your fingertips for easy access and can navigate through it as fast as you want. This works with two caveats:

1. By keeping *all* of your important video on your TiVo, you are raising the stakes in the betting game you have going on the life of your TiVo's hard drive. Luckily, since you're reading this book, you will be able to extend the life of your TiVo beyond the life of its original drives by using the backup you made in Chapter 3; that backup didn't contain video however, so your prized recordings would be lost.

2. There's only so much you can do to grow your TiVo. As we talked about in Chapter 3, you can't use more than 137 GB of any one hard drive without doing a risky kernel modification, and you can only have two drives. That might not seem like a problem, but once you're used to having the space you enjoy a whole new set of freedoms:

 - Recording everything at High or Best quality (for standalone users).

 - Recording entire seasons of television shows. (Some shows lend themselves well to this; Alias and 24 are good examples of shows where an episode caused Laurie and I to debate something that happened earlier in the season — all we had to do to resolve it was go back and watch the episode.)

 - Suggestions are great when there's tons of disk space, as there are more of TiVo's guesses to pick from.

So what's the solution? It's is a combination of two types of hacks: video extraction, and video insertion. Video extraction utilities let you copy recordings from your TiVo onto your PC. From there you have two options: burn the video to a removable storage medium (such as a Video CD [VCD] or DVD), or keep the video around such that it can be inserted back into your TiVo at a later date with video-insertion tools.

With mfs-ftp (which at the time of this writing is the most complete of the video insertion tools), you essentially have the ability to "eject" a recording (into a file) and later re-insert it any time you want. And even better than a VCR, when you insert it, it stays around as long as you want; it's a regular item in your Now Playing list that you can mark as Save Until I Delete, or leave for your TiVo to expire on its own like a regular recording.

(If you have lots of spare cash lying around, another solution is to buy Pioneer's new TiVo model with a DVD burner; it's a Series2 unit so hacking is more difficult, but the features seem pretty nice. Press releases had this unit coming out in the fall of 2003.)

I've wrestled with what order this chapter should be in; should I talk about the most recent and useful stuff up front and then cover the older approaches, or should I build up from the earliest to the latest? I've decided to go with the latter, though I will talk first about various file formats that are important, so if you're one to skip around be sure to check it out first. If you're reading this in order (which I recommend), just be aware that things do get easier — you might want to finish reading through the chapter before you start trying things out.

There is one other point I want to bring up here: I'm describing these tools for use on a Series1 standalone TiVo. These old TiVos have no video scrambling — video is simply stored on the MFS Media Region of the disk, and extraction tools read the video from the correct locations.

Series1 DirecTiVos and Series2 TiVos now actually scramble the video. For legal reasons, I won't be describing any methods of defeating the video scrambling that these other TiVo units do. Again, consider these instructions for Series1 standalone TiVos.

The Formats

There are various file formats you need to know about before using any of these tools.

MPEG

MPEG stands for Moving Picture Experts Group. It encompasses several related formats, all describing audio and video. The formats within it that are relevant to us include the MPEG-2 audio and video elemental formats.

tyStream (.ty Files)

TiVo stores recordings in the Media Region of its MFS database (we talk about MFS in Chapter 13). It stores these recordings in its own format, a `tyStream` object. This stream (which represents either a complete recording or a portion of a recording) contains within it both MPEG-2 audio and MPEG-2 video.

All of the video extraction tools fetch these tyStreams from disk. `.ty` files generated by some tools (including early versions of TyTool's `tserver`) omitted some data that was originally thought unimportant; lack of this data prevents re-insertion of the video. Be careful when deciding which tools to extract video with (I'll provide warnings when describing affected tools).

Tivo Media Format (.tmf Files)

With some recordings consisting of multiple `.ty` files, it was becoming unwieldy to name and store them as individual files. That combined with a desire to have metadata about the recordings (such as the title, actor list, description, etc) prompted the creation of the TiVo Media Format (`.tmf`) by several TiVo hackers. A `.tmf` file is basically a `tar` file whose first entry is an XML file called `showing.xml` and whose remaining entries are the `.ty` files that make up a recording.

At the time of this writing, the only tool that uses `.tmf` files directly is `mfs-ftp`. Since a `.tmf` file is just a `tar` file, you can still remove the individual `.ty` files from within it for use with other tools.

Note that other tools handled multiple `.ty` files by concatenating them all together into one large `.ty` file. It's easy to convert a `.tmf` file to one large `.ty` file: rename the `.tmf` file's `.tmf` extension to `.tar`, extract all of the files with the `tar` utility, and concatenate the `.ty` files together in order. The metadata contained in the file `showing.xml` has no place in a `.ty` file, but it does have a place in a `.ty+` file (see next section).

.ty+ Files

Since the existing tools handled `.ty` files but not `.tmf` files yet, a new format was created called `.ty+` that consists of a normal `.ty` file with 512 #'s appended to it, followed by what would

have been the contents of showing.xml if this had been a .tmf file, followed by another 512 #'s. This metadata being appended to a .ty file doesn't interfere with the existing tools' ability to read and handle the file, yet it still preserves the metadata for use later by other tools.

It's worth noting that the creator of the .ty+ format (Riley Cassel, rc3105 on dealdatabase.com[1]), has stopped referring to .ty+ files with the + at all, and now just calls them .ty files. His rationale was that the existing .ty-handling tools don't have a problem with the additional data appended to the end of the file, so it was good enough to just call them .ty files. If you start playing with several extraction utilities, be aware of what files you are extracting, lest you think you have the necessary metadata to reinsert when you actually don't. It may be a good idea to call them .ty+ files after all.

.tyx Files

The idea behind a .tyx file is basically that it's still a tar file like .tmf, but it also contains some extra header info that facilitates the streaming of insertions. These make the file slightly larger but make it easier to write an insertion tool that lets you view a recording as it's being inserted into your TiVo. At the time of this writing, .tyx files aren't being used much; time will tell if their use will become more frequent.

Video CD (VCD)

Video CD (VCD) is a movie format geared towards storing video on CDs. It's based on the MPEG-1 video standard. The video quality of a VCD is about the same as that of a VCR, at a resolution of 352 × 240. Many DVD players play Video CD discs, and many people use them because a pile of blank CD-ROMs is cheaper than blank DVD media. Around 70 minutes of audio/video can be stored on one VCD disc.

DVD

The video format used in DVDs is MPEG-2. Unlike the lesser-quality VCD format, DVDs have a resolution of 720 × 480. Unfortunately there are *six* different types of writable DVD media:

- DVD-R for General
- DVD-R for Authoring
- DVD-RAM
- DVD-RW
- DVD+RW
- DVD+R

[1] Whereas throughout the rest of the book I use tivocommunity.com as sort a name registry for people (jkeegan on tivocommunity.com, etc.), in this chapter I'll use dealdatabase.com instead (unless the user actually doesn't have an account there). This is done merely to stress the fact that the topic of video extraction is not allowed on tivocommunity.com; plus it's where most of the people mentioned in this chapter spend most of their online time these days.

DVD-R for General is the format used in the SuperDrive on Macintoshes. It breaks down like this: DVD-R (both for General and for Authoring) and DVD-RW are on one side of the fence, while DVD+R and DVD+RW are on the other, with both sides competing (DVD-RAM kind of sits on the sidelines). Just like the industry battle that brought us record players that played at 33, 45, and 78 rpm speeds, this war will similarly create the need for DVD players to accommodate many (very similar) formats, just because people can't agree on a format. Anyway, as you can probably guess by the names, DVD-R (both types) and DVD+R can record once onto a drive, whereas the rest let you write data onto a disc over and over.

Note

Now is as good a place as any to mention that it's possible to instruct your TiVo to record at a different resolution and bitrate so that the MPEG streams are already at SVCD- or DVD-compliant resolutions when extracted. The Resource Editor in TivoWeb (see Chapter 7) contains resources that control just that (under the Bitrate sub-menu). You basically sacrifice one of your recording qualities, and change that quality's resolution and bitrate to be compliant with your desired output (SVCD or DVD). Obviously be very careful—you don't want to go changing settings like this on a whim and forget about them, then wonder for years why everything you're recording at "Basic" quality is of different quality than it should be. A Google search for 'tivo "resource editor" bitrate' will bring up more info on this if you're curious.

The Tools

There have been many tools relevant to this chapter, and unfortunately I don't have space to write about all of them here. Instead, I've chosen to describe some of the most relevant ones out there today, and just a few of the earliest endeavors. For instance, Andrew Tridgell wrote video-extraction tools long ago. He talked to TiVo about them, and they asked him to hold off releasing them for a while, and then others came along and developed their own extraction tools and released them. After the other tools had been released, Tridge finally released his. I'm not even spending time talking about Tridge's `vplay` tool (well, not more time than I just did).

If you're interested in the history of video-extraction/insertion tools, check out dealdatabase.com for more info. In fact, I urge you to consult the forum anyway when you're done with this chapter, because the development of extraction tools has been rather fast-paced, and you'll want to read up on the latest updates.

ExtractStream

"Alex" (d18c7db on dealdatabase.com) released a program called PlayStream. First you had to shut down TiVo's user interface by killing myworld (there's a backdoor in Chapter 2 that does it—Clear-Enter-Clear-ThumbsDown). Then, you'd call PlayStream and pass it the fsid of a tyStream; it would read that tyStream (containing audio and video) from disk, and send it directly to the correct chips in your TiVo so the video/audio would play on-screen. This was cool from a playing-around-with-the-machine perspective, but it wasn't of much value to your average Joe user.

Five months later, ExtractStream was released by Nick Hull (who was nickhull on tivocommunity .com until his account was revoked for announcing it there). It performed the same functions as PlayStream, except that it also let you dump the tyStream to standard output. ExtractStream was

the first publicly released video-extraction tool for the TiVo, and within a day the thread describing it was removed from tivocommunity.com by the moderator David Bott (see Appendix A for more information about the various forums and what is allowed where), which started the rule that you can't talk about video extraction at tivocommunity.com.

Tangent: How Small Backups and Video Extraction Were Briefly Related

Before MFS tools, backups of hard drives took up a lot of space. People used to back up their TiVo's hard drives by buying another hard drive of the same size and running the Unix command dd to copy the disk byte for byte. However if you had a large drive lying around, you could dd into a file instead of onto another disk — but it would still be a 15-GB or 30-GB file (depending on your drive size). That file wasn't compressed though, it was just an exact image of the drive — so if you then compressed the file, it would get considerably smaller. How much smaller depended on what was on your hard drive — if you had a drive full of recordings, forget it, it wouldn't compress much at all.

People (myself included) went looking for "virgin" TiVo drives that had never been booted and that had never had any video on them. If you could back up one of those drives and compress that, perhaps you'd achieve the holy grail of the time — a backup small enough to fit on a CD-ROM. You couldn't just wipe out the video partition, because you needed to know how to do that and keep MFS consistent. People tried recording several hours worth of a blank (black) video signal so that perhaps it would compress better.

When PlayStream 0.1b was released, "Alex" (d18c7db on dealdatabase.com) hinted in the documentation that it wouldn't be difficult to create a tool to allow very small backups. One could modify the code that currently *retrieves* audio/video bytes from tyStreams to instead *modify* those bytes, zeroing them all out. This would preserve the structure of the MFS database itself, while blanking out the video.

When ExtractStream was released 5 months later, Trevor Heartfield (TiVoMad on dealdatabase.com) got Nick Hull's permission and modified it to create and release ZapStream. Given a tyStream's fsid, it would zero out the stream as Alex had originally suggested. People went back to the practice of erasing all video on their hard drive through TiVo's UI and starting a 14-hour long recording, except that they made no effort to record blank video. Zapping this stream (as well as any live recording streams) then backing up and compressing the hard drive resulted in a backup small enough to fit on a CD-ROM!

Two months later, mfstools was released. With mfstools at our disposal now, creating a backup that fits on a CD-ROM hardly seems like an impressive feat anymore. Back then however, it was what we'd all been waiting for.

ExtractStream shipped with four files:

1. The `ExtractStream` tool itself

2. A multiplexer tool called `mplex` that combined the MPEG-2 audio and MPEG-2 video streams into a MPEG-2 "program" stream

3. A modified version of httpd.tcl (Stephen Rothwell's early SFR web server, which TivoWeb would later be based on) that output which tyStreams make up a given recording

4. A popular program called netcat (`nc`) that let you stream arbitrary data over a socket connection

Descriptions of how ExtractStream worked are on the accompanying CD-ROM under `/cdrom/doc/ExtractStream/doc/extract-stream.htm`, and on the web at:

`http://www.9thtee.com/extractstream.html`

You could use `netcat` to stream the video, or save the video to a remote filesystem via NFS. Early approaches had you combining the audio and video streams on the TiVo with mplex, then transmitting that; later approaches using `netmplex` would stream data across the web and do the multiplexing on your PC.

The instructions also made mention of the ability to *not* split the tyStream up into the MPEG-2 audio and video streams, but rather to keep it intact. It suggested this might be useful for re-insertion someday: "We don't know how to restore the files yet, but we can at least archive them."

ExtractStream opened the door; people could actually move recordings off of their TiVos, to be kept on their PCs or burned to some variety of disc. It was cumbersome and involved many steps, but the door was open.

TyTool

TyTool was written by jdiner on dealdatabase.com. It is similar in design to an earlier tool called TivoApp by Gary Williams (garyw90 on dealdatabase.com). TyTool is made up of a server that sits on your TiVo and a Windows client that runs on your PC. The client program is implemented as a Windows dialog app, and as such it's a bit rough on the edges eye-candy-wise, but that doesn't seem to have been the design goal. What TyTool does for you is to let you easily pull tyStreams from your TiVo over onto your PC, where you can either store them as a `.ty` file, have them split up into MPEG-2 audio/video streams, or have them multiplexed into a playable MPEG file.

 Caution Video-extraction tools were around for a while before people figured out how to re-insert video into their TiVos. As such, early versions of TyTool's server component "tserver" were omitting the master chunk of data during tyStream extraction—this data wasn't necessary if your goal was to burn to VCD or DVD, but it turns out it was very important for video insertion. Be careful what version of TyTool you use to extract video, especially if you think you may ever want to re-insert it.

Once you've installed the server on your TiVo and started the client on your PC, clicking `Refresh` fetches your Now Playing list to let you select a recording to fetch (see Figure 10-1).

FIGURE 10-1: TyTool client displaying Now Showing list to choose from.

Before you click the Get button in the lower corner, you want to choose how you'd like this recording to be stored on your hard drive. From the File menu (see Figure 10-2) you can choose TyStream Mode to save it as a .ty file, VSplit Mode to split it into MPEG-2 audio and video streams via the vsplit command, or MultiPlex Mode to have it multiplexed into a playable MPEG file. The Options menu also has some important preferences used during conversions.

Once you click Get, the recording will be fetched from your TiVo and placed in the directory that you've specified in the Local Dir: field at the top of the window. If you don't want to fetch all of a particularly long program, you can click Get Parts instead (which will let you select which individual tyStreams from a recording to download).

You do have the ability to edit out portions of the video, but how you go about it is a little drawn out. First you choose Make Key File(s) from the File menu, which lets you select one or more .ty files from a non-standard open-file dialog. That generates one or more key files; now choose Edit KeyFiles(s) to get the same strange open-file dialog again, and select the newly made key file. This will launch GOPEditor, a separate executable (that ships with TyTool).

GOPEditor lets you edit video on Group-Of-Picture (GOP) boundaries; you can't edit frame by frame, but you can get within a half a second or so of your intended cut. You use the "[" and "]" buttons to start and stop cut sequences, which you then add to the cut-list with the Add Cut button. On the left side of the window, you can see the video itself, and you can move around with the slider control on the right or via the keyboard. Figure 10-3 shows the GOPEditor; note that the video displayed isn't the right aspect ratio — it's scrunched into a square display.

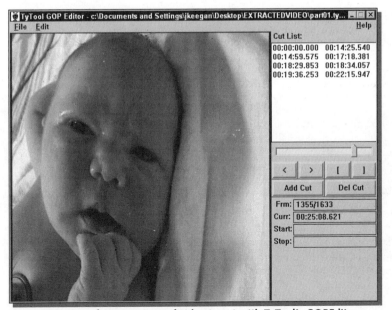

FIGURE 10-2: Choosing what format the recording will be stored in.

FIGURE 10-3: Specifying portions of video to cut with TyTool's GOPEditor.

One thing that GOPEditor has over its TyStudio competition (at least at the time of this writing) is that moving through the video with the slider control is *fast*.

The latest version of TyTool can be found in the following thread at dealdatabase.com:

`http://dealdatabase.com/forum/showthread.php?threadid=25588`

The version I used for the screenshots above was `tytool7r7a.zip`. That version was missing some components (namely the TiVo server), which were bundled up separately at:

`http://dealdatabase.com/forum/showthread.php?threadid=25648`

in the attachment "`tytool extraction files.zip`".

You basically place the server (called tserver_mfs6 in this version) on your TiVo along with a horribly named script called `NowShowing.tcl` (which has nothing to do with TivoWeb's `nowshowing.tcl` or any of the other files floating around with that name; it's another derivation of Stephen Rothwell's SFR web server, which is very specific to TyTool). You have to put them both in the same directory, and you can't rename `NowShowing.tcl` because the server is hard-coded to launch it by that name.

On the PC side, extract the zip file wherever you want the TyTool client to live, and you're done. Running `TyTool7r7.exe` brings up the dialog box in Figure 10-1.

The author of TyTool points out that you should be realistic about how much you do to your TiVo at one time; extracting video while reorganizing your Season Pass Manager priorities and also using TivoWeb isn't the best idea. The author also acknowledges that there seem to be two camps of extraction users right now on dealdatabase.com — those using TyTool, and those using TyStudio.

TyStudio

TyStudio is the result of the work of an entire team of developers. At the time of this writing, the main project team is Olaf Beck (olaf_sc on dealdatabase.com), John D. Barret (MrBassMan on dealdatabase.com), and Rowan McFarland (Rowan on dealdatabase.com), with numerous contributors as well.

TyStudio is made up of a collection of open source video tools, though it is most easily recognizable by its editing tool, TyStudio Editor (`tyEditor.exe`). Like tyTool you can use it to pull `.ty` files off of your TiVo, split them into their audio/video components, and multiplex them into an MPEG stream. Unlike tyTool, editing of the video stream occurs directly within the main application itself, with no "key file" preprocessing stage.

The User Interface is more polished in TyStudio. Figure 10-4 shows the initial window that is displayed when you start up the editor.

You can edit local `.ty` files or fetch them from your TiVo. Clicking "Click here to load from Now Showing" brings up the window in Figure 10-5; clicking Refresh fetches the list of episodes. Note that you don't have to fetch the entire recording itself if you don't want to — leaving Copy to PC First unchecked edits cut-lists on video that still resides on your TiVo.

FIGURE 10-4: TyStudio Editor upon starting up.

FIGURE 10-5: Selecting a recording from your TiVo.

Once you've selected a recording (either locally or remotely), you'll be able to move through the video and specify which sections you want to cut. Figure 10-6 shows the editor after several cut-start/cut-stop pairs have been added. Note also that the video's aspect ratio is correct.

When the Frame Mode button is selected, video will always be paused (you can step forward and back with the arrow keys). Deselecting Frame Mode makes Play (>) actually move, though it's a bit slow and jerky. Moving around with the slider isn't as quick as it could be (at least with the Windows version I use), but hopefully that will improve with new releases.

FIGURE 10-6: Specifying areas of video to cut.

Once you've set up any items for the cut-list, you pick what video and audio flavors you want, click Process, and it generates your results for you. Choosing a video type of Elemental Stream will cause separate audio and video streams to be generated; otherwise it will multiplex them into a .mpg file.

There are currently Windows and Linux versions of the client software (including the editor, etc.). All the necessary files can be obtained from:

```
http://dvd-create.sourceforge.net/tystudio/download.shtml
```

If you installed the software distribution from the accompanying CD-ROM, then the server for TyStudio 0.5.0 Beta 2 is already on your TiVo. The Windows and Linux versions of the client are on the CD-ROM under:

```
/cdrom/nonTiVoFiles/tystudio/setup.exe
```

and

```
/cdrom/nonTiVoFiles/tystudio/tystudio.i386.sh
```

respectively. Documentation and the source code are located in:

```
/cdrom/doc/tystudio-0.5.0-beta2/
```

If you want to use tyStudio, edit /var/hack/etc/hacks_callfromrc.sysinit and make sure that the following lines exist and are uncommented:

```
if test -x /var/index/tyindex -a -x /var/index/tyserver
then
  /var/index/tyindex > /dev/null 2>&1 &
  /var/index/tyserver > /dev/null 2>&1 &
fi
```

Caution

Be aware that the directory /var/index/index keeps data around. If you're using a normal (small) sized /var partition, this might cause you to run out of space if you don't check it from time to time; a full /var partition can cause TiVo to delete it all to clean house, and you'd have to re-install any hacks.

mfs-ftp

TyTool and TyStudio both tend to focus on getting video from your TiVo onto either removable storage media (such as DVDs or VideoCDs) or into a generic .mpg file for use on a computer.

mfs-ftp, on the other hand, focuses more on being able to extract *and then re-insert* video from/into your TiVo. It looks to the outside world like a normal FTP server (although it typically runs on a different port — 3105 — so as not to conflict with the existing tivoftpd described in Chapter 6). Instead of serving up files from a filesystem however, it serves up recordings from the MFS database. You can fetch these recordings as either .tmf, .ty, or .ty+ files. And here's the really good part — you can upload these files into your TiVo as well (after which they will show up in your Now Playing list again).

mfs-ftp was written by Riley Cassel (rc3105 on dealdatabase.com). It can be downloaded[2] from its official home thread at:

```
http://dealdatabase.com/forum/showthread.php?threadid=21915
```

As of version 1.2.8a, the directory it needs to live in is /var/mfs_ftp (yeah, that's a "_", not a "-"). I place my copy in /var/mfs_ftp and create a symbolic link called /var/hack/mfs_ftp that points at the directory, just for consistency — I like having hack directories all near each other.

After downloading the appropriate files, putting them on your TiVo, and setting up /var/hack/etc/hacks_callfromrc.sysinit to start it after reboots, you should now be able to ftp into your mfs-ftp server to extract video. At the time of this writing, some versions of FTP cause problems, and "passive mode" (the default on most FTP clients) doesn't work, so you need to disable it. Listing 10-1 shows a sample FTP session from a Red Hat Linux box into a TiVo running version 1.2.8a of mfs_ftp. Because the directory listings are very long, I'm truncating them in this listing. So that you can see the filename syntax, here are some examples of the full names of the entries from Listing 10-1:

```
{South Park}{}{08-13-1997}{04-10-2002 10.00 PM}{COMEDY}.tmf
{Mother}{}{01-01-1970}{11-22-2002 05.00 PM}{MAX}.tmf
{The Screen Savers}{}{12-20-2002}{12-23-2002 01.00 PM}{TECHTV}.tmf
{The Shawshank Redemption}{}{01-01-1970}{06-01-2003 11.45 AM}{TBS}.tmf
{Enterprise}{Dawn}{01-08-2003}{07-09-2003 08.00 PM}{WSBK}.tmf
```

[2] Riley didn't want his tool included on the CD-ROM, so you will have to go download it and set it up yourself. Though earlier versions of the code were released under the GNU Public License, Riley states in the code that the newer versions (from version 1.6 and on up) are not. Rather than ship an extremely old version, I've decided to keep it off the CD-ROM.

Listing 10-1: Example mfs-ftp Session: Extracting Video

```
# ftp 192.168.1.101 3105
Connected to 192.168.1.101 (192.168.1.101).
220 mfs_ftp server ver 1.2.8a - connect from 192.168.1.2 1112
Name (192.168.1.101:jkeegan):
331 User name okay, need password.
Password:
230 Running in TiVo Mode.
Remote system type is UNIX.
ftp> type binary
200 Type set to I.
ftp> passive
Passive mode off.   <-- check to make sure it's off.. passive toggles
ftp> ls
227 Entering Passive Mode (192,168,1,101,12,32).
150 Opening ASCII mode data connection for /.
drwxr-xr-x  1 0          0            1024 Jan 01  1972 tmf
drwxr-xr-x  1 0          0            1024 Jan 01  1972 ty
drwxr-xr-x  1 0          0            1024 Jan 01  1972 ty+
drwxr-xr-x  1 0          0            1024 Jan 01  1972 xml
drwxr-xr-x  1 0          0            1024 Jan 01  1972 txt
drwxr-xr-x  1 0          0            1024 Jan 01  1972 phoenix
drwxr-xr-x  1 0          0            1024 Jan 01  1972 shutdown
226 Transfer complete.
ftp> cd tmf
250 Directory change successful.
ftp> ls
227 Entering Passive Mode (192,168,1,101,12,32).
150 Opening ASCII mode data connection for tmf.
-rwxr-xr-x 1 0 0 0382730240 Jul 28 19:30 {The Simpsons}{I Love Lisa}{02-...
-rwxr-xr-x 1 0 0 0767557632 Nov 07  2001 {Sesame Street Unpaved}{}{02-02...
-rwxr-xr-x 1 0 0 0931135488 Dec 13  2001 {Sesame Street Unpaved}{}{02-02...
-rwxr-xr-x 1 0 0 0385875968 Apr 10  2002 {South Park}{}{08-13-1997}{04-1...
-rwxr-xr-x 1 0 0 1147142144 Jun 01  2002 {Saturday Night Live}{}{10-11-1...
-rwxr-xr-x 1 0 0 0385875968 Jul 29 21:00 {Curb Your Enthusiasm}{Aamco}{1...
-rwxr-xr-x 1 0 0 1648361472 Nov 22 17:00 {Mother}{}{01-01-1970}{11-22-20...
-rwxr-xr-x 1 0 0 2292187136 Jun 01 11:45 {The Shawshank Redemption}{}{01...
-rwxr-xr-x 1 0 0 0765460480 Jul 09 20:00 {Enterprise}{Dawn}{01-08-2003}{...
-rwxr-xr-x 1 0 0 2474639360 Jul 22 03:00 {Emily's Actual Birthday}} (052...
-rwxr-xr-x 1 0 0 0382730240 Jul 28 23:30 {X Play}{}{07-28-2003}{07-28-20...
   (...many lines omitted...)
-rwxr-xr-x 1 0 0 2169503744 Dec 23 13:00 {The Screen Savers}{}{12-20-200...
226 Transfer complete.
ftp>get "{Mother}{}{01-01-1970}{11-22-2002 05.00 PM}{MAX}.tmf" Mother.tmf
local: Mother.tmf remote: {Mother}{}{01-01-1970}{11-22-2002 05.00 PM}{MAX}.tmf
200 PORT command successful.
150 About to open data connection.
226 Transfer complete.
1648367616 bytes received in 2.27e+03 secs (7.1e+02 Kbytes/sec)
ftp> close
```

```
221 Server Closing Control Connection by client request
ftp> quit
#
# ls -l Mother.tmf
-rw-rw-r--   1 jkeegan  jkeegan  1648367616 Jul 29 09:35 Mother.tmf
# tar tfv Mother.tmf
-rw-r--r-- tivo/tivo      2968 2003-07-29 07:38:07 showing.xml
-rw-r--r-- tivo/tivo 536870912 2003-07-29 07:38:07 part00.ty
-rw-r--r-- tivo/tivo 536870912 2003-07-29 07:50:34 part01.ty
-rw-r--r-- tivo/tivo 536870912 2003-07-29 08:02:50 part02.ty
-rw-r--r-- tivo/tivo  37748736 2003-07-29 08:15:05 part03.ty
#
```

In the FTP session in Listing 10-1, I saved the recording locally by another name (Mother.tmf in this case) only because the Unix FTP client I was using wouldn't save the curly braces correctly.

As you can see, the top-level "directory" (which in fact isn't a directory at all but rather a sort of virtual menu) contains seven other directories beneath it: tmf, ty, ty+, xml, txt, phoenix, and shutdown. If you cd into the shutdown directory, mfs-ftp will quit; cd'ing into phoenix causes it to shutdown and then restart. The tmf, ty, and ty+ directories each contain entries for every recording in your TiVo. When you fetch a recording, the format it is returned in is determined by the directory you're in: cd'ing into ty and fetching a recording will yield that recording encoded as a .ty file.

The xml and txt directories also contain entries corresponding to each recording, but fetching them merely returns the metadata describing that recording (without any audio or video).

A text FTP client is good for automating fetches and retrievals, but it's nice to have a graphical client to use as well. Figures 10-7 and 10-8 show how you can fetch recordings using even Internet Explorer as an FTP tool.

FIGURE 10-7: Internet Explorer accessing mfs-ftp virtual directories.

Inserting video back into your TiVo is easy (as long as it's a .tmf file or a .ty+ file): you just upload the file via FTP instead of downloading it. In the command-line tool this means using put, and in the Internet Explorer example above it means dragging the file into the IE window.

{ftp://192.168.1.101:3105/tmf/ - Microsoft Internet Explorer}

File Edit View Favorites Tools Help

Back ▼ → ▼ 🖾 | 🔍 Search 📂 Folders 🕑 | 🖺 🖺 🗙 ⋈ | 🎟▼

Address 🖳 ftp://192.168.1.101:3105/tmf/ ▼ ∂Go

Name △	Size	Type	Modified
{Making Mr. Right}{}{01-01-1970}{06-28-2003 09.00 AM}{COMEDY}.tmf	1.42 GB	TMF File	6/28/2003 9:00 AM
{Monk}{Mr. Monk and the Very, Very Old Man}{07-25-2003}{07-25-2003 10.00 PM}{...	730 MB	TMF File	7/25/2003 10:00 PM
{Monk}{Mr. Monk Goes to Mexico}{06-27-2003}{06-27-2003 10.00 PM}{USA}.tmf	730 MB	TMF File	6/27/2003 10:00 PM
{Monty Python's Flying Circus}{The Nude Man}{12-14-1972}{06-12-2003 01.20 AM}{...	487 MB	TMF File	6/12/2003 1:20 AM
{Most Extreme Elimination}{}{04-19-2003}{07-12-2003 09.00 PM}{TNN}.tmf	366 MB	TMF File	7/12/2003 9:00 PM
{Mother}{}{01-01-1970}{11-22-2002 05.00 PM}{MAX}.tmf	1.53 GB	TMF File	11/22/2002 5:00 PM
{Mr. Show With Bob and David}{Sad Songs are Nature's Onions}{12-28-1998}{06-27-...	426 MB	TMF File	6/27/2003 5:25 AM
{Mr. Show With Bob and David}{The Return of the Creature's Ghost}{12-05-1997}{07...	366 MB	TMF File	7/20/2003 4:05 AM
{Next at CNN}{}{01-26-2002}{02-01-2003 03.00 PM}{CNN}.tmf	304 MB	TMF File	2/1/2003 3:00 PM
{NOW With Bill Moyers}{}{07-18-2003}{07-18-2003 08.00 PM}{WGBH}.tmf	730 MB	TMF File	7/18/2003 8:00 PM
{Saturday Night Live}{}{04-08-2000}{07-25-2003 02.00 AM}{COMEDY}.tmf	730 MB	TMF File	7/25/2003 2:00 AM
{Saturday Night Live}{}{10-11-1975}{06-01-2002 11.30 PM}{WHDH}.tmf	1.06 GB	TMF File	6/1/2002 12:00 AM
{Saturday Night Live}{}{12-09-1995}{03-08-2003 03.00 PM}{COMEDY}.tmf	1.04 GB	TMF File	3/8/2003 3:00 PM
{Saturday Night Live}{Christopher Walken}{01-01-1970}{07-17-2003 01.00 PM}{COM...	730 MB	TMF File	7/17/2003 1:00 PM
{Saturday Night Live}{Tom Hanks}{01-01-1970}{07-26-2003 04.00 PM}{COMEDY}.tmf	730 MB	TMF File	7/26/2003 4:00 PM
{Sesame Street Unpaved}{}{02-02-1999}{01-04-2002 05.00 AM}{NOGN}.tmf	992 MB	TMF File	1/4/2002 12:00 AM
{Sesame Street Unpaved}{}{02-02-1999}{01-07-2002 05.00 AM}{NOGN}.tmf	992 MB	TMF File	1/7/2002 12:00 AM

User: Anonymous 💮 Internet

FIGURE 10-8: Recordings you can drag to your desktop, via mfs-ftp and IE.

Caution

When inserting a `.tmf` or `.ty+` file into your TiVo via mfs-ftp, it will appear on the destination machine's Now Playing list immediately. If you try to start viewing it before the transfer is done, don't fast-forward past what has already downloaded. Since it won't be clear how much has downloaded, it's safest to not fast-forward, or to only fast-forward back to where you were after rewinding.

TiVo MPlayer

MPlayer (*Movie Player*) is a tool by Aprad Gereoffy originally written for Linux that lets you view audio/video streams of many formats. The reason that it's mentioned here is because Christopher Wingert (cwingert on dealdatabase.com) modified it to be able to play video streamed from your TiVo. This modified version will also play `.ty` files stored elsewhere. Christopher's changes have been submitted to the MPlayer authors, and will eventually be rolled into the official release.

By the time this goes to press things may have changed with regard to its release status. Check Christopher's TiVo MPlayer page first at:

```
http://tivo-mplayer.sourceforge.net/
```

for more info on the current state of things and what version to download.

He has it working on Linux, MacOS X, and Windows (via cygwin). In addition to the client, there is yet-another-tyStream-server for your TiVo, called `vserver` that you need to run on your TiVo to serve up the Now Playing list and the video itself.[3]

[3] There *has* been talk about creating one standard tyStream server that every tool can use, but it hasn't happened yet. Ideally this would provide mfs-ftp-like access, normal FTP file access, and other random-access streaming facilities necessary for every tool out there. Perhaps by the time you're reading this such a server will exist, or one will be agreed upon as the standard that everyone else codes to. Until then, multiple servers will sit on your TiVo waiting to serve up basically the same data.

Once it's installed, you can use the new "tivo://" URL mechanism coded into MPlayer to obtain Now Playing info and view recordings on-screen. Listing 10-2 shows an example of how to obtain Now Playing info via "tivo://192.168.1.101/list".

Listing 10-2: Fetching Now Playing List Using MPlayer

```
$ mplayer tivo://192.168.1.101/list
Using GNU internationalization
Original domain: messages
Original dirname: /usr/share/locale
Current domain: mplayer
Current dirname: /usr/local/share/locale

MPlayer 0.90rc4-3.2 (C) 2000-2003 Arpad Gereoffy (see DOCS)

CPU: Advanced Micro Devices Athlon 4 PM Palomino/Athlon MP Multiprocessor/Athlon
 XP eXtreme Performance (Family: 6, Stepping: 2)
Detected cache-line size is 64 bytes
3DNow supported but disabled
3DNowExt supported but disabled
CPUflags:  MMX: 1 MMX2: 1 3DNow: 0 3DNow2: 0 SSE: 0 SSE2: 0
Compiled for x86 CPU with extensions: MMX MMX2 SSE SSE2

Reading config file /usr/local/etc/mplayer/mplayer.conf: No such file or
directory
Reading config file /home/jkeegan/.mplayer/config
Reading /home/jkeegan/.mplayer/codecs.conf: can't open
'/home/jkeegan/.mplayer/codecs.conf': No such file or directory
Reading /usr/local/etc/mplayer/codecs.conf: can't open
'/usr/local/etc/mplayer/codecs.conf': No such file or directory
Using built-in default codecs.conf
font: can't open file: /home/jkeegan/.mplayer/font/font.desc
font: can't open file: /usr/local/share/mplayer/font/font.desc
Using usleep() timing
Input config file /home/jkeegan/.mplayer/input.conf parsed : 16 binds

Playing tivo://192.168.1.101/list
[   1853262][ 3][Live             ][(null)                      ]

[   1713743][ 3][24               ][Day 2: 7:00 - 8:00AM        ]

[   1476448][ 3][24               ][Day 2: 5:00 - 6:00PM        ]

[   1748702][13][44 Minutes: The Nort][(null)                   ]

[   1731883][ 2][60 Minutes       ][(null)                      ]

[    895353][ 6][9/11             ][(null)                      ]

[   1731977][ 2][Adoption Stories ][The Cote Bunch              ]
```

Continued

Listing 10-2 *(continued)*

```
[   1780729][ 2][The Amazing Race 4  ][I Could Never Have Been Prepared fo]

[   1755764][ 3][America's Sweetheart][(null)                              ]

  (...many lines omitted...)

[   1827796][ 1][X Play             ][(null)                              ]

[   1772313][ 1][The Young and the Re][(null)                            ]

ty_streaming_start failed
Unable to open URL: tivo://192.168.1.101/list

Exiting... (End of file)

$
```

You can then pull up a window to view a recording by supplying its fsid in the "`tivo://`" URL. For instance, to view the X Play recording from Listing 10-2, you would use:

`mplayer tivo://192.168.1.101/1827796`

While it's displaying video you can control it via the keyboard. The Space key plays and pauses video, the left/right arrows rewind/fast-forward 10 seconds, and q quits. I configured my copy of MPlayer to make the up and down arrows control volume as well; see MPlayer's man-page at:

`http://tivo-mplayer.sourceforge.net/docs/mplayer-man.html`

for more info on changing `~/.mplayer/input.conf` to your liking.

I'd show you a screenshot, but screenshot programs don't capture the video portion of the screen, since it's displayed similarly to the way that DVD-player applications display video. Besides that, there's nothing much to show — it's just a window with video — no frills or controls.

A simple graphical user interface for TiVo MPlayer (TiVo MPlayer GUI) was put together by Burriko from dealdatabase.com. It is pointed at by the TiVo MPlayer URL above. Upon downloading and unpacking the distribution, you can start the Java-based player (which requires at least JRE 1.3 to be installed) by typing:

`java -jar mplayerGUI.jar 192.168.1.101`

What you get is a simple UI displaying the items in your Now Playing list. Selecting one then clicking Play starts it just as if you had entered the recording's fsid on the command line using the "`tivo://`" URL syntax described previously. Figure 10-9 shows the UI.

FIGURE 10-9: TiVo MPlayer GUI.

Users of the roll-your-own-PVR project MythTV can now access video from the MythTV UI itself, via the MythTV plug-in called MythTiVo. This interface lets you select which TiVo you want to view recordings from, then which recording you wish to view (similar to the TiVo MPlayer GUI, but in the context of MythTV, with a MythTV look-and-feel). Users who have MythTV already installed can check out MythTiVo at:

```
http://tivo-mplayer.sourceforge.net/mythtivo.html
```

More Tools

Like I said at the beginning of the chapter, there are many other tools that have existed that I simply haven't had the space to cover here. Andrew Tridgell's vplay not only let you extract video, but it even let you extract video from a TiVo hard drive mounted in your PC (versus mounted in in a running TiVo). TivoApp by Gary Williams (garyw90 on dealdatabase.com) let you fetch tyStreams from your TiVo, similarly to tools mentioned here. Playitsam by Warren Toomey (DoctorW on dealdatabase.com) let you edit video while watching TV, then you could extract just the pieces you wanted. Unfortunately, it required shutting down myworld to work, but it was a great tool. The MfsStream TivoWeb module, by John Sproull, lets you easily download .ty files for recordings on your TiVo. These can be found at:

```
http://dealdatabase.com/forum/attachment.php?postid=77812
http://cvs.samba.org/cgi-bin/cvsweb/tivo/vplay/
http://home.earthlink.net/~garyw90/TivoApp.html
http://minnie.tuhs.org/Programs/Playitsam/
http://dealdatabase.com/forum/showthread.php?threadid=20901
```

There are undoubtedly even more tools out by the time you're reading this. There is a thread on dealdatabase.com dedicated entirely to pointing to extraction tools, HOWTO documents, etc. Don't go posting any help questions in this thread, but be sure to check it out:

```
http://dealdatabase.com/forum/showthread.php?threadid=8092
```

Burning Audio/Video onto Removable Storage

There used to be many steps involved in taking an extracted `.ty` file and putting it onto a VideoCD or a DVD. Well, there still are several steps, but it's much easier now with tools like TyTool and TyStudio that do lots of the splitting and multiplexing for us. There are many ways to do this, and many HOWTO documents exist on the web describing them.

A word of warning: there are many tools not covered here that people use to "make things better" with the video and audio streams, to eliminate compatibility problems. I don't profess to be an expert on burning media or on every tool out there, so I'll just introduce you to the basics and defer to those whose documentation stems from repeatedly burning discs and playing with all of the options. Consult the documentation on dealdatabase.com's extraction forum for more detailed info.

Note

Remember—these steps convert your video into a format easily viewed on many DVD players and computers, but it will no longer be in a format that you can re-insert into your TiVo. If you wish to preserve your ability to do this, keep the `.tmf` or `.ty+` file of the recording around—don't discard it after creating your VideoCD or DVD.

The first step is extracting the recording. If you'd like to re-insert the video later (unrelated to this disc we're about to create), then fetch a `.ty+` file via mfs-ftp (or fetch a `.tmf` file and concatenate its `.ty` files together in order).

(If you're thinking of putting several *recordings* together on the same media, don't jump to the conclusion that you want to append the `.ty` files from one recording to the end of another—that's wrong. Go through this entire exercise once for each recording, and we'll deal with the fact that you have multiple resulting `.mpg` files later.)

Follow these steps to generate edited .mpg files from your `.ty` file sources:

STEPS: Generating Suitable .mpg Files to Burn With

1. Use TyTool or TyStudio to edit out any portions of the `.ty` file that you don't want by creating cuts.

2. Set the intended audio output. For VCD/SVCD you probably want to choose 44.1 KHz @ 224 Kbits/sec. For DVDs, you probably want to chose 48 KHz @ 224 Kbits/sec.

 In TyTool you set this under Options → Audio. In TyStudio, this is the "Audio to:" field in the bottom-right corner of the window.

3. Set the multiplexing output, to specify whether you are creating video for DVD or VCD/SVCD:

 - In TyTool, for a VCD/SVCD, choose Options → MUX → VCD/SVCD Mux Output.

 - For DVDs in TyTool, choose Options → MUX → Standard Mux Output.

 - In TyStudio, choose either SVCD or DVD in the "Video to:" field in the bottom-right corner of the window.

4. Begin multiplexing (to generate one `.mpg` file for each recording). In TyTool this is done via File → Multiplex File(s). In TyStudio, click the Process button in the bottom-right corner of the window.

Ok, you have your `.mpg` files ready. If you're burning a VCD, then depending on what you need the disc to play in, you might want to use a tool called TMPGEnc (available at `http://www.tmpgenc.net/`) now to create yet another `.mpg` file, in MPEG1 instead of MPEG2 to be more compliant with VCD standards.

From this point on, the steps are specific to what burning software you're using, and I won't try describing them here. There are detailed HOWTOs out there for different burning tools. Basically you want to provide the `.mpg` file(s) you've created, fill in any info the tool wants (like a volume label, etc.), possibly create menus (even for VCDs), and then burn.

For more info on VCD/SVCD and DVD burning, consult the various HOWTO documents listed at:

`http://dealdatabase.com/forum/showthread.php?threadid=8092`

Good luck, and happy burning!

Where This Leads

Hopefully people can see the tremendous possibilities that this can bring us all. If one of the best hacks ever was the ability to add a larger disk, then this certainly rides its coattails since it allows you to have more storage than the TiVo's limited kernel allows. Create a huge video server in your basement! It also gives us back what we certainly took for granted with our VCRs: the ability to move recordings from place to place. Before going on that long trip, burn a DVD of your kids' latest recordings to keep them occupied in the back seat. Feel more confident that the shows you care about most will outlive your next hard drive failure. Write scripts to automate inserting your favorite holiday specials a few months early! All the tools are there now; all you have to do is use them.

Other Miscellaneous Hacks

There are still a few existing hacks that we haven't covered so far, but that are worth mentioning before we move on to doing things of your own. So, here they are, in no particular order (and not related to each other at all).

TPOP

TPOP is a program written by Douglas Mayle that lets you view email on your TiVo. Inspired by the TivoWeb Mail module, TPOP creates TiVo Messages like the ones you get occasionally from TiVo Inc. (see Figures 7-11, 7-14, and 7-15 in Chapter 7 to see what TiVo Messages look like). However unlike the TivoWeb Mail module, TPOP gets its input from a POP (Post Office Protocol) mail server. This means that you can receive copies of your actual incoming email on your TiVo.

If you installed the software distribution from the accompanying CD-ROM in Chapter 4, TPOP is already installed in `/var/hack/bin/tpopd.tcl` and `/var/hack/bin/tpopd.conf`. If not, you can fetch the gzipped tar file containing both from:

`http://www.networkhackers.com/tpop`

Unzip and untar the file and place both files in `/var/hack/bin`, making sure to do a `chmod 555 /var/hack/bin/tpopd.tcl` to make `tpopd.tcl` executable.

Before trying TPOP you need to edit the configuration file `tpopd.conf`. The configuration file specifies where to grab mail from, and how often. Set `server` to the IP address of your POP mail server. `user` and `pass` should be set to the username and password for the email account on that POP server that you want to fetch mail from. You can specify how often to check mail with the value `interval`; the time is specified in milliseconds, so a value of 600000 means check every 10 minutes.

If you leave the line `delete false` in `tpopd.conf`, then mail will *not* be removed from the POP server.

Various command-line options let you override all of these values from the configuration file — you can see these by typing `tpopd.tcl -h`.

Caution

Version 1.0 can have problems with large inboxes, sometimes causing your TiVo to reboot. Before you set it up to run after every reboot (either via modifying `/etc/rc.d/rc.sysinit` or `/var/hack/etc/ hacks_callfromrc.sysinit` from Chapter 4), try it out and see how it works for you.

Batch Save (merge.tcl)

Being able to Save-to-VCR is a nice feature for when you want to keep a show around but can't afford to have it taking up space on your TiVo. But what if you want to dump several episodes to tape at once? It'd be nice to be able to queue up eight episodes of something, throw in a tape, and record them overnight.

Users ask TiVo Inc. for this all the time, but it's not too high on TiVo's priority list for new features. Mike Baker (embeem on tivocommunity.com) wrote a simple Tcl script to allow you to save multiple recordings to tape in a row.

The Tcl script that does this is called `merge.tcl`. It creates a huge "fake" recording for you, which is made up of the video and audio of other recordings. The new recording takes up almost no extra space, and will disappear soon after it's created (during the next record activity). Once you've created this new aggregate recording object, you select it and choose Save to VCR, causing all of the shows it represents to play one after another for your VCR to record.

The script `merge.tcl` can be found at:

`http://tivo.samba.org/download/mbm/misc/merge.tcl`

Place the file in `/var/hack/bin/merge.tcl` and make it executable by typing the command `chmod 777 merge.tcl`.

Table 11-1 shows the remote control button presses that `merge.tcl` listens for in the Now Playing program screens.

Table 11-1 Button Presses That merge.tcl Listens For

Remote Control Button Press	Action
9	Add a program to the queue for our new fake recording. The program to be added is the one whose Now Playing screen is currently being viewed.
7	Create a multi-part "fake" recording out of the recordings queued up via 9 (above).
1	Exit merge.tcl

To create one of these multi-part aggregate recordings, first run `merge.tcl` from the command line. Then using your remote control, go to the Now Playing screen. Select the first item you wish to add, and when you are on that program description screen press the 9 key on your remote control. The window containing the command line that you ran `merge.tcl` from should output something like "adding 1739719/-1", indicating that the video segment(s) from that recording have been queued up for your new fake recording.

Go back to the Now Playing list and select the next recording that you want, then again press 9 to add it. When you've added all of the programs you wish to add, press 7 on your remote control. The `merge.tcl` command should now output a message saying that it's merging the pieces; it may need to automatically retry certain commands internally due to transactions, and it will say so if it does — this is normal. When all of the pieces are merged, go back to the Now Playing screen. When you see a recording called "multipart", you can now quit `merge.tcl` by pressing "1" on your remote control.

Select the "multipart" object. You'll note that the description lists the titles of the shows that it is made up of. Choose "Save to VCR" as you normally would, and all of the recordings will be displayed in order. You can sometimes get strange behavior if you try to fast forward or rewind while playing, since the rendering of the green play-bar won't accurately reflect where you are in your multi-part recording. It's best to just start playing, hit record on your VCR, and let it play all the way through.

Also be aware that since this program registers for remote button press events, it's susceptible to the "Event bug" that sometimes causes the remote to hang. (The Event bug is described in Chapter 15 in the "What Is There to Work With?" section.) You may want to consider running `merge.tcl` only when you need it, rather than starting it after each reboot via `/etc/rc.d/rc.sysinit` or `/var/hack/etc/ hacks_callfromrc.sysinit` from Chapter 4.

Screensaver

After sitting on the menu screen for a while, TiVo goes to LiveTV to keep from burning images into your screen, but there is one case that it doesn't handle: paused video. If you pause a video image, the image will remain on the screen until you turn it off, which can adversely affect your TV (especially in the case of some projection TVs). The `screensave` program by Mike Baker (embeem on tivocommunity.com) solves this problem, by blanking out the screen after 30 seconds of still video.

If you installed the software distribution from the accompanying CD-ROM in Chapter 4, screensave is already installed in `/var/hack/bin/screensave`. If not, it can be found at:

`http://tivo.samba.org/download/mbm/bin/screensave`

Place the file in `/var/hack/bin/screensave` and make it executable by typing the command `chmod 777 screensave`.

To run `screensave` in the background, type:

`/var/hack/bin/screensave &`

You can add that line to either `/etc/rc.d/rc.sysinit` (or `/var/hack/etc/ hacks_ callfromrc.sysinit` if you followed the instructions in Chapter 4) to cause `screensave` to be started every time your TiVo reboots.

The source code to `screensave` is available from this thread:

`http://alt.org/forum/index.php?t=msg&th=28&start=0&rid=83`

(It is also included on the accompanying CD-ROM, in `/cdrom/doc/screensave.c`.)

Preventing Software Upgrades

Normally, your TiVo unit updates its software automatically. During a daily call, if a new version of the software is available, it will be downloaded. This will cause your TiVo to be in a "pending restart" state. The next time it's 2:00 A.M., your TiVo will reboot (if it hasn't already rebooted after the download due to a power outage or your manual disconnecting of the power). After the reboot, your TiVo detects the newly downloaded software and runs a script to install it. It's possible to keep that installation step from happening.

The line of code that controls this is in `/etc/rc.d/rc.sysinit` — it checks to see if a variable named `upgradesoftware` has a value of false or not. If it isn't false, your TiVo looks for a newly downloaded version of the software and installs it.

If for whatever reason you want your TiVo to stay at a particular version, you can stop this installation from occurring by changing the boot parameters of your TiVo to include the variable declaration `upgradesoftware=false`. (This isn't as much a hack as it is a piece of info that's worth mentioning, since the TiVo software itself is what examines this variable.) There aren't many reasons to do this, but I'm mentioning it here anyway. Some people prefer the behavior of previous versions of the software. Maybe you just want to see what Teach TiVo (Chapter 2) looked like back in 2.0, and you happen to have a 2.0 backup lying around. Or you might be going on a long vacation and want to make sure that a software update doesn't stop TivoWeb from working while you're away. Whatever your reason, it will most likely be short lived since newer versions of the software have invariably been better in many ways, so keep track of what you do so you can reverse it later.

There are several ways to keep the installation from occurring. I'll list three of them here. Note that if TiVo wanted to they could probably find a way to override such measures, so if you have a reason to want to keep the old software, make a backup.

Changing Boot Parameters via TiVo bash Prompt

If you already have a bash prompt (see Chapter 5), you can change the boot parameters with the `bootpage` program to include `upgradesoftware=false`. Long ago some people reported not having the `bootpage` executable on their TiVos, so you'll have to check — it should be in `/sbin/bootpage`. First, determine what the current boot parameters are:

```
=[tivo:root]-# bootpage -p /dev/hda
root=/dev/hda4
=[tivo:root]-#
```

On your TiVo, that might be hda7 instead of hda4 (see Chapter 4 for an understanding of partitions 4/7). If so, use hda7 in the replacement string below.

To change the boot parameter to include upgradesoftware=false, we use the -P argument:

```
=[tivo:root]-# bootpage -P "root=/dev/hda4 upgradesoftware=false" /dev/hda
Updated boot page on /dev/hda
=[tivo:root]-# bootpage -p /dev/hda
root=/dev/hda4 upgradesoftware=false
=[tivo:root]-#
```

(Note that's a capital P for modification, then we use the lowercase p to verify the change.)

Again, be very careful that your replacement string contains the same value for root as it had before you made your change (hda4 or hda7).

Changing Boot Parameters via the Boot CD

If you happen to already have your TiVo disassembled and your "A" drive is connected to your PC, you can use the accompanying CD-ROM to change the boot parameters similar to the "Changing Boot Parameters via TiVo bash Prompt" steps given in the last section.

Boot the CD-ROM, with your A drive connected to your PC. For the sake of these instructions, we'll assume that it's connected to the secondary IDE bus as Master, which would make its device name /dev/hdc. If it's connected differently, adjust the device name appropriately.

Once booted, verify that you have the drive connected correctly via the checkdrivesetup script described in Chapter 4. Once you're sure you have the drive connected correctly (and that you know the device name for that drive), use the /tivomad/edit_bootparms program to change the boot parameters to include upgradesoftware=false. Be sure to note your value of root (/dev/hda4 or /dev/hda7) and keep it in your replacement string!

```
=[HackingTiVoCD]-# /tivomad/edit_bootparms hdc
edit_bootparms Version 1.20.01
Current boot parameters :-
root=/dev/hda4
Enter new parameters or '-' to leave unchanged.
root=/dev/hda4 upgradesoftware=false
Boot parameters written successfully
=[HackingTiVoCD]-#
```

Changing Scripts Directly

Another option is to change rc.sysinit itself to keep the update from running. Note that this won't work on any TiVo that checks for modified system files, such as unmodified DirecTiVo units or Series2 TiVos.

First, remount your root partition as read-write via:

```
mount -o remount,rw /
```

Make a backup of /etc/rc.d/rc.sysinit, then using a text editor such as vi, find the line:

```
if [ "$upgradesoftware" = false ]; then
```

and insert the following line directly above it:

```
export upgradesoftware=false
```

Don't forget to return your root partition to read-only mode:

```
mount -o remount,ro /
```

Negative Padding

Version 2.0 of the TiVo software introduced an extremely useful feature: padding. Padding allows you to tell your TiVo that you'd like it to record a show, but to also record extra before or after the show. You are allowed to start recording 1, 2, 3, 4, 5, or 10 minutes early, and to recording 1, 2, 5, 15, 30, 60, 90, or 180 minutes longer than the recording.

These options all let you record *more* than a recording, but none of them let you record *less* of a recording. In some cases, users had certain shows that always started early, and shows immediately before them that always ended early as well. Both shows couldn't be recorded, because there was no way to say, "stop recording 2 minutes *before* the end of the first show."

Negative padding lets you do just that.

Buried away in MFS (see Chapter 13 for more info) are two string resources that control what time increments are allowed for start and stop padding. For those of you who are curious and have already skipped ahead to read Chapter 13, the resources are the 20th and 22nd ResourceItems in the 33rd ResourceGroup of the /SwSystem/ACTIVE MFS object under 3.0. The strings are made up of time-increment-names and time-increment-values. The default value for the Start string is (all on one line):

```
On-time|0|1 minute early|60|2 minutes early|120|3 minutes early|180|
4 minutes early|240|5 minutes early|300|10 minutes early|600|
```

while the default value for the Stop string is (again all on one line):

```
On-time|0|1 minute longer|60|2 minutes longer|120|
5 minutes longer|300|15 minutes longer|900|30 minutes longer|1800|
1 hour longer|3600|1 1/2 hours longer|5400|3 hours longer|10800|
```

In version 3.0, the system software suddenly started accepting *negative* numbers as acceptable values for pad times. The pad times are specific to their function, so a negative value means the opposite of what that string is for; a start pad value of -60 means you want to start 1 minute *late*, and a stop pad value of -60 means you want to stop one minute *early*.

Mike Baker (embeem on tivocommunity.com) wrote a small script called padhack.tcl that basically changed the Start string to:

```
On-time|0|1 minute early|60|2 minutes early|120|3 minutes early|180|
4 minutes early|240|5 minutes early|300|10 minutes early|600|
1 minute late|-60|2 minutes late|-120|3 minutes late|-180|
4 minutes late|-240|5 minutes late|-300|10 minutes late|-600|
```

and changed the Stop string to:

```
On-time|0|1 minute longer|60|2 minutes longer|120|
5 minutes longer|300|15 minutes longer|900|30 minutes longer|1800|
```

```
1 hour longer|3600|1 1/2 hours longer|5400|3 hours longer|10800|
1 minute shorter|-60|2 minutes shorter|-120|3 minutes shorter|-180|
4 minutes shorter|-240|5 minutes shorter|-300|10 minutes shorter|-600|
```

That script can be found in this thread:

```
http://www.tivocommunity.com/tivo-vb/showthread.php?s=&threadid=66425
```

The script only needs to be run once — move it to your TiVo, make it executable via `chmod 555 padhack.tcl`, then run it via `./padhack.tcl` (on 3.0 only!).

Another way to set those values is by using the Resource Editor module in TivoWeb. If you have TivoWeb installed, make a backup of the file `/var/hack/tivoweb-tcl/modules/tvres-3.0.res`, then edit it with a text editor and add these two lines at the end:

```
PaddingValues StartRecordingNameValuePairs 32 19
PaddingValues StopRecordingNameValuePairs 32 21
```

Quit TivoWeb, restart it, and go to Resource Editor. There you will now see another Resource Group called PaddingValues. Click on it to see the Start and Stop name/time pairs. These need to be changed one at a time; change the Start list to whatever value you want, then hit return. Go back into the Resource Editor, select PaddingValues again, and make any changes to the Stop list the same way. When both changes have been made, go to the Resource Editor one last time and click Update Resources. You will be instructed to reboot your TiVo, and then the change will take effect.

Again, this doesn't work for versions of the TiVo software before 3.0.

The result of either of these methods is that the Start Recording and Stop Recording fields on any Recording Options page will now contain your new added "negative" values (for example, "1 minute late" for Start Recording and "1 minute shorter" for Stop Recording).

Dual Lineups for Series1 Cable Box Users

One feature that I wish TiVo supported on its own is the idea of using your cable box only when necessary. With most cable setups, your TiVo *could* be tuning most of the channels directly through raw RF input (because they are unscrambled), but the cable box is needed for any premium channels (which are scrambled). What would be nice is if you could plug your cable box output *as well as* a raw cable signal input into your TiVo, and have it rely on the cable box only for channels that need it. This would reduce the number of times your TiVo needed to use its IR blasters, thus reducing the number of times that channel changing errors cause you to miss a program.[1]

[1] Users of Motorola Digital Cable Boxes had another solution for IR-blaster troubles for a while as well (some still do). On some models of TiVos, a feature was enabled that let you communicate with your cable box via the serial port (thus eliminating the communication problems inherent to infrared transmissions). As it turned out, a single resource needed to be changed from 0 to 1 to turn on that support for serial control in *all* TiVo models. Use of this feature required your cable box have the right (new) version of firmware; the cable provider Comcast recently upgraded cable boxes to an *even newer* firmware revision that no longer supports serial control. For those that are still able to do it, you can find out more about this hack in the "HOWTO: Enabling serial control of some brands of digital cable boxes …" thread at `http://www.tivocommunity.com/tivo-vb/showthread.php?threadid=62212`

For those who have read Chapter 13 and the "Resource Editor" section of Chapter 7, I'll just say that the resource in question is in the 35th ResourceItem of the 31st ResourceGroup of the MFS object `/SwSystem/ACTIVE`.

Mike Baker (embeem on tivocommunity.com) wrote a script to allow this, at least for people whose cable box has RCA audio output and either RCA video or S-Video output. His script causes your TiVo to create two lineups, one coming from raw RF (coax) input, the other coming in over the line-in audio/video outputs.

The reason that TiVo supports dual lineups at all is because it allows you to connect a satellite dish to a standalone TiVo. To do that, TiVo provides the functionality of letting some channels (that come from the satellite dish) come in on the line-in jacks, and letting other channels (usually local channels, over cable or antenna) come in via the RF coax-in jack. Mike's script lets you create a setup where your TiVo knows that the device going to the line-in jacks is still your specific brand of cable box, but that it should still have a dual lineup enabled for easy access to specified channels from raw RF input.

You can download the script that enables this in 3.0 from:

`http://www.tivocommunity.com/tivo-vb/attachment.php?s=&postid=544347`

The thread that it was discussed in was the "HOWTO: Enabling serial control of some brands of digital cable boxes . . ." thread mentioned in footnote 1. The specific post within that thread was:

`http://tivocommunity.com/tivo-vb/showthread.php?postid=544347#post544347`

Getting Camcorder Footage onto Your TiVo

Once you're used to TiVo's excellent video navigation (fast-forward/rewind/instant-replay/etc.), it's easy to get aggravated at your DVD player, and even easier to become truly enraged with your VCR. Plus, everything on your TiVo is a few remote presses away, whereas videotapes get stored away in closets, stacked away on shelves, and so on. If you have video you'd like to be able to view often, it'd be nice to have it on your TiVo.

Well, it's not as easy as it could be, but you *can* put video from your camcorder or other device onto your TiVo (well, your standalone TiVo — DirecTiVo owners are out of luck). Once you've accepted that it takes extra work, you can even get into it and fix up the title, actors, etc.

Getting the Video onto Your TiVo

There are two approaches to doing this. If your recorder lineup (TiVo Central ➔ Messages & Setup ➔ Recorder & Phone Setup ➔ Cable/Satellite Box ➔ Connection to Recorder) is already set up to use Composite Video (line-in, red/white/yellow, and/or S-Video) inputs, then you can temporarily disconnect those inputs and replace them with your camcorder's output. Set up a manual recording (or record an existing recording of the length that you want) on a channel that exists on the line-in lineup[2], and hit play on your camcorder. Your TiVo will think it's recording from your cable-box/satellite-dish over the video-in jacks, when in fact it's getting your camcorder input.

[2] Users have either one or two channel lineups, depending on how they have their TiVo connected up to their input source. Users of a normal cable box have one lineup (unless they've changed it as described in the previous section). Satellite users with standalone TiVos usually have two channel lineups — one via line-in jacks for satellite audio/video, and another via RF coax input for local channels. If you have two lineups, create your manual recording on one of the channels that would have gone to the line-in jacks, such as a channel you know to be satellite-based. Cable-box users who aren't using line-in jacks but rather use RF coax to connect their cable box to their TiVo should continue on to the second approach described in the next paragraph.

The second approach to doing this (which is a bit more permanent, will take some time, will require a few phone calls be initiated by your TiVo, and may result in a loss of guide data for a few hours) applies to cable-box users who originally had just one lineup. Note that this procedure isn't a good idea if you want to run S-Video or line-in input to your TiVo from your cable box — instead you'll have to use the RF input.

What you do is you repeat the guided setup of your TiVo (TiVo Central ➜ Messages & Setup ➜ System Reset ➜ Repeat Guided Setup). When it asks you what your cable setup is, tell it that you have a satellite dish, and that you use a cable-box for local channels. This will create two lineups for you to use. When it asks what brand satellite dish you're using, pick one randomly. When it asks what brand cable box you're using, be sure to tell it the correct brand you're using, and tell it the correct cable provider, etc.

Eventually you'll get to a page where you decide which channels exist on which device. Move *all* of the channels onto the RF (coax) input, except one. Pick some random channel that you'll never ever use, and have that reside on the line-in jacks (either as Composite Video or S-Video); note that you will no longer be able to access the channel you've picked, so make it something you don't like.

Once all that is done, any time TiVo goes to record something on that channel, it will look to the line-in jacks for input. This way you can schedule a manual recording on that channel, hit play on your camcorder (which is connected up to those line-in jacks), and record your video onto your TiVo.

Labeling Your Recording More Accurately

After doing either of the two methods above, you'll end up with a recording on your TiVo whose name is whatever random show was scheduled to be on the fake channel that you used. What you want to do now is rename the recording so that it's more appropriate.

There are three simple solutions. The first is to pull up your recording in TivoWeb (described in Chapter 7), and click the Edit Program link (see Figures 7-44 and 7-45 in Chapter 7, in the Now Showing section). This will let you edit the title, actors, etc. of your recording. See Figures 10-1, 10-2, 10-3, and Figure 1-13 (in Chapter 1) to see how good it can look (the channel logo was the result of the Logo module in Chapter 7, and the modified Now Playing title was done with dbget/dbset in Chapter 13).

The second solution is to modify the fields in MFS yourself using dbget/dbset, as described in Chapter 13. That's actually how I modified the episode number and original air date for Figure 11-3.

The third is to use a script called EditTitle3.tcl (by Netboy on dealdatabase.com) which lets you modify many fields of an existing recording. It can be downloaded from:

http://dealdatabase.com/forum/attachment.php?postid=39147

The thread it was mentioned in is at:

http://dealdatabase.com/forum/showthread.php?threadid=10229

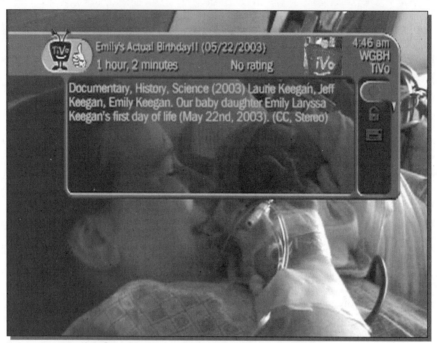

FIGURE 11-1: Emily's first day, on our TiVo, with on-screen description.

FIGURE 11-2: Result of editing titles, actors, and description.

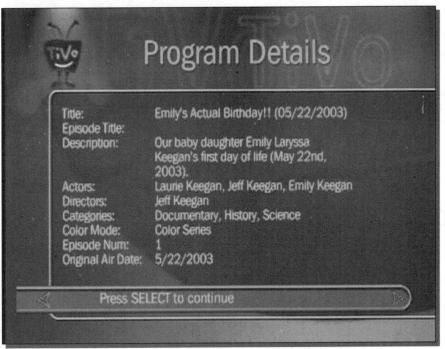

FIGURE 11-3: Program details screen shows actors, original air date, etc.

PAL Hacking

I'm not going to give many details here, but I did want to make mention of this. One of the hacks done by Andrew Tridgell (which was very important to some people) was to modify a TiVo to output PAL instead of NTSC (PAL is the video standard used in the U.K. and Australia). TiVos were later made available officially in the U.K. that supported PAL, but this was done first (on a normal US TiVo). It's worth pointing out that even though TiVo didn't offer service in Australia, Andrew Tridgell paid for his service subscription anyway, which is thankfully a very good example of how the TiVo Hacking community feels as a whole.

The first goal was to get a TiVo to output video in PAL format. The next goal was to replace the NTSC tuner with a PAL tuner. Lots of work has been done in this area by many individuals, and many people have modified TiVos that can input/output PAL video.

Australian users wishing to find more should consult Appendix A for a link to the Australian TiVo Owners List. U.K. users should check the appendix as well, for two groups. Ok, while we're at it, Canadian users (Hello up there! Thanks for Rush!) should consult the appendix as well (though they won't be using PAL — they just share the Australian users' plight of not having TiVo service offered in their area).

Here are some links that might help you along (though doing a few Google searches on this one will give you some interesting reading). All on one line:

HOW TO - PAL modification for US TiVo Running 3.0 SW:

```
http://minnie.tuhs.org/TiVo/files/howto/us/
        3.0/PAL_mod_for_US_Tivo_running_30_SW.doc
```

HOW TO - Getting TiVo Running 2.5.1 for Australian Conditions:

```
http://minnie.tuhs.org/TiVo/files/howto/us/2.5.1/
```

The OzTiVo TWiki Site:

```
http://minnie.tuhs.org/TiVo
```

HMO Hacks

Owners of Series2 TiVos have the option of purchasing something called the Home Media Option.[3] For a one-time fee (with an additional lesser fee for each extra TiVo), users can get advanced features including remote scheduling via the web, video sharing among HMO-enabled Series2 TiVos, and the ability to view photos and play MP3 files from another computer within the house.

The way that photos and MP3s are shared with the TiVo is via software installed on your computer that communicates with your TiVo. On Windows it's an application, and on MacOS X it takes the form of a control panel. There is no support for Linux at the moment.

Luckily, TiVo has made the protocol for these communications public. You can download the specifications for the protocol from:

```
http://www.tivo.com/developer
```

A sample (yet buggy) Perl library and Perl CGI are available as well, that let you serve up music and photos from your Linux box to your TiVo.

HMO Server

Enhancements have been made to the Perl release by members of the TiVo community, and have been made available for download. Paul Linder (plinder on tivocommunity.com) fixed up the code pretty nicely and has a version available at:

```
http://www.inuus.com/~lindner/tivo/TiVoServer-0.12.tar.gz
```

The thread mentioning that link is:

```
http://www.tivocommunity.com/tivo-vb/showthread.php?threadid=111903
```

[3] At the time of this writing, DirecTV has declined to offer the Home Media Option to Series2 DirecTiVo owners.

Reading Email via HMO

Since the majority of Series2 users haven't lugged out their soldering iron to replace the PROM in their TiVos, they aren't able to install hacks such as TiVo Control Station (described in Chapter 8) or TPOP (described earlier in the chapter). Tobias Hoellrich (who runs the www.kahunaburger.com web site) put together a few tools and wrote some code to render his email into Portable Network Graphics (PNG) files which are viewable on your TiVo via the HMO's photo-viewing feature.

His description of how to do it (and what additional Perl modules you need) is located at:

```
http://www.kahunaburger.com/blog/archives/000052.html
```

Hearing Email via HMO

Building upon his experience from the work mentioned in the "Reading Email via HMO" section, Tobias Hoellrich next put together pieces to actually *speak* some of his email to him. His code called various tools to use a speech synthesizer to speak the first few lines of his email into a .wav file, converted that to MP3, then placed that in his music library where his TiVo could see it via the HMO's MP3-playing feature.

His description of how to do it (and what additional tools you need) is located at:

```
http://www.kahunaburger.com/blog/archives/000055.html
```

Current Weather/Radar via HMO

PhilCase on tivocommunity.com also described displaying data via the HMO's photo-viewing feature. In his case, he described how to get weather and radar maps, so you could see them on screen (Series1 users may also want to check out TCS's weather module in Chapter 8).

The thread where he talks about his approach is the "Using HMO for Current Weather and Live Radar (A How-To)" thread, at:

```
http://www.tivocommunity.com/tivo-vb/showthread.php?threadid=112907t
```

Advanced Work (Going Off on Your Own)

U sing hacks written by others is fine, but don't you have any ideas for things you'd like to do on your TiVo? If you own a TiVo and like writing code, it's not much of a leap to realize it'd be pretty damned cool to implement your own ideas.

Developing software for any new platform requires an investment of time and effort to learn the specifics of that platform. Developing for an *unsupported* platform is astoundingly more difficult since you must start with layers of reverse engineering, educated guesses, and experimentation.

This section aims to help developers who want to implement an idea for a TiVo hack, both by motivating them and showing them some of the knowledge that's already been accumulated about the TiVo platform.

Chapter 12 describes utilities you can use when writing and debugging your own hacks, or when observing the behavior of other programs. Chapter 13 talks about TiVo's custom Tcl interpreter tivosh and MFS. Chapter 14 talks about the hardware components inside your TiVo and what they do, including the data flow from signal reception to playback.

Chapter 15 is a guide to writing your own hacks. It describes tracking and implementing ideas, as well as development and release cycles. Detailed walkthroughs are included on writing TivoWeb and TCS modules. Steps for setting up a cross-compiler let you compile C/C++ programs for your TiVo.

Chapter 16 talks about hardware hacks that increase speed and memory, and repair/enhance your internal modem.

Hacking Utilities

There are some tools that you will find useful when you go off exploring and writing new hacks on your own. Many of these are just existing Linux tools compiled for the TiVo platform, but they are briefly covered here both to educate those who don't know about them and to indicate that TiVo versions of the tools exist. Appendix C covers Linux tools in general, and people unfamiliar with Linux should read it.

If you're familiar with the Linux tools mentioned below, feel free to skip that section and move onto the next chapter.

TiVo-Specific Utilities

There are two (well, three) utilities specific to TiVo that aren't covered elsewhere, so we'll discuss them here. Those utilities are `eclient`, which is a program that lets you monitor TiVo events flowing through the system, and `getpri/setpri`, which manage TiVo's custom priority mechanism.

eclient

The TiVo software uses *events* to communicate with itself about actions that occur. An event is thrown by some piece of code (say, for instance, when a remote-control keypress is detected by the infrared receiver), and somewhere in the system there is an event handler ready to handle that type of event.

We'll talk more about events in Chapters 12 and 14, but here we'll talk about a tool that lets you observe what events are being thrown in the system. Eric McDonald (MuscleNerd on tivocommunity.com) discovered that a mechanism exists within the TiVo software to communicate events over a network socket. He wrote a client program called `eclient` that demonstrates this mechanism. Using `eclient`, you can observe all of the events that occur during the normal use of your TiVo. This tool is a very handy tool when trying to figure out how the system works.

`eclient` can either be run on a remote system (to observe the TiVo events from an external machine), or directly on a TiVo itself. There are `eclient` binaries for Series1 TiVos, Series2 TiVos, and Red Hat Linux systems. Source code for `eclient` is available as well. If you installed the distribution on the accompanying CD-ROM in Chapter 4, then the Series1 `eclient` executable is already installed on your TiVo in `/var/hack/bin/eclient`, and the Red Hat Linux executable and source code are available on the CD-ROM under `/cdrom/doc/eclient`. If not, you can download `eclient` from the thread:

http://www.tivocommunity.com/tivo-vb/showthread.php?threadid=69105

After downloading the zip file, decompress it and move the file `eclient` onto your TiVo in the directory `/var/hack/bin`. Make sure it's executable by typing:

```
chmod 555 /var/hack/bin/eclient
```

Running eclient Locally (on the TiVo)

To run `eclient` locally on a TiVo, just type "`eclient`". To see a sample event, press some buttons on your TiVo remote and watch as the events are caught. Listing 12-1 shows the output of running `eclient` while a few buttons are pressed on the remote control, and Listing 12-2 shows the same button presses as observed with the -a option (which displays more types of events, in greater detail, including a hexadecimal dump of the event data for each event).

Listing 12-1: Output of Local eclient with No Arguments

```
=[tivo:root]-# eclient
Connected to local queue!
Remote:  TIVO
Display: TiVo Central
Remote:  SELECT
Display: Now Playing
Remote:  UP
Remote:  UP
Remote:  RIGHT
Display: Now Playing (detail)
Remote:  RIGHT
Display: Recorded program
Remote:  PAUSEKEY
« Ctrl-C »
=[tivo:root]-#
```

Listing 12-2: Output of Local eclient with "-a" Argument

```
=[tivo:root]-# eclient -a
Connected to local queue!
event: REMOTEEVENT (TIVO)
  0000001c 00000005 00000001 00000001 00000000 0ea447c3 1c133ba0 00000000
event: REMOTEEVENT
  0001001c 00000005 00000001 00000001 00000001 0ea447c3 2f2294e8 00000000
event: MW_STATUS
  0000001b 00000002 7ffff5a0 01c5165c 00000000 00000000 7ffff5b0 01c51750
event: REMOTEEVENT (SELECT)
  0000001c 00000004 00000001 00000001 00000000 0ea447c4 2da84030 00000000
event: REMOTEEVENT
  0001001c 00000004 00000001 00000001 00000001 0ea447c4 41515cc0 00000000
```

```
event: MW_STATUS
   0000001b 00000007 7ffff540 7ffff588 7f7f3efc 00000000 7ffff550 01c848dc
event: REMOTEEVENT (UP)
   0000001c 00000000 00000001 00000001 00000000 0ea447c4 e79f94c0 00000000
event: REMOTEEVENT
   0001001c 00000000 00000001 00000001 00000001 0ea447c4 f679c038 00000000
event: REMOTEEVENT (UP)
   0000001c 00000000 00000001 00000001 00000000 0ea447c5 65fdb978 00000000
event: REMOTEEVENT
   0001001c 00000000 00000001 00000001 00000001 0ea447c5 74d77790 00000000
event: REMOTEEVENT (RIGHT)
   0000001c 00000003 00000001 00000001 00000000 0ea447c6 284c27f8 00000000
event: REMOTEEVENT
   0001001c 00000003 00000001 00000001 00000001 0ea447c6 37373b90 00000000
event: MW_STATUS
   0000001b 00000008 7ffff530 7ffff578 00000001 7f827ed8 7ffff540 01c848dc
event: REMOTEEVENT (RIGHT)
   0000001c 00000003 00000001 00000001 00000000 0ea447c7 f3d9d8d8 00000000
event: REMOTEEVENT
   0001001c 00000003 00000001 00000001 00000001 0ea447c8 02bbd450 00000000
event: BACKHAUL
   000a002d 00110052 7ffff500 034d5600 0199d9e0 2f8a016d 00000000 00000003
event: MW_STATUS
   0000001b 00000079 7ffff4c0 01c35200 7f7e0bb8 00000000 00000001 7f8050c4
event: BACKHAUL
   0003002d 0100fffe 0000085f 3eacc48c 7f7dbfc4 034d5600 0199d9e0 7f839e54
event: BACKHAUL
   001a002d 00000001 fc0c950d 0000291b 00000000 00000000 7ffff6a0 01c8b000
event: REMOTEEVENT (PAUSEKEY)
   0000001c 0000001d 00000001 00000001 00000000 0ea447c9 a8c07b20 00000000
event: BACKHAUL
   0009002d 0000001d 000e0000 00019e54 00000000 7f7dad80 7ffff590 01cd9d28
event: REMOTEEVENT
   0001001c 0000001d 00000001 00000001 00000001 0ea447c9 bc5ea300 00000000
« Ctrl-C »
=[tivo:root]-#
```

Note that in Listing 12-2 we witness not only the REMOTEEVENT event for the keypress, but also other events that were thrown as a result of that action (such as MW_STATUS and BACK-HAUL). Using the -A argument generates the same output as -a, except that *heartbeat events* are displayed as well. The heartbeat event is used to make sure the system is still running smoothly. Since a heartbeat event is generated about once every 2–3 seconds, the output generated by the -A argument can grow pretty long if allowed to run for a long time.

Running eclient Remotely (on Your PC)

To run eclient from a remote machine is a bit more work, but not much more. First, the TiVo to be observed needs to have the environment variable tcp_tvbus set to 1 in the boot script /etc/rc.d/rc.sysinit. Follow these steps:

STEPS: Setting tcp_tvbus in /etc/rc.d/rc.sysinit

1. Telnet into your TiVo (see Chapter 5 if that's not set up yet).

2. Type the following command to remount the root partition as read-write:

   ```
   mount -o remount,rw /
   ```

 Between now and the time that we remount it as read-only below, be careful not to unplug the machine. The main reason that the root filesystem can handle abrupt power disconnects is because it's mounted as read-only.

3. Move to the /etc/rc.d directory by typing

   ```
   cd /etc/rc.d
   ```

4. Make a backup copy of rc.sysinit via:

   ```
   cp rc.sysinit rc.sysinit.ORIG
   ```

5. Edit rc.sysinit and add the following line before the first occurrence of the word "switcherstart" within the file:

   ```
   export tcp_tvbus=1
   ```

6. Remount the root partition as read-only again:

   ```
   mount -o remount,ro /
   ```

Reboot your TiVo, causing the environment variable tcp_tvbus to be set to 1 before switcherstart starts. Now your TiVo will accept TCP connections on port 53162, using the protocol demonstrated by the eclient tool (as seen in eclient's source code).

To connect remotely, you need a version of eclient compiled for the computer that you're using. A compiled version of eclient for Red Hat Linux exists in the zip file you downloaded (or it's on the accompanying CD-ROM at: /cdrom/nonTiVoFiles/eclient.redhat). When running it you can specify the same arguments as in the "Running eclient Locally (on the TiVo)" section above, but you also need to specify the hostname of the TiVo you wish to connect to. Listing 12-3 shows the remote equivalent of Listing 12-1.

Listing 12-3: Output of Remote eclient

```
# eclient.redhat 192.168.1.101
Connected to remote queue!
Remote:  TIVO
Display: TiVo Central
Remote:  SELECT
Display: Now Playing
Remote:  UP
Remote:  UP
Remote:  RIGHT
Display: Now Playing (detail)
Remote:  RIGHT
```

```
Display: Recorded program
Remote:  PAUSEKEY
« Ctrl-C »
#
```

getpri/setpri

There are standard Linux methods for controlling the priority of processes within your system, but TiVo doesn't use any of these. Instead, they have their own priority system, with their own commands to modify priority levels. The official commands that ship with the TiVo software are the tivosh internal commands getpri and setpri described in Chapter 13, though stand-alone executable versions of these exist as well.

If you installed the distribution on the accompanying CD-ROM in Chapter 4, then the two executable commands getpri and setpri are already installed on your TiVo in /var/hack/bin/. If not, you can download both of them (including the source code) from:

```
http://tivo.samba.org/download/mbm/bin/getpri
http://tivo.samba.org/download/mbm/bin/setpri
http://tivo.samba.org/download/mbm/src/getpri.c
http://tivo.samba.org/download/mbm/src/setpri.c
```

Be sure to make both commands executable:

```
chmod 555 /var/hack/bin/getpri
chmod 555 /var/hack/bin/setpri
```

For a given process, you set the scheduling policy, and the priority. "ts" stands for time-sharing, "rr" stands for round-robin, and "fifo" stands for first-in-first-out. If the <pid> argument is omitted, the current process' process-id is used.

Be careful when modifying the priority of system processes or raising your own processes to a higher priority than the system processes. Setting priorities incorrectly can result in video stuttering, a general sluggishness of the UI, and other problems.

The getpri command takes one argument—the ID of the process you wish to examine the priority of. The setpri command takes three arguments: the scheduling policy ("ts", "rr", or "fifo"), the priority (larger numbers indicate a higher priority), and the ID of the process to set the priority of.

Linux Utilities

There are a bunch of utilities that are really useful for learning about your TiVo. People have had to port these over since for one reason or another, these programs aren't included in the TiVo software distribution. I'll describe them all briefly here, then talk about where to get them.

cron

Suppose that you write a small chunk of code to delete all recorded TiVo Suggestions that contain an actor you don't like. Rather than then having to write scheduling code to perform that task every 24 hours, you could instead schedule that program to run with cron.

cron is a generic scheduling tool used in all flavors of Unix to run tasks at given times. For each task you want to schedule, you include a line in your crontab file (the version of cron compiled for the TiVo looks at /var/hack/etc/crontab). You start the cron daemon itself once at boot time, and it monitors all crontab files for changes[1], triggering scheduled events when it's time to do so.

Each line in the crontab file is made up of six fields:

1. **Minute.** Values range from 0–59.

2. **Hour.** This is in military time (GMT-based). Values range from 0–23.

3. **Day of month.** Values range from 1–31.

4. **Month.** Values range from 1–12.

5. **Day of week.** Values range from 0–7, where Sunday is 0 or 7.

6. **Command line** to run at the specified time.

For instance, to specify that you want the command mycustomhack to run once per year, at precisely 3:59 P.M. on May 22nd. You could use the line:

```
59 15 22 5 * /var/hack/root/mycustomhack
```

The "*" in the fifth field indicates that you don't care which day of the week May 22nd falls on — you only care about it being May 22nd. An "*" can be used in any of the fields — so for instance to schedule a backup of your /var/hack directory partition every night at 2 A.M., you could say something like:

```
0 2 * * * rsync --numeric-ids -PavzH /var/hack 192.168.1.2::tivobkup/.
```

The "*"s mean that you don't care what day or month it is, as long as the command runs at 2:00 A.M.

Note the 0 in the first (minute) field — you wouldn't want to use a "*" there, as it would cause the command to run *every minute* between 2:00 A.M. and 2:59 A.M., every night.

The numeric values specified above can also be of the form "*/x", which can be read as "every x (units)". For instance the line:

```
0 12 */2 * * /var/hack/root/everyotherdaylunchscript
```

runs the command at noon on odd-numbered days.

[1] Actually on normal Unix systems, you must edit your crontab file via a command also named crontab, which informs the cron daemon of changes. The version of cron compiled for the TiVo doesn't have this requirement (in fact there is no "crontab" command).

Finally, you can also specify ranges, such as `1-10`, and lists, such as `3,5,9`. A complicated (and quite contrived) example is:

```
*/2 7,15-18 x 9-12,1-6 [1-5] /var/hack/root/tvoff_homework
```

If `tvoff_homework` was a script that blanked out the video to discourage TV watching during homework time for the kids, you could use the above `crontab` entry to run it every 2 minutes, from 7 A.M.–8 A.M. and 3 P.M.–6 P.M., on weekdays, during the school year. Of course anyone who remembers childhood will agree that was a contrived example, because that would never deter your kids. Hide those torx screwdrivers!

Note

All of the above examples are actually wrong because none of the times were adjusted to Greenwich Mean Time (GMT), and they need to be. I held off stressing that point until now to make the examples more readable. On a TiVo, the command line utility "date" will always report the current time according to GMT—you can use that to help you remember your timezone offset. For instance, for the above examples to work in Boston during the summer, the hours fields for the above examples should have been "19", "6", "16", and "11,19-22", respectively.

Day and month names (Jan, Feb, Mon, Tue, etc.) can be used for the day-of-week and month fields respectively (use the first three characters of each name), but ranges (for example, `Jan-Mar`) are *not* allowed. Instead you can use lists and specify each day or month you want:

```
0 14 * Jun,Jul,Aug Sun /var/hack/bin/jpegwriter /var/hack/root/mowlawn.jpg
```

If you specify both a day-of-month value and a day-of-week value, *either* rule will cause the triggering of the command. So for example:

```
0 12 2,4,6 * 1 command
```

will cause command to be run at noon on the second, fourth, and sixth days of the month, *as well as every Monday*. This seems a bit counterintuitive, but maybe it's a bit more useful. The trivial downside is that you can't specify a rule like "On September 19th only during years where it lands on a Tuesday."

If you installed the software distribution on the accompanying CD-ROM, following the instructions in Chapter 4, then `cron` is already installed in `/var/hack/bin/cron`, and the `crontab` file is in `/var/hack/etc/crontab`. In the startup script `/var/hack/etc/hacks_callfromrc.sysinit`, I've left `cron` enabled by default (since with an empty `crontab` file it won't affect system performance in any noticeable way), so you won't have to add that either; `cron` will start after each reboot.

If you didn't install the software distribution, you can download `cron` yourself from:

```
ftp://ftp.alt.org/pub/tivo/dtype/cron-3.0pl1_TiVo-2.tar.gz
```

You first have to create three directories, via:

```
mkdir /var/hack/cron /var/hack/etc /var/hack/etc/cron.d
```

Then unpack the downloaded file. Place `cron` in `/var/hack/bin/`, and place `crontab` in `/var/hack/etc`. Make sure that `cron` is executable via:

```
chmod 555 /var/hack/bin/cron
```

To get `cron` to start up after every reboot, add the following lines to either `/var/hack/etc/hacks_callfromrc.sysinit` (if you set that up previously to be called from `/etc/rc.d/rc.sysinit`), or directly to `/etc/rc.d/rc.sysinit` itself:

```
if test -x /var/hack/bin/cron
then
   /var/hack/bin/cron
fi
```

strace

The `strace` command (which is similar to `truss`, `ktrace`, and `trace` from other Unix systems) lets you track what system-calls an executable makes when it runs. This isn't a debugger—you don't need the source code to the program to do the trace; `strace` intercepts the calls made by any old executable you throw at it. You can start a process with `strace`, or attach to an existing process after it has already started.

This is extremely useful in figuring out how things work. For instance, Listing 12-4 shows a trace of the TiVo program `text2osd` (which draws text on the screen) in action.

Listing 12-4: Starting and Tracing text2osd with strace

```
=[tivo:root]-# echo "testing 1 2 3 4 5 6 7 8 9 10" | strace text2osd
execve("/tvbin/text2osd", ["text2osd"], [/* 35 vars */]) = 0
brk(0)                                  = 0x1848c28
open("/etc/ld.so.preload", O_RDONLY)    = -1 ENOENT (No such file or dir)
open("/var/hack/lib/libc.so", O_RDONLY) = -1 ENOENT (No such file or dir)
open("/lib/libc.so", O_RDONLY)          = 3
mmap(ptrace: umoven: Operation not permitted
)                                       = 0x3000d000
munmap(0x3000d000, 4096)                = 0
mmap(ptrace: umoven: Operation not permitted
)                                       = 0x30050000
mprotect(0x300eb000, 378916, PROT_NONE) = 0
mmap(0, 0, PROT_NONE, MAP_FILE, 0, 0)   = 0x30120000
mmap(0, 0, PROT_NONE, MAP_FILE, 0, 0)   = 0x30139000
close(3)                                = 0
mmap(ptrace: umoven: Operation not permitted
)                                       = 0x3000d000
fstat(0, {st_mode=S_IFIFO|0600, st_size=29, ...}) = 0
mmap(ptrace: umoven: Operation not permitted
)                                       = 0x30148000
read(0, "testing 1 2 3 4 5 6 7 8 9 10\n", 4096) = 29
read(0, "", 4096)                       = 0
close(0)                                = 0
munmap(0x30148000, 4096)                = 0
mmap(ptrace: umoven: Operation not permitted
)                                       = 0x30148000
open("/dev/mpeg0v", O_WRONLY)           = 0
```

```
ioctl(0, 0x403, 0x7ffffb08)          = 0
ioctl(0, 0x404, 0)                   = 0
ioctl(0, 0x405, 0x10)                = 0
ioctl(0, 0x3f3, 0x10)                = 0
exit(0)                              = ?
=[tivo:root]-#
```

Running strace on text2osd showed some interesting things: the directory /var/hack/lib is checked for libc.so by TiVo's own software, the device /dev/mpeg0v is the device accessed, and the ioctl commands sent to it are 0x403, 0x404, 0x405, and 0x3f3 (see Chapter 14 for more information about ioctls).

The syntax above used strace to start a new program (text2osd). You can also attach to an existing process using "-p", and stop tracing any time you want by interrupting with Ctrl-C. Listing 12-5 shows a portion of an strace of the fancontrol process that's always running on your TiVo.

Listing 12-5: Tracing Existing fancontrol Process with strace

```
=[tivo:root]-# ps x | grep fancontrol
  135  ?   S    0:02 fancontrol
  947  p0  SW   0:00 grep fancontrol
=[tivo:root]-# strace -p 135
open("/proc/therm", O_RDONLY)        = 3
read(3, "33C\n", 256)                = 4
close(3)                             = 0
open("/dev/fan", O_RDWR)             = 3
ioctl(3, 0x20004600, 0x7)            = 0
close(3)                             = 0
nanosleep({30, 0}, {30, 0})          = 0
open("/proc/therm", O_RDONLY)        = 3
read(3, "33C\n", 256)                = 4
close(3)                             = 0
open("/dev/fan", O_RDWR)             = 3
ioctl(3, 0x20004600, 0x7)            = 0
close(3)                             = 0
nanosleep({30, 0}, [« Ctrl-C »] <unfinished ...>
detach: ptrace(PTRACE_DETACH, ...): Operation not permitted
=[tivo:root]-#
```

The "-s <strsize>" argument lets you change the maximum size of strings that are printed (the default is 32). The "-e" argument lets you limit which system calls to trace; "-e trace=file" traces only file-related system calls, "-e trace=signal" traces only signal-related calls, etc. You can also specify specific system calls to trace (for example, "-e trace=mkdir,ioctl,unlink").

There are many arguments to strace; you can get a list of all of them by typing "strace -h", or by consulting strace's man page (which also contains more details on the "-e" command above). A text copy of the documentation (its man-page) is on the accompanying CD-ROM under /cdrom/doc/strace_manpage.txt.

If you installed the software distribution on the accompanying CD-ROM in Chapter 4, then strace is already installed in /var/hack/bin/strace. If not, the following two downloads both contain versions of strace for your TiVo:

```
http://prdownloads.sourceforge.net/tivoutils/native_compiler_tivo.tar.gz
http://www.9thtee.com/tivo-bin.tar.gz
```

Download one of them, unpack it, and locate a file named strace within it. Copy it to /var/hack/bin, and make it executable via:

```
chmod 555 /var/hack/bin/strace
```

lsof

To see what files are currently open by one or more processes, you use the lsof command. By default it displays all open files for all running processes, but you can limit it to just showing the files from a particular process as well via the "-p <process-id>" argument. You can also display just the open files from within a given directory.

Listing 12-6 shows the output of running lsof on the myworld process; you can see all open devices, sockets, and directories.

Listing 12-6: Listing Open Files/Sockets/Devices with lsof

```
=[tivo:root]-# ps x | grep /tvbin/myworld
  186  ?  S   0:06 /tvbin/myworld
 1016  p1 SW  0:00 grep /tvbin/myworld
=[tivo:root]-# lsof -p 186
COMMAND PID USER FD   TYPE    DEVICE   SIZE  NODE NAME
myworld 186 root cwd  DIR      3,4     2048 26625 [0304]
myworld 186 root rtd  DIR      3,4     1024     2 [0304]
myworld 186 root txt  REG      3,4   675372 26682 [0304]
myworld 186 root 0r   CHR      1,3          14343 /dev/null
myworld 186 root 1w   CHR      1,100        14348 /dev/console
myworld 186 root 2w   CHR      1,100        14348 /dev/console
myworld 186 root 3u   unix 0x80fffd20        1809 [0000]
myworld 186 root 4u   unix 0x8050fd00        1811 /tmp/S_EvtSwtchrSckt118
myworld 186 root 5u   inet     1813          TCP *:53162 (LISTEN)
myworld 186 root 6u   unix 0x804aa420        1846 /tmp/S_EvtSwtchrSckt118
myworld 186 root 7u   unix 0x804aa700        1847 /tmp/S_EvtSwtchrSckt118
myworld 186 root 8u   unix 0x804a8100        1922 /tmp/S_EvtSwtchrSckt118
myworld 186 root 9u   unix 0x804a8c80        1943 /tmp/S_EvtSwtchrSckt118
myworld 186 root 10u  unix 0x80441980        1954 /tmp/S_EvtSwtchrSckt118
myworld 186 root 11u  unix 0x805230c0        1966 /tmp/S_EvtSwtchrSckt118
myworld 186 root 12u  unix 0x802e9c00        1977 /tmp/S_EvtSwtchrSckt118
myworld 186 root 13u  unix 0x80649620        1980 [0000]
```

```
myworld 186 root 14u unix 0x80649be0        1982 [0000]
myworld 186 root 15r  BLK      3,10        14414 /dev/hda10
myworld 186 root 16u  BLK      3,10        14414 /dev/hda10
myworld 186 root 17u  BLK      3,11        14416 /dev/hda11
myworld 186 root 18u  BLK      3,12        14418 /dev/hda12
myworld 186 root 19u  BLK      3,13        14420 /dev/hda13
myworld 186 root 20u  BLK      3,66        14399 /dev/hdb2
myworld 186 root 21u  BLK      3,67        14401 /dev/hdb3
myworld 186 root 22w  CHR    127,2         14392 /dev/mixaud2
myworld 186 root 23u  CHR      1,1         14341 /dev/mem
myworld 186 root 24u  CHR      1,11        14347 /dev/mem2
myworld 186 root 25u  CHR      1,11        14347 /dev/mem2
myworld 186 root 26w  CHR     78,8         14394 /dev/mpeg0v
myworld 186 root 27w  CHR     78,4         14393 /dev/mpeg0a
myworld 186 root 28u  CHR     90,4         14356 /dev/mswitch0a
myworld 186 root 29u  CHR     90,8         14359 /dev/mswitch0v
myworld 186 root 30u  CHR     90,28        14365 /dev/mswitch0vbi
myworld 186 root 31u  CHR     90,20        14364 /dev/mswitch0vsync
myworld 186 root 32r  CHR      1,1         14341 /dev/mem
myworld 186 root 33r  CHR     90,16        14362 /dev/mswitch0e
myworld 186 root 34u unix 0x809dfba0        2005 /var/tmp/SrlPrtArbtratr
myworld 186 root 35u  CHR      4,64        14349 /dev/ttyS0
myworld 186 root 36u  CHR     78,8         14394 /dev/mpeg0v
=[tivo:root]-#
```

As with `strace`, there are many arguments to `lsof`; you can get a list of all of them by typing "`lsof -h`", or by consulting `lsof`'s man page. A text copy of the man page is on the accompanying CD-ROM under `/cdrom/doc/lsof_manpage.txt`.

If you installed the software distribution on the accompanying CD-ROM in Chapter 4, then `lsof` is already installed in `/var/hack/bin/lsof`. If not, you can download a copy of `lsof` for your TiVo from:

`http://www.xse.com/leres/tivo/downloads/lsof/lsof`

Download it, and place it in `/var/hack/bin`. Make sure it is executable via:

`chmod 555 /var/hack/bin/lsof`

strings

The `strings` command scans through a file (or standard input), printing all sequences of printable characters of at least four characters in length. This is useful when looking through a binary file (such as a compiled executable program) for some data embedded within it.

Error messages, usage strings, hard-coded filenames and paths, and any other messages lying around inside are all easily viewed with the `strings` command (along with all of the other output that gets caught in the net).

While the entire output of running `strings` on any of the TiVo executables is too long to list here, I'll show just a few snippets (see Listing 12-7).

```
=[tivo:root]-# strings /tvbin/tivosh
xH+j
xHN^
?E89)
#x8`
xHNc

[... Portion Skipped ...]

setsema
MakeMempoolItem
0x%#x
transaction
itrans
exit
holdoff
usage: transaction { list ... }
transaction already active
%s (%s)
commit failed
usage: itrans [start|abort|commit]
start
abort
commit
transaction not active
transaction aborted
unknown interactive transaction command
aborting open transaction ...
« Ctrl-C »
=[tivo:root]-#
```

Note the garbage at the beginning (that went on for about 500 pages). One way to reduce the amount of garbage strings that `strings` catches is by increasing the minimum required string length from 4 to something larger, via "`-n <minsize>`". Running "`strings -n 15 /tvbin/tivosh`" brought up interesting strings within a page or so, but would have eliminated small valid strings such as "`itrans`" and "`setsema`" above. As such it usually makes sense to either redirect the output of `strings` to a file (e.g. "`strings /tvbin/tivosh > /tmp/strings_in_tivosh`"), or to pipe the output of strings to `less` (e.g. "`strings /tvbin/tivosh | less`").

If you installed the software distribution on the accompanying CD-ROM in Chapter 4, then `strings` is already installed in `/var/hack/bin/strings`. If not, you can download a copy of `strings` for your TiVo from:

```
ftp://ftp.courtesan.com/pub/millert/TiVo/strings.gz
```

Download it, uncompress it, and place it in /var/hack/bin. Make sure it is executable via:

```
chmod 555 /var/hack/bin/strings
```

objdump

The objdump program displays information about object files. The specific function it performs that's worth mentioning here is that it disassembles executables (with the "-d" argument). Listing 12-8 shows a partial listing of the output of an objdump disassembly.

Listing 12-8: Partial Output of "objdump -d /tvbin/fancontrol"

```
=[tivo:root]-# objdump -d /tvbin/fancontrol
objdump: /tvbin/fancontrol: No symbols

/tvbin/fancontrol:      file format elf32-powerpc

Disassembly of section .text:

01800b40 <.text>:
  1800b40:       3d a0 01 84     lis     r13,388
  1800b44:       61 ad db 14     ori     r13,r13,56084
  1800b48:       2c 1f 76 54     cmpwi   r31,30292
  1800b4c:       41 82 00 28     beq     0x1800b74
  1800b50:       7c 3d 0b 78     mr      r29,r1
  1800b54:       38 21 ff c0     addi    r1,r1,-64
  1800b58:       80 7d 00 00     lwz     r3,0(r29)
  1800b5c:       38 9d 00 04     addi    r4,r29,4
  1800b60:       7c 85 23 78     mr      r5,r4
« Ctrl-C »
=[tivo:root]-#
```

Since that was run on a Series1 TiVo executable (in this case, fancontrol), the output is PowerPC assembly code. Needless to say, if you don't know PowerPC assembly, it won't mean much to you; however, if you do (in which case you're probably already familiar with objdump), then it's a good tool to have on hand.

If you installed the software distribution on the accompanying CD-ROM in Chapter 4, then objdump is already installed in /var/hack/bin/objdump. If not, the following download contains a version of objdump compiled for your TiVo:

```
http://sekrut.net/~tivo/s1/native_compiler_tivo.tar.gz
```

Download it, unpack it, and locate a file named objdump within it. Copy it to /var/hack/bin, and make it executable via:

```
chmod 555 /var/hack/bin/objdump
```

tivosh and Playing with MFS

Luckily for us, TiVo made some interesting decisions when writing the software for its devices. It seems that they realized that a good portion of the code needed to be fast and efficient, while other code should be easier to design and tweak. To accomplish this they wrote a lower level in C/C++, which was fast and compiled, and a higher level in an interpreted scripting language.

They created this abstraction layer by having the main process in the system — myworld — also act as a Tcl interpreter.[1] This let them write scripts in Tcl that could access compiled functions.

This separation of code served multiple purposes. Compiled, efficient functions could perform important actions such as controlling devices and accessing file systems, while interpreted scripting languages could use these low-level functions to coordinate a higher-level design.

From the looks of it, the benefits for the TiVo development team included easier testing and the ability to tweak scripts without requiring a recompile, while at the same time being able to move more sensitive or performance-critical functions deeper into the system. They were able to compile the code that read their proprietary media file system (MFS) into myworld itself, and create functions that let Tcl scripts easily access this data. This way the audio, video, and meta information could still be accessed by simple Tcl scripts, though the actual code handling this access was efficient, compiled, driver-like code.

[1] Tcl (Tool Command Language) is a scripting language where the interpreter is custom to your application. You build your own custom Tcl interpreter that also knows about low-level functions you've compiled into it. Appendix B gives a brief intro to Tcl. And yes, that's the way it's supposed to be capitalized, even though it's an acronym.

Again, it's lucky for us that they chose this approach, as it benefits us as well. Since Tcl scripts are interpreted (not compiled), they're there for the reading. There are many examples in which you can see how to use the internal functions built into myworld. With a simple Tcl script, you can get access to metadata about almost everything in your TiVo from the database portion of MFS.

This chapter discusses some of those internal functions, and how to use them yourself from a Tcl script. It also talks about the MFS database that these functions provide access to, and gives some examples of data in that database that you can programmatically access and modify.

 Caution You should have a backup of your TiVo before you even consider mucking around with tivosh commands. The goal of this chapter is to get you to explore, and in that exploration all sorts of horrible things could happen, from rebooting your TiVo to corrupting the database. You've been warned.

tivosh

The three executables myworld, tivosh, and tivoapp are all actually the same program (myworld and tivosh are symbolic links to tivoapp). When being run as myworld, it acts as the user interface for the TiVo, drawing menus on the screen, performing recordings, and so on. When being run as tivosh, it acts as a Tcl interpreter that can understand various compiled-in TiVo-specific commands. If run directly on the command line, you can even enter commands to it directly, though it's more commonly run via Tcl scripts that start with the line "#!/tvbin/tivosh". tivosh processes interpreting Tcl scripts should never be killed via kill, as it will cause your TiVo to reboot if they were accessing MFS at the time.

When it starts up, tivosh first reads three files: /tvlib/itcl/itcl.tcl, /tvlib/tcl/init.tcl, and /tvlib/tcl/tv/tv.ini. That last file tv.ini then causes another three files to be read: /tvlib/tcl/tv/Inc.itcl, /tvlib/tcl/tv/fsdir.tcl, /tvlib/tcl/tv/dumpobj.tcl. dumpobj.tcl then causes /tvlib/tcl/tv/mfslib.tcl to be read as well. All of the commands that you have access to in tivosh are either procedures defined in one of these seven files, or C/C++ commands compiled into tivosh.

Since most of the interesting commands are related to accessing MFS, let's move ahead to talking about MFS and discuss the built-in (and external) commands as we encounter them.

MFS

MFS is the proprietary internal database that TiVo uses to store most of its data (including video, audio, scheduling information, To Do Lists, and configuration information). The database is hierarchical, looking something like a directory tree with files in it. It's stored on disk in the form of two proprietary partition types: the MFS Application region, and the MFS Media region. Access to the Application portion of this database is possible via commands in tivosh. See Figure 13-1.

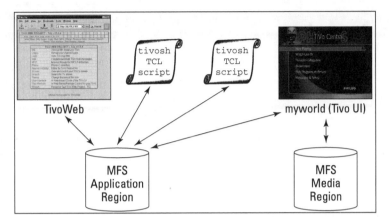

Figure 13-1: Accesses to Application and Media Regions of MFS database.

All elements in this "directory" structure are one of four types: tyDir, tyDb, tyFile, or tyStream. Various convenience functions exist to handle three of these four types. tyDir objects represent directories in this tree, and can be viewed with the mls command. tyDb objects are database entries, which can be printed (recursively if desired) via dumpobj. tyFile objects represent actual files within the MFS filesystem, such as image or sound files for the user interface, or index files for searching. tyFiles can be moved to and from MFS with the ToMFS and FromMFS commands. tyStream objects represent the combined audio and video of a show you've recorded; unlike other MFS objects, they live in the MFS Media Region partition on disk. There is very little support via Tcl for tyStream objects.[2]

The rest of this section details the MFS-related commands in the system (some of them built-in to tivosh, and other Tcl scripts that use those primitives to build convenience functions).

mls

The tivosh command mls (defined in /tvlib/tcl/tv/fsdir.tcl) lists this hierarchy. Listing 13-1 shows how to list all objects on the top level (/) of the database hierarchy. Each line of these listings represents either another directory of data (tyDir), a database entry (tyDb), an actual file residing in MFS (tyFile), or a video/audio stream also residing in MFS (tyStream).

[2] The reason there is very little support via Tcl for tyStreams is probably that it wasn't necessary to extract digital audio/video from machines directly during TiVo's internal testing phases (which seem to be what the Tcl interface was primarily used for — testing). Various tools now exist to extract the data from these tyStreams, and they are discussed in Chapter 10. Discussion of the topic of video extraction is not acceptable on tivocommunity.com per orders of the forum administrator David Bott, though it is acceptable just about everywhere else.

Listing 13-1: Using mls to View the MFS Database Hierarchy

```
=[tivo:root]-# tivosh
% mls /
Directory of / starting at `'
```

Name	Type	FsId	Date	Time	Size
----	----	----	----	----	----
Anchor	tyDir	674118	03/27/03	09:30	4036
AreaCode	tyDir	27597	10/13/11	09:36	16
AuxInfo	tyDir	704952	11/21/01	18:57	32
Avalanche	tyDir	1095178	06/24/02	08:27	20
CaptureRequest	tyDir	634586	06/19/02	19:34	68
Clips	tyDir	674120	11/04/01	09:30	44
Component	tyDir	212	08/23/99	16:22	40
CorrelationIndexPart	tyDir	1080332	06/17/02	11:38	16
DataSet	tyDir	1995	03/27/03	13:37	668
Database	tyDir	1615	04/02/03	22:20	224
Genre	tyDir	76	01/29/03	06:20	2856
GuideIndex	tyDir	205885	06/17/02	07:21	4
GuideIndex.temp	tyDir	203632	06/16/02	01:59	4
GuideIndexV2	tyDir	1080187	04/02/03	20:41	372
GuideIndexV2.temp	tyDir	1080155	04/02/03	20:41	4
Headend	tyDir	2201	02/19/01	21:06	32
HeadendPostalCode	tyDir	2202	03/02/02	14:20	284
HeadendTms	tyDir	2203	02/19/01	21:06	36
LeadGeneration	tyDir	903922	03/21/03	12:55	136
LinkTag	tyDir	704956	02/18/02	01:57	4
LogoGroup	tyDir	205783	01/18/01	19:10	52
MenuItem	tyDir	652458	10/23/01	10:29	12
MessageItem	tyDir	27562	10/12/00	18:02	48
ObjectType	tyDir	3	10/24/01	04:26	4
Package	tyDir	2219	04/02/03	04:30	3888
Person	tyDir	34155	01/20/01	06:27	32
PostalCode	tyDir	2205	10/11/00	02:11	16
Preference	tyDir	27236	10/11/00	04:48	12
Recording	tyDir	1883	06/24/02	08:22	384
Resource	tyDir	1280	08/23/99	17:30	72
Rubbish	tyDir	203551	04/02/03	22:20	20
Schedule	tyDir	203552	03/29/03	11:44	1212
ScheduledAction	tyDir	27214	01/18/01	07:03	4
SeasonPass	tyDir	27210	06/17/02	07:26	76
SeriesTitleGS	tyDir	26887	03/27/03	13:13	3440
Server	tyDir	4	04/02/03	20:58	1848
Service	tyDir	1083343	06/17/02	11:58	24
Setup	tyDb	1878	03/29/03	21:17	18200
Showcase	tyDir	2309	04/01/03	08:27	484
ShowcaseIndex	tyDir	634526	04/02/03	20:09	216
ShowcaseIndex.temp	tyDir	634560	04/02/03	20:09	4
State	tyDir	203578	06/17/02	07:06	212

```
       StationTms                tyDir     634572   03/27/03 13:01    5180
       SwModule                  tyDir         72   06/20/02 13:22     148
       SwSystem                  tyDir       1877   06/19/02 10:03      40
       Table                     tyDir     205458   01/18/01 19:06      52
       Theme                     tyDir     203657   03/19/03 11:52    1640
       TiVoClipPass              tyDir     653002   06/17/02 07:06       4
       Uri                       tyDir    1087053   06/21/02 04:28      20
       User                      tyDir     203584   06/17/02 07:06      20

       ...

%
```

In Listing 13-1 we run `tivosh` interactively by typing `tivosh` and get the `%` prompt. Upon entering `mls /`, we get to see the top level of the MFS database. `tivosh`'s `mls` has the strange design quirk that the output is truncated after 50 entries (probably for performance reasons, to break transactions up into smaller chunks). To continue listing `/`, you use the bizarre syntax of specifying the entry to start listing with, followed by a `/`. For example, to continue listing `/` starting with the `State` entry near the bottom of Listing 13-1, you'd type `mls /State/` (see Listing 13-2).

Listing 13-2: Continuing an mls Listing

```
% mls /State/
Directory of / starting at 'State'

    Name                     Type       FsId      Date  Time    Size
    ----                     ----       ----      ----  ----    ----
    State                    tyDir     203578   06/17/02 07:06    212
    StationTms               tyDir     634572   03/27/03 13:01   5180
    SwModule                 tyDir         72   06/20/02 13:22    148
    SwSystem                 tyDir       1877   06/19/02 10:03     40
    Table                    tyDir     205458   01/18/01 19:06     52
    Theme                    tyDir     203657   03/19/03 11:52   1640
    TiVoClipPass             tyDir     653002   06/17/02 07:06      4
    Uri                      tyDir    1087053   06/21/02 04:28     20
    User                     tyDir     203584   06/17/02 07:06     20
    Uuid                     tyDir       2209   03/27/03 03:45   4300
    tmp                      tyDir      27246   04/02/03 22:19      4

%
```

The reason that syntax is bizarre is because you would think `mls /State/` would list the `/State` directory, but it doesn't; it lists the `/` directory, starting with `State`. To actually list the `/State` directory, you use `mls /State` (with no trailing slash), as shown in Listing 13-3.

Listing 13-3: Listing a Subdirectory with mls

```
% mls /State
Directory of /State starting at ''

    Name                Type       FsId       Date   Time    Size
    ----                ----       ----       ----   ----    ----
    ArmConfig           tyDb    1080149    04/02/03 12:41     248
    AvConfig            tyDb    1080145    12/12/02 00:45      60
    Avalanche           tyDb     634517    02/03/03 09:32     128
    Database            tyDb     203580    04/02/03 20:41     100
    GeneralConfig       tyDb    1080146    02/09/03 17:13     100
    LocationConfig      tyDb    1080148    06/17/02 07:06      88
    Media               tyDb     634519    10/20/01 22:45      60
    Modem               tyDb     634566    06/16/02 09:06      60
    MyWorld             tyDb     203582    04/02/03 22:20     116
    PhoneConfig         tyDb    1080147    04/02/03 22:19     236
    ServiceConfig       tyDb    1080150    04/02/03 12:41    2536
    UpdateHistory       tyDb     203577    01/18/01 07:10      68

%
```

There is no equivalent of cd; all MFS paths must be absolute, starting with /.

Steven Lang (tiger on tivocommunity.com) created a separate, compiled version of mls, which allows you to list a whole directory at once. If you installed the software all at once in Chapter 4 from the accompanying CD-ROM, then it's currently installed on your TiVo in /var/hack/bin/mls. If not, you can download it at:

```
http://www.tyger.org/~tiger/tivo/mls.tivo
```

Its syntax is almost opposite that of tivosh's mls with regard to trailing /'s; typing "mls /State/" is required to view the State directory, while "mls /State" just displays the single line representing the directory (like the -d option for the Unix command ls).

Another good tool for listing parts of the MFS database is TivoWeb's MFS module. See Figures 7-19, 7-20, and 7-21 in Chapter 7.

And now, you can even list the MFS database when your TiVo is turned off and its drives are connected to your PC. Steven Lang's mls executable exists in PC form as well, and is part of the mfstools distribution. Next time that you have your TiVo's drive(s) attached to your PC (you need both connected if you have two), you can try it out. Boot the accompanying CD-ROM, and the executable is already in your path (in /bin/mls). Before running it though, you must set the variable MFS_HDA (and MFS_HDB also, if you have two drives) to point to your A (and B) drives:

```
=[HackingTiVoCD]-# export MFS_HDA=/dev/hdc
=[HackingTiVoCD]-# mls
    Name                Type       FsId       Date   Time    Size
    ----                ----       ----       ----   ----    ----
    Anchor              tyDir    674118    04/03/03 09:30    3644
```

```
      AreaCode                tyDir      27597  10/13/11 09:36     16
      AuxInfo                 tyDir     704952  11/21/01 18:57     32

      ...
```

dumpobj

You can display a tyDb database entry with the tivosh command dumpobj (defined in
/tvlib/tcl/tv/dumpobj.tcl). For example, Listing 13-4 shows the dump of the MFS
object /State/LocationConfig.

Listing 13-4: Displaying Database Entry with dumpobj

```
=[tivo:root]-# tivosh
% dumpobj /State/LocationConfig
LocationConfig 1080148/10 {
  DaylightSavingsPolicy = 2
  IndexPath       = /State/LocationConfig
  PostalCode      = 01844
  TimeZoneOld     = 1
  Version         = 1
}
%
```

This particular object had fields whose values were all simple values. PostalCode, for
instance, is the value of the zip code you've told your TiVo that you live in. Objects can also
have fields that point to other database objects. Listing 13-5 shows dumpobj output for a
SeasonPass object (whose Series and Station fields point at other objects). Listing 13-6
shows dumpobj output for the same object, this time passing "-depth 1" to cause the
Series and Station objects to be printed as well.

Listing 13-5: Fields Pointing to Other Objects

```
% dumpobj /SeasonPass/User/000~1611959
SeasonPass 1611959/10 {
  EndTimePadding  = 120
  IndexPath       = /SeasonPass/User/000~1611959
  MaxRecordings   = 5
  Priority        = 0
  RecordQuality   = 0
  Series          = 7977/-1
  Station         = 2049/-1
  Version         = 4
}
%
```

Listing 13-6: Using "dumpobj -depth" to Print Recursively

```
% dumpobj -depth 1 /SeasonPass/User/000~1611959
SeasonPass 1611959/10 {
  EndTimePadding = 120
  IndexPath       = /SeasonPass/User/000~1611959
  MaxRecordings  = 5
  Priority        = 0
  RecordQuality  = 0
  Series          = 7977/-1
    Series 7977/236 {
      Episodic       = 1
      Genre          = 34 48 49 65 72 80 180 1000 1004 1007
      IndexPath      = /Server/17544
      ServerId       = 17544
      ServerVersion  = 154
      ThumbData      = Explicit 1 255
      Title          = Frontline
      TmsId          = SH001762
      Version        = 221
    }
  Station         = 2049/-1
    Station 2049/15 {
      Affiliation     = {PBS Affiliate}
      AffiliationIndex = 31
      CallSign        = WGBH
      City            = Boston
      Country         = {United States}
      DmaName         = {Boston, MA-Manchester, NH}
      DmaNum          = 6
      FccChannelNum   = 2
      IndexPath       = /StationTms/11460:801 /Server/1202
      LogoIndex       = LogoSpace=Tivo     LogoIndex=4000
      Name            = WGBH
      ServerId        = 1202
      ServerVersion   = 16
      State           = MA
      TmsId           = 11460
      Version         = 11
      ZipCode         = 02134
    }
  Version         = 4
}
%
```

Those examples used MFS paths (/State/LocationConfig and /SeasonPass/User/ 000~1611959) to refer to an object, but you can also use an object's fsid. If you do an mls /SeasonPass/User, the one line of the output that corresponds to the example above looks like:

Name	Type	FsId	Date	Time	Size
----	----	----	----	----	----
000~1611959	tyDb	1611959	04/03/03	18:45	124

(Ok, fine, that's three lines; I put the header in there as well for clarification). The name of the object is 000~1611959, but its fsid is 1611959. The command "dumpobj 1611959" would generate the same output as displayed in Listing 13-5.

As with mls, the TivoWeb MFS module is also very good at displaying database objects. Figure 7-21 in Chapter 7 shows a tyDb object displayed via the MFS module. Fields that point to other objects are rendered as links, so you can browse the connections between objects. TivoWeb actually lets you specify an MFS object to display in three ways. The first way is by clicking your way down to the object, not caring about what URL is displaying it. The second way is to specify a URL that contains the MFS path, such as:

```
http://192.168.1.101/mfs/SeasonPass/User/000%7e1611959
```

(The ~ should be changed to %7e to maintain valid URL syntax, though it does also work if you leave it as a ~.) The third way is to specify the fsid of an object. This URL syntax actually harks back to the original SFR Tcl web server by Stephen Rothwell, and as such doesn't use the /mfs/ path. Instead, the URL looks like:

```
http://192.168.1.101/object/1611959
```

One final note about the last example; if you noticed that the name of the object happened to contain the fsid and were wondering about it, know that this isn't always the case. The SeasonPass directory happens to have season passes named such that their first three digits are the priority in the Season Pass Manager, followed by a ~ and the fsid. As you saw above, the /State/LocationConfig object in the /State directory was named LocationConfig (with an fsid of 1080148 on my machine); in that case, the name has nothing to do with the fsid.

ForeachMfsFile, RetryTransaction, and *db* Tools

Let's write a simple example that iterates through all of the existing TiVo Messages, and simply prints out the Subject and From fields of each entry. First, here's the code (Listing 13-7), then we'll walk through it.

Listing 13-7: Example Script listMessages.tcl

```
01  #!/tvbin/tivosh
02
03  set db [dbopen]
04
05  ForeachMfsFile fsid name type "/MessageItem/MessageBoard" "" {
06    RetryTransaction {
07      set obj [db $db openid $fsid]
08      set from [dbobj $obj get From]
09      set subject [dbobj $obj get Subject]
10    }
11    puts "/MessageItem/MessageBoard/$name (fsid=$fsid, type=$type)"
```

Continued

Listing 13-7 *(continued)*

```
12    puts "==============================================================="
13    puts "From: $from"
14    puts "Subject: $subject"
15    puts ""
16  }
17
18  dbclose $db
```

We start out on line 3 by opening the MFS database with the `dbopen` command (which is built into `tivosh`), and placing a reference to this open database in the variable `db`. (It's important to never call `dbopen` from within a transaction, since doing so can sometimes cause a reboot of your TiVo; more on transactions below.)

The main purpose of this example is to iterate through the `MessageItem` objects in the MFS directory `/MessageItem/MessageBoard`. The loop that performs this iteration is started on line 5, with the `ForeachMfsFile` command (defined in `/tvlib/tcl/tv/mfslib.tcl`). Each time through the loop, the variables `fsid`, `name`, and `type` are set to the appropriate values for the `MessageItem` object currently being processed. (The last `""` argument to `ForeachMfsFile` specifies a name prefix; if specified, only names beginning with that prefix will be included.)

To actually access database data, the `db` and `dbobj` commands are used (they're built-in to `tivosh`). To use those however, one must be in either a `transaction {}` block or a `RetryTransaction {}` block. The `transaction` command is built into tivosh, while `RetryTransaction` is defined in `/tvlib/tcl/tv/mfslib.tcl`. Just as it sounds, `RetryTransaction` will continue attempting to perform the actions in its block until it is successful without being interrupted by the operating system (whereas `transaction` can fail to finish). The other command that only works inside a `transaction` block is `mfs`, which we'll cover later.

Inside the `RetryTransaction` block, we open the `MessageItem` object itself via the `db` command and its `openid` subcommand, on line 7 (we'll talk about some more of the `db` subcommands soon). We use this object with the `dbobj` command in lines 8 and 9 to get its From and Subject fields.

We print out our results for each item in the for-each loop on lines 11–15. When the loop is finished, we finally close the database via `dbclose`. Sample output of the program is shown in Listing 13-8.

Listing 13-8: Sample Output of listMessages.tcl

```
=[tivo:root]-# ./listMessages.tcl
/MessageItem/MessageBoard/12112~44315~1442686 (fsid=1442686, type=tyDb)
=================================================================
From: {The TiVo Service}
```

```
Subject: {There are new dial-in numbers!}

/MessageItem/MessageBoard/12145~75039~1506968 (fsid=1506968, type=tyDb)
======================================================================
From: Jeff
Subject: {This Message Created With TivoWeb Mail Module}

=[tivo:root]-#
```

As with the example in Listing 13-4, this was a simple example because all of the data we were printing existed entirely within the MessageItem object itself. A more interesting example is to print a list of the titles of all season passes; as we see in Listing 13-6, the Title of a season pass doesn't actually exist in the SeasonPass object itself, but rather in the Series object that it points to. Listing 13-9 shows our next example, a script to list the title, priority, and channel name of all season passes.

Listing 13-9: Example Script listSeasonPasses.tcl

```
01  #!/tvbin/tivosh
02
03  set db [dbopen]
04
05  ForeachMfsFile fsid name type "/SeasonPass/User" "" {
06    RetryTransaction {
07      set seasonpassobj [db $db openid $fsid]
08      set priority [dbobj $seasonpassobj get Priority]
09      set seasonpasstype [dbobj $seasonpassobj get Type]
10
11      if { $seasonpasstype == "" || $seasonpasstype == 1} {
12        # Normal season pass
13
14        set seriesobj [dbobj $seasonpassobj get Series]
15        set title [dbobj $seriesobj get Title]
16
17        set stationobj [dbobj $seasonpassobj get Station]
18        set chantitle [dbobj $stationobj get Name]
19
20      } elseif {$seasonpasstype == 2 } {
21        # Manual recording - has no Series field
22
23        set title "Manual Recording"
24
25        set stationobj [dbobj $seasonpassobj get Station]
26        set chantitle [dbobj $stationobj get Name]
27
28      } elseif {$seasonpasstype == 3 } {
29        # Wishlist - has neither Series nor Station fields
30        # (just a Theme object, which has a Name field).
```

Continued

Listing 13-9 *(continued)*

```
31
32      set themeobj [dbobj $seasonpassobj get Theme]
33      set title [dbobj $themeobj get Name]
34
35      set chantitle "WISHLIST"
36
37    }
38  }
39  puts "Priority $priority: $title ($chantitle)"
40 }
41
42 dbclose $db
```

This example is very similar to the `listMessages.tcl` example in Listing 13-7 up until line 9. There are multiple types of `SeasonPass` objects: normal season passes, manual recordings, and WishLists. Manual recordings don't have a Series field, and WishLists don't have a Series or Station field. As a result, we have to use the `SeasonPass` object's Type field to determine which set of code to use for a given type. In the normal season pass example (lines 14–18), you can see how we fetch the Series object (from the Series field of the `SeasonPass` object) and obtain its Title field. The rest of the script is pretty straightforward; the main difference is loading a database object from a field rather than from an `fsid`.

Sample output of the program is shown in Listing 13-10.

Listing 13-10: Sample Output of listSeasonPasses.tcl

```
=[tivo:root]-# ./listSeasonPassesExample.tcl
Priority 0: Frontline (WGBH)
Priority 1: Friends (WHDH)
Priority 2: {Six Feet Under} ({Home Box Office})
Priority 3: Manual Recording (WHDH)
Priority 4: {Curb Your Enthusiasm} ({Home Box Office})
Priority 5: Enterprise (WSBK)
Priority 6: {The Shield} ({FX Networks Inc.})
Priority 7: {The Sopranos} ({Home Box Office})
Priority 8: {Movies & DANIELLE} (WISHLIST)
Priority 9: {The Simpsons} (WFXT)
Priority 10: {Andy Richter Controls the Universe} (WFXT)
Priority 11: {Jimmy Kimmel Live} (WCVB)
Priority 12: {South Park} ({Comedy Central})
Priority 13: {Interests/Music & RUSH} (WISHLIST)
Priority 14: {Da Ali G Show} ({Home Box Office})
Priority 15: {Sesame Street Unpaved} ({Noggin & The N})
=[tivo:root]-#
```

By this point if you're new to Tcl you might be asking "What's with all of the curly braces?" Curly braces are used to quote strings in Tcl. Before printing those values out, you probably want to strip away the braces with Tcl's string trim command.

More db Tools, and mfs

In the last section, we described how to use dbopen, dbclose, db's openid, and dbobj's get. Here, we'll list more of the subcommands of db and dbobj, and cover another command that has subcommands: mfs.

Tables 13-1 and 13-2 list the subcommands of db and dbobj, and give a brief description of each. Examples of their use can be found in various scripts in /tvlib/tcl/tv, as well as in various TivoWeb code and modules.

Table 13-1 db subcommands

Command	Description
db <db> open <path>	Open a database object (tyDb) by its path.
	Example:
	`set obj [db $db open /State/LocationConfig]`
db <db> openid <fsid> [<subid>]	Open a database object (tyDb) by its fsid (and optional sub-fsid[1]).
	Examples:
	`set obj [db $db openid 1080148]`
	`set obj [db $db openid 1080148 10]`
db <db> openconstruction <path>	Open a database object (tyDb) by its path, while the database is under construction[2].
	Example:
	`set obj [db $db openconstruction /State/LocationConfig]`
db <db> openidconstruction <fsid> [<subid>]	Open a database object (tyDb) by its fsid (and optional sub-fsid[1]), while the database is under construction[2].
	Examples:
	`set obj [db $db openidconstruction 1080148]`
	`set obj [db $db openidconstruction 1080148 10]`

Continued

Table 13-1 *(continued)*

Command	Description
`db <db> canopenconstruction <path>`	Return true or false, depending on whether an `openconstruction` command would succeed right now. Example: `if { [db $db canopenconstruction /State/LocationConfig] }{ ... }`
`db <db> canopenidconstruction <fsid> [<subid>]`	Return true or false, depending on whether an `openidconstruction` command would succeed right now. Examples: `if { [db $db canopenidconstruction 1080148] } { ... }` `if { [db $db canopenidconstruction 1080148 10] } { ... }`
`db <db> create <type>`	Create a database object, returning a reference to it. (This reference can be used with dbobj's `set` command to fill in fields of the new object) *Warning: Use this with care, lest you create stray objects that float around.* Example: `set newobj [db $db create MessageItem]`
`db <db> createsub <type> [<dbobj>]`	Create a sub-object within an existing object. This returns a reference to a new sub-object. If the `<dbobj>` argument is omitted, you would then set a field of an existing object to point to this new sub-object. *Warning: Use this with care, lest you create stray subobjects that float around.* Examples: `set newsub [db $db createsub ResourceItem $existingresourcegroupobject]` `set newsub [db $db createsub ResourceItem]`

Command	Description
`db <db> schema [types \| attrs \| attrinfo] ...`	Return a list of schema information about the database (that is, information about the existing valid datatypes).
	`db schema types` returns a list of all object types (e.g. Series, Station, SeasonPass, etc.).
	`db schema attrs <objecttype>` returns a list of all valid fields for that object type (e.g. for `MessageItem`: Subject, From, Body, etc.)
	`db schema attrinfo <objecttype> <attr>` returns type info for that attribute of that type (e.g. for `MessageItem From`: "string optional {} base").
	Examples:
	`set types [db $db schema types]`
	`set miattrs [db $db schema attrs MessageItem]`
	`set mifromtype [db $db schema attrinfo MessageItem From]`

1 Objects can contain sub-objects. The sub-object of an object can be referred to by using its fsid and sub-fsid. A sub-object's id is usually displayed as fsid/subfsid (for example, `1080148/10`).

2 What exactly makes an object be considered "under construction" isn't clear. `open` and `openconstruction` often have the same effect, just as `openid` and `openidconstruction` often have the same effect. According to one post on dealdatabase.com, sometimes you'll get the `errDbUnderConstruction` error when using `open` or `openid`, whereas `openconstruction` and `openidconstruction` will succeed in those cases.

Table 13-2 dbobj subcommands

Command	Description
`dbobj <dbobj> get [-noerror] <attr> [<indxnum>]`	Fetch the value of a named field of a database object. If `-noerror` is specified, there is no error thrown when trying to fetch a field name that doesn't exist. If the field is a multi-object field, `<indxnum>` specifies which item within that list to return.
	Examples:
	`set subj [dbobj $obj get Subject]`
	`set bar [dbobj $obj get -noerror Foo]`
	`set subj [dbobj $obj get Image 3]`

Continued

Table 13-2 *(continued)*

Command	Description
`dbobj <dbobj> set <attr> <tclobj>`	Set the value of a named field of a database object. This ups the reference count of the object. Example: `dbobj $msgitemobj set From "Santa Claus"`
`dbobj <dbobj> add <attr> <tclobj>`	Add an item to a multi-object named field of a database object. This ups the reference count of the object. Example: `dbobj $resgrp add Item $resitemobj`
`dbobj <dbobj> gettarget <attr> [<indxnum>]`	Fetch the `objectid` (either a lone fsid or fsid/subobjid) of the object that a named field points to. If the field is a multi-object field, `<indxnum>` specifies which item within that list to return the `objectid` of. Examples: `set id [dbobj $sigsource gettarget Headend]` `set id [dbobj $obj gettarget Image 3]`
`dbobj <dbobj> remove <attr> [<tclobj>]`	Remove a value from a named field of a database object. If the field is a multi-object field, you can specify the actual object to remove by passing it in as `<tclobj>`; otherwise, the entire list is removed. To remove a particular object from a multi-object field by its index number, see `dbobj removeat` below. This decreases the reference count of the object. *Warning: Be careful removing things.* Examples: `dbobj $progobj remove Actor` `dbobj $sourceobj remove Channel $chanobj`
`dbobj <dbobj> removeat <attr> <indxnum>`	Remove a value from a multi-object named field of a database object. `<indxnum>` specifies which item within that list to remove. This decreases the reference count of the object. Example: `dbobj $sourceobj removeat Channel 0`

Command	Description
`dbobj <dbobj> fsid`	Return the fsid of a database object. If the object in question is a subobject, only the major portion of the number is returned. Example: `set fsid [dbobj $obj fsid]`
`dbobj <dbobj> subobjid`	Return the sub-id of a subobject. Only return the sub-portion of the id. Example: `set subid [dbobj $obj subobjid]`
`dbobj <dbobj> type`	Return the type of a database object. Example: `set type [dbobj $obj type]`
`dbobj <dbobj> attrs`	Return a list of all the field names of a database object. Example: `set fields [dbobj $obj attrs]`
`dbobj <dbobj> attrtype <attr>`	Return the type of a particular field of a database object. Example: `set fieldtype [dbobj $miobj attrtype From]`
`dbobj <dbobj> copyfrom <srcdbobj>`	Copy all fields from the `<srcdbobj>` database object into the `<dbobj>` object. This doesn't create a new object, it merely populates an existing object with values from another object. Example: `dbobj $newprogobj copyfrom $origprogobj`
`dbobj <dbobj> markasrubbish`	Mark a database object as rubbish, making it eligible for garbage collection. There are convenience commands that do even more to delete things properly (see "Deletion Commands" later in this chapter). *Warning: Be careful with this, you don't want to accidentally cause something to be deleted.* Example: `dbobj $seaspassobj markasrubbish`

Continued

Table 13-2 *(continued)*

Command	Description
`dbobj <dbobj> construction`	Return true or false, depending on whether the specified object is currently under construction or not. Example: `if { [dbobj $obj construction] }{ ... }`
`dbobj <dbobj> primary`	Return true or false, depending on whether the specified object is a "primary" object[1]. Example: `if { [dbobj $obj primary] }{ ... }`
`dbobj <dbobj> secondary`	Return true or false, depending on whether the specified object is a "secondary" object[1]. I haven't seen this used. Example: `if { [dbobj $obj primary] }{ ... }`
`dbobj equal <dbobj1> <dbobj2>`	Return true or false, depending on whether the two specified objects are equal. Example: `if { [dbobj equal $obj1 $obj2] } { ... }`

[1] What makes an object a primary or secondary object isn't as clear as you'd think either. A top-level object does seem to always be a primary object, but it's not the case that sub-objects simply return true for secondary.

The `mfs` command also provides access to database functionality. The various subcommands of the `mfs` are listed in Table 13-3. Again, examples of their use can be found in various scripts in `/tvlib/tcl/tv`, as well as in various TivoWeb code and modules.

Table 13-3 mfs subcommands

Command	Description
`mfs find <path>`	Find the database object from the specified MFS path, and return its fsid and type (where type is `tyDb`, `tyDir`, `tyFile`, or `tyStream`). Examples: `set mywstfsid [lindex [mfs find /State/MyWorld] 0]` `set mywsttype [lindex [mfs find /State/MyWorld] 1]`

Command	Description
`mfs scan <path> [-start <string>] [-count <number>] [-backward]`	Read an MFS directory (`tyDir`) and return a list of items within it. Items in this list are lists themselves, with three values: the item's fsid, its name, and its type (where type is `tyDb`, `tyDir`, `tyFile`, or `tyStream`). If "`-start <string>`" is specified, all items whose name are alphabetically before the start string are omitted. If "`-count <number>`" is specified, only that many items are returned in the list. If "`-backward`" is specified, the original list is reversed in order before any processing of "`-start`" or "`-count`".

Note: If you use `-backward`, it seems you must specify a start string, otherwise it defaults to the first item and you only get back one result.

Examples:

```
set msgitemlist [mfs scan
/MessageItem/MessageBoard]
```

```
set bkwmsgitemlist [mfs scan
/MessageItem/MessageBoard -backward]
```

```
set somemsgs [mfs scan
/MessageItem/MessageBoard -start 11]
```

```
set lastfivemsgs [mfs scan
/MessageItem/MessageBoard -start ZZZZZ
-count 5 -backward]
```

```
set fsidoffirstmsg [lindex [mfs scan
/MessageItem/MessageBoard -count 1] 0]
```

```
set nameoffirstmsg [lindex [mfs scan
/MessageItem/MessageBoard -count 1] 1]
```

```
set typeoffirstmsg [lindex [mfs scan
/MessageItem/MessageBoard -count 1] 2]
```

Command	Description
`mfs scancount <path>`	Read an MFS directory (`tyDir`) and return the number of items within it.

Example:

```
set numberofseasonpasses [mfs scancount
/SeasonPass/User]
```

Continued

Table 13-3 *(continued)*

Command	Description
`mfs size <fsid>`	Return the size (in bytes) of the database object whose fsid is `<fsid>`. This works for `tyDb`, `tyDir`, and `tyFile` objects. *Warning: Don't try this on a `tyStream` object, you can corrupt the database!* Example: `set msgsizeinbytes [mfs size 1010673]`
`mfs streamsize <fsid>`	Return size information about the `tyStream` whose fsid is `<fsid>`. This returns three values: `recordsize` (always 0x20000?), `recordsallocated`, and `recordsrecorded`. `recordsize` is in bytes. *Warning: This won't succeed if you try obtaining the `streamsize` of a stream you're currently watching, and it can sometimes cause a reboot.* Example: `set strmsize [mfs streamsize 1514374]`
`mfs get <fsid> [<filetype>]`	Fetch a `tyFile` from within MFS and return it. For large files, grab the file piece by piece with multiple calls to `mfs getpart` instead. If you specify a `filetype` of `tyDb` or `tyDir`, you can fetch `tyDb` and `tyDir` objects in their binary form. The default `filetype` is `tyFile`. *Warning: Don't try this on a `tyStream` object; you can corrupt the database!* *Note: see "FromMfs" later in this chapter.* Examples: `set imagedata [mfs get 925162]` `set imagedata [mfs get 925162 tyFile]`
`mfs getpart <fsid>` `<offset> <length>`	Fetch a portion of a `tyFile` from within MFS and return that portion. The portion to be fetched starts `<offset>` bytes into the file, and will contain `<length>` bytes. *Warning: Don't try this on a `tyStream` object, you can corrupt the database!* *Note: see "FromMfs" later in this chapter.* Examples: `set imagedata [mfs getpart 1514398 12288 4096]`

Command	Description
`mfs put <string>`	Create a new `tyFile` object, inserting `<string>` as its contents. This returns the fsid of the new `tyFile` object. If this object isn't referenced before the end of the transaction, it will be deleted immediately. It can be referenced either by setting/adding it to a named field of an object that points at `tyFiles`, by linking it with "mfs link", or by adding a reference count with "mfs ref" (dangerous). *Warning: In my experience, "mfs put" ends up chopping off one byte of the file. I haven't seen "mfs put" used anywhere; "mfs putpart" is used instead.* *Note: see "ToMfs" below.* Example: `set newfsid [mfs put $filedata]`
`mfs allocate <size>`	Create a new `tyFile` object, of `<size>` bytes in length. This is used with several subsequent "mfs putpart" calls to move data from outside of MFS into a `tyFile` within MFS, chunk by chunk. If this object isn't referenced before the end of the transaction, it will be deleted immediately. It can be referenced either by setting/adding it to a named field of an object that points at `tyFiles`, by linking it with "mfs link", or by adding a reference count with "mfs ref" (dangerous). *Note: see "ToMfs" later in this chapter.* Example: `set newfsid [mfs allocate $sizeoffileinbytes]`
`mfs putpart <fsid> <offset> <string>`	Place the contents of `<string>` in the `tyFile` object whose fsid is `<fsid>`, `<offset>` bytes from the beginning of the file. Typically you use "mfs allocate" to create a new `tyFile`, then move data over one chunk at a time with calls to "mfs putpart". Once the last "mfs putpart" is done, you need to make sure you reference this object somewhere before the end of the transaction, or the object will be deleted immediately. It can be referenced either by setting/adding it to a named field of an object that points at `tyFiles`, by linking it with "mfs link", or by adding a reference count with "mfs ref" (dangerous). *Note: see "ToMfs" later in this chapter.* Example: `mfs putpart $newfsid 1514398 $chunkdata`

Continued

Table 13-3 *(continued)*

Command	Description
`mfs link <path> <fsid>`	Create an entry in the MFS hierarchy that points to the object whose fsid is `<fsid>`. The path needs to be a full path, including the name of the object to be created. Doing an `mls` of the directory in which it was created will then show the new object. Typically you'd do this with a new object you just created, though you could link an existing object to a second location as well. Example: `mfs link /Resource/Image/jefficon 1514461`
`mfs unlink <path>`	Remove an entry in the MFS hierarchy that points to either a `tyDb`, a `tyFile`, or a `tyStream`. This removes the link from the `tyDir` that contained it, and decreases the reference count (as if "`mfs deref`" was called). The object is deleted when the reference count of the object is zero. *Note: In later versions of the TiVo software, "`mfs unlink`" will not work unless the environment variable TV_ALLOW_UNLINK_DB_OBJ has been set to 1 prior to starting tivosh.* *Warning: Be careful with this, you don't want to accidentally cause something to be deleted.* Example: `mfs unlink /Resource/Image/jefficon`
`mfs linkpath <path> <fsid>`	I haven't seen this used. It seems to perform the same function as "`mfs link`" above. I'm not sure if there's actually a difference or if it's an old function that's left around.
`mfs mkdir <path>`	Create a new `tyDir` in the MFS hierarchy. Path needs to be an absolute path (starting with "`/`"). Example: `mfs mkdir /jeffwashere`
`mfs rmdir <path>`	Remove a `tyDir` in the MFS hierarchy. The directory must already be empty, otherwise this returns with an error. Path needs to be an absolute path (starting with "`/`"). *Warning: Be careful with this. Don't delete any directories that you didn't create; they are all there for a reason.* Example: `mfs rmdir /jeffwashere`

Command	Description
`mfs ref <fsid>`	Increase the reference count on the object whose fsid is `<fsid>`. This is dangerous, as you end up leaving an object with a higher reference count than it actually has references, and thus it is ineligible for garbage collection. If you just moved a file into MFS with "`mfs put`", "`mfs allocate/mfs putpart`", or "`ToMfs`", then doing a "`mfs ref`" is one way of having the object survive past the end of the transaction block. Be very careful to keep track of that fsid though, or it will never be deleted (clogging up your system). Typically this isn't an end user function; usually you increment the reference count on an object by setting/adding the object to another object's named field, or by linking it into the MFS hierarchy via "`mfs link`". Those methods update the reference count automatically. If you do find a need to up the reference count on a newly created object, be sure to "`mfs deref`" the object after officially adding it somewhere else, to correct the reference count to what it should be. *Warning:* Only use this if you know what you're doing and have a good reason to do this rather than using other safer methods of keeping an object alive. Example: `mfs ref 1514398`
`mfs deref <fsid>`	This is the opposite of "`mfs ref`". It decreases the reference count on an object. If the object only has one reference before this command is run, the result will be to delete the object. This is just as dangerous as "`mfs ref`", for similar reasons. Typically this isn't an end user function; usually you decrement the reference count on an object by removing the object from another object's named field, or by unlinking it from the MFS hierarchy via "`mfs unlink`". Those methods update the reference count automatically. *Warning:* Only use this if you know what you're doing and already have knowledge that an object has a higher reference count than it should. You should not attempt to remove an object with "`mfs deref`" if links exist to it elsewhere that need to be removed via "`mfs unlink`" (or by removing an object from a named field). Example: `mfs deref 1514398`

Continued

Table 13-3 *(continued)*

Command	Description
`mfs copy <srcpath> <dstpath>`	Copy the database object specified by the MFS path `<srcpath>` (creating a new object with its own fsid), and link the new destination object to the MFS path `<dstpath>`. This doesn't affect the refcount of the original object since it's a copy, not a link, though it will affect the refcounts of any objects pointed to by fields (since those objects are now being pointed to by two the fields of two separate objects). Example: `mfs copy /MessageItem/MessageBoard/` `11528~03744~1514499 /jeffwashere/msgcopy`
`mfs moddate <fsid>`	Return the modification data of the MFS object whose fsid is `<fsid>`, in seconds. The return value can be passed into the Tcl `clock` command to format it as desired. Remember that on a TiVo this date doesn't have any timezone info applied to it; it's GMT time. Example: `set msgdategmtstr [clock format [mfs` `moddate $msgfsid] -format "%D %R"]`
`mfs streamfill <recordsize> <numrecords>`	Create (and zero out) a new `tyStream` and return its fsid. As with "`mfs streamsize`" above, it seems that `<recordsize>` should always be 0x20000. *Note: This won't be of much use on its own; tivosh doesn't provide the ability to insert data into a tyStream Various video insertion tools exist (see dealdatabase.com); See Chapter 10 for a description of mfs-ftp.* Example: `set newfsid [mfs streamfill 131072 2920]`
`mfs streamcreate`	Create a new `tyStream` and return its fsid. As with "`mfs streamsize`" above, it seems `<recordsize>` should always be 0x20000. *Note: This won't be of much use on its own; tivosh doesn't provide the ability to insert data into a tyStream Various video insertion tools exist (see dealdatabase.com); See Chapter 10 for a description of mfs-ftp.* Example: `set newfsid [mfs streamcreate 131072 2920]`

ToMfs / FromMfs

Two convenience functions allow you create your own `tyFile` objects and fetch the contents of existing `tyFile` objects. These are `ToMfs` and `FromMfs`, both defined in `/tvlib/tcl/tv/mfslib.tcl`. They use "`mfs allocate`", "`mfs putpart`", and "`mfs getpart`" to move file data in either direction, in small parts.

Both of these functions still have to be called from within a transaction. The reason why the functions don't have their own transaction in them is because any new `tyFile` would be immediately deleted at the end of that transaction, since it hadn't been referenced anywhere. Actually that's a reason why `ToMfs` can't have its own internal transaction; `FromMfs` probably lacks one just for consistency.

First let's start with the simple example of pulling *from* MFS. Listing 13-11 shows an example script that pulls an image file out of MFS with `FromMfs`.

Listing 13-11: Using FromMfs: grabiconexample.tcl

```
#!/tvbin/tivosh

set db [dbopen]

RetryTransaction {
  set iconobj [db $db open /Resource/Image/IPreviewIcon1.14]
  set iconfilefsid [dbobj $iconobj get File]
  FromMfs "oursnatchedfile.png" $iconfilefsid
}

dbclose $db
```

Running that script extracts the image pointed at by `/Resource/Image/IPreviewIcon1.14`'s `File` field and places it in the current directory.

A more involved example is moving one of our own PNG files into MFS. It's not enough to just move it in with `ToMfs`, because as soon as our transaction is done it will be deleted. We need to reference it somewhere (or increment its reference count with `mfs ref`, which is a bad idea). So, we'll create our own Image object (a tyDb), move our own PNG file over with `ToMfs` into a `tyFile`, and set our new Image object's File field to point to that new `tyFile`. "`db $db create`" will link our new Image tyDb into the MFS hierarchy under `/Resource/Image`, so we do *not* need to use `mfs link` to add it there. Listing 13-12 shows this advanced example.

Listing 13-12: Using ToMfs: insertimageexample.tcl

```
#!/tvbin/tivosh

set pngfile "imagetoinsert.png"
```

Continued

Listing 13-12 *(continued)*

```
set pngfilemfsname "ourinsertedimage"

set db [dbopen]

RetryTransaction {
  set filefsid [ToMfs $pngfile]

  set newimg [db $db create Image]
  dbobj $newimg set Name $pngfilemfsname
  dbobj $newimg set File $filefsid
  dbobj $newimg set Format 2

  set newimgfsid [dbobj $newimg fsid]
}

puts "New image object created.. fsid=$newimgfsid"

dbclose $db
```

To give that example a little more oomph, let's replace the banner image on a showcase item with our new image. (The details are an exercise for the reader; I'll just describe the broad strokes). Using the actual TiVo interface and your remote control, find a showcase you want to experiment with (perhaps a temporary one such as a promotion; this isn't about defacing showcases, it's just an experiment to demonstrate our new Image object).

Then using `mls` and `dumpobj` (or the MFS TivoWeb module), locate that showcase under /Showcase. The Showcase object's Banner field will point at an Image object. That Image object's File field should contain the `fsid` of a `tyFile` that has the actual banner (a picture in PNG format). Using what you've learned above, extract a copy of that PNG file on your PC.

Using your favorite image program (that understands PNG files), determine the exact dimensions of the banner (in my case it was 480 × 60). Create your own image of the same size. You'll want to use the same color palette as well; I made a copy of the extracted image and pasted my picture into it, which preserved the color palette of the original. Use more of what you've learned above to move your new PNG file into MFS as a `tyFile` and create a new Image object that references it.

Once all of that is done, the code snippet in Listing 13-13 shows you how to make the Showcase's Banner field point at your new Image object (obviously you must change the hard-coded `fsid`s in the example to match your own). Note that we have to load both the Showcase object *and* the Image object, and set the Banner field to the object itself. Before attempting this, make note of the `fsid` of the original Image object pointed at by the Banner field so you can restore things back to the way they were later.

Listing 13-13: Using Our Image: changebannerexample.tcl

```
#!/tvbin/tivosh

set showcasefsid 652724
set newimagefsid 1636799

set db [dbopen]

RetryTransaction {
  set showcaseobj [db $db openid $showcasefsid]
  set imgobj [db $db openid $newimagefsid]
  dbobj $showcaseobj set Banner $imgobj
}

dbclose $db
```

If you're currently in the Showcase menu, exit out to TiVo Central with the remote, then walk back down into the Showcase you've modified. Your banner image should be visible at the top.

Deletion Commands

Needless to say, deleting anything in an unknown database is extremely dangerous. Though it's been said before it warrants being said again: be careful. Unless you have created something, don't delete it. If you really need to delete an existing object (for instance if you're trying to emulate some behavior of the regular TiVo interface when it deletes something), do lots of testing to make sure you're doing exactly what they do. Have a recent backup of your TiVo before you try deleting objects.

There are several commands related to the deletion of MFS objects. If you didn't already read about the following built-in commands, then go back and read the descriptions for dbobj markasrubbish (Table 13-2), mfs rmdir, mfs unlink, mfs ref, and mfs deref (Table 13-3).

In addition, there are some Tcl functions that do more for you: MfsRubbishTree, MfsRemoveTree, and RubbishObjectByFsid (all defined in /tvlib/tcl/tv/mfslib.tcl). While you might want to call these, it makes sense to look at the functions themselves to see what they do.

MfsRubbishTree takes an MFS path as an argument. Starting at the location that the path points to, it recurses down the tree deleting all tyFiles, deleting all tyStreams, deleting all tyDirs, and rubbishing all tyDbs.

MfsRemoveTree does the same thing as MfsRubbishTree, but instead of rubbishing tyDbs it removes them with dbunload. The code mentions that this can only be run on databases with refcounts; theoretically the tivosh command dbhasrefcounts tells you

whether the database supports refcounts or not. I've always had `dbhasrefcounts` return 0, so I wouldn't run `MfsRemoveTree` for anything. There are some other `dbload` database commands to load portions of databases, but I won't be covering them here (nor have I played around with them).

`RubbishObjectByFsId`, which seems to have been written for use in `MfsRubbishTree`, takes an `fsid` and rubbishes the `tyDb` that it points to (removing any `RecordingPart` objects it encounters, to free up the `tyStreams` they hold).

Other tivosh Commands

There are many other `tivosh` commands that exist. Reading through the scripts in `/tvlib/tcl/tv` will give you a sense of the Tcl procedures, but a brief mention of some more of the built-in `tivosh` commands is warranted. This section is presented more for completeness; you can get by fine without most of these.

Table 13-4 describes some more of the built-in `tivosh` commands.

Table 13-4 More Internal tivosh Commands

Command	Description
dbopen [<poolsize>]	As we've seen above, this command opens up the database and returns a reference to it, which is needed by the db command and its subcommands.
	The <poolsize> argument allows you adjust the resources used by the system when handling this database. The few times I've seen it used, the poolsize specified is a multiple of 1024 (such as 102400).
dbclose <db>	Close an open database handle.
dbhandles	Return a list of database handles that have been opened in this tivosh session.
dbload <db> <slicefile>	This command is used to load a portion of a database (from a "slice" file) into the specified database.
dbunload <db> <fsid> [secondary]	dbunload is used to remove database objects (tyDbs). The way has been called in Tcl scripts is: `catch {dbunload $db $id secondary}` `if { [catch {dbunload $db $id}] } {` `puts "Couldn't delete"` `}`
dbhasrefcounts	Return either 0 or 1, indicating whether the database supports refcounts or not.

Command	Description
`dbindex <db> <type>`	Cause a portion of the database to be indexed. Examples I've seen are: `dbindex $db Showing` `dbindex $db StationDay`
`setpri ts\|rr\|fifo [<pri> [<pid>]]`	TiVo doesn't handle priorities the same way most Unix operating systems do (for example, "nice" does nothing). Instead, it uses its own two commands (`getpri` and `setpri`) to get and set priorities. (There are command line equivalents of these as well[1], installed in `/var/hack/bin` if you installed the distribution in Chapter 4. When using these executables, all of the parameters are *required*.) For a given process, you set the scheduling policy, and the priority. `ts` stands for time-sharing, `rr` stands for round-robin, and `fifo` stands for first-in-first-out. If the `<pid>` argument is omitted, the current process' process-id is used. Larger numerical values for `<pri>` indicate a higher priority. (There is also a standalone "`setpri`" command available, separate from tivosh, which is discussed in Chapter 12.) ***Warning:*** *Be careful; modifying the priority of system processes, or raising your own processes to a higher priority than the system processes. Setting priorities incorrectly can result in video stuttering, a general sluggishness of the UI, etc.* Example: To set your Tcl script to a very low priority (to keep from interfering with the normal operation of your TiVo), put the following line near the beginning of the script: `setpri fifo 1`
`getpri [<pid>]`	This gets the current scheduling policy and priority number of the current (or the specified) process. Larger numerical values for the priority number indicate a higher priority. The scheduling policy will be either "`ts`", "`rr`", or "`fifo`". See `setpri`, described earlier, for an explanation of priorities in the TiVo operating system. (There is also a standalone `getpri` command available, separate from tivosh, which is discussed in Chapter 12.)

Continued

Table 13-4 *(continued)*

Command	Description
EnableTransactionHoldoff true\|false	Placing "EnableTransactionHoldoff true" at the beginning of your script will cause transactions to wait for results during contentions, rather than exiting with failure messages.
event register <type> <script>	Register the Tcl procedure <script> to be called when the specified type of event occurs. A good example of this can be found in the source code of Tivo Control Station (TCS), which is covered in Chapter 8. Valid event types are declared in /tvlib/tcl/tv/Inc.itcl.
	Warning: *Be aware of the "event bug" described in Chapter 15 in the "What Is There to Work With?" section. The more processes that register for event callbacks, the greater the frequency of the problem.*
	Example:
	`event register $TmkEvent::EVT_REMOTEEVENT MyEventCallback`
	(where MyEventCallback is a Tcl procedure `upi write` that takes two parameters, `event` and `subevent`).
event send <type> [<subtype>] <data>	Create and send an event of type <type> to all processes with callbacks registered for that event type. Good examples of this can be found in /tvlib/tcl/tv/sendkey.tcl, in the source code of TCS, and in the source code for TivoWeb's "ui" module (TivoWeb is covered n Chapter 7). Valid event types are declared in /tvlib/tcl/tv/Inc.itcl.
	Example:
	`set remevent [binary format $format $keycode $id $keysource $timelow $timehigh]`
	`event send $TmkEvent::EVT_REMOTEEVENT $remevent`
event qsize <numevents>	Set the size of the event queue.

Command	Description
`pool allocate [-force {-name` `\|<poolname>} {-size` `<sizeinbytes>}]`	Create a pool[2], which is a mechanism through which processes can communicate with one another. If you specify a `<poolname>` and a size for that pool (`<sizeinbytes>`), a file will be created in `/tmp` called `<poolname>.mpkey`. This 12-byte file (which points to a shared memory object) acts as a placeholder for other processes to attach to.
	What is returned is a pool. It can be used just like a file descriptor (to be used with `read`, `seek`, `puts`, `gets`, etc). It can also be used with the other "pool" commands below, by specifying it as the `<channel>` argument.
	Note: When you start up a tivosh shell, a default pool is created for you already, which you can refer to as `pool0` (although it isn't named, so there won't be an entry in `/tmp` for it).
`pool attach <poolname>`	This lets you attach to an existing pool (presumably from another process). The directory `/tmp` will be searched for a file called `<poolname>.mpkey`, which points to the pool in shared memory.
	What is returned is a pool. It can be used just like an I/O channel (to be used with `read`, `seek`, `puts`, `gets`, etc). It can also be used with the other "pool" commands below, by specifying it as the `<channel>` argument.
`pool <channel> address`	Return the location in memory of the specified pool.
`pool <channel> size`	Return the size of the specified pool, in bytes.
`pool <channel> dump`	Display statistics about the specified pool.
`pool <channel> registery` `<itemno>`	(Command is spelled incorrectly, and this text reflects that)
	This function returns various addresses (one per call) within the specified pool that are registered with an item number. For instance, the pool "`fsmem`" has an item numbered 0x10007 that is initialized to the starting address of the globals in the `fsmem` pool. Different pools have different valid item numbers.
`pool <channel> info`	Display information about the specified pool. The number (and max number) of blocks, bytes, and chunks is printed, along with the number of empty bytes, blocks, and chunks.

Continued

Table 13-4 *(continued)*

Command	Description
`pool handles`	Return a list of open pools.
`ioctl <channel> <cmd>` `[-out <string> \|` `-param <string>]`	Send `ioctl` commands to the kernel for a given device. In particular, this is useful for talking to devices such as `/dev/mpeg0v`. Example: To cause the `/dev/mpeg0v` device to display only the key-frames of video (which is an interesting effect), you can run: `#!/tvbin/tivosh` `set mpg [open "/dev/mpeg0v" "w+"]` `ioctl $mpg 1013` The ioctl command 1000 restores normal video play: `ioctl $mpg 1000` In Chapter 14 we talk more about the `/dev/mpeg0v` device and its `ioctl` commands.

[1] Thanks again to Mike Baker (embeem at www.tivocommunity.com).

[2] More info on pools at: http://alt.org/forum/index.php?t=msg&th=19 . Credit goes to everyone who posted info in that thread.

dbget / dbset

Two convenient Tcl scripts by Andrew Tridgell are `dbget` and `dbset`. They let you easily get and set database fields (at least for fields with simple values). If you installed the software distribution from the accompanying CD-ROM in Chapter 4, then these will both already exist on your TiVo in `/var/hack/bin`. If not, they can be fetched from:

```
http://tivo.samba.org/download/tridge/dbget
http://tivo.samba.org/download/tridge/dbset
```

and then placed in the `/var/hack/bin` directory on your TiVo.

The `dbget` command allows three syntaxes:

```
dbget <mfspath> <fieldname>
dbget <fsid> <fieldname>
dbget <fsid>/<subobjid> <fieldname>
```

It returns the value of the field. Here's an example of using `dbget` to obtain the name of the current version of TiVo software:

```
=[tivo:root]-# dbget /SwSystem/ACTIVE Name
3.0-01-1-000
=[tivo:root]-#
```

The dbset command allows three similar syntaxes:

```
dbset <mfspath> <fieldname> <value>
dbset <fsid> <fieldname> <value>
dbset <fsid>/<subobjid> <fieldname> <value>
```

Let's pick an interesting example of something to change (rather than just changing the From field of an existing TiVo Message or something). My wife and I have multiple TiVos, and it's always been confusing remembering which TiVo we're looking at (we can watch any TiVo from any room, thanks to video distribution devices such as ChannelPlus's All-in-One Modulators). One of the first things I wanted to change when I started playing around was the title of the TiVo Central and Now Playing screens. My goal was to make it obvious which TiVo we were looking at, just from looking at the screen.

After hunting through MFS, I found that in the /SwSystem/ACTIVE database entry there was a multi-object field called ResourceGroup that pointed at ResourceGroup objects. Each ResourceGroup object had a multi-object field called Item that pointed at a bunch of ResourceItem sub-objects. Each ResourceItem had an Id and a String, where the String was some textual part of the user interface (such as "PG-13", "Search By Title", "Press Select To Record", or "TiVo Central").

In my case, I found that 925135/17 was the fsid for the ResourceItem that defined Now Playing, and 925135/18 was the fsid for TiVo Central. Here's how to use dbset to change the title of these pages (see Listing 13-14).

Listing 13-14: Using dbset to Change Menu Titles

```
=[tivo:root]-# dbget 925135/17 String
{Now Playing}
=[tivo:root]-# dbget 925135/18 String
{TiVo Central}
=[tivo:root]-# dbset 925135/17 String "Now Playing - TiVo1(main)"
=[tivo:root]-# dbset 925135/18 String "TiVo Central - TiVo1(main)"
=[tivo:root]-# tivosh
% dumpobj 925135/17
ResourceItem 925135/17 {
  Id            = 131094
  String        = {Now Playing - TiVo1(main)}
}
% dumpobj 925135/18
ResourceItem 925135/18 {
  Id            = 131095
  String        = {TiVo Central - TiVo1(main)}
}
=[tivo:root]-#
```

There's a catch to this particular example, however. If you just tried that (with your own fsid's of course) and ran to your TiVo, you'd be disappointed to see that it hadn't made any visible change to the screen. This is because TiVo caches its resource items.

The easy way to cause these changes to be detected is to go to the Resource Editor module in TivoWeb and click on "Update Resources". You then have to reboot your TiVo for those changes to take effect.

If you're wondering what's needed code-wise, the CompressedFile field on a ResourceGroup object needs to be removed. The code that TivoWeb's Resource Editor actually uses is equivalent to:

```
set db [dbopen]
RetryTransaction {
   set objSwSystem [db $db open "/SwSystem/ACTIVE"]
   set objResourceGroup [dbobj $objSwSystem get ResourceGroup]
   set objMpaaRating [lindex $objResourceGroup 0]
   catch { dbobj $objMpaaRating remove CompressedFile }
}
dbclose $db
puts "Reboot Your TiVo Now... "
```

We just edited a resource to demonstrate how to use dbget and dbset. However, when editing Resources there's a convenient TivoWeb module called the Resource Editor that specializes in doing just that. See the Resource Editor section in Chapter 7 to learn how to add other resources to those displayed in the Resource Editor.

Some Examples of Things in MFS

Most of the fun of playing around here is exploring. Still, I'll give a few examples of some of the database entries that are interesting. Feel free to skip ahead to the next section if you'd rather look for yourself.

Table 13-5 lists some MFS paths and gives brief hints about what they contain.

Table 13-5 Some Interesting MFS Paths

Path	Description
/Clips	The video "clips" that TiVo creates out of the daily recordings from the Discovery Channel[1]. These are used in Showcase entries and "Gold Star" promotions.
/Component	Various info about different components you'd use with your TiVo (for use in the Remote Control Setup pages of the TiVo UI, and for controlling cable boxes and sat receivers via IR blasters).

Path	Description
/DataSet	DataSet objects here seem to act as named sets of pointers to objects elsewhere in the system. For example, my TiVos currently have at least one MenuItem-related DataSet object that contains pointers to several MenuItem objects to be cycled through.
/GuideIndexV2	This directory contains a bunch of tyFiles; they are indexes used by TiVo's Wishlist function and TivoWeb's Search module. Actor, Director, Keyword, Title, and TitleKeyword are all simple text files, mapping to program-unique TmsIds.
/Headend	This contains information about your cable/satellite provider channel lineups, etc.
/LeadGeneration	The LeadGeneration objects in this directory occasionally occur; they are used inside promotional Showcases. They represent a screen of text with menu items for the user to select from (such as "To hear more about this product, select Yes and we'll send you a brochure").
/LogoGroup	Channel logos are all stored in LogoGroup objects, located here. These objects are manipulated by the TivoWeb Logos module.
/MenuItem	These objects represent the promotional "Gold Star" menu items that frequently appear at the bottom of the TiVo Central screen. They can trigger the playing of a video clip, or cause a Showcase to be displayed.
/MessageItem	TiVo Messages and "Pre-TiVo-Central" Messages are MessageItem objects. The former live in /MessageItem/MessageBoard, and the latter in /MessageItem/PreTivoCentral. These are used by the "TiVo Messages" feature in the TiVo UI, and can be created via the TivoWeb Mail module.
/Package	Package items represent nested menus beneath a Showcase or the TiVolution Magazine. They are often pointed at by ShowcaseItems (which are sub-objects of Showcases).
/Person	Person objects live under this directory. /Person/8 contains actors, /Person/9 contains directors, and /Person/12 contains writers.
/Preference	All preferences derived from Thumbs-Up/Thumbs-Down ratings (whether it be for a series, genre, actor, or director) exist here. The function ReadableThumbs in /tvlib/tcl/tv/dumpobj.tcl helps make sense of ThumbData and Thumbness fields.
/Recording	This is where all of the metadata about your recordings exists, in the form of Recording objects. There's an interesting web of associated objects for each recording.
/Resource	Various resources for use in the TiVo UI. Images, Fonts, Sounds, VideoClips, and Loopsets (backround repeating loops for the various menu screens) live here.

Continued

Table 13-5 *(continued)*

Path	Description
/Schedule	This is where guide data lives. StationDay objects have lineups for each channel for a given day.
/SeasonPass/User	All of your Season Passes are stored here (as we saw in the example of Listing 13-9 above).
/Setup	This database entry contains a pointer to your SignalSource object (containing info such as tuner digit delay, the number of digits your cable box uses, whether the enter button is required after entering channel numbers to your cable box, a pointer to which Component from /Components is your cable box / sat receiver, and pointers to channel lineups.
/Showcase	Showcase objects which make up the Showcases feature exist here, with ShowcaseItem subitems for the entries in the showcase. Sub-pages are contained in referenced Package objects.
/State	Here you can find interesting state information about the system. Among other pieces of data, /State/General config contains the remote address (remote control ID) of your TiVo, /State/LocationConfig has your zip code and daylight savings time info, /State/MyWorldState has the last channel you've been on, and /State/PhoneConfig has your dial-in configuration information.
/SwModule	The SwModule objects each represent part of the software installation that goes on the ext2 partitions (they each point to a gzipped tyFile). For instance, one contains all files for the /bin directory, another for /etc, /lib, /sbin, /tvbin, /tvlib, and so on. The kernel and prom have SwModule objects/tyFiles as well.
/SwSystem	The SwSystem object contains the version number of the TiVo software, a link to all of the appropriate SwModule objects (see above), and all of the ResourceGroups used by the system (see the section "dbget / dbset" for an example).
/Theme	Theme objects are where Wishlists are stored.

[1] Around once a week The Discovery Channel airs a paid program specifically designed to be viewed by all TiVo units (this is also mentioned in Chapter 2). This program is broken up into several smaller clips, which get stored in the /Clips path under MFS.

schema.tcl

To find out more about objects, it helps to know what the schema is (that is, what all the available datatypes are, and what fields they can have). As we saw above, the db schema, dbobj

`type`, `dbobj attrs`, and `dbobj attrtype` commands give us that information. A convenient script that displays the entire schema for all objects is `schema.tcl` by Mike Baker (embeem on tivocommunity.com).

If you installed the software distribution from the accompanying CD-ROM in Chapter 4, `schema.tcl` is already installed in `/var/hack/bin/schema.tcl`. If not, you can fetch it at:

`http://tivo.samba.org/download/tridge/schema.tcl`

The version on the CD-ROM has been slightly modified to make it current. If you download it from the above URL, you'll need to comment out the four `tvsource` lines containing `Ident.itcl`, `SvrResp.itcl`, `LogMgr.itcl`, and `DataSet.itcl` (since those files no longer exist).

What's Inside

Complex machines are possible because of the parts they are made up of. Here we'll briefly talk about what components make up a TiVo, how data flows through them, and in some cases, how to access those components directly.

Since there are four different architectures to deal with (Series1 standalone, Series1 DirecTiVo, Series2 standalone, and Series2 DirecTiVo), we'll focus on the Series1 standalone architecture for the most part, pointing out a few differences along the way.

Core Computer Components

At the heart of the system are four familiar components found in all PCs: a microprocessor, memory, a clock, and a fan. There's also a programmable read-only memory (PROM) chip that holds key pieces of data specific to your TiVo, as well as a crypto chip.

Processor

TiVos are computers. The central processing unit (CPU) of a computer serves as its brain, processing all of the instructions that make up the operating system and software.

Series1 TiVos use the 66-MHz PowerPC 403GCX microprocessor as their CPU, while Series2 TiVos use the 200-MHz NEC R5432 MIPS microprocessor. The fact that two different processors exist in separate TiVo lines has two consequences worth mentioning. First, executables you compile for one processor obviously have to be recompiled to work on the other platform. Second, the PowerPC chip is big-endian, whereas the MIPS processor is little-endian. Among other things, this means that byte ordering on the drives are different between Series1 and Series2 units.

Memory

Series1 standalone TiVos have 16 megabytes (MB) of RAM, whereas Series1 DirecTiVos and Series2 TiVos have 32 MB. Some brave Series1 standalone owners actually added memory chips to their units, upgrading from 16 MB to 32 MB. The intent was to see if it would speed up the performance of the user interface, which tends to get sluggish after adding lots of disk storage. Although this did make marginal improvements, it turned out that the bottleneck was disk access due to database transactions rather than memory page faults. This was the motivation behind the CacheCard, which aims to specifically cache database transactions.

Chapter 16 talks more about increasing memory (more for a historical perspective) and about the CacheCard.

PROM

A PROM is a chip containing instructions and data that can be accessed and modified. In a TiVo, it's used to store configuration data that's needed before the hard drive is accessed, and to store instructions to be carried out before the kernel is loaded. Instructions in the PROM are instrumental in making DirecTiVos and Series2 TiVos difficult to hack.

In some early versions of the firmware stored on the PROM, there is a diagnostic mode that can be triggered by sending a carriage return over the serial line at 9,600 baud immediately after the unit is powered on. This is discussed in the section titled "The PROM Menu (Diagnostic Mode)" in Chapter 16.

Depending on how a PROM is wired onto the motherboard (and depending on what type of PROM it is), it may or may not be possible to write new data onto a PROM. Writing content onto a PROM like this is called *flashing* the PROM. Series1 TiVos (including Series1 DirecTiVos) have flashable PROMs. Series2 TiVos do not.[1]

To explain why someone would want to modify the contents of their PROM, I'll describe the boot process of Series1 DirecTiVo units and Series2 units. I won't talk about how to actually circumvent the mechanism (i.e. I won't describe what changes would be made to the PROM image); you can search for that yourself on the various forums (see Appendix A). But suffice it to say, DirecTiVo owners typically flash their PROM with a modified version, and some Series2 owners use a soldering iron to replace their non-flashable PROM with a modified version, specifically to get around the following boot sequence.

[1] Actually, some Series2 standalone units *may* have flashable PROMs. Series1 TiVos used the SST MPF 39VF010 chip. Some Series2 units contain the same "39" chip, while others contain one of the "37" models that does not allow flashing. Rumors circulated for a while about some people who had flashed the "39" PROM on their Series2 successfully, and those rumors were then later followed up with actual code. Of course, to run the code to flash the PROM, they needed to already have access via other means. If you're curious, do some searches on the more lenient forums for more info.

DirecTiVo / Series2 Boot Sequence

When a DirecTiVo or Series2 TiVo is turned on, the first thing that happens is that instructions are fetched from the PROM and executed. The first thing done by these instructions is to check the signature of the current kernel on the "A" drive. The kernel was signed by TiVo Inc. with their private key, and the TiVo unit can use TiVo's public key to verify that the kernel is from TiVo Inc. and hasn't been modified by anyone else. The PROM also checks a signature on itself to make sure that it hasn't been modified, though that's rather pointless (I'll leave it to the reader to determine why).

Since no one but TiVo can create a kernel that passes this test, the code in the PROM can now be sure that this kernel is free from any outside hacking. The kernel is loaded, and control is passed to the kernel. Embedded within the kernel is a ramdisk ("initrd", for initial-ramdisk). That ramdisk is loaded, and instructions within that ramdisk check key files on the `ext2` partitions, looking for modifications or extra files. Extra files are deleted, and modified files are replaced with originals from the ramdisk, which are known to be safe (since the kernel from which the ramdisk was extracted has passed the signature test). If anything was deleted or replaced, the machine then reboots.

This effectively prevents any modifications to startup scripts like `/etc/rc.sysinit`, preventing users from even getting a bash prompt. This boot sequence is why users modify their PROMs (either via on-board flashing in Series1 DirecTiVos or soldering in Series2 TiVos), and why they then modify their kernels as well. Again, I won't give specifics here on how to do this.

Clock Battery

All TiVo models contain a clock battery to power a clock. This clock remembers the current time and date when the power goes out. Sometimes gunk can form between the battery and the contact, preventing the battery from providing power to the clock. In this case, after rebooting your TiVo, the date and time will be wrong. All recordings not marked as Save-Until-I-Delete will appear as yellow exclamation points, and the TiVo will believe that it doesn't have any current guide data.

This condition will cause TiVos with recent software revisions to do a daily call immediately, during which the clock will be set. Still, this can be a pain, so you might want to consider cleaning off the battery contact if you experience these problems.

Figures 14-1 and 14-2 show the location of the clock batteries for a Philips standalone and a Series2 unit. Unfortunately, the old Philips batteries are extremely difficult to remove. You have to remove the three very small screws on the back of the TiVo, then use pliers to twist all of the metal tabs holding down the motherboard until they are straight (one of these tabs is also shown in the upper-right part of Figure 14-1). Once they're all adjusted and you've disconnected the necessary cables, you should be able to (carefully!) pull off the motherboard, all just so you can slide out the battery and scrape away at the contacts with something to clean the stuff off.

FIGURE 14-1: Clock battery on Philips standalone unit.

FIGURE 14-2: Newer clock battery mount on a Series2 TiVo.

Crypto Chip

To perform various cryptographic functions, TiVo units contain a crypto chip. Series1 TiVos use the Atmel AT90SC3232C Secure Microcontroller, while Series2 TiVos use the Atmel AT90SC6464C Secure Microcontroller.

These chips also contain a small One-Time-Programmable area of memory that can be written to only once. Most likely, this is where the serial number for each TiVo is stored (it's not stored on disk).

Fan

To keep heat from the drives and microprocessor down, TiVos contain a fan. The only reason I bother to mention it here is that it actually has a device name. The fan's device name is /dev/fan, which is used by /tvbin/fancontrol.

Drives

One of the most obvious components of a TiVo is the hard drive. Some TiVo models ship with one drive, while others ship with two. Most TiVos can accommodate a second drive, and those that can't can be made to with a special mounting bracket (see Chapter 3).

The hard drives in a TiVo store both the operating system and all recorded audio/video. The "A" drive is the drive set to Master, and it's device name is /dev/hda. If a second drive is present (set to Slave), it is known as the "B" drive, and its device name is /dev/hdb. We talked about the partitions of an A drive in Chapter 4; a B drive merely contains more MFS-Application-Region/MFS-Media-Region pairs.

The MFS Application Region partitions contain the database portion of TiVo's Media File System (MFS), while the MFS Media Region contains recorded audio/video. The audio/video is stored in a TiVo format known as a tyStream. A tyStream object contains both MPEG-2 audio and MPEG-2 video.

See Chapter 3's "Expansion Drive(s)" section for information regarding size limitations on TiVo drives, as well as drive speed and heat issues. Also realize that on-drive caches are useless since the TiVo is constantly writing out data, and therefore flushes out any potential working sets. The attempt to work around this is the CacheCard, mentioned in Chapter 16.

Three tools for obtaining drive info are included on the accompanying CD-ROM, which I describe here: pdisk, hdparm, and smartctl.

pdisk

The pdisk utility is Apple's disk partitioning code, modified to work with TiVo disk partitions. The pdisk executable on the accompanying CD-ROM is only for use when booting the CD-ROM; there is no TiVo-native pdisk on the distribution.

Listing 4-1 in Chapter 4 shows sample output from "pdisk -l <drivename>", which lists all of the partitions on the drive.

hdparm

The hdparm utility lets you get and set hard drive parameters. One version of hdparm is included on the accompanying CD-ROM. Actually, the CD-ROM contains the x86 version of hdparm for use when booting the CD-ROM, while the TiVo version of hdparm ships with all TiVos (in /bin/hdparm).

You can mess up your drive if you don't know what you're doing, so use this utility with care. The main thing most people will find hdparm useful for is to get drive information with the "-i" command. Listing 14-1 shows sample output from the "hdparm -i" command.

Listing 14-1: Sample Output of "hdparm -i"

```
=[tivo:root]-# hdparm -i /dev/hda

/dev/hda:
Model=MAXTOR 4K080H4, FwRev=A08.1500, SerialNo=674119726058
 Config={ HardSect NotMFM HdSw>15uSec Fixed DTR>10Mbs }
 RawCHS=16383/16/63, TrkSize=32256, SectSize=21298, ECCbytes=4
 BuffType=3(DualPortCache), BuffSize=2000kB, MaxMultSect=16, MultSect=off
 DblWordIO=no, maxPIO=2(fast), DMA=yes, maxDMA=2(fast)
 CurCHS=16383/16/63, CurSects=-66060037, LBA=yes, LBAsects=156301487
 tDMA={min:120,rec:120}, DMA modes: mword0 mword1 *mword2
 IORDY=on/off, tPIO={min:120,w/IORDY:120}, PIO modes: mode3 mode4

=[tivo:root]-#
```

smartctl

Most hard drives today have a reliability protection technology built into them known as Self-Monitoring Analysis and Reporting Technology (S.M.A.R.T.). Drives with S.M.A.R.T. technology monitor their own performance, and can predict drive failure before it happens.

One of the S.M.A.R.T. tools to interface with such drives is smartctl, which is part of the smartmontools project:

http://smartmontools.sourceforge.net

smartmontools is an open-source project written by Bruce Allen. You can use the utility smartctl to fetch S.M.A.R.T. data from a drive to monitor its health. Steve White (subuni on tivocommunity.com) ported smartctl to the TiVo platform and posted it in this thread:

http://www.tivocommunity.com/tivo-vb/showthread.php?s=&threadid=108337

If you installed the software distribution as described in Chapter 4, then smartctl is already installed on your TiVo in /var/hack/bin/smartctl. Otherwise, the executable can be downloaded from:

http://erik.rainey.name/tivo/s1/smartctl.gz

Sample output of "smartctl -a" (which obtains all S.M.A.R.T. information from a drive) is shown in Listing 14-2.

Listing 14-2: Sample Output of "smartctl -a"

```
=[tivo:root]-# smartctl -a /dev/hda
smartctl version 5.1-9 Copyright (C) 2002-3 Bruce Allen
Home page is http://smartmontools.sourceforge.net/

=== START OF INFORMATION SECTION ===
Device Model:     MAXTOR 4K080H4
Serial Number:    674119726058
Firmware Version: A08.1500
ATA Version is:   5
ATA Standard is:  ATA/ATAPI-5 T13 1321D revision 1
Local Time is:    Mon May  5 09:06:47 2003 localtime
SMART support is: Available - device has SMART capability.
SMART support is: Enabled

=== START OF READ SMART DATA SECTION ===
SMART overall-health self-assessment test result: PASSED

General SMART Values:
Off-line data collection status: (0x00) Offline data collection activity
                                        was never started.
Self-test execution status:      (   0) The previous self-test routine
                                        completed without error or no
                                        self-test has ever been run.

Total time to complete off-line
data collection:                 (  44) seconds.
Offline data collection
capabilities:                    (0x1b) SMART execute Offline immediate.
                                        Automatic timer ON/OFF support.
                                        Suspend Offline collection upon new
                                        command.
                                        Offline surface scan supported.
                                        Self-test supported.
SMART capabilities:            (0x0003) Saves SMART data before entering
                                        power-saving mode.
                                        Supports SMART auto save timer.
Error logging capability:        (0x01) Error logging supported.
Short self-test routine
recommended polling time:        (   2) minutes.
Extended self-test routine
recommended polling time:        (  50) minutes.

SMART Attributes Data Structure revision number: 11
Vendor Specific SMART Attributes with Thresholds:
ID# ATTRIBUTE_NAME          FLAG     VALUE WORST THRESH TYPE      FAIL RAW_VALUE
  1 Raw_Read_Error_Rate     0x0029   100   253   020    Old_age    -        0
  3 Spin_Up_Time            0x0027   074   074   020    Old_age    -     3250
```

Continued

Listing 14-2 *(continued)*

```
  4 Start_Stop_Count          0x0032  100  100  008  Old_age  -        94
  5 Reallocated_Sector_Ct     0x0033  100  100  020  Old_age  -         0
  7 Seek_Error_Rate           0x000b  100  100  023  Old_age  -         0
  9 Power_On_Hours            0x0012  100  100  001  Old_age  -       265
 10 Spin_Retry_Count          0x0026  100  100  000  Old_age  -         0
 11 Calibration_Retry_Count   0x0013  100  100  020  Old_age  -         0
 12 Power_Cycle_Count         0x0032  100  100  008  Old_age  -        85
 13 Read_Soft_Error_Rate      0x000b  100  100  023  Old_age  -         0
194 Temperature_Celsius       0x0022  088  085  042  Old_age  -        31
195 Hardware_ECC_Recovered    0x001a  021  010  000  Old_age  - 86346931
196 Reallocated_Event_Count   0x0010  100  100  020  Old_age  -         0
197 Current_Pending_Sector    0x0032  100  100  020  Old_age  -         0
198 Offline_Uncorrectable     0x0010  100  253  000  Old_age  -         0
199 UDMA_CRC_Error_Count      0x001a  200  253  000  Old_age  -         0

=[tivo:root]-#
```

Simple I/O Components

TiVos have several I/O ports that are more common on a computer than on a home theater component.

InfraRed (IR) Device

Well, ok, this isn't common on computers, but it's basically a serial port. The IR blaster that controls your cable box is the output of the device, and the IR receiver on the front of the unit is the input of the device. The device name for the IR device is /dev/ttyS0. If you're running the TiVo interface (myworld), you'll have problems trying to access this device raw, as you'll be wrestling with myworld for control of the device. The best way to use the IR device while myworld is running is via the event mechanism (see Chapters 12, 14, and the source code to TiVo Control Station).

Serial Port

TiVos have a serial port that's supposed to be used to change channels on a cable box or satellite dish. Before the TiVoNet card came along, people used to use the serial line to get a bash prompt (and soon after, to house a full PPP connection).

The port is a stereo headphone jack, taking a 1/8-inch stereo mini plug as input. TiVos ship with a cable that has a male stereo mini plug on one side (like a pair of headphones would have), and a male DB-9 connector on the other. Since that cable is intended to connect a TiVo

to a *device*, you'd need a DB-9 null modem (and a DB-9 female gender bender) to connect your TiVo to a *computer*. You can however construct your own cable that switches pins 2 and 3, eliminating the need for a null modem altogether.

Figure 14-3 shows the pinouts for the standard TiVo cable and for a "switched" cable (which doesn't need a null modem).

FIGURE 14-3: Serial cable pinouts.

Since the cable only has three lines (TD, RD, and GND), no hardware flow control is possible (since there is no RTS or CTS line).

The device name for the serial port is /dev/ttyS3.

Modem

Each night TiVo units uses their internal 56-Kbps modem to call into TiVo headquarters to download new guide data. On Series1 standalones, the modem chips used are the Conexant RP336LD Data Pump and the Conexant L2701-15 Micro Controller Unit. Series1 DirecTiVo units instead use the Conexant CX88168 SmartSCM chip and the CX20437 Voice Codec.

The modems all respond to familiar AT commands. The device name for the on-board modem is /dev/ttyS1.

The advanced modem chipset in Series1 DirecTiVos allows them to receive caller-ID information, whereas the older Series1 standalone modem does not. This means that DirecTiVo owners can use the caller-ID hack in Chapter 9 directly, whereas Series1 standalone users need to get their caller-ID information externally (for instance, from a PC whose modem supports the retrieval of caller-ID data).

Debugging Edge Port on Series1 TiVos

There is an edge connector on all Series1 TiVo motherboards that looked intriguing to early hackers. It appears it was used by TiVo employees to do testing/debugging, with a custom test harness they had in-house. Andrew Tridgell reverse-engineered the edge port, and developed a card he attached to it called a TiVoNet card. You'd plug the TiVoNet card onto the connector, plug an Ethernet card into the TiVoNet card, install some software on your TiVo, and voilá — Ethernet access on your TiVo. Another card followed later called the TurboNet card, which has the Ethernet card built in (and is faster). The AirNet card lets you plug in an 802.11 wireless card.

As of TiVo software version 3.0, the software for TivoNet/TurboNet cards is included with the official TiVo software release, so you no longer need to install it yourself. Chapter 5 talks more about getting access with one of these cards.

The edge port doesn't exist on Series2 units. That's ok though, because Series2 units have USB ports.

USB Ports (Series2)

Added by TiVo to officially support the concept of networked TiVos, USB ports are a part of all Series2 units. USB Ethernet adapters allow Ethernet access (the drivers are already installed with the TiVo software). Some early Series2 models have only USB 1.1, whereas newer models are USB 2.0. At the time of this writing, even units with USB 2.0 were limited to 1.1 speeds.

Audio/Video Components

What sets TiVo units apart from normal computers is that they are designed primarily to handle audio and video. As such, there are several dedicated chips that take audio and video into the system, prepare it for storage, retrieve it when needed, and prepare it for output.

Figure 14-4 shows the flow of audio and video data into the TiVo during the recording phase, and back out of the TiVo for video playback. The components shown in this figure (as well as others) are described in the sections that follow.

Note that Figure 14-4 is only a rough approximation of what's going on, since it doesn't show RF coax input, various input/output switches, and so on. Also, remember that the flow is very different on a DirecTiVo: a digital signal comes in directly from the satellite, not requiring any audio/video decoder or MPEG encoder chips in the input stage.

Video Decoder

Standalone TiVos take an analog video signal as input and first convert it to VGA. In Philips standalone units, this is done with the Phillips SAA7114H video decoder/scaler chip. This chip does the analog-to-digital conversion of the signal, and also extracts closed captioning text from the vertical blanking interval (VBI) data.

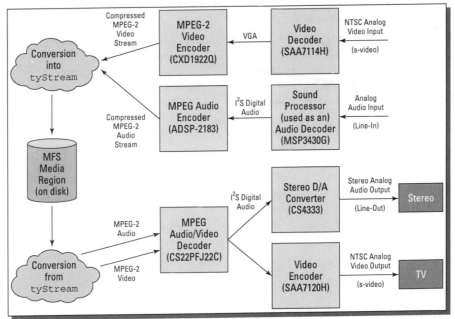

FIGURE 14-4: Audio/video data flow in a standalone Series1 TiVo.

MPEG-2 Video Encoder

Next, the video is passed on to an MPEG-2 encoder. This chip compresses the video stream into the MPEG-2 video format. Closed captioning text is passed along to this chip as well, and the data is entered into the MPEG-2 stream as encapsulated data. The MPEG-2 video encoder chip used in Philips standalone units is the Sony CXD1922Q.

Software combines the compressed video output from this chip with compressed audio (see the next section) to form a tyStream, which is then stored on disk.

Audio Decoder

In parallel with the video decoder and MPEG-2 video encoder steps above, audio is processed via an audio decoder and an MPEG audio encoder as well. The Micronas MSP3430G Sound Processor chip is used in Series1 standalones (as is the MSP4448G in Series2 standalones) to do the analog-to-digital (ATD) conversion, outputting I²S digital audio to the MPEG audio encoder chip.

MPEG Audio Encoder

The digital I²S audio is compressed into an MPEG-2 audio stream by the MPEG audio encoder. Series1 standalones use the Analog Devices ADSP-2183. As mentioned above, the compressed audio output from this chip gets combined with compressed video in software, to form a tyStream. This tyStream is stored on disk in the MFS Media Region partition.

MPEG Audio/Video Decoder

When it's time to display video on-screen, the tyStreams that make up the requested recording are fetched from the MFS Media Region on disk. Software splits out the audio and video MPEG streams, and passes each to the MPEG audio/video decoder chip. The compressed MPEG audio/video streams are decoded by the chip, outputting I²S digital audio to the audio encoder chip and digital video to the video encoder chip.

On Series1 standalone TiVos, this is done by the IBM MPEGCS22 Decoder chip (CS22PFJ22C). Its device name is /dev/mpeg0v.

All of the on-screen displays are done through this chip as well. The chip provides for an on-screen display layer that can be turned on and off.

You can control the MPEG decoder directly, through the use of ioctl's. An ioctl is a command sent to the kernel, to control a device. The kernel passes ioctl commands to the appropriate kernel module for that device. Mike Baker (embeem on tivocommunity.com) documented the MPEG decoder ioctls that he was able to figure out, at:

http://alt.org/forum/index.php?t=msg&th=37

Table 14-1 lists some of the ioctls mentioned in that thread, as well as a few others.

Table 14-1 MPEG Decoder ioctls

Command	Description
1000 (0x3E8)	Normal play
1001 (0x3E9)	Pause
1009 (0x3F1)	Freeze frame (video pauses, audio continues). Normal play (ioctl 1000) returns to normal audio/video playing.
1010 (0x3F2)	? Returns 0 while in menus or when paused on video, and usually returns 351 when you're watching video (live or recorded). Sometimes when you change the channel or skip ahead to live, it briefly returns a number smaller than 351.
1011 (0x3F3)	Turn on On-Screen-Display (OSD)
1012 (0x3F4)	Turn off OSD
1013 (0x3F5)	Play only MPEG key-frames of video (audio continues) Normal play (ioctl 1000) returns to normal audio/video playing.
1015 (0x3F7)	Slow Motion. Pass in a value between 0 and 7 for the speed to use, where 0 is normal and 7 is very slow. The chip accomplishes slow motion by repeating frames.

Command	Description
1016 (0x3F8)	Audio sync off.
1017 (0x3F9)	Audio sync on.
1019 (0x3FB)	Set timestamp. This sets a value for the timestamp of the current location within the available buffer. For instance, if you paused video with 1001 and set the current timestamp to "12345" with this ioctl, then calling "get timestamp" below (1021) would return "12345". If you unpaused, then quickly paused again and called "get timestamp", the number would be slightly higher. This function is close to useless, however, since the TiVo software updates the actual timestamp value (very often) with the actual timestamp within the recording.
1021 (0x3FD)	Get timestamp. This returns the current timestamp, which is either a value set in "Set timestamp" above, a value slightly larger than it, or more likely, the offset into the given recording. Dividing the result by 90000 yields the number of seconds into the recording, if it has been updated by the TiVo software (that is, if you didn't just recently change it with the "set timestamp" ioctl above.
1027 (0x403)	MPEG_OSD_WRITE. This writes data into the memory used for the OSD layer. The data parameter for this ioctl is a structure of the form: ```struct osd { unsigned start; unsigned len; void *buf; }``` (See the files osd.c and osd.h in the source code for tivovbi for more info.) Because the structure contains a pointer, it's not clear how you could use the tivosh ioctl command to call this from Tcl; instead you'll need to call it from C.
1028 (0x404)	? "OSD Link Address" Related to the feature of the CS22 chip that lets you have a linked list of OSD items for display.
1030 (0x406)	? "MPEG_OSD_ANIMATE" Related to the feature of the CS22 chip that lets you animate items in the OSD layer by linking to multiple OSD items, one at a time.

Continued

Table 14-1 *(continued)*

Command	Description
1032 (0x408)	? "MPEG_INT_MASK_WRITE"
1043 (0x413)	Turn on or off RF passthrough (if this is on, it sends the cable spectrum from coax-in straight to coax-out rather than outputting TiVo output on channel 3/4). Pass in either 0 or 1 to specify whether RF passthrough should be off or on.
1050 (0x41A)	Obtain information about myworld's video context. It sometimes takes a second or so for calls to this ioctl to catch up with the current state. The number returned seems to have two bits of importance (perhaps there are more): a mask of 0x8000 corresponds to a bit that indicates whether video is playing, and a mask of 0x0040 corresponds to a bit that indicates whether video is at normal speed or not. To clarify, the following four values are returned: 0x0000 — Either a menu is on-screen, or video is paused. 0x0040 — This is returned rarely, usually between state changes. 0x8000 — Video is being fast-forwarded, rewound, or viewed at slow speed. 0x8040 — Video is playing (whether livetv or recorded)
1051 (0x41B)	Blank out the video content (with black). The OSD screen may still be displayed.
1052 (0x41C)	Turn back on the video content which was blanked out by ioctl 1051 above.
1057 (0x421)	Disable both the audio and video.
1058 (0x422)	Re-enable the audio and video from ioctl 1057.
1061 (0x425)	Turn audio off.
1062 (0x426)	Turn audio on.

Here are quick examples of how to control the MPEG decoder from both Tcl and C, as well as a program called displayctl, which performs these ioctl calls for you.

Controlling the MPEG Decoder with ioctls in Tcl

To send ioctl commands to a device, you can use the tivosh command ioctl (described in the "Other tivosh Commands" section of Chapter 13). You pass it an open file channel associated with the device name (in this case, /dev/mpeg0v), the number of the ioctl command you want to issue, and any required parameters.

We'll start with the example in Table 13-4 from Chapter 13. To put the MPEG decoder into a state where it only plays key-frames of video, you can run this script:

```
#!/tvbin/tivosh

set mpg [open "/dev/mpeg0v" "w+"]
ioctl $mpg 1013
close $mpg
```

The ioctl 1000 returns everything to normal and resumes playing:

```
#!/tvbin/tivosh

set mpg [open "/dev/mpeg0v" "w+"]
ioctl $mpg 1000
close $mpg
```

The Slow Motion ioctl (1015) looks at the data parameter to determine the speed to display video at (between 0 and 7). This example plays video at the slowest speed of 7 (for the few seconds until TiVo's software resets things to normal):

```
#!/tvbin/tivosh

set mpg [open "/dev/mpeg0v" "w+"]
ioctl $mpg 1015 -param 7
close $mpg
```

Controlling the MPEG Decoder with ioctls in C

A more direct way to send ioctl commands to a device is by writing your program in C and making the usual call to the system command ioctl. See Chapter 15 to learn how to set up a cross-compiler to compile executables for your TiVo.

Here is the key-frames example from above, this time in C:

```
/* cs22_keyframesonly.c */
#include <fcntl.h>
int main(int argc, char *argv[]) {
  int mpg = 0;
  mpg = open("/dev/mpeg0v", O_RDWR);
  ioctl(mpg,1013,0);
  close(mpg);
}
```

Note that the data parameter (the third argument to ioctl) should be zero for ioctls that don't use it. As before, to restore play to normal you use ioctl 1000:

```
/* cs22_normalplay.c */
#include <fcntl.h>
int main(int argc, char *argv[]) {
  int mpg = 0;
  mpg = open("/dev/mpeg0v", O_RDWR);
  ioctl(mpg,1000,0);
  close(mpg);
}
```

The C version of the slow-motion example is:

```
/* cs22_slowmotion.c */
#include <fcntl.h>
int main(int argc, char *argv[]) {
  int mpg = 0;
  mpg = open("/dev/mpeg0v", O_RDWR);
  ioctl(mpg,1015,7);
  close(mpg);
}
```

displayctl

Graham R. Cobb wrote a C program called `displayctl` which lets you issue many of the known ioctls to the MPEG decoder chip. If you installed the software distribution on the accompanying CD-ROM in Chapter 4, then `displayctl` is already on your TiVo in `/var/hack/bin/displayctl`. If not, you can download it from:

`http://www.cobb.uk.net/Tivo/Displayctl`

The `displayctl` command lets you turn on and off the video display, OSD display, and sound, as well as pausing, resuming, entering slow motion mode, and specifying OSD data for various OSD-related ioctls. It also lets you specify an ioctl by number, for ioctls that `displayctl` doesn't have a command-line option for.

You can get a list of supported options by typing "`displayctl -h`". A few simple options are:

- `-v on|off` turns on/off the video layer
- `-t on|off` turns on/off the OSD display
- `-s on|off` turns on/off sound
- `-d on|off` turns on/off the entire display

One trick you can do (if you want to play with listening to remote codes and drawing things on-screen as a result) is to put the TiVo in Standby mode (TiVo Central ➔ Messages & Setup ➔ Standby), then use "`displayctl -d on`" to turn back on the video and OSD layers. Now your TiVo will be in a state where it will still record shows that it's supposed to, and you can still display things on-screen with the various tools from Chapter 9, but it won't respond to any TiVo remote control codes (except the TiVo and LiveTV buttons).

Audio Encoder (Stereo D/A Converter)

Audio exiting the MPEG audio/video decoder chip is still in digital (I²S) form, and needs to be converted to an analog line-out signal for use by stereo equipment or a television. In Series1 TiVos, this digital-to-analog (DTA) conversion is done by the Cirrus Logic CS4333 Stereo D/A Converter.

Series2 standalone TiVos use the Broadcom BCM7040 chip in place of both this chip and the video encoder chip described below.

Video Encoder

Video exiting the MPEG audio/video decoder chip is also still in digital form, and needs to be converted to an analog NTSC signal for use with a television. In Series1 TiVos, this DTA conversion is done by the Phillips SAA7120H video encoder chip.

As mentioned above, Series2 standalone TiVos use the Broadcom BCM7040 chip in place of both this chip and the audio encoder described previously.

Note One of the early hacks (done by Andrew Tridgell) was to modify a normal U.S. TiVo model to output PAL video instead of NTSC. The video encoder chip does support it — it was just a matter of randomly trying calls until he found the correct bits to enable PAL output. I briefly mention PAL hacking more in Chapter 11.

MPEG Clock Synthesizer

The ICS MK2745-265 MPEG Clock Source chip provides synchronized clock signals that drive the audio/video chips, keeping them in sync.

The Whole Is Greater Than the Sum of Its Parts

Well, you've seen what makes your TiVo tick (or at least a Series1 standalone TiVo, but that's enough to get a basic feel for it). One thing that seeing all of the parts does for me is to make me grateful that someone sells this as a packaged device. It seems like every month or so someone else is posting some new article or comment about building their own TiVo-like PC/device. As a hobby or experiment, I can understand, but from a usage point of view — no way; using a TiVo is a far better experience than using any of the home-brewed solutions that are out there so far. The hardware inside your TiVo isn't some huge set of magic — yet when put together and directed by TiVo Inc.'s software, you get the device we've all been enjoying for so long.

Developing Your Own Hacks

It's always more rewarding and fun to build something that will affect you than something that won't. If you're a carpenter, it's got to be much more satisfying to build a new set of stairs for your house than to build a set for the customer of the week. Every time you walk up and down those new stairs, you're benefiting from your work.

If you're a dressmaker, it has to feel better to have made your favorite dress that you wear all the time than to have made a shirt for a distant cousin.

In this same way, it's extremely cool to be able to write software that effects how you watch TV.

If the carpenter who loved his staircase design gets to have his blueprints used by others, and the dressmaker shares her pattern with thousands of dressmakers in a magazine submission, then they've both benefited twice; once in doing something fun for themselves, and a second time by sharing that with others.

That's what it's like when you take an idea, and actually go ahead and turn it into something. It's easy to figure, "eh, someone will get around to doing that; someone must have thought of it." But to actually sit down and do it—to write something useful, and share it, and have it out there—that's incredible.

When I created the Search module for TivoWeb, it started with my checking to see if it could be done; was the index accessible, or was it buried away in some incomprehensible format? I hunted around for the index files, found they were in MFS, tried pulling them out of MFS, got that working, and wrote a simple prototype to `grep` through the file for results. I threw together an early UI, and I now knew I had something I wanted to polish.

After a while, I'd built something I was happy with and used on a regular basis. I'd always planned on releasing it but wanted to finish up one feature, got distracted, etc. Then I finally released it. Now, everyone gets to use it, because it's a part of TivoWeb. Even better than that, more work was done to make other parts of TivoWeb use the search module; every actor and director are now clickable links that use the search module to display every upcoming movie and show that they've been in. My releasing the software not only gave everyone else that new functionality, but it actually caused the software to grow!

Methodology of Writing a New Feature

When you get an idea, the first thing you should do is write it down (or rather, type it up). You might know the entire idea in your head, but the act of writing it down can flush out even more details than you've explored so far. Plus, getting it out of your head can clear your mind, so you're not trying to remember a web of interconnected details.

Then, by all means, create a prototype. Don't worry about things being optimized or quick; get a proof of concept going. The main thing you want to do is get yourself working on your idea, and rewarding yourself with small amounts of progress. Once you're in the swing of things and committed to the project, it'll be easy to justify rewriting portions to make them faster (without risking that despair or apathy will take over and convince you to do something else). Get your first milestone of progress done before anything else.

What form that first milestone should take will vary from project to project. Maybe you'll want to work out what the user interface is first — what the resulting web pages or screens will look like. Or maybe if you're trying to control some piece of hardware, your first goal is just to prove that you can do it. Basically, start with the piece that will keep you going, and give you some quick short-term goal.

Once you've written out your idea and thrown together some jury-rigged proof of concept, put your code under source code control. You want to be able to completely re-arrange/re-write code without having to worry about bailing out of those changes later with backups. Even the most ardent fans of using source code control at work sometimes make the mistake of thinking that it's overkill on some project they're doing for fun in their spare time. It doesn't have to be anything fancy either; I swear by ClearCase at work, but for home projects even RCS is good enough for me. If you don't know anything about source code control, you can make backups every couple of hours for now, but do yourself a favor and go read a quick intro on RCS or CVS.

When you've got that much done, start a To-Do list in the same directory where you're keeping your project. Just keep adding things to it as you think of them. One at a time, you'll end up implementing the ideas on the list and crossing them off.

This seemingly obvious set of ideas helps immeasurably. It can be the difference between having a good idea that you forget about and having a good idea that you turn into something useful for the community.

Lastly, have a directory where you're going to keep all of your hacks. Create subdirectories for each hack you write. If you don't have the time to implement something now (but want to remember it), keep the idea that you've written up in a subdirectory. Later if you find some piece of info that will make the project easier, you can just throw it in the directory for when you finally get interested in it again.

Writing a TivoWeb Module

To show you how TivoWeb modules work, I'll walk you through a very simple TivoWeb module I wrote: the logs module. All it does is allow the user to view the log files located in

the /var/log directory of your TiVo. TivoWeb modules are written in Tcl, so if you're
unfamiliar with Tcl you may want to consult Appendix B, or buy an introductory book on
the subject.

However, before covering the logs module, let's do the obligatory Hello, World! example we're all
so used to (see Listing 15-1). To try this out, create this file (naming it helloworld.itcl),
place it in the directory tivoweb-tcl/modules, and perform a "Quick Reload" of TivoWeb
(Restart → Quick Reload).

Listing 15-1: TivoWeb HelloWorld Module: helloworld.itcl

```
01  #
02  # HelloWorld TivoWeb Module
03  #    by Jeff Keegan
04  #
05
06  proc action_helloworld {chan path envr} {
07
08    puts $chan [html_start "Hello World"]
09    puts $chan "<FONT SIZE='+1'><B>Hello, World!!!</B></FONT>"
10    puts $chan [html_end]
11
12  }
13
14  register_module "helloworld" "Hello World" "Greet the World"
```

A TivoWeb module defines at least one "action" procedure that is called when a request comes
in for a particular URL pattern. Since we want http://192.168.1.101/helloworld
to output the result of our module, we name this procedure action_helloworld in line 6.
It takes three arguments — a channel to output to ($chan), the path of the URL after
/helloworld but before any "?" ($path), and a bunch of Tcl commands to set any CGI
variables specified in the URL after a "?" ($envr).

Inside the body of this procedure, we output HTML headers via the html_start command,
output the string "Hello World!!!" with some HTML decorations around it, and then close up
the HTML tags with html_end. Many HTML helper commands exist; they can be found in
tivoweb-tcl/html.itcl.

Outside of this procedure, we have the command that registers our code with TivoWeb (on line
14). The first argument ("helloworld") determines what the starting link will be for the
Hello World module on the Main Menu page (http://192.168.1.101/helloworld).
The second argument describes the name to be printed on the Main Menu page, as well as in
the header of all TivoWeb pages. The third is the text description for the Main Menu page.
Figure 15-1 shows the Main Menu with our Hello World module installed, and Figure 15-2
shows the very simple output of the Hello World module itself.

The title "Hello World" is the second
argument to the register_module command

Third argument to
register_module command

These links go to http://192.168.1.101/helloworld since the
first argument to the register_module command was "helloworld".

FIGURE 15-1: Hello World Installed, and the effects of the register_module arguments.

That's it. This module is pretty simple, not using the path of the URL or any CGI parameters. The logs module will show us more of that.

Listing 15-2 shows the entire source code for logs.itcl, which resides in the tivoweb-tcl/modules directory.

FIGURE 15-2: Output of Hello World module.

Listing 15-2: The TivoWeb logs Module: logs.itcl

```
01  # Copyright (c) 2001 Jeff Keegan (jkeegan@keegan.org)
02  # $Id:
03  #
04  # Logs module by Jeff Keegan, http://www.keegan.org/jeff
05  #
06  # History:
07  #    First version, August 27, 2001
08  #    August 27, 2001:  Version 1.0
09  #
10
11  proc action_logs {chan path envr} {
12    global tzoffset env
13    set TIVO_ROOT $env(TIVO_ROOT)
14
15    if {[string index $path 0] == "/"} {
16      set path [string range $path 1 end]
17    }
18
19
20    if {$path == ""} {
21      puts $chan [html_start "Logs"]
22      puts $chan [html_table_start "" "" ""]
23      foreach vers {Current Old} {
24        set logs ""
25        if {$vers == "Current"} {
26          puts $chan [tr "" [th "COLSPAN=3" "Current Logs"]]
27          set logs [lsort [glob "$TIVO_ROOT/var/log/\[a-z\]*"]]
28        } elseif {$vers == "Old"} {
29          puts $chan [tr "" [th "COLSPAN=3" "Old Logs"]]
30          set logs [lsort [glob "$TIVO_ROOT/var/log/O*"]]
```

Continued

Listing 15-2 *(continued)*

```
31              }
32          puts $chan [tr "" [th "Filename"] [th "Size"] [th "Date"]]
33          foreach log $logs {
34            regsub "$TIVO_ROOT/var/log/" $log {} logname
35            puts $chan [tr "" \
36              [td [html_link "/logs/$logname/" "$logname"]] \
37              [td [file size $log]] \
38              [td [clock format [expr [file mtime $log] + $tzoffset] \
39                    -format "%b %d %H:%M:%S"]]]
40          }
41        }
42
43      puts $chan [html_table_end]
44      puts $chan [html_end]
45    } else {
46      puts $chan [html_start "Logs: $TIVO_ROOT/var/log/$path"]
47      if { [regexp {\.\.} $path]} {
48        puts $chan "please don't do that"
49        puts $chan [html_end]
50        return
51      }
52      puts $chan [html_table_start "" "$TIVO_ROOT/var/log/$path" ""]
53      puts $chan "<TR><TD>"
54      set fsize [file size "$TIVO_ROOT/var/log/$path"]
55      set logfile [open "$TIVO_ROOT/var/log/$path" "r"]
56      while { ! [eof $logfile] } {
57        set line [gets $logfile]
58        puts $chan [htmlEncode "$line\n"]
59      }
60      puts $chan "</TD></TR>"
61      close $logfile
62      puts $chan [html_table_end]
63      puts $chan [html_end]
64    }
65  }
66
67  register_module "logs" "Logs" "View TiVo log files"
```

Lines 15–17 strip any trailing "/" from the $path variable. For example, if the URL requested was http://192.168.1.101/logs/tvlog/, then $path would now be "tvlog".

If $path is empty, then a list of the existing logs is displayed for the user to choose from. This is done by the code from lines 21–44. You can see here how HTML tables are created with the html_table_start, tr, th, td, and html_table_end commands. Technically, this could all be achieved by outputting the HTML yourself, but these helper commands make sure tags are balanced, and some would argue that they make the code more readable.

If $path isn't empty, then someone has clicked a link and is trying to view a particular log file. Lines 46–64 handle this case. The file in /var/log with the name in $path is opened, read, HTML-encoded (with htmlEncode), and outputted, inside an HTML table.

Since the logs module has such a simple task, it doesn't need extra parameters to function; it gets all of its data via the part of the URL after /logs ($path). If we wanted parameters, it would be easy to do. If you requested the URL:

```
http://192.168.1.101/logs/tvlog?x=1&y=5&name=foo+bar
```

then the $envr variable would come back as:

```
set "x" "1";set "y" "5";set "name" "foo bar";
```

You would put "eval $envr" somewhere near the top of action_logs, and then the variables $x, $y, and $name would be there for you to access.

You can use output forms with html_form_start, html_form_select, html_form_text, html_form_checkbox, html_form_input, html_form_hidden, and html_form_end. If you want, you can create another URL to send forms (or simple links) to, with another action_someothernamehere procedure.

The best thing to do when getting up to speed is to take a look at the existing modules. Once you get the language (Tcl) down, it's pretty easy to follow. It's particularly useful to look at how the latest versions of modules are handling time zone adjustments, sharing globals, and so on. Also, be sure to test your module under various themes if you use any custom HTML.

Writing a Tivo Control Station Enhancement

The directory tcs/modules/samples contains examples of how to write Tivo Control Station modules that fetch data from the web, and respond to socket requests (like TivoWeb modules, TCS modules are written in Tcl). Check out those examples as well as the existing TCS modules for the best information about how to create a TCS module.

But again, let's do the Hello, World! example. Listing 15-3 shows a TCS Hello World example that says Hello World on-screen, and also responds to socket requests. To install it, create this file (naming it helloworld.tcl) and place it in the directory tcs/modules. Shutdown TCS (cd /var/hack/tcs ; ./shutdowntcs), then start it up again (./starttcs).

Listing 15-3: TCS HelloWorld Module: helloworld.tcl

```
01  #
02  # HelloWorld Tivo Control Station (TCS) Module
03  #   by Jeff Keegan
04  #
05
06  proc ShowHelloWorld { sock } {
07    global Newtext2osdCommand
08
```

Continued

Listing 15-3 *(continued)*

```
09    if {[catch {exec $Newtext2osdCommand --gardavis --bg yellow \
10              --fg red3 -s 8 -x 6 -y 7 -t "   Hello, World!!!   " \
11              > /dev/null 2>/dev/null "&"} result]} {
12      puts "[CurrentTime] Can't launch newtext2osd ($Newtext2osdCommand)"
13    }
14  }
15
16  proc NetworkHelloWorld {sock} {
17    global Newtext2osdCommand
18
19    puts "[CurrentTime] HLOW"
20    puts $sock "Hello, World!!!"
21    flush $sock
22
23    ShowHelloWorld $sock
24  }
25
26  proc InstallHelloWorldModule {} {
27
28    global HelloWorldDisplayStyle
29    global HelloWorldClearScreenStyle
30    global evrc
31
32    set remotecommand [list $evrc(1) $evrc(2) $evrc(clear)]
33    set periodicupdatefrequency 0
34    set periodicupdatecommand "None"
35    set displaycommand "ShowHelloWorld"
36    set HelloWorldDisplayStyle 0
37    set HelloWorldClearScreenStyle 0
38    set updateisgreedy 0
39
40    set networkcommand "HLOW"
41    set networkcall "NetworkHelloWorld"
42
43    set moduleversion "1.0.0.0.0"
44    set loaded [RegisterModuleVersion "HelloWorld" $moduleversion]
45
46    if {$loaded} {
47      InstallRemoteCommand "HelloWorld" \
48                           $remotecommand \
49                           $periodicupdatefrequency \
50                           $displaycommand \
51                           $periodicupdatecommand \
52                           $HelloWorldDisplayStyle \
53                           $HelloWorldClearScreenStyle \
54                           $updateisgreedy
55
56      InstallNetworkCommand "HelloWorld" \
```

```
57                          $networkcommand \
58                          $networkcall
59
60    }
61 }
62
63  InstallHelloWorldModule
```

We'll walk through the code first, and try it later.

Lines 6–14 make up our callback procedure (ShowHelloWorld), which will be called when the user triggers the HelloWorld module via the remote control. There is nothing special about the name of the procedure—we'll be explicitly registering it later on. The callback basically does one thing: it calls the external program newtext2osd to display the string "Hello, World!!!" on-screen. We pass a bunch of arguments to it, setting the foreground and background colors of the text, describing where on the screen to draw it, what text to draw, how many seconds to leave it on screen, and that it should be drawn with a slightly larger font. You can find out more about newtext2osd in Chapter 9.

The only other things worthy of mention about this procedure are that we get the location of the newtext2osd executable from a global variable set by TCS itself, and that we catch any exceptions and output an error message if something goes wrong.

Lines 16–24 define another callback procedure (NetworkHelloWorld), to handle command requests that come in on port 8762 (again, there's nothing special about the procedure name; we register it later on in the code). In this callback, we output a one-line log entry, write "Hello World!!!" back to the socket that we received the request from, and then call ShowHelloWorld to display the greeting on-screen as well (just as if someone had triggered it via the remote control).

The InstallHelloWorldModule procedure makes up the rest of the code of the module; it doesn't really need to be in its own procedure, but it makes the code look a little nicer. Nothing special about this procedure name either; you can see that we explicitly call it on the last line of the script (line 63).

This remaining code boils down to three function calls. Line 44 calls RegisterModuleVersion, providing TCS with the current version number of HelloWorld.tcl (this info is used by the UpdateCheck code, which looks for new downloadable versions of TCS modules). Line 47 registers the ShowHelloWorld callback to be triggered when the user presses 1-2-clear on the remote control (the button sequence itself is defined on line 32). Line 56 registers the HelloWorld callback to be triggered when the user sends a "HLOW" command via a socket connection to port 8762.

Ok, let's try using it. Take your remote control, start watching video (either livetv, or a prerecorded recording; just get off of the menus), then press 1-2-clear. Within a second or two, you should see the results on-screen (see Figure 15-3). It should disappear after around 8 seconds. Performing a 9-0-clear command from the remote (to display all available commands) will reflect the addition of the new module, as seen in Figure 15-4.

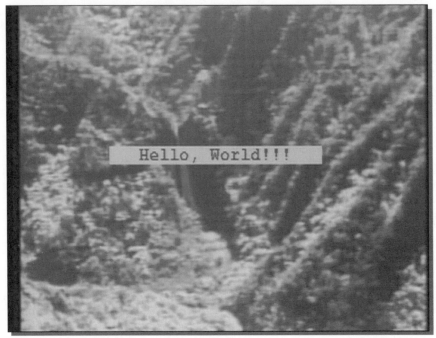

FIGURE 15-3: HelloWorld TCS module in action.

Remote	Net	Function
0 0 clr	----	Caller-ID History
0 1 clr	----	eBay
0 2 clr	----	ResetEBayTimers
0 8 clr	----	Caller-ID Phonebook
1 1 clr	KTEL	KillTelnet
1 2 clr	HLOW	HelloWorld
2 2 clr	KFTP	KillFtp
3 3 clr	KWEB	KillTivoWeb
5 5 clr	KVBI	KillTivovbi
6 0 clr	----	SportsCommands
6 4 clr	----	NHL
6 5 clr	----	NBA
7 1 clr	----	Interest Rates
8 1 clr	----	GetWeatherZipFromRe
8 2 clr	----	LocalRadar
8 3 clr	----	NationalRadar
9 0 clr	----	ShowCommands
9 1 clr	DOOR	EnableBackdoors
9 2 clr	SORT	EnableSortNowPlayin
9 3 clr	CLCK	ToggleClock

--- more ---

FIGURE 15-4: HelloWorld module appears in ShowCommands (9-0-clear) list.

As we saw above, the module also registers a new command, HLOW (HelLOWorld), that can be invoked by connecting via socket to port 8762. Listing 15-4 shows a telnet connection into a running instance of TCS. Issuing the HLOW command causes the module to not only say Hello World to us over the socket, but to draw it on-screen as well (just like when you trigger the module via the remote control).

```
# telnet 192.168.1.101 8762
Trying 192.168.1.101...
Connected to 192.168.1.101.
Escape character is '^]'.
HLOW
Hello, World!!!

Connection closed by foreign host.
#
```

Our example doesn't take any arguments, but you can write these network commands such that they do (see tcs/modules/samples/MisterEcho.tcl). You can enter multiple commands (one on each line); entering a blank line will close the socket connection.

This HelloWorld module is very simple; it doesn't need to perform any tasks other than those initiated by the user, and it doesn't need to fetch any data. Most TCS modules are more sophisticated, pre-fetching data on a regular basis so that it's available in the event that a user invokes the module. You can specify a callback to be called periodically, on lines 33, 34, 49, and 51. For example, the Weather module has a callback RefreshWeather that fetches new weather data every 5 minutes.

Another thing that's rather simple about our example is that we only output one line of text to the screen, so we call newtext2osd directly. Most modules outputting text-based data will instead use the DisplayFile procedure, which is defined in tcsd.tcl. Basically, you have your periodicupdate callback generate text files such as tcs/displayfiles/helloworld.out, tcs/displayfiles/helloworld.out1, tcs/displayfiles/helloworld.out2, and so on. Then during your remote-triggered callback you call DisplayFile, passing it the full pathname of the first output file (for example, /var/hack/tcs/displayfiles/helloworld.out). The DisplayFile procedure will call newtext2osd for you to display the first page, and will then listen for up or down button-presses on the remote. Those button-presses will cause the next (or previous) display file to be displayed. Pressing clear will cause DisplayFile to clear the screen, and exit.

If your module wants to display graphics on-screen, you can call the JPEGDisplay procedure (also defined in tcsd.tcl). This calls jpegwriter for you, and clears the screen when clear is finally pressed.

Basically, you can do whatever you want in these callbacks (though there is a throttling mechanism that helps keep the system running without hiccups; see the existing modules for examples

of Throttle). The eBay module checks items on your eBay watch-list during its periodic updates, and displays a notification on-screen when an auction you're watching is about to end. It also can send out mail at that time as well.

Writing a Standalone Hack

If the tool you want to build doesn't fit the model of TivoWeb or Tivo Control Station, then write it as a standalone application of its own. There's nothing inherently special about TivoWeb or TCS — they themselves are standalone applications, that happen to be expandable. But there are some things you'll want to think about.

Launching Your Standalone Hack

First, if your entire application performs one task, and needs to do it on a periodic basis, you could leave all of the scheduling to `cron` (Chapter 12) and just write the guts of the task itself. Suppose that you decide to write a hack that notifies a friend about new shows you've recorded. You could spend your time writing a scheduling mechanism that sleeps for most of the day and wakes up long enough to perform your task, or instead you could just do the scheduling with `cron`.

Next, if your application isn't started exclusively via `cron` (perhaps because it needs to be running all the time), then you'll need a way to start it. When developing it, you can start it by hand, but ultimately you'll want it to start when your TiVo boots up (and so will the users of your hack). You'll either want to start it from `/etc/rc.d/rc.sysinit`, `/etc/rc.d/rc.sysinit.author`, or some other script that you've already set up to get started via `rc.sysinit` (like `/var/hack/etc/hacks_callfromrc.sysinit`). In the documentation for your hack, you're going to need to describe to the user how to do this.

As mentioned in earlier chapters, the `/var/hack/etc/hacks_callfromrc.sysinit` file that I've introduced here is started by adding these lines to `/etc/rc.d/rc.sysinit`:

```
if [ -f /var/hack/etc/hacks_callfromrc.sysinit ]; then
  . /var/hack/etc/hacks_callfromrc.sysinit
fi
```

You'll want to either set this up, having `hacks_callfromrc.sysinit` launch your hack, or have `rc.sysinit` launch it directly. It's also a good idea to have a wrapper script that starts/stops your hack in the background if it's a Tcl script; this is what you should tell people to use, either by hand or in one of the startup scripts mentioned above. Listing 15-5 shows an example startup script called `tellfriendsmyshows` for a fictitious hack "`tellfriendsmyshows.tcl`", which is somewhat based on the startup scripts for TivoWeb and TCS.

Listing 15-5: Example Startup Script tellfriendsmyshows

```
#!/bin/sh

shopt -s extglob
```

```
dir=${0%%+([^/])}

tclfile="tellfriendsmyshows.tcl"
logfile="tellfriendsmyshows"
bin=${dir}${tclfile}

if test -f "$bin"
then
   case ${1:-null} in
   "console")
       tivosh $bin &
       ;;
   "devnull")
       tivosh $bin >> /dev/null 2>> /dev/null &
       ;;
   *)
       tivosh $bin >> /var/log/$logfile 2>&1 &
   esac
else
   echo "Error: could not locate ${tclfile} in dir '${dir}'"
fi
```

The first two lines basically set `dir` to point at the directory where `tellfriendsmyshows` lives (it's like a `dir=`dirname $0`), to allow a few other variables to be set on the next few lines. Then if the Tcl file to be executed exists, it is started in the background, handling output in one of three ways: sending output directly to the terminal that ran it, discarding the output by sending it to `/dev/null`, or storing it in a log file in `/var/log`.

Providing a helper script like this makes installation easier for your users, reducing the number of requests you'll get from people who are having trouble starting it.

If Appropriate, Set Priority Low within Your Hack

It's not always the best of ideas to set the priority of your process low (sometimes that control should be left up to the user), but if you know your hack is going to be a big resource hog, it might be worth considering setting your priority to low directly within your hack. TiVo uses their own custom priority scheme, so don't go looking for the Unix command "nice". Instead, you use `setpri` and `getpri`.

If your hack is a Tcl script, you can use the `tivosh` internal command `setpri` (see Chapter 13) to lower the priority of your hack's process, so that it doesn't interfere with normal TiVo operations (put "`setpri fifo 1`" near the top of your script). There is also an external command-line version of `setpri` (see Chapter 12), so you could also lower the priority of a bash-only script by adding "`/var/hack/bin/setpri fifo 1 $$`" to the beginning of your script, though now you're dependant on that executable being in that location.

The source code to the external version of `setpri` is available (and is included on the accompanying CD-ROM at `/cdrom/doc/setpri.c`), so if your hack is compiled C code, you might find it interesting and/or useful to see how `setpri` works.

Allow Users to Quit

If your standalone application is a Tcl script, you're going to need to build in a way for users to quit (though that's desirable if your application is compiled, too). The reason that this is important is that `tivosh` (which is actually just `myworld`) doesn't handle getting killed well; it usually causes the machine to reboot. Thus, if someone wants to kill your hack, they can't safely use `kill`, and need another way to quit. The script `shutdowntcs` in the TCS directory merely puts one line of text in a well-known file, and the script itself periodically checks it to see if the user has requested the application to quit. TivoWeb has a web-based menu item Restart ➔ Quit, which exits. Be aware of the need for a quitting mechanism.

Allow Users to Start/Stop via TCS

Consider allowing your users to start and stop your standalone hack via Tivo Control Station. TCS already allows you to start/restart or stop TivoWeb, `tivoftpd`, `tivovbi`, and the telnet daemon `tnlited`, via remote control or socket.

What you need to do is make the appropriate changes to `KillApplications.tcl` and `RestartApplications.tcl`. Upon releasing your hack, it would make sense to supply instructions to users on how to patch those scripts, and it would also make sense for you to contact Zirak with the patch.

What Is There to Work With?

There are many things at your disposal when writing a standalone hack. You obviously have access to the Unix filesystem and all of the files in it. If your hack is a Tcl script, you have access to the MFS database (discussed in Chapter 13). You can output things to the screen with the various tools described in Chapter 9. There is limited net access (no DNS library exists, except the one that ships with TCS). You also have the ability to monitor events.

There are various events in the system, indicating occurrences such as remote control button presses, context changes, dial-home events, and so on. You can register callbacks in your Tcl scripts to be called when events occur. If your hack is written C, you can still access (and issue) Tcl events, thanks to `eclient` (see Chapter 12). The source code to `eclient` is available (and is on the accompanying CD-ROM under `/cdrom/doc/eclient`), so you can compile it with your code (as long as your resulting derived work is also released under the GNU Public License). It was posted on tivocommunity.com at:

http://www.tivocommunity.com/tivo-vb/showthread.php?threadid=69105

For examples of how to register events in a Tcl script, I recommend you take a look at the source code for Tivo Control Station (`tcsd.tcl` and `eventroutines.tcl`), as well as `/tvlib/tcl/tv/screenTestsFramework.tcl` (if it exists on your TiVo). There is also an event server (tivo concurrent event server, written by Kevin Livingston) at:

http://www.tivocommunity.com/tivo-vb/showthread.php?threadid=72686

Spend some time browsing through the scripts beneath `/tvlib/tcl/tv`, by the way. There are good examples buried in there of how to use many of the `tivosh` Tcl functions.

Be aware that there is something commonly referred to as The Event Bug in current versions of the TiVo software. The symptom is that the machine becomes extremely slow (if not totally frozen), with event-fetching ceased completely. This usually also causes the remote control to become completely unresponsive. The more processes that register for events, the more likely the problem is to occur, it seems.

One last thing: resources are tight. Memory is precious, as is processor time. Prototyping something slow or inefficient is ok while it's just for you, but if it's particularly slow or memory-intensive, have a plan for solving that before you expect to release it.

Setting Up a Cross-Compiler

Sometimes you'll find that you miss some Unix tool that doesn't exist on your TiVo. Or, you might have written some really cool hack, but it's way too slow. Or maybe you'd just rather code in C/C++ than Tcl. For all of those cases, you can set up a cross-compiler on your Linux, BSD, or MacOS X machine to compile C/C++ programs to run on your TiVo. Here, I'll only talk about Series1 cross-compilers, but there are Series2 cross-compilers out there as well.

Linux

Mike Baker (embeem on tivocommunity.com) is responsible for the script that made setting this up much easier than it was in the past. There are a few files that you'll need. First, download the file `tivo-build-xcompiler.tgz` from:

```
http://tivo.samba.org/download/mbm/tivo-build-xcompiler.tgz
```

or get it off of the accompanying CD-ROM, where its location is:

```
/cdrom/nonTiVoFiles/crosscompiler/tivo-build-xcompiler.tgz
```

Create a directory somewhere called `tivo-xcompiler`, put the file in that directory, then `cd` into it. Then unpack the file by typing:

```
tar xfvz tivo-build-xcompiler.tgz
```

You should now have a file called `tivo-build.sh`, a directory called `src-v2.5`, and another directory called `patched-v2.5`. `cd` into the `src-v2.5` directory. This is where you need to put the source code available at TiVo's site. You want to put four files in this directory: `TiVo-2.5.x-cmd.tar.gz`, `TiVo-2.5.x-linux-2.1.tar.gz`, `TiVo-2.5.x-toolchain.tar.gz`, and `TiVo-2.5.x-modules.tar.gz`. Download these from:

```
http://www.tivo.com/linux/25/TiVo-2.5.x-cmd.tar.gz
http://www.tivo.com/linux/25/TiVo-2.5.x-linux-2.1.tar.gz
http://www.tivo.com/linux/25/TiVo-2.5.x-toolchain.tar.gz
http://www.tivo.com/linux/25/TiVo-2.5.x-modules.tar.gz
```

or get them off of the accompanying CD-ROM, where they are all located in the directory:

```
/cdrom/nonTiVoFiles/crosscompiler/tivosources
```

Place them all in this `src-v2.5` directory (don't uncompress them; leave them as they are). `cd` back up to the parent directory (which contains `tivo-build.sh`). By default, this script will create a directory called `/usr/local/tivo` (with several subdirectories). If you absolutely can't have it installed there, then you will need to modify `tivo-build.sh` now to change `$OUTPUT` to determine where it should be installed.

Become root (unless you've changed `$OUTPUT` in `tivo-build.sh` to a directory you can write to), and run the install script by typing:

```
./tivo-build.sh
```

I had better luck running this on Red Hat Linux 7.2 than on Red Hat Linux 8.0. If you can't get the cross-compiler built on 8.0, I've tar'ed up my `/usr/local/tivo` directory, and that might work for you. That's located on the accompanying CD at:

```
/cdrom/nonTiVoFiles/crosscompiler/redhat72usrlocaltivo.tgz
```

Now set your path so that `/usr/local/tivo/bin` is before anything else. If you're using `bash`, you can add:

```
export PATH=/usr/local/tivo/bin:$PATH
```

to the end of `$HOME/.bash_profile`. If you're using `tcsh`, you can add:

```
set path=(/usr/local/tivo/bin $path)
```

to the end of `$HOME/.tcshrc`.

Now, jump ahead to the "Compiling" section.

BSD

The instructions for setting up a cross-compiler on BSD are very similar to those for Linux, since it was based on the same script that Mike Baker (embeem on tivocommunity.com) created. The BSD script was modified from the Linux script by Todd Miller (Todd Miller on tivocommunity.com). There are a few files that you'll need. First, download the file `tivo-build-xcompiler-obsd.tgz` from:

```
ftp://ftp.courtesan.com/pub/millert/TiVo/tivo-build-xcompiler-obsd.tgz
```

or get it off of the accompanying CD-ROM, where its location is:

```
/cdrom/nonTiVoFiles/crosscompiler/tivo-build-xcompiler-obsd.tgz
```

Create a directory somewhere, put the file in that directory, then `cd` into it. Then unpack the file by typing:

```
tar xfvz tivo-build-xcompiler.tgz
```

You should now have a directory called `tivo-xcompiler`. `cd` into it, and you should see a `README` file, a file called `tivo-build.sh`, a directory called `src-v3.0`, and another directory called `patched-v3.0`. `cd` into the `src-v3.0` directory. This is where you need to put the source code available at TiVo's site. You want to put four files in this directory: `TiVo_3.0_cmd.tar.gz`, `TiVo_3.0_linux_2.1.tar.gz`, `TiVo_3.0_modules.tar.gz`, and `TiVo-2.5.x-toolchain.tar.gz`. Download these from:

```
http://www.tivo.com/linux/30/TiVo_3.0_cmd.tar.gz
http://www.tivo.com/linux/30/TiVo_3.0_linux_2.1.tar.gz
http://www.tivo.com/linux/30/TiVo_3.0_modules.tar.gz
http://www.tivo.com/linux/25/TiVo-2.5.x-toolchain.tar.gz
```

or get them off of the accompanying CD-ROM, where they are all located in the directory:

```
/cdrom/nonTiVoFiles/crosscompiler/tivosources
```

Place them all in this `src-v3.0` directory (don't uncompress them; leave them as they are). `cd` back up to the parent directory (which contains `tivo-build.sh`). By default, this script will create a directory called `/usr/local/tivo` (with several subdirectories). If you absolutely can't have it installed there, then you will need to modify `tivo-build.sh` to change the variable `$OUTPUT` to indicate where it should be installed.

Become root (unless you've changed `$OUTPUT` in `tivo-build.sh` to a directory you can write to), and run the install script by typing:

```
./tivo-build.sh
```

Now, set your path so that `/usr/local/tivo/bin` is before anything else. If you're using bash, you can add:

```
export PATH=/usr/local/tivo/bin:$PATH
```

to the end of `$HOME/.bash_profile`. If you're using `tcsh`, you can add:

```
set path=(/usr/local/tivo/bin $path)
```

to the end of `$HOME/.tcshrc`.

Now, jump ahead to the "Compiling" section.

MacOS X

Setting up a cross-compiler for MacOS X is extremely easy. Download the file `usr.local.tivo.dmg` from:

```
http://tivoutils.sourceforge.net/
http://www.2150.com/tivo/files/usr.local.tivo.dmg
```

or get it off of the accompanying CD-ROM, where its location is:

```
/cdrom/nonTiVoFiles/crosscompiler/usr.local.tivo.dmg
```

Double-click on the `usr.local.tivo.dmg` file, which will mount the image. On the desktop should appear a volume called `usr.local.tivo`. Open it, and you'll find a package file. Double-click it, and an installer will come up that will install the cross-compiler for you. When it asks for which volume you want to install it on, place it on your startup volume if you have space. That way, `/usr/local/tivo` will be put in `/usr/local/tivo`, instead of `/Volumes/DriveTwo/usr/local/tivo`.

After the installation is complete, *if you had to install it on another volume*, create a symbolic link to make it look like you installed it on your startup volume:

```
sudo mkdir -p /usr/local
sudo ln -s /Volumes/DriveTwo/usr/local/tivo /usr/local/tivo
```

Now, set your path so that /usr/local/tivo/bin is before anything else. If you're using tcsh (the default shell for MacOS X), you can add:

```
set path=(/usr/local/tivo/bin $path)
```

to the end of $HOME/.tcshrc . If you're using bash, you can add:

```
export PATH=/usr/local/tivo/bin:$PATH
```

to the end of $HOME/.bash_profile .

Native Compiler (on Your TiVo)

I'm not going to spend too much time on this one, but I'll mention it: you can also download a native compiler that was itself compiled to run on your TiVo. The disk space required is pretty large so what you end up doing is putting it all on a Unix box somewhere and NFS-mounting the directory onto your TiVo.

You can download a native compiler for your Series1 TiVo which was put together by Steve White (subuni on tivocommunity.com) at:

```
http://prdownloads.sourceforge.net/tivoutils/native_compiler_tivo.tar.gz
http://tivoutils.sourceforge.net/
```

One major downside of this approach is that it is slow: most likely your TiVo is a very slow machine compared to your PC. If you can, it's just easier to set up a cross-compiler on your PC.

If, however, you do decide to try out the native compiler, here are some general steps to set it up:

STEPS: Setting Up Native Compiler on Your TiVo

1. Uncompress native_compiler_tivo.tar.gz and place the resulting tivo directory somewhere on your Unix box.

2. Set up /etc/exports on the Unix box such that the tivo directory from Step 1 can be accessed remotely via NFS (Chapter 6 talks more about NFS).

3. Fix all permissions on all of the files and directories under tivo such that they can be seen and accessed by everyone.

4. On your TiVo, create the directory that you will mount this on:

   ```
   mkdir -p /var/tivo
   ```

5. Mount the directory (substitute in your own IP and path, all on one line):

   ```
   mount -t nfs 192.168.1.2:/home/usernm/nativecompiler/tivo
       /var/tivo
   ```

6. Add the following lines to your /var/hack/root/.bashrc file, if they are not there already; make sure they are after any previous definitions of these variables:

   ```
   export PATH=/var/tivo/bin:$PATH
   export CPATH=/var/tivo/include
   export LD_LIBRARY_PATH=/var/tivo/lib:$LD_LIBRARY_PATH
   ```

7. Log out of that shell and back in again.

You should now be able to compile (ever so slowly). You may have trouble using the `--static` option.

Compiling

Now that you've got the compiler in place, let's compile something simple. Make sure that `/usr/local/tivo/bin` is indeed at the front of your path (source your `$HOME/.bash_profile` if you're using `bash`, or your `$HOME/.tcshrc` if you're using `tcsh`. tcsh users, remember to type `rehash`). Create a simple file called `hello.c`:

```c
#include <stdio.h>

int main(int argc, char *argv[])
{
  printf("Hello, World!\n");
}
```

Compile it by typing:

```
gcc hello.c -o hello --static
```

You should end up with a file called hello. Move it to your TiVo, make it executable via `chmod 555 hello`, and run by typing: `./hello`.

If you don't want to link statically (for instance, for your own work where you're less concerned with distributing a self-contained binary), `/usr/local/tivo/lib.tgz` can be moved to your TiVo and be merged with whatever existing `/var/hack/lib` directory you have.

For information on what options to use with `configure` (when porting applications), see `tivo-build.sh` for examples; usual arguments include:

```
--target powerpc-TiVo-linux --host powerpc-TiVo-linux
```

libtivohack

Because TiVo devices weren't meant to be generic programming platforms, it wasn't a high priority for the developers to include all of the Linux operating system and its functionality. When TiVos first came out, there was no reason for a TiVo to support the hostname command, or to do name resolution. One consequence of that is that the libc that ships with the TiVo software doesn't *have* system calls like `gethostbyaddr`, `gethostbyname`, etc. This makes compiling arbitrary Linux code problematic if it contains calls to these common functions.

Craig Leres solved this problem by writing `libtivohack`, which is a simple library with stub functions to replace the missing libc functions. The stub functions don't do anything — they just return gracefully. Linking this in with the executable you're compiling can fix linking errors you're encountering, rather than requiring you to change lots of source code to comment out calls to those functions.

You can find out more about `libtivohack` (and other executables he has compiled for the TiVo) at:

```
http://www.xse.com/leres/tivo/downloads/libtivohack/
http://www.xse.com/leres/tivo/downloads/
```

Final Checklist before Releasing

When you've finally have something working to your satisfaction that you'd like to share it with others, check these last few things first

Documentation

You don't need much, but at the least you should ship your hack with a README file and an INSTALL file. The README file should describe what the hack does, give credit to yourself and those whose work contributed to your hack, and describe how to use it. It should mention where the user should go to find this software (that is, where they downloaded it from). The INSTALL file should describe how to unpack the file, where to install it, and so on. If it's a standalone application, describe how the user should set it up to start after each reboot (see the earlier "Launching Your Standalone Hack" section). Mention any necessary variables, how to set them, and so on.

If your work is derived from others, you probably want to include a CREDITS file too (if you don't put that info in the README file instead). People like getting recognition for work they've done. Give credit where credit is due. Most of the best things out there were all made up of things that came before it.

Version Numbers

Give your software a version number on every release. There is no benefit to having people tell you something is broken, only to have you wondering which version they're running. Don't wait until your second release to give a version number to your software, or you'll have people looking at an unlabeled version 1 not knowing if it's old or new. If something is broken or crashes regularly, you can call it an alpha or beta, but once something works, don't be afraid to call it 1.0. You can add new features in later versions. Mention the version number in the README file, and keep it up to date. Name your distribution file with the version number in the filename; don't just use the same URL for the latest version all the time. If people want to download earlier versions to debug something, great, let them! They might surprise you and tell you when a particular bug crept into the code. Make your newest version prominent, but don't eliminate access to the old ones.

Where to Post It

You don't *need* a web site to distribute a hack you've written. Many people post their hacks on tivocommunity.com, dealdatabase.com, and alt.org as attachments. If you get a web site of your own later, you can host your hacks there and post links to them on the forums mentioned above.

On forums, one common practice is to keep the most recent release as an attachment in either the first post of the thread or of later and later posts in the thread, but eliminating all older versions via editing previous messages. This keeps people from downloading old versions by mistake, which is more likely to happen in a thread on a forum than from a download page on a web site.

Listen to Feedback

If you post something that's getting a lot of feedback, that's generally a good thing. It means people are using (or interested in) your hack. After posting a new version of something, check the forums for a while afterwards to look for feedback and/or problems. These are communities of people, and they grow through people contributing, whether it's though development, praise, testing, or just general feedback.

Ship Entire Versions

Even if your hack is just one Tcl file, it's good to distribute it along with at least a README file. Don't ship individual files; ship versions. Ship either gzip'ed `tar` files (`.tar.gz` or `.tgz`), or zip files (`.zip`). If you have a hack with multiple files and you start releasing new versions of just this or that file, it'll become a headache quickly (for the users, and ultimately for you as well).

Again, name the file uniquely, with the version number. The unique name `tellfriend myshows1.0.tgz` is much better than a `tellfriendmyshows.tgz`, which might be one of five versions.

Windows Users: Use dos2unix on Text Files

Last, if you're using a Windows machine to modify any scripts, make sure that you run `dos2unix` on them before shipping them. This will strip out carriage returns. If you don't do this, the "`#!/path/to/shell`" mechanism in scripts won't work (because the extra carriage return is included as part of the pathname, and there is no `/bin/bash^M`), causing your script to fail.

Now Go Write Some Cool Stuff

If you've had any ideas for things you wanted to write, go write them down now. Work out the rough idea of what it will do and how it will do it, then get more and more specific. *Get some quick mockups or prototypes working* to keep yourself motivated. It can be easy to get distracted in this particular field — the device we're playing with does deliver passive entertainment to us! Spend the time getting that cool idea working, then when it's ready, package it up and let the world know about it. Have fun!

Hardware Hacks

When I was a kid, my Dad built computers from scratch. The one I remember most was a towering three feet tall, with hundreds of wires running everywhere. There were switches, knobs, lights, and a small blue and black keyboard (with 0–9, A–F, and various other bizarre keys) fashioned out of strange pushbuttons purchased from who knows where. On the top right of its massive metal frame were four 7-segment LEDs, like those you'd find on a watch. There was also this 4 × 4 matrix of green LEDs with a red 1 × 4 column to the left of it.

One day he called me into the room, saying that he wanted to show me something. He turned on the machine, flipped this big switch, and then started pressing buttons to enter a program he'd written. I looked at the page he was typing from; it was indecipherable. I was 10 years old and had no idea what it meant. I just knew there was a lot of it, because he kept on entering codes. As he entered the hexadecimal instructions from the page on the keyboard, the numbers were displayed in binary on the 4 × 4 grid (not that I fully knew what that meant yet).

Eventually, he asked me if I was ready. I said yes, he flipped a big switch (labeled RUN/DMA on a piece of masking tape), and pressed a button. The result of all of that work was that the seven segment LEDs lit up, to spell JEFF (Figure 16-1).

FIGURE 16-1: Result of all that work.

We've since found the program that he actually wrote that day (see Figure 16-2).

PROGRAM ___ MUX 7 seg Displ. ___ DATE ___

page 1 JEFF OR JON $ ___ 36 bytes 24$_H$

ADDR	LABEL	MNEM	OPER.	CODE	COMMENTS
8 0		NOP		08	
1	INIT	LDI	X'05'	C4	value for count
2				05	
3		ST	COUNT	CA	
4				A0	
5		LDI	X'10'	C4	set up init value for digit
6				10	
7		ST	DIGIT	CA	
8				A1	
9		LDI	X'1C'	C4	addr of list
A				9C	
B		XPAL 3		33	addr list in PC 3
C	LOOP	LD	DIGIT	C2	get digit
D				A1	
E		SR		1C	check
F		ST	DIGIT	CA	addr = FCA
0				A1	
1		XPAH 1		35	
2		LD @1(3)		C7	0111 addr = FCA
3				01	
4		ST 0(1)		C9	
5				00	
6		DLD	COUNT	BA	
7				A0	
8		JNZ	LOOP	9E	
9				9B	
A		JMP	INIT	92	
B				90	
C	LIST	X'70' 70		8E	JON X'70'
D		X'9E' 9E		8E	X'FC'
E		X'8E' 8E		9E	X'2A'
F		X'8E' 8E		70	X'00'

FIGURE 16-2: My Dad's assembly code, Copyright © 1980 Lawrence V. Keegan.

Today (being the sap that I am) I almost get a tear in my eye thinking of how cool that was at the time, and that he did it for me. Back then though, while I appreciated my Dad's work and was curious about it, I was shocked that it had taken so much effort, and that it was so foreign

to me. I remember thinking of computers as extremely complex advanced machines that I was obviously too young to understand. My Dad must have picked up on this, because a few days later he bought me a Radio Shack book on programming computers in BASIC. By an extremely fortunate coincidence, one of my fifth grade teachers, Miss Blankenheim, brought a computer into class a few days later, which lo and behold, understood BASIC. From then on I was hooked, eventually leading to my getting my master's degree in computer science.

Although I'd taken excellent hardware-related classes such as Digital Logic, VLSI Design, and Computer Architecture, they were still all just classes. There was something I felt that I'd missed that my Dad hadn't — *really* getting one's hands dirty building circuits, just as a hobby. The electronics class I took in high school didn't count — it would really be cool to build some useful hardware for myself, even if it was a kit. I hadn't put my years of soldering fun to *real* use. It was haunting me.

So, when people started talking about building their own Ethernet interfaces for their TiVo units, my ears perked up. Andrew Tridgell had built the TiVoNet card, and made the design available for the world to see. Back then, at www.9thtee.com you could buy either a completed TiVoNet card or a kit to build one from yourself. I placed my order for my TiVoNet card kit, and bought an ISA Ethernet card to put in it.

As anyone who has soldered surface mount chips can tell you, it wasn't easy, and it wasn't pretty. I spent many grueling hours on it, but alas when I finally got up the courage to test it in one of my TiVos — nothing. I'm sure I could have eventually debugged it, but the allure of the cheaper faster and smaller TurboNET card did me in; I swallowed my pride, yanked out the failed board, and bought two TurboNET cards instead.

Despite who assembled them, these boards greatly enhanced my TiVos, and my TiVo hacking experience. Here, I talk about four other hardware hacks you can do (or can have done) to your TiVo, made possible by people who aren't haunted as I am by the unfulfilled desire to build hardware to do something as cool as printing "JEFF" on four 7-segment LEDs.

CacheCard

Nick Kelsey (jafa on tivocommunity.com), who created the TurboNET card mentioned above, has now also created a device called the CacheCard. Its goal is to speed up the user interface of a Series1 TiVo, which can become extremely slow on hacked machines with large amounts of recordings.

The CacheCard (Figure 16-3) sits on the IDE bus, directly between the TiVo and the hard drive. You plug the CacheCard into your TiVo motherboard's IDE connector, and then plug the drive's IDE cable into the CacheCard. It has a socket on top where you plug in memory. Figure 16-4 shows how it looks plugged in between your TiVo and the hard drive. Working in conjunction with a kernel module that you load at boot time, it caches all data written to the *database* section of the hard drive. It's a write-through cache, meaning that all writes are written to disk immediately, but they're also written to the CacheCard's memory. When reads come in for the database, the data will be fetched from the cache (instead of the hard drive) if it's available.

FIGURE **16-3:** CacheCard.

FIGURE **16-4:** Installing the CacheCard.

The reason this is necessary (and that the normal caches built into most hard drives don't per-form the same task) is because TiVo units are constantly writing video data to the drive, 24 hours a day. The caches inside your hard drive continually get flushed with new data, leaving no room for a working set to form. Here, however, the only thing cached is database data.

Nick's performance tests showed an increase of about 2 to 6 times normal speed, depending on the task. Rearranging season passes went from an average of 3 minutes 45 seconds to and average of 1 minute 41 seconds. Resetting Thumbs-Up/Down status (with no video being recorded at the time) went from 9 minutes 30 seconds down to 1 minute 32 seconds.

The CacheCard can be purchased from 9thtee.com, at:

`http://www.9thtee.com/tivocachecard.htm`

In addition to physically installing the CacheCard itself, you need to install the kernel module (`cachecard.o`) and a control application (`cachectl`). Both can be obtained from the site (along with directions for installing them). You may wish to place the kernel module in `/var/hack/kernelmods`, and load it from either `/var/hack/etc/hacks_call-fromrc.sysinit` or directly from `/etc/rc.d/rc.sysinit` via:

```
if test -f /var/hack/kernelmods/cachecard.o
then
   insmod /var/hack/kernelmods/cachecard.o
fi
```

The CacheCard installation instructions provide more detailed instructions.

Increasing Memory

Before the CacheCard, people thought the answer to sluggish menus might be to increase the amount of memory on their TiVos. It turns out the bottleneck was database access (hence the CacheCard above). There was still a benefit to having more memory however — the loading of some non-disk-related menus was definitely faster. Plus, if you run several hacks, more memory keeps your TiVo from swapping out to disk as much. Series1 TiVos shipped with 16 megs of memory, but there was space on the motherboard for another 16 megs to be added.

Brave people started soldering two 8-MB chips identical to the ones in their TiVo onto the motherboard. Using a special PROM menu available via the serial port, they configured their TiVos to recognize the extra memory. Some people even reported that the menus did feel a little quicker after all.

The first person who reported that he'd done it successfully was Joel Winarske (who used to be joelw on tivocommunity.com but the name is now in use by someone else). After that, reports started coming in of some successes and some failures. Shipping costs were insane, so T. McNerney (ElectricLegs on tivocommunity.com) said he'd sell chips to people who wanted them, and offered to do the installation for a fee for those nervous about doing surface-mount soldering onto their TiVo motherboards.

The chip he sells is the Micron MT4LC4M16R6TG-5 (which is the same chip used in most TiVos). You can order the chips ("ElectricLegs TiVo Memory Upgrade") from:

`http://www.9thtee.com/tivomemory.htm`

At the time of this writing, the costs for the kit alone (including two 8-MB chips) is $20, or you can send your motherboard to him and he'll sell you the chips and solder them on for you for a total of $50.

Success was also achieved with the Samsung KM416V4104CSL-5 chips. For more information, see the original thread ("Serious about adding more ram") at:

```
http://www.tivocommunity.com/tivo-vb/showthread.php?threadid=25231
```

The PROM Menu (Diagnostic Mode)

If you try installing the memory yourself (and you're ready to accept the loss of your TiVo should you demonstrate anything less than exemplary soldering skills), then you'll still need to tell your TiVo that you're using 32 megs now instead of 16. There is a menu that can be accessed at boot time where you can change the memory configuration. This menu is commonly referred to as the PROM menu, diagnostic mode, or the ROM Monitor.

To access this menu, you need to connect your computer to your TiVo's serial port. If you're using the serial cable that came with your TiVo, you'll need to put in a null-modem adapter. If you want, you can make your own cable that switches pins 2 and 3 (eliminating the need for a null-modem adapter). Figure 14-3 (in Chapter 14) shows the pinouts for both the normal TiVo serial cable and a custom switched cable.

You'll need a terminal program on your computer. Set the port settings in that terminal program to 9600, N-8-1. You want to reboot your TiVo, and then as soon as you see the TiVo guy standing there (within 2–3 seconds of powering on, at most), *instantly* hit Enter on the terminal program. You should see "Verify password:" in your terminal program. The password that shipped with most original standalone TiVos was "factory". Type it and press return. If it was successful, you should see something like Listing 16-1. Credit for finding the "factory" password goes to Dan Stagner (sorphin on tivocommunity.com).

If you saw the "Verify password:" prompt and typing "factory" didn't work, try it again to be sure. If it still fails, you can reset the password to something you know (like, say, "factory"). To reset the password, boot up your TiVo and telnet into it to get a bash prompt (if you haven't set up your TiVo to do this yet, see Chapter 5). Type the following command (including the quotes):

```
crypto -u -srp "factory"
```

That command will reset the password. Yes, you can put in whatever password you want, but again keep the quotes, and make sure it's something you will remember.

Listing 16-1: Initial PROM Menu via Serial Port

```
Verify password: *******
Console switched to DSS port

 ------- System Info --------
 Processor speed = 50 MHz
 Bus speed       = 25 MHz
 Amount of DRAM  = 16 MBytes
 Video configuration 3, Serial number 0
 Enet MAC address= 0:4:ac:e3:0:54
 Hostname        = debug-13
 Auto disk locking disabled
 --------------------------
 IDE err = 0x4
```

```
IDE drive 0 doesn't challenge security..  Assume insecure device
IDE err = 0x4
IDE drive 1 doesn't challenge security..  Assume insecure device

 --- Device Configuration ---
 Power-On Test Devices:
   000  Enabled   System Memory [RAM]
 --------------------------
 Boot Sources:
   002  Enabled   EIDE disk Controller [EIDE]
 gateway: 192.168.1.227
 --------------------------
  B - Boot from disk
  N - Network (tftp) boot
  X - print extended menu
 ->
```

The menu choice we want is buried away under the extended menu displayed by "x". Pressing "x" shows the extended menu (see Listing 16-2).

Listing 16-2: Extended PROM Menu

```
->X
 B - Boot from disk
 N - Network (tftp) boot
 U - Update flash from tftp flash image
 T - Teleworld menu
 V - Print TiVo Prom Version
 W - Word Write
 R - Word Read
 P - Change Boot Parameters
 M - Configure Memory
 C - Configure Video
 E - Configure Ethernet
 K - Set backdoor password
 k - Verify backdoor password
 z - Change Serial Number
 Z - Run memory tests
 1 - Enable/disable tests
 2 - Enable/disable boot devices
 3 - Change IP/MAC addresses
 4 - Ping test
 5 - Toggle auto disk locking
 6 - Toggle automatic menu
 7 - Display configuration
 8 - Save changes to configuration
 9 - Unlock TiVo Secure Disk
 0 - Exit menu and continue
 ->
```

If you had just soldered in memory and wanted to enable it, you would choose "M", and see:

```
->M
Current configuration: 16MB (1 bank of 16)
  1 - 8MB (2 banks of 4)
  2 - 16MB (2 banks of 8)
  3 - 32MB (2 banks of 16)
  4 - 16MB, (1 bank of 16)
  0 - Return to main menu
->
```

After soldering on two extra 8-MB chips, you'd be at 32 MB and select 3. You may have noticed the "Z" option in the extended menu for running memory tests — that would be next. The test will run to completion, then repeat the test over and over until you press return.

Note The PROM menu was taken out in later versions of the firmware. There were reports that in fact the menu still existed, but it had been switched to the alternate serial port, which only existed on internal TiVo debugging hardware. Apparently some people even modified their motherboard to switch the two serial port lines (thus re-enabling the menu through the standard serial port), which seems like a lot of work for so little reward — but surely it's to be respected!

Other Menu Items

Ok, while we're here, it's worth mentioning a few other things about the extended menu. First of all, many of the items here do nothing exciting, despite how they might sound. The tftp, Ethernet, and IP/MAC address items were all in there way before Andrew Tridgell built the TiVoNet card; they have nothing to do with it. Presumably somewhere inside TiVo headquarters there are debugging rigs that must have attached to the TiVo's edge connector (or alternate hardware for all we know) that provided such things as Ethernet and a second serial port. Bottom line, those menu items won't do any good for a TiVoNet/TurboNet/AirNet card.

The serial number item doesn't do anything either — that's stored away, probably in the crypto chip.

There are a few items that actually do work though.

"V" prints the current version number of your PROM:

```
->V
TiVoProm Monitor version 1.84b
```

"P" lets you change your TiVo's boot parameters. This is the same piece of information that the bootpage executable changes (as described in Chapter 11) and that the TiVo uses to determine which partition to boot from (as described in Chapter 4). You can add additional environment variables to the line, and all processes in your TiVo will inherit them. *Be careful not to accidentally change the value of* root *or your TiVo will boot the wrong partition and could cause damage.*

```
->P
Old: root=/dev/hda4
New(- to abort): root=/dev/hda4 upgradesoftware=false
```

"5" toggles automatic disk locking. This is the same disk locking that I described in Chapter 3 that used to occur to Quantum drives (in an effort to discourage people from buying TiVos from stores just to gut them for their hard drives). If you turn this option off and introduce a new quantum drive to the mix, it will no longer actively try to unlock it.

```
->5
ROM auto disk locking will not be active on exit
```

Finally, typing "B" will exit the menu and boot up your TiVo.

Repairing a Broken Modem

One of the most common hardware problems reported is a broken internal modem. People buy a used TiVo cheap, get it home, and then find out that it doesn't successfully dial home to TiVo Inc.

After a lot of work, T. McNerney (ElectricLegs on tivocommunity.com) provided detailed instructions for testing various chips on the motherboard to determine which components needed to be replaced. One thread detailing these steps was the "Modem Repair Thread" at:

```
http://www.tivocommunity.com/tivo-vb/showthread.php?threadid=24428
```

He now sells a modem repair kit, or will repair your TiVo for you for around $40–$60, depending on the number of parts that need to be repaired. The repair kit is available at:

```
http://www.9thtee.com/tivomodemrepair.htm
```

People also have successfully managed to connect external modems to the serial line and have the daily call go through those. See the "PPP over Serial Line - With Modem Emulation" section in Chapter 2 for more info.

Enabling the Caller-ID Function on a Series1 Modem

Here's one to research and experiment with a bit on your own if you're curious. T.McNerney (ElectricLegs on tivocommunity.com) contributed to the "Caller-id program for DirecTivo" thread the idea that some standalone Series1 TiVos actually have chips that support caller-ID, but the ability is inhibited by a bit of wiring.

By soldering a wire between two pins of the K2 952 (and placing a 47K resistor between another pin and transistor Q3), you might be able to get caller-ID to work. See the thread for more info: (all on one line)

```
http://www.tivocommunity.com/tivo-vb/showthread.php?postid=488985#post488985
```

This ability of the modem to use caller-ID data lets you use the caller-ID application elseed completely within a series1 standalone (see Chapter 9).

Links—
References—
Resources

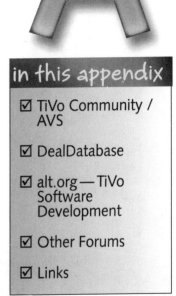

in this appendix

☑ TiVo Community / AVS

☑ DealDatabase

☑ alt.org — TiVo Software Development

☑ Other Forums

☑ Links

The TiVo hacking community exists because there are places where we can all go to converse with one another. Online forums let people tell the world about some new piece of code they've written, or some discovery they've made. They let beginners lurk silently at first, to soak things in, then dive in later to ask questions about unclear topics. These forums gather knowledge, create friendships and foster collaboration.

There are multiple forums, yet some of the people are the same. In that sense it sometimes feels like an even larger community, not defined by any one forum alone. Then again, each of the forums does have a different feel to it.

One thing that makes the TiVo hacking community as a whole different from many other hacking endeavors is that a huge majority of its participants *like* the company whose product they are tinkering with. TiVo has a reputation for being "hacker-friendly" (though don't expect them to tell you that). When progress was first made on certain TiVo hacks, a TiVo representative (Richard Bullwinkle aka TiVolutionary) publicly gave credit to those involved, and advice to those who would follow—watch out for the unshielded power supply, *make backups of your drives*, and don't interfere with the TiVo service. Where many companies would have had lawyers sending out cease and desist letters, TiVo instead decided to look the other way and not form official policies on the issues of people hacking their TiVos. (Note: TiVo Inc. does not endorse nor condone any actions whatsoever, and I don't mean to imply they do. When you open your TiVo, you take on all the risk of doing that, and should never call TiVo tech support again about that TiVo.) However, the "unofficial" attitude was much appreciated by many, and is a large part of why TiVo hacking is so popular. There are certainly (as with any group) a bunch of "Screw TiVo!" people looking for someone to rebel against, but they are clearly in the minority; if you see someone telling you the sky is falling and that TiVo suddenly hates its users, take it with a grain of salt.

Note

Before I list and describe the forums, I want to make an important plea to everyone reading this, for both the sake of the forums mentioned and for your own sake. Participation is encouraged — that's what makes a community grow. However, before posting any *questions* (or requests for help), *please* search the forums yourself for an answer. People are on these forums for free — no one is getting paid. People help out other people because they remember being there themselves and want to help. No one will identify with you (which is necessary for them to want to help you) if you haven't done your homework and made sure you've searched for the answer to your problem first. Every one of the forums mentioned has a search feature that lets you search all of the posts made in the years that they've been up. If you do exhaust all avenues and have to resort to asking others for help, say up front what you've tried and what hasn't worked. Show that you're not just lazily trying to have someone else solve your problem for you. If you start with this as your attitude, you'll find the forums a great experience and meet lots of interesting people. If you don't, you'll burn out within a few posts and wonder why no one seems helpful. If you'd like to read more on how to ask good technical questions, take a look at the document "How to Ask Questions The Smart Way" by Eric Steven Raymond, at http://www.catb.org/~esr/faqs/smart-questions.html . The document can sometimes seem a bit condescending, and I don't agree with some of the terminology, but the message is on target.

Here are some of the forums that make up the TiVo hacking community, with a description of what to expect on each.

TiVo Community / AVS

`http://www.tivocommunity.com/`

Members: 36,587 - Threads: 114,019 - Posts: 1,154,988 (as of 6/27/2003)

The TiVo Community forum is one of the largest TiVo forums around, and it's where this all started. It originally was part of the AV Science (AVS) forum at www.avsforum.com , but now is its own site (still run by the same owners). TiVo Inc. is involved with this forum: they link to it directly from their site, they advertise on it, and for a while they hosted the forum itself on their own servers. Several TiVo employees post on and monitor discussions on the forum.

There are many sub-forums, including the TiVo Underground (where the hacking discussions live), the TiVo Upgrade Forum (a help forum devoted to helping people add storage to their TiVos), the TiVo Coffee House (for TiVo-related conversations that aren't hacking-related), and the Happy Hour - General Chit Chat forum (where people talk about everything else).

The forum is run by David Bott, who also runs the AVS forum. It is stressed in the TiVo Forum FAQ (www.tivofaq.com) that TiVo has no editorial control over tivocommunity.com, and that no TiVo employee has permission to change anyone's posts. There are several moderators on the forum who *are* allowed to do that, but they don't work for TiVo. Despite this freedom from TiVo's influence, there are certain topics that are banned on tivocommunity.com.

One topic that is banned on most forums is any discussion of service theft — that is, any discussion about trying to steal guide data from TiVo Inc. without paying for either a monthly or lifetime subscription (or trying to steal cable or satellite access, etc). Most people agree that such discussion is bad for TiVo (because it directly affects their revenue stream), and since people want the company to stay alive the subject is taboo just about everywhere.

Another topic though that gets a lot of attention is that of "video extraction". Video extraction (discussed in Chapter 10) is the act of removing video from a TiVo and placing it onto your PC. When video extraction discussions began, David Bott declared that because he wasn't sure if it was a Digital Millennium Copyright Act (DMCA) violation or not, he didn't want the topic discussed on his forum. By extension, the topic of video insertion (which came along at least a year later) seems to be banned as well, although there is no official rule. Discussions talking about video extraction tend to get closed (prohibiting further posts), and therefore people on the forum tend to become vigilante-like in stopping such discussions before they get far enough to become locked down by a moderator.[1]

Lastly, discussion of TiVo's stock is banned as well.

With all of these banned topics, why do people continue to stay? There are several reasons. For one, the forum has been around for a long time, and the archives are a wealth of knowledge. Also, during that period of time people got to know one another, and that's where their new friends were; it would take a mass exodus for an entire group to leave. TiVo's employees frequenting the site help somewhat as well, since from time to time a nugget of news or information is given out to eager listeners.

The bottom line is, it's still a great place to be, whether it's to hang around discussing TV shows with other TiVo owners, or to read a discussion about some cool new TivoWeb module. It's unfortunately just not the place for particular topics.

 Note Throughout the book I've referred to people by their name and their nickname on tivocommunity.com (such as in the sentence: "The extremely humble, modest, and good-looking author of the TivoWeb Search module is Jeff Keegan [jkeegan on tivocommunity.com]".) I mention people's tivocommunity.com nickname because this is the largest TiVo forum around; almost everyone from anywhere else has an account here, and it acts sort of like a name server. jkeegan on tivocommunity.com is usually the same guy as jkeegan on any of the other forums.

DealDatabase

http://dealdatabase.com/forum/forumdisplay.php?forumid=23

Members: 6,337 - Threads: 24,688 - Posts: 102,125 (as of 6/27/2003)

On June 18th, 2001, Vadim Ratinov (vadimr on tivocommunity.com, but more relevant is that he's Vadim on dealdatabase.com) posted on tivocommunity.com that he was thinking of sponsoring his own TiVo hacking forum, where people could discuss some of the hacks that he felt shouldn't be banned (such as video extraction). He did, and many people went there.

[1] Of course most of these same people who point out that extraction talk is banned also frequent the other forums (where video extraction talk is encouraged), and end up having to make cryptic references to the other forums. I say cryptic because some of the other forums' names are listed as censored words. If you see *********** on tivocommunity.com it probably means dealdatabase.

In contrast to the TiVo Community forum (tivocommunity.com), topics such as video extraction/insertion are allowed. People are much more likely to ask how to do something on dealdatabase.com because there is less fear that they'll be told a topic isn't acceptable. That can be good and bad. There is generally a different feeling on this forum than tivocommunity.com; it's not a better or worse feeling, just a different attitude.

Another pattern that sometimes emerges is that if a topic or announcement isn't against tivocommunity.com's rules, it's often posted on tivocommunity.com rather than dealdatabase.com, because of the larger number of people on tivocommunity.com. Some people have migrated to dealdatabase.com completely (i.e. "I'm not going back.") because of irritation with banned topics on tivocommunity.com, but most still read both (many primarily contributing only to tivocommunity.com).

There are many TiVo-related sub-forums on dealdatabase as well.

alt.org — TiVo Software Development

`http://alt.org/forum/`

Members: 124 - Threads: 68 - Posts: 486 (as of 6/27/2003)

On July 1st, 2002, M. Drew Streib (dtype on tivocommunity.com) posted on tivocommunity.com that he had created a new forum as well, but that this one was specifically for software developers. Designed to complement forums such as tivocommunity.com and dealdatabase.com, its goal was to house detailed technical discussions.

The act of posting "help" questions is strongly discouraged, and such posts often get moved to an off-topic sub-forum. This helps explain the low post count — there is a deliberate effort to keep the "noise" low.

Sometimes a thread will be started to discuss a topic or tool, and a similar "accompanying" thread will be started on dealdatabase.com at the same time (with cross-links between the threads). Facts and conclusions of substance are posted on alt.org, whereas people's questions, bug reports, and general comments all go in the dealdatabase.com forum.

At the time of this writing there are only two sub-forums. The main forum itself, and the off-topic forum where help questions are moved to.

Other Forums

There are other places where you can talk about TiVo as well. I won't go into much detail on these, but will list them here for reference. If I miss any, it's not deliberate, these are the ones I know of. See the Links section at the end of this Appendix for the URL of the accompanying web site for this book.

tivo_canada Yahoo Group

http://groups.yahoo.com/group/tivo_canada/

If you live in Canada (and can prove Canadian residency), you can join the `tivo_canada` Yahoo group. TiVo doesn't offer service in Canada, so Canadians who want TiVo have had to resort to hacking their way in. The group is locked out so as to limit such discussion to those who *need* it. Reportedly most people in the group claim to pay for TiVo service anyway, despite the fact that TiVo doesn't offer Canadian guide data.

oztivo — Australian TiVo Owners List

http://minnie.tuhs.org/mailman/listinfo/oztivo

There is also an email list for Australian users, since TiVo doesn't offer TiVo service in Australia either.

TiVo_UK Yahoo Group

http://groups.yahoo.com/group/TiVo_UK

This is a Yahoo group for TiVo users in the UK.

TiVo UK Announcements / Newsletter Mailing Lists

http://www.tivonews.co.uk/

These are two mailing lists for TiVo users in the UK.

alt.video.ptv.tivo

On Usenet there is a newsgroup called `alt.video.ptv.tivo` that discusses TiVo.

AvalonCourt

http://www.avaloncourt.com/

This forum does contain a TiVo-related sub-forum, which is one reason that I'm mentioning it here, but it's not terribly large yet. The other reason I mention this forum is because many of the people from the other forums meet here as well. Where dealdatabase.com was started to discuss TiVo hacking topics banned on tivocommunity.com, avaloncourt.com was in part started to discuss *non*-TiVo-related topics banned on tivocommunity.com. This is another forum whose name is listed as a censored word on tivocommunity.com.

Links

I'd originally thought about including a ton of links here (all of the URLs from the book, URLs of other general sites, and so on) but there are two problems with that:

1. I don't want to leave anyone out, and couldn't add to this list once the book was published if people pointed out an omission.

2. Sometimes web sites disappear for good (or change their URL slightly), and this would be a list of broken links.

As a result, I've decided to keep that list of links on the web site associated with this book. For the current list of links mentioned in this book (as well as others), check out the accompanying web site for this book on my web site, at:

```
http://keegan.org/hackingtivo
```

Wiley Publishing, Inc., is hosting a similar page at:

```
http://www.wiley.com/compbooks/keegan
```

Tcl

The Tool Command Language (Tcl[1]) scripting language, created by John Ousterhout, is unique in that the interpreter for the language is typically custom to your application. When creating a Tcl-scriptable application, you write your own commands in C/C++ that your Tcl scripts will be able to call.

This is what TiVo did when designing their software. An executable called `tivosh` lives in `/tvbin/tivosh` on all TiVos. It is a Tcl interpreter (that is, it can read and execute Tcl scripts), but it also has some extra built-in functions that do TiVo-specific tasks. This lets sensitive or performance-critical functions be compiled into the application, while allowing access to them via Tcl scripts.

This appendix won't deal with any of the TiVo-specific routines, but instead will give an introduction to the Tcl language itself, and some of the code library functions. The compiled-in routines that are unique to `tivosh` are discussed in Chapter 13.

The Language

First we'll talk about the language itself, and then later we'll discuss some important library functions. Again, this is just a brief introduction; you may want to buy a book on Tcl.

The Tcl interpreter can execute scripts, or be run interactively. If you run it interactively (either by typing `tclsh` on a Unix box or `tivosh` on a TiVo), you'll get a command prompt (`%`) that lets you enter commands. After you enter a command in interactive mode, it will be executed and its return value will be displayed. You can exit when you're done by typing `exit`, or Ctrl-D on a new line.

Command Syntax

Command invocations take the form of a command name followed by zero or more arguments (all separated by spaces). For instance, this is a valid Tcl command:

```
puts "Hello, World!"
```

[1] Yes, that capitalization is correct. Despite the fact that Tcl is an acronym, its official capitalization is Tcl, not TCL.

You can create your own commands by defining a procedure:

```
proc printthemessage {} {
  puts "Hello, World!"
}
```

which you can then call with the new Tcl command:

```
printthemessage
```

You can define your procedures to take parameters as well:

```
proc sayhello { audience } {
  puts "Hello, $audience!"
}
```

The call to sayhello requires a parameter now:

```
sayhello World
```

Square brackets ([,]) cause the command within them to be evaluated, and the return value to be put in its place. So for example, the following causes "Hello, World!" to be printed:

```
proc formatgreeting { audience } {
  return "Hello, $audience!"
}

puts [formatgreeting "World"]
```

The return command above causes the procedure to exit immediately, with the specified return value. All procedures return a value however, regardless of whether they have a return command or not. If there is no return command in a procedure, the value of the last command within its body is what is returned. The following will output a value of 7:

```
proc foo {} {
  set x 5
  set y 7
}

foo
```

Commands are separated by either newlines or semicolons (if you want to specify multiple commands on one line). To make a command span multiple lines, end the line with the "\" character, which escapes characters (including newlines), removing any special behaviors they have:

```
puts "The \\ character allows quotes (\"), \
brackets (\[,\]), etc."
```

Variable Syntax

All variables in Tcl are essentially strings, but some commands interpret those strings differently (as numeric expressions or lists). You don't have to declare variables ahead of time; to create a variable you just assign it a value. You assign a value to a variable with the set command:

```
set number 42
```

You can then later refer to that variable (as we did above) by using $<variablename>:

```
puts "The number is $number"
```

If you were trying to output the string "42JLK" above, you couldn't say $numberJLK since the Tcl interpreter would think you were looking for a variable called numberJLK, so you can also specify a variable substitution with ${<variablename>}:

```
puts "The code is: ${number}JLK"
```

Just saying "set <variablename>" (with no third argument) returns the value of the variable itself. "unset <variablename>" will remove a variable from existence.

Variables can also hold lists and arrays, which I'll talk about later.

Quoting

Quoting allows you to specify that a bunch of text with spaces in it is to be treated as one argument. The following would generate an error:

```
proc printnameandphone { name phone } {
   puts "Name:    $name"
   puts "Phone:   $phone"
}

printnameandphone Thomas Veil 978-555-1234
```

The procedure takes two arguments, yet we've tried to pass in three. Quoting allows you to group the parts of the name together:

```
printnameandphone "Thomas Veil" 978-555-1234
```

This may seem simple enough, but it's a bit more significant than you think. The reason has to do with the fact that there are two different methods of quoting strings. You can use quotation marks as we just did, or curly braces:

```
printnameandphone {Thomas Veil} 978-555-1234
```

So, why are there two quoting methods, and why is one more significant? When you use curly braces, no substitution occurs on anything inside (unlike what happens with quotation marks). The commands:

```
set x 42
puts "Number: $x, time in seconds: [clock seconds]"
puts {Number: $x, time in seconds: [clock seconds]}
```

generate the output:

```
Number: 42, time in seconds: 1050425169
Number: $x, time in seconds: [clock seconds]
```

If you look back at the procedures we've defined, you'll see that the syntax has been proc {params} {body}. This is because proc is just another command, which takes two arguments. As we'll see later, even control statements like if and while are just commands that take their conditions and bodies as arguments.

Comments

Comments in Tcl are strange, and can cause headaches. Read this section.

One problem you're sure to run into eventually is the bizarre implementation of comments in Tcl. Rather than having comments stripped out early on, comments actually make it through to the Tcl parser. The "#" character is actually a command name. The command does nothing, ignoring its arguments. So, a simple example of how comments are supposed to work is:

```
# Be sure to set your own zip code on the next line!
set zipcode 01844
```

That worked because the rest of the line was a bunch of arguments to the # command. However, that means that you can't just throw a comment at the end of an existing command. To place a comment on the same line as code, you have to end the previous command with a ; before starting your new comment command:

```
verifyzip $zipcode   ;# Check for valid zip code formats
```

What's even more disturbing is that you can't just go blindly commenting out lines of code that you're debugging, because one of them might contain a "{". Remember, # is just a command, so the entire text up until the closing "}" will be considered part of an argument to #. The following is *wrong*:

```
proc greetneighbors { zipcode } {
  # if {$zipcode == "02180"} {
  if {$zipcode == "01844"} {
    # puts "Ah, you're from Stoneham!"
    puts "Ah, you're from Methuen!"
  }
}
```

It's wrong because of the first comment; the { at the end of the line is seen, and then the parser continues until it finds the matching }. It thinks the } on the last line is the one that goes with the one from the first commented-out line, and then you get an error because the proc command never found a } for its body argument.

Basically, try to remember that # is just a command.

Lists

A list is merely a string that contains one or more items, separated by whitespace. However, there are many commands in the core Tcl library that perform list-related tasks. The following are all valid ways to set a list variable:

```
set list1 "January February March"
set list2 {January February March}
set list3 [list January February March]
set nestedlist {a b {c1 c2 c3} d}
```

As you can see in the last example, lists can be nested. Again, there's nothing particularly interesting about a list variable without the commands that use it. Although the list commands aren't technically part of the language (but rather part of the core Tcl library), I'll still describe them here since they are what make lists useful.

lindex <list> <indexnum>

lindex lets you fetch an individual item from a list. Its first argument is a list, and the second is the index number of the item to fetch.

```
# tclsh
% set list {a b {c1 c2 c3} d}
a b {c1 c2 c3} d
% puts "The first item is [lindex $list 0]"
The first item is a
% puts "The third item is [lindex $list 2]"
The third item is c1 c2 c3
% puts "2nd of 3rd: [lindex [lindex $list 2] 1]"
2nd of 3rd: c2
%
```

llength <list>

llength returns the number of elements in <list>. A nested list counts as one object.

```
% set list {a b {c1 c2 c3} d}
a b {c1 c2 c3} d
% llength $list
4
%
```

list [<arg>]...

list returns a list made up of the arguments passed to it. At first one might wonder why such a command is necessary; you've created lists above without needing this function. This next example shows where it's at least convenient (if not necessary), when you want to set x to {a1 a2 a3} {b1 b2 b3} c1 from the variables $a, $b, and $c, without knowing if $a, $b, or $c are lists or not.

```
set cheating_notusingvariables {{a1 a2 a3} {b1 b2 b3} c1}
set a {a1 a2 a3}
set b {b1 b2 b3}
set c c1
set thisiswrong1 "$a $b $c"
set thisiswrong2 {$a $b $c}
set thisiswrong3 "{$a} {$b} {$c}"
set cheating_thisassumesweknowCisntalist "{$a} {$b} $c"
set x [list $a $b $c]
puts "thisiswrong1: $thisiswrong1"
puts "thisiswrong2: $thisiswrong2"
puts "thisiswrong3: $thisiswrong3"
puts "x:           $x"
```

When run, this outputs:

```
thisiswrong1: a1 a2 a3 b1 b2 b3 c1
thisiswrong2: $a $b $c
thisiswrong3: {a1 a2 a3} {b1 b2 b3} {c1}
x:           {a1 a2 a3} {b1 b2 b3} c1
```

lappend <listvarname> [<arg>] ...

`lappend` takes the list contained in the variable whose name is `<listvarname>` and appends all of the `<arg>` parameters to it. Note that this takes the list's variable name, since it changes the variable itself (unlike some other list functions that leave the original list alone).

```
set y {a b c}
set d {d1 d2 d3}
puts "y is originally: $y"
lappend y 123
puts "then y was:      $y"
lappend y $d 456
puts "then y was:      $y"
```

prints out:

```
y is originally: a b c
then y was:      a b c 123
then y was:      a b c 123 {d1 d2 d3} 456
```

linsert <list> <indexnum> [<arg>] ...

`linsert` returns a new list which is identical to `<list>` except that all of the `<arg>` parameters have been inserted in it, at location `<indexnum>`. A special value of "end" can be specified for `<indexnum>` to indicate insertion at the end of the list. Note the difference between this and `lappend`; here, a new list is created and returned, whereas there the existing list was modified.

```
# tclsh
% set z {a b c d e}
a b c d e
% set ins1 [linsert $z 0 first second {aa bb cc}]
first second {aa bb cc} a b c d e
% set ins2 [linsert $z 2 middle {dd ee ff}]
a b middle {dd ee ff} c d e
% set ins3 [linsert $z end {gg hh} 42]
a b c d e {gg hh} 42
%
```

lreplace <list> <startindexnum> <endindexnum> [<arg>] ...

`lreplace` returns a new list which is identical to `<list>` except that the items between index locations `<startindexnum>` and `<endindexnum>` have been replaced with all of the `<arg>` parameters. A special value of "end" can be specified for `<endindexnum>` to indicate the end of the list.

```
# tclsh
% set z {a b c d e}
a b c d e
% set rep1 [lreplace $z 1 3 W X Y Z]
a W X Y Z e
% set rep2 [lreplace $z 0 2 {foo bar} 6667]
{foo bar} 6667 d e
% set rep3 [lreplace $z 3 end 1 2 3]
a b c 1 2 3
%
```

lrange <list> <startindexnum> <endindexnum>

lrange returns a new list which is made up of elements of <list> from between its index locations <startindexnum> and <endindexnum>. A special value of "end" can be specified for <endindexnum> to indicate the end of the list.

```
# tclsh
% set z {a b c d e}
a b c d e
% set rng1 [lrange $z 0 3]
a b c d
% set rng2 [lrange $z 2 3]
c d
% set rng3 [lrange $z 2 end]
c d e
%
```

concat [<arg>] ...

concat takes multiple <arg> parameters and concatenates them into one new list, which it returns. Each <arg> parameter is treated as a list. Note the difference in behavior between concat and list: concat ends up creating new siblings for elements, whereas list ends up creating new cousins.

```
set a {a1 a2 a3}
set b {b1 b2 b3}
set c c1
set d {d1 d2 {d31 d32 d33} d4}
set abc [concat $a $b $c $d]
puts "abc: $abc"
```

When run, this outputs:

```
abc: a1 a2 a3 b1 b2 b3 c1 d1 d2 {d31 d32 d33} d4
```

As you can see from the {d31 d32 d33} entry, it's not that concat flattens lists out; it just goes into the list elements it's passed as <arg> parameters, pulls out their children, and puts them all in one list.

join <list> [<str>]

join returns a single string that is made up of all of the values of the elements of <list>, separated by <str>. If <str> isn't specified, a space is used by default.

```
# tclsh
% set x {{a1 a2 a3} {b1 b2 b3} c1 {d1 {d21 d22} d3 d4}}
{a1 a2 a3} {b1 b2 b3} c1 {d1 {d21 d22} d3 d4}
% set j1 [join $x]
a1 a2 a3 b1 b2 b3 c1 d1 {d21 d22} d3 d4
% set j2 [join $x -]
a1 a2 a3-b1 b2 b3-c1-d1 {d21 d22} d3 d4
% set j3 [join $x \n]
a1 a2 a3
b1 b2 b3
c1
d1 {d21 d22} d3 d4
%
```

split <str> <delimiterchars>

split takes the string <str>, goes through it looking for characters in <delimiterchars>, and splits the string up based on those delimiters. It places all of the parts in a new list, which it returns.

```
# tclsh
% set str "a1 a2 a3-b1 b2 b3-c1-d1 {d21 d22} d3 d4"
a1 a2 a3-b1 b2 b3-c1-d1 {d21 d22} d3 d4
% split $str -
{a1 a2 a3} {b1 b2 b3} c1 {d1 {d21 d22} d3 d4}
% set str2 "One|Two|Three||Five|{a b {c1 c2} d}|Seven"
One|Two|Three||Five|{a b {c1 c2} d}|Seven
% split $str2 |
One Two Three {} Five {{a b {c1 c2} d}} Seven
%
```

lsearch [-exact | -glob | -regexp] <list> <pattern>

Search through <list> for the first item matching <pattern>, returning the index number of the matching item in the list (or -1 if there was no hit). -exact means the list item must match the pattern exactly. -glob means that glob-style wildcards can be used during the search.[2] -regexp means that the pattern is a regular expression. The default is -exact.

```
# tclsh
% set names {Amy Sally Suzy Jennifer Julie Jenny Debbie}
Amy Sally Suzy Jennifer Julie Jenny Debbie
% lsearch $names Debbie
6
% lsearch -exact $names Debbie
6
% lsearch -glob $names Je*
3
% lsearch -regexp $names "^.....$"
1
%
```

lsort [options] <list>

lsort creates and returns a new sorted list, from the <list> argument. How it does its sorting depends on the options specified. The available options are:

-increasing	Items are sorted from low to high values. This is the default.
-decreasing	Items are sorted from high to low values.
-ascii	Sort the list alphabetically, according to the ASCII character set. This is the default.
-dictionary	Sort the list alphabetically, but ignoring case. If numbers are present within strings, they are compared numerically. For example, here is how it would sort the following four items: abc2def abc3def ABC4def abc10def

[2] See the glob command in Table B-11 for more information about glob patterns.

-integer	Treat each list item as an integer, and sort the list numerically.
-real	Treat each list item as a real (floating point) number, and sort the list numerically.
-index <indexnum>	If your list is actually a list of lists, you can sort that list based on an item from each sublist. You specify the location of the item within the sublists with <indexnum>. All sublists need to have at least <indexnum> + 1 items in them, or an error will be returned. See the following example.

```
# tclsh
% set list1 {abc3def abc10def ABC4def abc2def}
abc3def abc10def ABC4def abc2def
% set list2 {42 70 72 46 26 35}
42 70 72 46 26 35
% set list3 {3.1415 0.5 42.0 15 5.75}
3.1415 0.5 42.0 15 5.75
% set list4 {{Halo 49.95} {{SSX Tricky} 19.99} \
{GTA3 29.99} {Ico 17.99}}
{Halo 49.95} {{SSX Tricky} 19.99}  {GTA3 29.99} {Ico 17.99}
%
% lsort -ascii $list1
ABC4def abc10def abc2def abc3def
% lsort -dictionary $list1
abc2def abc3def ABC4def abc10def
% lsort -integer $list2
26 35 42 46 70 72
% lsort -decreasing -integer $list2
72 70 46 42 35 26
% lsort -real $list3
0.5 3.1415 5.75 15 42.0
% lsort -real -index 1 $list4
{Ico 17.99} {{SSX Tricky} 19.99} {GTA3 29.99} {Halo 49.95}
% lsort -index 0 $list4
{GTA3 29.99} {Halo 49.95} {Ico 17.99} {{SSX Tricky} 19.99}
%
```

-command <command>	Use your own custom sorting command to determine order. The command must take two arguments, and return either -1, 0, or 1, depending on whether the first argument was smaller than the second, the arguments were equal, or the first argument was larger than the second.

For an example of how to use -command, let's write a custom sort command that only looks at the third through seventh character of each string. If two entries have the same characters in that range, we'll use the full string for comparison. We will return that they are equal if and only if the entire full strings are the same.

```
proc customsort {arg1 arg2} {
  set arg1slice [string range $arg1 2 6]
  set arg2slice [string range $arg2 2 6]
  if {$arg1slice != $arg2slice} {
    if {$arg1slice < $arg2slice} {
      return -1
    } else {
      return 1
    }
  } else {
    # The slices are equal, now compare the whole string
    if {$arg1 < $arg2} {
      return -1
    } elseif {$arg1 > $arg2} {
      return 1
    } else {
      return 0
    }
  }
}

set list5 {J_abcde_35 L_xyzzy_26 K_plugh_46\
           A_xyzzy_49 J_abcde_35}

puts [lsort -command customsort $list5]
```

When run, the output generated by that example is:

```
J_abcde_35 J_abcde_35 K_plugh_46 A_xyzzy_49 L_xyzzy_26
```

The only new things there that you haven't seen yet are the string and if/elseif/else commands, which will be described below.

It should be noted that you should try to avoid using a custom sort routine if possible, as it's less efficient than other methods.

Arrays

Array items in Tcl are fetched from their array variables with parentheses. They are indexed by a name rather than by their location, so really they're more like hash tables or maps than arrays. Since variables don't have to be declared, you can create an array just by assigning a value to one of its children:

```
set bandmembers(drummer)  "Neil Peart"
set bandmembers(bass)     "Geddy Lee"
set bandmembers(guitar)   "Alex Lifeson"
```

You can have multidimensional arrays just as easily:

```
set bandmembers(Rush,drummer)     "Neil Peart"
set bandmembers(Rush,bass)        "Geddy Lee"
set bandmembers(Rush,guitar)      "Alex Lifeson"
set bandmembers(Genesis,drummer)  "Phil Collins"
set bandmembers(Genesis,bass)     "Mike Rutherford"
set bandmembers(Genesis,keyboard) "Tony Banks"
```

Note however that multidimensional arrays aren't exactly a feature; the name of a variable is simply Rush,drummer. Doing `array size bandmembers` with the above example returns 6.

To access an array element, you use the same syntax (starting with a $):

```
puts "All hail $bandmembers(Rush,drummer)!"
```

Because of the example I've used here, it should be pointed out that you'd have trouble if you wanted to add someone from Pink Floyd, because of the space in the name. It's still legal to have it in the name, but the parentheses won't handle that for you. One solution would be to enclose the entire first argument of set in curly braces:

```
set {bandmembers(Pink Floyd,bass)} "Roger Waters"
```

What make arrays useful are the array commands in the Tcl core library. As with Lists above, I'll describe the array functions here rather than with the other library functions, since they are important when using arrays.

array get <arrayvarname> [pattern]

`array get` returns a list of name/value pairs from a selected portion of the array. If no pattern is specified, the entire array is selected; otherwise, the name of the array element is compared against the pattern (it's a filename-style glob pattern).

```
% array get bandmembers
{Pink Floyd,bass} {Roger Waters} Genesis,drummer {Phil Collins}
Rush,guitar {Alex Lifeson} Rush,drummer {Neil Peart}
Genesis,keyboard {Tony Banks} Genesis,bass {Mike Rutherford}
Rush,bass {Geddy Lee}
% array get bandmembers Genesis,*
Genesis,drummer {Phil Collins} Genesis,keyboard {Tony Banks}
Genesis,bass {Mike Rutherford}
% array get bandmembers *,bass
{Pink Floyd,bass} {Roger Waters} Genesis,bass {Mike Rutherford}
Rush,bass {Geddy Lee}
% array get bandmembers *board
Genesis,keyboard {Tony Banks}
%
```

array set <arrayvarname> <namevaluelist>

`array set` sets the variable named <arrayvarname> to be an array with values from the list of name/value pairs <namevaluelist>.

```
% array set array2 {{Pink Floyd,bass} {Roger Waters}
Genesis,drummer {Phil Collins} Rush,guitar {Alex Lifeson}
Rush,drummer {Neil Peart} Genesis,keyboard {Tony Banks}
Genesis,bass {Mike Rutherford}}
% array get array2 Rush,*
Rush,drummer {Neil Peart} Rush,guitar {Alex Lifeson}
%
```

array names <arrayvarname> [pattern]

array names basically performs the same function as array get, except that it only returns a list of the names of all of the array items (not their values).

```
% array names bandmembers
{Pink Floyd,bass} Genesis,drummer Rush,guitar Rush,drummer
Genesis,keyboard Genesis,bass Rush,bass
% array names bandmembers *,drummer
Genesis,drummer Rush,drummer
%
```

array size <arrayvarname>

array size returns the number of elements in the array.

```
% array size bandmembers
7
%
```

array exists <arrayvarname>

array exists returns 1 if an array with the specified name exists, or 0 if it doesn't.

```
% array exists bandmembers
1
% array exists thisvardoesntexist
0
% set xyz 42
42
% array exists xyz
0
%
```

array startsearch <arrayvarname>

array startsearch (which works in conjunction with array nextelement, array anymore, and array donesearch), starts an array search. It sets up an iterator, and returns an id suitable for use with array nextelement, array anymore, and array donesearch. (See the example at the end).

array anymore <arrayvarname> <id>

array anymore returns 1 if the iterator specified by <id> (obtained from array startsearch) isn't yet at the end of the array. That is, it returns true if there are any more items to search through. (See the example at the end).

array nextelement <arrayvarname> <id>

array nextelement returns the *name* of the next item in an array during a search. It fetches the item at the iterator specified by <id>, then increments the iterator. (See the example at the end).

array donesearch <arrayvarname> <id>

You use `array donesearch` to tell Tcl that you've found the item you were looking for, and that the search is over. This lets it know it can free up the iterator it created during the `array startsearch` call.

This example searches through the `bandmembers` array looking for Neil Peart. It uses a few things we haven't discussed yet, but it should be pretty self-explanatory:

```
set lookingfor "Neil Peart"
set iter [array startsearch bandmembers]
set foundit 0

while {!$foundit && [array anymore bandmembers $iter]} {
  set nextname [array nextelement bandmembers $iter]
  set nextval "$bandmembers($nextname)"
  if {$nextval == $lookingfor} {
    puts "Found $lookingfor: $nextname"
    set foundit 1
  }
}

array donesearch bandmembers $iter

if {!$foundit} {
  puts "Couldn't find $lookingfor"
}
```

parray <arrayvarname>

To print out an array, use the `parray` convenience function.

```
% parray bandmembers
bandmembers(Genesis,bass)      = Mike Rutherford
bandmembers(Genesis,drummer)   = Phil Collins
bandmembers(Genesis,keyboard)  = Tony Banks
bandmembers(Pink Floyd,bass)   = Roger Waters
bandmembers(Rush,bass)         = Geddy Lee
bandmembers(Rush,drummer)      = Neil Peart
bandmembers(Rush,guitar)       = Alex Lifeson
%
```

The procedure `parray` isn't built into Tcl; it's actually a Tcl function, defined in your Tcl library in a file called `parray.tcl`. This file doesn't happen to exist on TiVos, but if you want it you can move it over from an existing Tcl installation, source it (`source /path/to/parray.tcl`), and use it there too.

Tcl Expressions

Some commands interpret strings as numerical or conditional expressions. It is only in these commands that you can do arithmetic and comparisons. These commands include expr, if, for, and while. if, for, and while (which are described later under "Control Statements") all make an implicit call to expr to evaluate their expression arguments. The expr command takes its arguments, joins them together as a string, and evaluates them as an expression (returning the result):

```
# tclsh
% expr 42 * 47
1974
%
```

Expressions are made up of operands and operators, with parentheses optionally used for grouping. The operators act almost identically to their counterparts in the C programming language. Operands can be integers, floats, strings, variable references, or calls to the math functions listed below.

Integers can be represented either in decimal, in octal (start the number with a 0), or in hexadecimal (start the number with 0x). Floats are represented the same way they are in C.

Strings have the appropriate substitutions carried out on them before being treated as operands. For instance, strings quoted with curly braces ({,}) will have no substitutions, but those quoted with quotation marks (") will have variables expanded and commands within square brackets ([,]) executed, as well as backslash substitution (see "Character Substitution" later in this chapter).

Take note that since expr, if, for, and while are just commands, some expansions will happen before operands are passed to those commands, unless the operands are quoted with curly braces. To borrow an example from the Tcl expr documentation, the commands:

```
set a 3
set b {$a + 2}
expr $b*4
```

Return a value of 11, not 20. This is because "$b*4" has substitution done on it by Tcl, and the result "$a+2*4" is what is sent to the expr command. If 20 had been desired, you'd instead use either set b {($a + 2)} or expr ($b)*4.

Operators

Table B-1 lists the operators available in Tcl expressions. The operators are listed in order of precedence, from highest to lowest.

Table B-1 Operators in Tcl

Operator	Description
+ - ~ !	Unary plus, minus, bitwise NOT, logical NOT
	+, -, and ! are valid for all numerical values. ~ is only valid for integers.
* / %	Multiply, divide, remainder
	* and / valid for all numerical values. % is only valid for integers.
+ -	Add, subtract. Valid for all numerical values.
<< >>	Bitwise left and right shift. Valid for integers only.
< > <= >=	Less-than, greater-than, less-than-or-equal, greater-than-or-equal.
	Valid for all types of values (including strings).
== !=	Tests for equality and inequality.
	Valid for all types of values (including strings).
&	Bitwise AND. Valid for integers only.
^	Bitwise XOR (exclusive or). Valid for integers only.
\|	Bitwise OR. Valid for integers only.
&&	Logical AND. Valid for all numerical values.
	If first argument is false, the operator shortcuts (not evaluating the second). See note below regarding shortcutting.
\|\|	Logical OR. Valid for all numerical values.
	If first argument is true, the operator shortcuts (not evaluating the second). See note below regarding shortcutting.
x?y:z	Short form of an if-then-else, all within an expression.
	If x != 0, then use the value of y, otherwise use the value of z.
	Only one of y or z will be evaluated. See note below regarding shortcutting.

The &&, ||, and x?y:z operators *shortcut*. What that means is that not all operands will always be evaluated (at least not by expr; they might be evaluated by Tcl prior to reaching expr if not quoted with curly braces). && doesn't evaluate its second operand if the first operand evaluates to false, since && now already knows its answer will be false. || doesn't evaluate its second operand if the first operand evaluates to true, since || now already knows its answer will be true. x?y:z only evaluates x and then one of y or z (depending on the value of x).

This matters if the operand that isn't evaluated had any side effects. The following examples illustrate this:

```
# tclsh
% proc myproc {} {
  puts "myproc was called.."   ;# This is the side effect
  # return value doesn't really matter for example, but..
  return 1
}
%
% # Here || won't shortcut here since the first arg is 0
% expr { 0 || [myproc] }
myproc was called..
1
% # But now || will shortcut because the first arg is 1
% expr { 1 || [myproc] }
1
% # see? myproc wasn't called..
%
% # If we hadn't quoted that expression with curly braces,
% # Tcl would have evaluated it before it got to expr:
% expr " 1 || [myproc] "
myproc was called..
1
%
% # Same exercise with &&:
% expr { 0 && [myproc] }
0
% expr { 1 && [myproc] }
myproc was called..
1
%
% # And the x?y:z example:
% expr { 0 ? 438 : [myproc] }
myproc was called..
1
% expr { 1 ? 438 : [myproc] }
438
%
```

Math Functions

Math functions are unique in that they're not normal Tcl commands. They're a built-in part of expr. New math functions can be implemented in C (as part of the Tcl interpreter), but not in Tcl. The syntax for a mathematical function is:

```
mathfunctionname(arg)
```

(with some taking two arguments, separated by a comma). The math functions supported by expr are listed in Table B-2. Angles are all in radians.

Table B-2 Math Functions

Function	Description
abs(arg)	Return absolute value of arg.
acos(arg)	Return the arc cosine of arg.
asin(arg)	Return the arc sine of arg.
atan(arg)	Return the arc tangent of arg.
atan2(y,x)	Return the arc tangent of y/x.
ceil(arg)	Return smallest integral floating point value not less than arg.
cos(arg)	Return the cosine of arg.
cosh(arg)	Return the hyperbolic cosine of arg.
double(arg)	Return the value of arg converted to a float.
exp(arg)	Return the exponential of arg.
floor(arg)	Return the largest integral floating point value not greater than arg.
fmod(x,y)	Return the floating-point remainder of x/y.
hypot(x,y)	Return length of hypotenuse of a right-angled triangle.
int(arg)	Return the value of arg converted to an integer.
log(arg)	Return the natural logarithm of arg.
log10(arg)	Return the base 10 logarithm of arg.
pow(x,y)	Return value of x raised to the power of y.
rand()	Return a pseudo-random floating-point number between 0 and 1.
round(arg)	Return the value of arg rounded and converted to an integer.
sin(arg)	Return the sine of arg.
sinh(arg)	Return the hyperbolic sine of arg.
sqrt(arg)	Return the square root of arg.
srand(arg)	Set the seed for the rand() function.
tan(arg)	Return the tangent of arg.
wide(arg)	Return the value of arg converted to a 64-bit wide value.

Control Statements

Unlike in other languages, the control statements in Tcl aren't special. if, for, foreach, while, and switch are all commands. In fact, nothing stops you from creating your own as well.

if <expr1> then <body1> [elseif <expr2> then <body2>] ... [else <bodyN>]

The if command allows you to run a group of commands only if a given condition is true. That usage string isn't the clearest way to start out, so let's jump right into an example:

```
if {$x == 42} {
  puts "So long, and thanks for all the..."
} elsif {$x == 47} {
  puts "Now where did I put that artifact?"
} else {
  puts "I have no obscure reference for your number."
}
```

(Note that with if, for, and while that the conditionals are enclosed in curly braces, whereas in other languages it would usually be enclosed in parentheses).

Looking at the example, you should get what it's supposed to do. As for *how* it's doing it, well let's look at it. The command if is given seven arguments in this case:

- The conditional expression for the if
- The body to run if that evaluates to true
- An "endif"
- The conditional expression for the endif
- The body for the endif
- An else
- The body for the else

The if command evaluates the first conditional expression (the same way that the expr command does). If the expression's value is true, it evaluates the corresponding body, then exits. If not, it moves to any next conditional expression (for an elseif), and so on. If none of the conditionals return true, it evaluates the body of the else block (if it exists).

for <start> <test> <next> <body>

Again, let's go with an example first:

```
for {set i 20} {$i > 0} {incr i -1} {
  puts "$i"
}
puts "Blastoff!"
```

The first argument to for is run once at the beginning of the loop (typically to initialize a counting variable). The for command evaluates the second argument (the same way that the expr command does) before each iteration of the loop; if it evaluates to false, the loop is finished and the body is not executed again. The third argument is run after each iteration of the loop (typically to increment or decrement a counting variable). The fourth argument is the body of the loop, containing commands that get run during each iteration.

As with the other looping commands, the body argument can contain `continue` and `break` commands, to exit the current iteration through the loop (and any further iterations, in the case of `break`).

foreach <varname> <list> <body>

There are two ways to use the `foreach` command, each warranting a separate description. Actually, this first case is merely a simple case of the second, but it's used so often that it should be described first.

Here, the `foreach` command loops through items in a list, assigning a variable to the current item during each iteration:

```
foreach genre {horror scifi action comedy crime drama} {
  puts "genre: $genre"
}
```

Each time through the loop, the variable `genre` gets another value from the list.

foreach <varlist1> list1 [<varlist2> list2 ...] <body>

The more general description of how `foreach` actually works is that it takes one or more `varlist/list` pairs, and then a body argument. Each time through the loop, every item in each varlist is given a value from its corresponding list. If a `varlist` contains *n* items, then *n* items from the corresponding list are used up during each iteration through the loop. All `varlist/list` pairs are done simultaneously; each time through the loop every item in every `varlist` is given another value (or {} if it has exhausted the items in its corresponding list). More so than any of the previous commands, this deserves a few examples.

```
foreach {town zip}\
    {Lowell 01852 Reading 01867 Wakefield 01880 Woburn 01801}\
    {lat long}\
    {42n38 71w19 42n32 71w06 42n30 71w04 42n29 71w09} {

  puts "Town: $town ($zip) coordinates: $lat, $long"
}
```

That example generates this output:

```
Town: Lowell (01852) coordinates: 42n38, 71w19
Town: Reading (01867) coordinates: 42n32, 71w06
Town: Wakefield (01880) coordinates: 42n30, 71w04
Town: Woburn (01801) coordinates: 42n29, 71w09
```

All of the `varlists` do *not* need to have the same number of items. If we omitted the zip code from the above list (leaving one `varlist` with one item and the other `varlist` with two items), the example would be:

```
foreach town {Lowell Reading Wakefield Woburn }\
    {lat long}\
    {42n38 71w19 42n32 71w06 42n30 71w04 42n29 71w09} {

  puts "Town: $town coordinates: $lat, $long"
}
```

which would output:

```
Town: Lowell coordinates: 42n38, 71w19
Town: Reading coordinates: 42n32, 71w06
Town: Wakefield coordinates: 42n30, 71w04
Town: Woburn coordinates: 42n29, 71w09
```

As alluded to previously, a list can even run out of data (due to one varlist/list pair being larger than another). Here's an example that illustrates that:

```
foreach town {Lowell Reading Wakefield Woburn Burlington}\
    {lat long}\
    {42n38 71w19 42n32 71w06 42n30 71w04 42n29 71w09} {

  if {$lat != {}} {
    puts "Town: $town coordinates: $lat, $long"
  } else {
    puts "Town: $town (no coordinates)"
  }
}
```

where the output is:

```
Town: Lowell coordinates: 42n38, 71w19
Town: Reading coordinates: 42n32, 71w06
Town: Wakefield coordinates: 42n30, 71w04
Town: Woburn coordinates: 42n29, 71w09
Town: Burlington (no coordinates)
```

As with the other looping commands, the body argument can contain continue and break commands, to exit the current iteration through the loop (and any further iterations, in the case of break).

while <test> <body>

The while loop lets you continue performing a group of commands as long as a given condition remains true. The while command evaluates the first argument (the same way that the expr command does) before each iteration of the loop. If that test expression evaluates to true, the commands with body are executed. If the test returns false originally, the body of the while statement is never executed.

As with the other looping commands, the body argument can contain continue and break commands, to exit the current iteration through the loop (and any further iterations, in the case of break).

A simple example is:

```
set I 0
while {$i < 10} {
  incr i
  puts $i
}
```

Here's an example that also shows the use of `continue` and `break`:

```
set numTries 0
while {$numTries < 20} {
  incr numTries
  set randnum [expr {int(floor(rand() * 10))} + 1]
  puts "random num between 1-10: $randnum"
  if {$randnum == 10} {
    puts "Hit magic lucky #10! Stopping.."
    break
  }
  if {$randnum >= 5} continue
  puts "  (that's a low number..)"
}
puts "And, we're done."
```

Sample output from that code:

```
random num between 1-10: 6
random num between 1-10: 5
random num between 1-10: 2
  (that's a low number..)
random num between 1-10: 9
random num between 1-10: 8
random num between 1-10: 4
  (that's a low number..)
random num between 1-10: 4
  (that's a low number..)
random num between 1-10: 10
Hit magic lucky #10! Stopping..
And, we're done.
```

switch [options] <str> [{] <pat> <body> [<pat> <body>]... [}]

The `switch` command decides which one of several bodies of code to execute, based on a pattern match. The type of pattern matching used depends on the options specified. The available options are:

> **-exact** The specified string must match the pattern exactly. This is the default.
>
> **-glob** The patterns may use glob-style wildcards.[3]
>
> **-regexp** The patterns are regular expressions.

(If `--` is encountered, it signifies the end of options; anything after that will be considered the `<str>` argument, even if it starts with `-`.)

Switch goes through the pattern/body pairs, comparing `<str>` with each of the patterns (according to the matching method specified by any options). If it finds a match, that corresponding `<body>` is executed. If instead of a body there is only a "`-`", then it the next body (from the next pattern/body pair) is executed. The word "`default`" can be used as a pattern to indicate the body to execute when no patterns match.

[3] See the glob command in Table B-11 for more information about glob patterns.

Curly braces may be placed around the entire group of pattern/body pairs, or they may be left off. Remember that using curly braces stops various types of substitution from happening.

Caution

Be sure not to put any comments within the pattern section of a `switch` statement. Within one of the body sections this is ok, but not alongside pattern/body pairs. The `switch` command will interpret the # as the pattern, and everything after that as the command (usually causing errors).

Here's a simple example:

```
proc dayofweekname {dayofweeknum} {
  set dayofweekstr {}
  switch $dayofweeknum {
     0        {set dayofweekstr "Sunday"}
     1        {set dayofweekstr "Monday"}
     2        {set dayofweekstr "Tuesday"}
     3        {set dayofweekstr "Wednesday"}
     4        {set dayofweekstr "Thursday"}
     5        {set dayofweekstr "Friday"}
     6        {set dayofweekstr "Saturday"}
    default {set dayofweekstr "INVALID DAY"}
  }
  return $dayofweekstr
}

dayofweekname 4
```

Here's another, this time using glob-matching and "-" to pass through:

```
switch -glob $str Tom - Thomas {puts "Hi Tom"}\
  Jon* {puts "Hi Jon"} default {puts "Hi $str"}
```

That example will print "Hi Tom" if `$str` is "Tom" or "Thomas", or "Hi Jon" if `$str` begins with "Jon".

And here's an example using regular expressions:

```
switch -regexp $str "^[0-9]*$" {puts "That was a number"}\
  [^a-zA-Z0-9] {puts "That was non-alphanumeric"}\
  default {puts "That must have been alphanumeric"}
```

return <value>

Stop executing the current procedure immediately, returning <value>.

exit <value>

Exit the entire process, returning <value> to the system as the exit code.

Miscellaneous Language Details

There are just a few more things to cover about the language itself, before moving on to the "Other Library Functions" section.

Character Substitution

Using the "\" character, you can not only escape Tcl-specific special characters, but also denote other special characters like newline and tab. Table B-3 lists the backslash substations that are possible in Tcl.

Table B-3 Backslash Substitutions

Substitition	Description
\n	
\<actualnewline>	Newline (0x0a)
\r	Carriage Return (0x0d)
\t	Tab (0x09)
\v	Vertical tab (0x0b)
\a	Bell (0x07)
\b	Backspace (0x08)
\f	Form feed (0xc)
\ddd	Octal value, in 1, 2, or 3 digits of 0–7
\xdd	Hexadecimal value, 1 or 2 digits of 0–F
\<space>	Space (0x20)
\\	Backslash

Script Headers

For a Tcl script to be run, you either need to explicitly run the Tcl interpreter (passing it your script as an argument), or you need to put a script header on the first line specifying that this is a Tcl script.

For a Tcl script running on a TiVo, the Tcl interpreter is /tvbin/tivosh. That means that the first line of all Tcl scripts on the TiVo should read:

```
#!/tvbin/tivosh
```

(Where # is the very first character on the very first line, and ! is the second character).

On a Linux machine, the Tcl interpreter is tclsh. Where it lives depends on where you installed Tcl. "which tclsh" should tell you the full pathname, if it's installed and in your path. A typical first line for a Tcl script on a Linux box is:

```
#!/usr/bin/tclsh
```

Once you've also made sure the file is executable (via the chmod command), the script can be run just by typing its name (provided that the directory it lives in is listed in your PATH environment variable).

Special Variables

There are some variables that are special to Tcl. These are either variables that are set for you before Tcl starts, or they're variables you can use to change how it behaves. Table B-4 lists some of the special variables in Tcl.

Table B-4 Some Special Tcl Variables

Variable	Description
Argc	How many arguments were passed in on the command line. This doesn't include argv0 (the name of the current script, or of the symbolic link pointing at it that this was called with).
Argv	List of all arguments passed in on the command line. This doesn't include argv0 (the name of the current script, or of the symbolic link pointing at it that this was called with).
argv0	Unlike in C and other languages, `argv0` (the name of the current script, or of the symbolic link pointing at it that this was called with) isn't actually a part of the argv variable. In Tcl, it is its own variable, `argv0`.
Env	Array containing all environment variables.
ErrorCode	Error code for the last Tcl error that has occurred.
ErrorInfo	Give more detailed debugging information about the last Tcl error that has occurred.
tcl_interactive	This is set to 1 if Tcl is being run interactively, and 0 if in batch mode.
tcl_library	This contains the location of the standard Tcl libraries.
tcl_pkgPath	This contains the location where packages are installed.
tcl_patchLevel	This is the patch level of the Tcl interpreter (tivosh or tclsh).
tcl_platform	This is an array containing the byteOrder, machine, os, osVersion, and platform that you're running on.
	On a Series1 TiVo, the values returned are:
	`tcl_platform(byteOrder) = bigEndian`
	`tcl_platform(machine) = ppc`
	`tcl_platform(os) = Linux`
	`tcl_platform(osVersion) = 2.1.24-TiVo-2.5`
	`tcl_platform(platform) = unix`

Variable	Description
tcl_precision	This contains the precision of floating point numbers, in digits. tcl_prompt1
tcl_prompt2	When running in interactive mode, the Tcl interpreter presents a prompt for user command. When the user enters a command that spans multiple lines (like a while loop), a secondary prompt is printed for those lines. If tcl_prompt1 is set to a command, such as: {puts -nonewline -+>} then the command will be run every time a prompt is needed. Similarly, tcl_prompt2 contains a command that is run before every secondary prompt. Lacking commands, prompts of {% } and {} are used.
tcl_traceCompile	This controls whether Tcl should trace bytecode compilation. 0=no, 1=give summary, 2=give detailed trace info
tcl_traceExec	This controls whether Tcl should trace bytecode execution. 0=no, 1=give summary, 2=give detailed trace info
tcl_version	This contains the version of the Tcl interpreter (tivosh or tclsh). tivosh uses Tcl version 8.0.

Other Library Functions

We've just gone over the Tcl language itself, and some of the library functions that back up the essential features of the language (such as array functions, etc). Here we'll list what other library functions exist. These will be covered in far less detail; consult the Tcl manual pages for more info on the library functions mentioned here.

String Manipulations

A key part of any core library is the ability to manipulate strings. The string command (and its many subcommands) provide most of this functionality, though some other commands prove useful for dealing with strings as well. Table B-5 gives a brief description of each command. All index locations in these commands are zero-based.

Table B-5 String Related Commands

Command	Description
string compare <str1> <str2>	Compare two strings and return either –1, 0, or 1 depending on whether the first string comes alphabetically before the second, the strings are equal, or the first string comes alphabetically after the second.
string first <str1> <str2>	Return the first location within <str2> where <str1> occurs, or –1 if <str2> doesn't contain <str1>.
string index <str> <charindexnum>	Return one character from <str>, which lies at location <charindexnum> (or an empty string if <charindexnum> is out of bounds).
string last <str1> <str2>	Return the last location within <str2> where <str1> occurs, or –1 if <str2> doesn't contain <str1>.
string length <str>	Return the length (in characters) of <str>.
string match <pat> <str>	Return whether or not <str> matches the pattern <pat>. Patterns can include * (match zero or more characters), ? (match any one character), \x (match x even if x is *, ?, \, [, or]), and [abcm-z] (match the character a, b, c, m, n, o, p, ..., x, y, or z).
string range <str> <firstindexnum> <lastindexnum>	Return a substring from <str> starting at location <firstindexnum> and ending at location <lastindexnum>. "end" may be used in place of <lastindexnum> to signify the end of the string.
string tolower <str>	Return a copy of <str> where all letters have been converted to lowercase.
string toupper <str>	Return a copy of <str> where all letters have been converted to uppercase.
string trim <str> [<chars>]	Return a copy of <str> where any instances of any of the characters in <chars> have been removed from the front and end of the string. The default for <chars> is the whitespace characters.
string trimleft <str> [<chars>]	Return a copy of <str> where any instances of any of the characters in <chars> have been removed from the front of the string. The default for <chars> is the whitespace characters.
string trimright <str> [<chars>]	Return a copy of <str> where any instances of any of the characters in <chars> have been removed from the end of the string. The default for <chars> is the whitespace characters.

Command	Description
`string wordend <str> indexnum`	Find the word in `<str>` containing the character at location `<indexnum>`, and return the location immediately after the completion of that word. Words are made up of letters, numbers, and underscores (_), although a lone non-whitespace character is considered its own word.
`string wordstart <str> indexnum`	Find the word in `<str>` containing the character at location `<indexnum>`, and return the location of the first character of that word. Words are made up of letters, numbers, and underscores (_), although a lone non-whitespace character is considered its own word.
`append <varname> [<arg>] ...`	Concatenate the value of `<varname>` with the values of all `<arg>` arguments, and leave the combined result in the variable named `<varname>`. This is more efficient because it's done in-place (rather than duplicating the contents of the variable named `<varname>`, copying it, and garbage collecting the old instance).
	`binary format <formatstr> <arg> ...`
`binary scan <str> <formatstr> <varname> ...`	Format (and decode) binary strings. `binary format` creates a binary string from values, while `binary scan` extracts values from a binary string. The format string `<formatstr>` is a sequence of field codes, each representing the data type for the next item in the binary string. Each field code may be followed by a count argument (an integer, or *). Table B-6 lists the fields codes for the `binary` command's `<formatstr>` argument.
	`binary format` returns the generated binary string, while `binary scan` returns the number of conversions performed.
`format <formatstr> [<arg>] ...`	Format a string from values and a formatting string. The format string `<formatstr>` is text containing placeholders of the format:
	`%[pos$][flag][width][.prec][h]<type>`
	The syntax is nearly identical to ANSI C's `sprintf`. `pos` specifies an argument to use instead of the next logical argument. `flag` can be - (left-justify), + (always print with a sign), `<space>` (use space where sign would be if no sign is printed), 0 (zero-padding), or # (an alternate format for each type). If `h` is specified, integers are truncated to shorts before conversion.
	The acceptable values for `<type>` are listed in Table B-7.

Continued

Table B-5 *(continued)*

Command	Description
`scan <str> <format>` `<varname> ...`	Extract values from a string, as specified by a formatting string. The format string `<format>` is text containing placeholders of the format: `%[*][width]<type>` The syntax is nearly identical to ANSI C's `sscanf`. If `*` exists in a placeholder, the value obtained for that placeholder is not assigned to anything (i.e. the placeholder is just used to skip ahead in the input string). The acceptable values for `<type>` are listed in Table B-8.
`regexp [options] <regexp>` `<str> [<matchvarname>]` `[<submatchvarname>] ...`	Return whether or not `<str>` matches the regular expression `<regexp>`. If `<matchvarname>` is specified, the variable with that name will be assigned the entire matching portion of the regular expression. All of the variables with names specified by all of the `<submatchvarname>` arguments are assigned values from any parenthesized expressions within `<regexp>`. The options you can specify include `-nocase` and `-indicies`. (`--` indicates the end of options.) When `-nocase` is specified, all pattern matching is case-insensitive. When `-indicies` is specified, instead of placing the matching text of parenthesized expressions in the `<subMatchVarName>` variables, indexes of where those expressions started and stopped are put in their place. Each `<subMatchVarName>` variable is assigned these indices as a list of two numbers. The regular expressions supported in Tcl are those specified under POSIX 1003.2 (POSIX.2). Tcl uses Henry Spencer's regex library.

Command	Description
`regsub [options] <regexp> <str> <subSpec> <varname>`	Perform substitutions on a copy of `<str>`, placing the resulting string in the variable whose name is `<varname>`, returning how many such substitutions actually occurred. To do these substitutions, `regsub` searches for a match of the regular expression `<regexp>` within `<str>`. (If `-nocase` is specified, it's a case-insensitive match.) When a match is found, it's replaced with the contents of `<subSpec>`. If the `-all` option is specified, the search continues until the end of `<str>`. If `<subSpec>` contains a `&` or `\0`, then the entire matching portion is substituted in its place. If `subSpec` contains a `\n` (where *n* is between 1 and 9), then the *n*th match is substituted in its place.
	The options available (which were mentioned above) are `-nocase` and `-all`. `--` indicates the end of options.
	The regular expressions supported in Tcl are those specified under POSIX 1003.2 (POSIX.2). Tcl uses Henry Spencer's regex library.
`subst [options] <str>`	Perform variable substitutions, command substitutions, and backslash substitutions on `<str>`, returning the modified copy of `<str>`. You may disable these substitutions with any combination of the options `-nobackslashes`, `-nocommands`, or `-novariables`.

Table B-6 Field Codes for binary Command's <formatstr> Argument

Field Code	Description
a	Character string. When used with `binary format`, padding is done with nulls. When used with `binary scan`, no stripping is done on the string that is read in.
A	Character string. When used with `binary format`, padding is done with spaces. When used with `binary scan`, stripping is performed on the string that is read in.
b	Binary digits (formatted low-to-high within each byte).
B	Binary digits (formatted high-to-low within each byte).
h	Hexadecimal digits (formatted low-to-high within each byte).
H	Hexadecimal digits (formatted high-to-low within each byte).
c	1-byte (8-bit) integer.
s	2-byte (16-bit) integer, little-endian.

Continued

Table B-6 *(continued)*

Command	Description
S	2-byte (16-bit) integer, big-endian.
i	4-byte (32-bit) integer, little-endian.
I	4-byte (32-bit) integer, big-endian.
f	Float. Size varies from platform to platform. On Tivo, it's 4 bytes.
d	Double. Size varies from platform to platform. On TiVo, it's 8 bytes.
x	When used with `binary format`, this adds null bytes to the binary string being generated. When used with `binary scan`, this skips bytes in the input string.
X	Move the input/output position within the string back a given number of bytes.
@	Move the input/output position within the string to a particular location within the string (using the count argument).

Table B-7 Conversion Types for % Placeholders in format Command

Conversion Type	Description
d, i	Integer to signed decimal string.
u	Integer to unsigned decimal string.
o	Integer to unsigned octal string.
x	Integer to unsigned hexadecimal string (lowercase a-f).
X	Integer to unsigned hexadecimal string (uppercase A-F).
c	Integer to ASCII character
s	String (unconverted)
f	Floating-point number to signed decimal string $xx.yyy$ (`.prec` specifies how many y digits).
e	Floating-point number to scientific notation $x.yyye(+/-)zz$, (`-prec` specified how many y digits).
E	Floating-point number to scientific notation $x.yyyE(+/-)zz$, (`-prec` specified how many y digits).
g	Floating-point number to best looking of either `%e` or `%f` notation (if exponent < -4 or exponent >= `.prec`, use `%e`).
G	Floating-point number to best looking of either `%E` or `%f` notation (if exponent < -4 or exponent >= `.prec`, use `%e`).
%	Escape for `%`. Perform no conversion, just use `%`.

Table B-8 Conversion Types for % Placeholders in scan Command

Conversion Type	Description
d	Decimal integer to decimal string.
o	Octal integer to decimal string.
x	Hexadecimal integer to decimal string.
c	Character to decimal string.
e	Floating-point number to floating-point string.
f	Floating-point number to floating-point string.
g	Floating-point number to floating-point string.
s	String until next whitespace.
[chars]	Any characters within chars are matched.
[^chars]	Any characters *except* those within chars are matched.

I/O Channels

Another important part of any library is access data, whether it be from a file, a socket, or an input/output stream such as a terminal. Several commands exist in Tcl to give you access to Tcl *channels*.

Three channels are available all the time: stdin, stdout, and stderr. You can use either of these three with any command that requires a channelId. stdin and stdout are used by default in the appropriate commands if an optional channelId is omitted.

The commands to handle Input / Output through channels are briefly described in Table B-9.

Table B-9 I/O Channel Commands

Command	Description
open <filename> [<access>] [<permissions>]	Open a file, device, or channel, and return a channelId that can be used with all channel-related commands. If <filename> begins with a l, a channel is created which is mapped to either the input or output of a new pipeline chain, to run the command(s) specified by the rest of <filename>.
	<access> may be one of: r (read-only, file must exist), r+ (read-write, file must exist), w (write only, erase if it exists), w+ (read-write, erase if it exists), a (write only, file must exist, writes appended to end of file), or a+ (read-write, writes appended to end of file).

Continued

Table B-9 *(continued)*

Command	Description
	The alternate POSIX format is supported as well. You can specify a list with exactly one of RDONLY, WRONLY, or RDWR, and additionally any of APPEND, CREAT, EXCL, NOCTTY, NONBLOCK, or TRUNC.
	The optional `<permissions>` argument is an integer. You would usually specify this as an octal number, such as 0755, similar to what you would pass to the chmod command in Unix.
close `<channelId>`	Chose the channel specified by `<channelId>`.
gets `<channelId>` `[<varname>]`	Read one line of text from the specified channel. If `<varname>` is supplied, the line of text is placed in that variable, and the number of characters read is returned; otherwise, the line of text itself is returned.
puts [-newnewline] `[<channelId>] <str>`	Write `<str>` to the specified channel, with a newline at the end (unless -nonewline was specified). If `<channelId>` is omitted, stdout is used.
read [-nonewline] `<channelId>` read `<channelId>` `<numBytes>`	Read data from the specified channel. If no `<numBytes>` argument is present, read will read the entire channel up until the end of file marker, omitting the last character if it was a newline and -nonewline was specified. If `<numBytes>` was specified, that is the number of bytes read (if present).
eof `<channelId>`	Return whether or not the end of file has been reached on the specified channel.
seek `<channelId>` `<offset> [<origin>]`	Move the current position within the channel specified by channelId to a location that is `<offset>` bytes away from the "origin" location. Valid values for `<origin>` are "start", "current", and "end" (where "start" is the default). `<offset>` may be negative.
tell `<channelId>`	Return the current position within the channel specified by `<channelId>`. Channels that don't support seeking return a value of -1.
flush `<channelId>`	Flush any buffered output on the channel specified by `<channelId>`.
fblocked `<channelId>`	Return whether or not the last input operation was unable to return the desired amount of data because of blocking.
fcopy `<inCh> <outCh>` `[-size <size>]` `[-command <callback>]`	Copy data from one channel to another. If a `<size>` has been specified, only that many bytes are copied over (otherwise the copy continues until the eof marker is encountered).

Command	Description
	`fcopy` returns when the copy is complete, unless a `<callback>` is supplied via `-command`. In this case, the copy runs in the background, calling the specified callback routine when the copy is completed. The arguments passed to such a callback procedure are the number of bytes written, and an optional error string.
`fileevent <channelId>` `readable [<script>]`	Register a callback procedure to be triggered when a channel changes in state to become readable or writable.
`fileevent <channelId>` `writable [<script>]`	Omitting `<script>` returns the script currently in place for the event; otherwise, an empty string is returned.
`socket [options]` ` <host> <port>` `socket -server <command>` ` [options] <port>`	`socket` allows you to open a TCP network socket connection. It returns a `channelId` that can be used just like the `channelId` of an open file.
	To act as a client and connect to an existing server, the first method is used. `<host>` represents the machine to connect to, and `<port>` is the port number on that machine to target. Though Tcl allows you to specify a hostname or IP address for `<host>`, be aware that TiVo's setup does not include any DNS resolving, so you'd want to use the IP address.
	When acting as a client, three additional options are available for use. `-myaddr <addr>` lets you provide the IP address of the network interface you want to use to do the connection (for those with multiple network connections). `-myport <port>` lets you provide the port number to connect *from*. `-async` causes the connection to be handled asynchronously, meaning that the command returns well before the connection is actually initiated. This is where `fblocked` comes in, since you'd be checking that on your first calls to a newly connected socket to see if it was actually connected yet.
	To act as a server and bind to your own port, the second method is used. `<port>` is the port number you'd like to bind to, and `<command>` is the callback that will get called when someone connects to it. That callback is called with three arguments: the name of the new channel, the address, and the client's port number. You may also specify the option `-myaddr <addr>`. This lets you provide the IP address of the network interface that you want to receive connections on.

Continued

Table B-9 *(continued)*

Command	Description
fconfigure <channelId> [<name> [<value>] ...]	The fconfigure command allows you to configure channels and how they behave, via five different options.
	fconfigure <channelId> with no other arguments will return a list of options (name, value, name, value, ...) for the specified channel.
	fconfigure <channelId> <name> with no other arguments will return the value for the setting called <name> for the specified channel.
	fconfigure <channelId> <name> <value> ... will set the value of the specified setting (on the specified channel) to the value <value>.
	The options that can be set on a channel are:
	-blocking {true\|false}
	Set whether the specified channel should have blocking I/O enabled or not.
	-buffering <mode>
	Set a buffering mode of full, line, or none. full (the default) specifies that the output should be buffered until the buffer overflows or there is an explicit flush call. line causes the buffer to be flushed after every newline. none turns off buffering completely, writing out to disk after every output operation.
	-buffersize <size>
	Set the size (in bytes) of the I/O buffer for the channel.
	-eofchar <char>
	Set the end-of-file character.
	-eofchar {<inChar> <outChar>}
	Set the input and output end-of-file characters separately.
	-translation <mode>
	Set end-of-line translation to be either auto, binary, cr, crlf, or lf.
	-translation {<inMode> <outMode>}
	Set the end-of-line translation mode for input and output separately, setting each to either auto, binary, cr, crlf, or lf.

File Commands: file

Yet another crucial part of a useful library is the ability to access metadata from within the filesystem about a file. Being able to obtain information about files, create files, delete files, create directories, delete directories, etc is obviously a required set of functions. The `file` command and its subcommands provide access to this functionality.

Table B-10 gives a brief description of each of the `file` commands.

Table B-10 file Subcommands

Command	Description
file atime <filename>	Return the time that the specified file was last accessed.
file mtime <filename>	Return the time that the specified file was last modified.
file attributes <filename> [option [value] ...]	Access or modify platform-specific file metadata.
	`file attributes <filename>` with no other arguments will return a list of platform-specific attribute names and values. For example on Linux a file might return:
	`-owner root -group root -permissions 00664`
	`file attributes <filename> <option>` with no other arguments will return the value for the attribute called `<option>` for the specified file.
	`file attributes <filename> <option> <value>` will set the value of the specified attribute (on the specified file) to the value `<value>`.
file copy [-force] [--] <src> <dest> file copy [-force] [--] <src> <destDir>	Make a copy of the file `<src>` into either the specified destination file path or the specified destination directory. Using `-force` causes files to be overwritten during collisions. `--` indicates the end of options.
file delete [-force] [--] <pathname> ...	Delete the file or directory `<pathname>`. Using `-force` causes non-empty directories to be deleted as well. `--` indicates the end of options.
file dirname <filename>	Return the directory portion of the specified filename.
file executable <filename>	Return whether the specified file is executable by the current user or not, based on its permissions.
file exists <filename>	Return whether or not the specified file exists.
file isdirectory <dirname>	Return whether or not the provided `<dirname>` actually points at a directory or not.

Continued

Table B-10 *(continued)*

Command	Description
file isfile <filename>	Return whether or not the provided <filename> actually points at a file or not.
file owned <filename>	Return whether or not the specified file is owned by the current user.
file readable <filename>	Return whether or not the specified file is readable by the current user.
file writable <filename>	Return whether or not the specified file is writable by the current user.
file extension <filename>	Return the extension of the specified file (i.e. the characters after the final ".”). If there is no "." In the name, return nothing.
file join <name> ...	Combine pathname fragments by putting the directory separator for the current platform between them.
file mkdir <dirname> ...	Create a new directory for each specified <dirname>. If necessary, make directories on the way down to the specified path.
file nativename <filename>	Return pathname in the format specific to the platform the code is running on.
file pathtype <pathname>	Return one of: absolute, relative, or volumerelative with regards to the type of pathname that was supplied.
file readlink <filename>	Dereference a symbolic link and return the location of the object it points at.
file rename [-force] [--] <src> <dest> file rename [-force] [--] <src> [<src2> ...] <destDir>	Move (or rename) a file from one name to another. If the destination is a directory, several files can be moved In the same command.
file rootname <filename>	Return the portion of the filename before the extension (i.e. the characters in the filename before the final ".”). If there is no "." In the filename, return the filename itself.
file size <filename>	Return the size of the specified file (in bytes).
file split <pathname>	Split the pathname at file separator boundaries into a list of pathname components, and return that list.
file stat <filename> <varname>	Return an array containing various pieces of metadata about the specified file. The key names of the elements in this array are: atime, ctime, dev, gid, ino, mode, mtime, nlink, size, type, and uid. These values are obtained by calling the system call stat.

Command	Description
`file lstat <filename> <varname>`	This is the same as "`file stat`" above, except that if `<filename>` is a symbolic link, the information returned describes the symbolic links itself rather than the file it points at.
`file tail <pathname>`	Return the filename of a path (i.e. the characters after the last directory separator if there is one, otherwise the entire path).
`file type <filename>`	Return the type of the file, which is one of: `file`, `directory`, `characterSpecial`, `blockSpecial`, `fifo`, `link`, or `socket`.
`file volume`	Return list of currently mounted volumes.

Other Commands

Some other useful commands (that don't fit well into any of the previous categories) are listed in Table B-11.

Table B-11 Other Miscellaneous Commands

Substitition	Description
`after <ms> [<script>] ...` `after idle <script> ...` `after cancel <id>` `after cancel <script> ...` `after info [<id>]`	The `after` command lets you schedule tasks to run after a given delay. It inserts events into a schedule that is triggered by a later call to either `vwait` or `update` (see below).
	Just running "`after <ms>`" causes the current process to sleep for a given number of milliseconds.
	You can specify a command to run with "`after <ms> <script> ...`". After the given number of milliseconds, a script (obtained by `concat`'ing all of the `<script>` arguments together) is run. Called like this, `after` returns an `id` that refers to the scheduled task.
	If you don't know exactly when you want a task to happen, you can schedule it using "`after idle`". "`after idle <script> ...`" does the same thing as above, except that, instead of scheduling execution after a set number of milliseconds, execution is scheduled for the next time that the process is idle.

Continued

Table B-11 *(continued)*

Substitition	Description
	A scheduled task can be canceled (before it begins) two ways. after cancel <id> cancels the future task identified by <id>. after cancel <script> ... does the same concat'ing of <script> arguments as above and compares the resulting body with any pending tasks; any that contain the same commands are canceled.
	To obtain a list of scheduled commands, use after info (with no <id> argument); it returns a list of existing task-ids. Specifying an <id> returns a list containing the body of commands to run, and the schedule type (timer or idle).
	Errors encountered during scheduled tasks are reported via bgerror (see below).
auto_execok <name>	This Tcl procedure is the equivalent to the Unix command which. It looks through the directories specified in your PATH environment variable, looking for the first instance of an executable file with the specified name.
bgerror "message"	You define this procedure yourself, to handle errors that might occur during a background task (see after described previously). You define a procedure called bgerror that takes one argument: an error message. If an error occurs in a background task, Tcl looks for a bgerror command and calls it with the error message.
catch <script> [<varname>]	Catch runs the commands in the <script> block, suppressing any exceptions thrown by errors. If <varname> is specified, a numeric return code will be placed in the variable it specifies (0 indicates that no errors occurred).
cd [<dir>]	Change the working directory of the process to <dir>.
clock clicks clock seconds clock format <timeinseconds> [-format <str>] [-gmt <gmt>] clock scan <datestr> [-base <timeinseconds>] [-gmt <gmt>]	The clock command performs time-related tasks. "clock clicks" returns a high-resolution version of the current time. "clock seconds" returns the current time in seconds. Both of these are system-dependant. "clock format" lets you convert a time-in-seconds value to a human readable form. The format string uses the following symbols: Weekday: %a (short), %A (long). Month: %b (short), %B (long). Local date and time: %c. Day (01–31):

Substitition	Description
	%d. Hour (0–23): %H. Hour (0–12): %h. Day (001–366): %j. Month (01–12): %m. Minute (00–59): %M. A.M./PM: %p. Seconds(00–59): %S. Week (01–52): %U. Weekday(0–6): %w. Local date: %x. Local time: %X. Year(00–99): %y. Full Year: %Y. If no format string is supplied the output is similar to the example below.
	"clock scan" lets you construct a time-in-seconds value from a string containing the date and time, optionally providing a base time for relative time references. A sample acceptable \<datestr> value is "Sun Jan 25 17:14:00 EST 1970"
error \<msg> [\<info>] [\<code>]	Create an error, causing the current procedure and all above it on the stack to return that error. This is akin to throwing an exception in other languages, and can be caught above with the catch command.
	\<info> contains data about the error, in the same format as the special variable $errorInfo. If you catch an error from a function you call, you can save value of $errorInfo after the catch, and eventually pass it in as the \<info> parameter to the error command (to continue the error up.
	\<code> contains the error code for the error you're generating; it's the same as what's normally in the special variable $errorCode.
eval \<arg> ...	After concat'ing all of the \<arg> arguments together, the resulting string is evaluated by a nested Tcl interpreter as if it were a Tcl script. The resulting value is returned.
exec \<arg> ...	Exec launches one or more subprocesses. The first \<arg> is treated as a command to launch, and subsequent \<arg>s are its parameters. If a \| is encountered, the next \<arg> after that will be the another command to create in the pipeline (where stdout from the previous command gets mapped to stdin of this new one), and so on. Other familiar shell syntaxes are honored like this, such as \|&, < filename, > filename, 2> filename, >& filename, >> filename, 2>> filename, and >>& filename.

Continued

Table B-11 *(continued)*

Substitition	Description	
	If you have an open `fileId` (returned from `open`), you can also use `<@fileId` (read input from that file), `>@fileId` (write output to that file), `2>@fileId` (write standard error to that file), and `>&@fileId` (write both standard output and standard error to that file).	
`glob [-nocomplain]` `<pat> ...`	The `glob` command allows you to take a glob pattern and return a list of files that match that pattern. You may also specify multiple patterns; the results are all combined into one large result set. If `-nocomplain` is specified, `glob` will not complain if there are no matches.	
	Glob patterns may contain these wildcards: "`?`" matches a single character. "`*`" matches zero or more characters. `[chars]` matches any single character one of the specified chars (ranges are allowed such as `a-z`). It may also contain `{abc,foo,bar}` which matches `abc`, `foo`, or `bar`.	
	Files beginning with "`.`" will only match if the glob pattern specifically matches it.	
	`~` completion (`~username` -> home directory for that user) is allowed within glob patterns.	
`global <varname> ...`	When used within the definition of a Tcl procedure, the `global` command specifies that references to a variable named `<varname>` should be resolved in the global scope, rather than creating a new local variable.	
`incr <varname>` `[<increment>]`	Increment (or decrement, in the case of a negative value of `<increment>`) the variable named `<varname>` by `<increment>`. The default value for `<increment>` is 1.	
`pid [<fileId>]`	If no `<fileId>` is passed to `pid`, it returns the process-id of the current process.	
	If you create a process pipeline with the `open` command (by passing in a filename with a "`	`" in it somewhere), you can pass the `fileId` (returned by `open`) to the `pid` command. This will obtain a list of the process-ids for the processes created for the pipeline.
	Passing a non-pipeline `fileId` to `pid` will return an empty list.	
`pwd`	Return the current working directory of the process.	

Substitition	Description
rename <oldprocname> <newprocname>	Rename an existing procedure. If <newprocname> is an empty string, then the procedure is deleted.
source <filename>	Read commands from the specified file and interpret them as Tcl code, returning the return value of the last command executed within that file. If the file contains a return command, sourcing of that file will cease, and source will return that value. Note that commands within the file *can* set variables that are visible to commands after the source command.
time <script> [<count>]	Execute the commands in <script>, timing how long it takes to complete. If <count> is specified, repeat the test that many times. After all iterations are complete, time reports how long in microseconds it took for each iteration.
trace variable <varname> <ops> <script> trace vdelete <varname> <ops> <script> trace vinfo <varname>	trace lets you tell Tcl to perform commands when the variable <varname> is accessed. You use "trace variable" to register the commands in <script> to be performed when one of the operations in <ops> occurs to the variable <varname>. <ops> is a string that can contain one or more of:: r (the variable has been read), w (the variable has been written), or u (the variable has been unset, whether via unset or returning from a procedure). The command in <script> has three arguments appended to it: name1, name2, and op. If the variable being traced is an array element, then name1 is the name of the array, and name2 is the name of the element within that array. If the variable being traced is not an array element, name1 is the name of the variable, and name2 is empty. op is the operation that triggered the call to the script. "trace vinfo" returns a list of current traces on that variable. Each trace in this list is another two-item list, the first item being the ops value, and the next being the script. "trace vdelete" lets you cancel a trace. Specify the same arguments that you used when setting up the trace, and the trace will be deleted.

Continued

Table B-11 (continued)

Substitition	Description
update [idletasks]	The update command causes Tcl to check for any scheduled tasks that are supposed to start. If you schedule a task with the after command, it won't be executed unless you occasionally call update from your script.
	You can indicate that you want idle tasks (scheduled with "after idle") to be run as well, with "update idletasks."
uplevel [<level>] [<script>] ...	uplevel causes commands to be run in a different context: in the scope of one of the parent procedures on the stack. You specify which parent with the <level> argument.
	<level> can either be an integer (representing how many levels up to go), or # followed by an integer (representing an absolute depth in the tree; #0 represents the top-most level).
	The code to be run is a script obtained by concat'ing all of the <script> arguments together.
upvar [<level>] {<othervar> <myvar>} ...	upvar links variables from different scopes to be within the current scope as well. The <level> argument is the same as in the uplevel command above.
	What looks like a new variable called myvar is "created" in the current scope, although it really points to the variable othervar in the stack frame specified by <level>.
vwait <varname>	Put the current process into an event loop, waiting for the variable <varname> to be modified by an event handler.

Finally, one last command is worth mentioning. The info command and its subcommands let you obtain information about the Tcl interpreter itself, such as what commands are available, what variables exist, etc.

Table B-12 describes some of the info subcommands.

Table B-12 Some info Subcommands

Command	Description
info args <procname>	Return the names of the arguments to the procedure <procname> as a list.
info body	Return the body of the procedure <procname>.

Command	Description
info cmdcount	Return the total number of commands that have been run by this interpreter.
info commands [<pattern>]	Return a list of all commands available within this Tcl interpreter (including Tcl procedures). If <pattern> is specified, only commands that match the pattern are displayed.
info default <procname> <arg> <varname>	Return the default values for arguments to a Tcl procedure. If there is a default value for the argument <arg> in the procedure <procname>, a copy of it is placed in <varname> and 1 is returned. If no default exists, 0 is returned and <varname> is left untouched.
info exists <varname>	Return whether or not a variable exists (and is visible from the current procedure).
info globals [<pattern>]	Return a list of all global variables within this Tcl interpreter. If <pattern> is specified, only globals that match the pattern are displayed.
info level [<level>]	The command "info level" (with no specified <level> argument) returns what nesting level the current procedure is at in the stack (with 0 being a command called from the top). If you specify a level number, "info level <level>" returns a list containing the procedure name (and that procedures argument names) for the procedure at the specified level in the stack.
info library	Return the directory where Tcl library scripts are stored (also contained in the special variable $tcl_library). On a TiVo this returns /tvlib/tcl.
info locals [<pattern>]	Return a list of all local variables within this scope. If <pattern> is specified, only variables that match the pattern are displayed.
info nameofexecutable	Return the full pathname of the executable that is interpreting this Tcl code. On a TiVo this will be /tvbin/tivosh.
info patchlevel	Return the current patch level of the Tcl interpreter (also contained in the special variable $tcl_patchLevel).
info procs [<pattern>]	Return a list of all Tcl procedures available within this scope (including Tcl procedures). If <pattern> is specified, only procedures that match the pattern are displayed.
info tclversion	Return the version of the Tcl interpreter (also contained in the special variable $tcl_version).
info vars [<pattern>]	Return a list of all currently visible variables within this scope (including globals not obscured by locals). If <pattern> is specified, only variables that match the pattern are displayed.

Quick Linux Primer

S ince a TiVo device runs Linux, it makes sense to have a brief intro to Linux for those unfamiliar with any Unix variants. It's still a good idea to go out and buy an introductory book on Linux if you're interested; this is meant only to get you through the material in this book.

You'll be using Linux in at least two different places; on a PC booted from the accompanying CD to upgrade your TiVo, and on your TiVo itself when you telnet into it from another machine. Mostly I'll be talking in terms of using Linux on your TiVo, but the advice should apply to both. This appendix assumes that you've completed Chapters 4 and 5, and now have the ability to telnet into your TiVo.

My goal here isn't to write a Linux book, but rather to give you a quick intro, so the pace will be pretty quick at times. I jump around a lot, mainly because I want to cover everything I think you'll need to know and want to get it done in a short amount of space.

Getting Your Feet Wet

Let's start by telnetting into your TiVo. Once in, you should see a command prompt. This prompt is printed out by a program known as a *shell* (in our case, bash). A shell prints out a prompt, reads commands, executes those commands, and handles the output of those commands, usually displaying them back to you. As you'll see below the prompt is customizable; initially it might be either "# ", "bash-2.02# ", or "=[tivo:root]-# ".

Let's start by moving into the /var/tmp directory to experiment a bit. To change which directory you're in, you use the cd command. Let's cd into /var/tmp (a temporary directory), make a directory of our own called mydirectory, then cd into that:

```
=[tivo:root]-# cd /var/tmp
=[tivo:root]-# mkdir mydirectory
=[tivo:root]-# cd mydirectory
=[tivo:root]-#
```

We can determine which directory we're in via the pwd command (print working directory):

```
=[tivo:root]-# pwd
/var/tmp/mydirectory
=[tivo:root]-#
```

Let's create a new text file in this directory. To do this, we'll use a simple command called cat, and a feature of the command shell called output redirection. The cat command is painfully simple; it reads in data (from either standard input, or from a file, as in "cat foo.txt") and then outputs that same data to standard output. So, we'll run cat and redirect the output into a file called myfile.txt using the file redirection operator ">". Type Ctrl-D (the end-of-file character) as the first character on a new line to end the input to cat:

```
=[tivo:root]-# cat > myfile.txt
This is the first line of our new text file.
This is the second.
Last line - I'll type ctrl-d on the next line.
« Ctrl-D »
=[tivo:root]-#
```

We can verify the contents of the new file we just created by viewing it with cat:

```
=[tivo:root]-# cat myfile.txt
This is the first line of our new text file.
This is the second.
Last line - I'll type ctrl-d on the next line.
=[tivo:root]-#
```

(We also could have typed "cat < myfile.txt", which would tell cat to read from standard input, and standard input would be read from the file myfile.txt instead of from the keyboard)

To view the contents of a directory, we use the ls command. Let's create a subdirectory called "sub" just to make for a more interesting directory listing, then use ls with the -l and -a options for a long description of the current directory, showing all files:

```
=[tivo:root]-# mkdir sub
=[tivo:root]-# ls -la
total 4
drwxr-xr-x    3 0         0          1024 Mar 16 11:09 .
drwxr-xr-x    3 0         0          1024 Mar 16 11:09 ..
-rw-r--r--    1 0         0           115 Mar 16 11:09 myfile.txt
drwxr-xr-x    2 0         0          1024 Mar 16 11:09 sub
=[tivo:root]-#
```

A quick description of this output: Lines beginning with a "d" represent a directory, while lines beginning with a "-" represent a file. The first line ("total 4") indicates how many entries are in this directory. The next two lines (".'' and ".."') represent the directory itself ("."), and its parent directory (".."). The next line represents the file myfile.txt, which is 115 bytes in length. The last line represents a subdirectory named sub. Without the -a argument, ls would hide all files and/or directories that begin with a dot (.), including the current directory entry and the parent directory entry. Without the -l argument, only filenames are listed:

```
=[tivo:root]-# ls
myfile.txt  sub
=[tivo:root]-#
```

(It's also worth mentioning that some Unix commands let you combine these arguments as we did here. "ls -la" is the same as "ls -l -a", which is also the same as "ls -al".)

We can also *pipe* the output of one command into another command, using the pipe operator (|). For our example we'll use a command called cut. cut reads in lines of input, and outputs only specified columns of characters from each line. So if we for some reason wanted the 2nd through 14th character of each line of myfile.txt, we could run:

```
=[tivo:root]-# cat myfile.txt | cut -c2-14
his is the fi
his is the se
ast line - I'
=[tivo:root]-#
```

This particular example could also have been done with

```
cut -c3-7 < myfile.txt
```

so maybe a better example would be

```
=[tivo:root]-# date | cut -c5-7
Mar
=[tivo:root]-#
```

since running the date command generates new output that could only have come from a process.

You can use wildcards to specify multiple files whose filename matches a pattern. For instance:

```
=[tivo:root]-# ls
abc       foo       foo2      foo3      lalafoolala  xyz
=[tivo:root]-# ls foo*
foo   foo2  foo3
=[tivo:root]-# ls *foo*
foo       foo2      foo3      lalafoolala
=[tivo:root]-#
```

Moving right along. Ok, multiple commands can be listed in a text file (called a script) to be run one after the other. If you had a file called "doit" in the current directory whose contents were:

```
echo "Hello, the date is:"
date
```

then you could execute that script by using the "source" command, which tells our shell to read commands from a file and execute them:

```
=[tivo:root]-# cat doit
echo "Hello, the date is:"
date
=[tivo:root]-# source doit
Hello, the date is:
Mon Mar 17 01:21:26 localtime 2003
=[tivo:root]-#
```

(The echo command simply outputs its arguments, and in this case it had one argument — the string enclosed in double quotes (" ").)

Having to use the source command though is also a pain, so what would be better is if we could tell Linux that this script is essentially another command in the system. We do two things to make this happen. First, we edit our doit script so that the first line reads "#!/bin/sh":

```
#!/bin/sh
echo "Hello, the date is:"
date
```

(It's important that there are no spaces at the beginning; the first character must be "#", and the second must be "!".) This tells Linux that when someone tries to run this file, the program /bin/sh should be used as the shell (and it's implied that the contents of this script are written in a language /bin/sh understands). Actually you could use /bin/bash here, instead of /bin/sh; /bin/sh is actually a pointer (a symbolic link) to /bin/bash anyway.

Files that begin with "#!/tvbin/tivosh" are Tcl scripts, to be interpreted by the TiVo-specific Tcl interpreter called tivosh.

The second thing we need to do to make doit into a new command is change the permissions of the file so it's seen as an executable. It's worth discussing the output of ls -l a bit more now. If we do an ls -l doit right now, we'll probably see:

```
=[tivo:root]-# ls -l doit
-rw-r--r--   1 0          0              5 Mar 17 01:39 doit
=[tivo:root]-#
```

Notice the -rw-r--r-- at the beginning of the line. We know what the first character (-) is for; it says this is a file, not a directory (d). But we haven't talked about the remaining nine characters. Those represent the permissions on a file. A " " represents a denied permission, whereas a letter indicates a granted permission. There are three groups of permissions: owner, group, and other. On the TiVo, however, it doesn't matter much since there is only one user — root. So for Linux on the TiVo, all we really care about are the first three of these nine characters. The first of these is the read permission bit; it's either - or r. The second of these is the write permission bit; it's either - or w. The third of these is the executable permission bit; it's either - or x. That's the one we want to change.

Use the chmod program to make our script doit be marked as an executable:

```
=[tivo:root]-# chmod ugo+x doit
=[tivo:root]-# ls -l doit
-rwxr-xr-x   1 0          0              5 Mar 17 01:39 doit
=[tivo:root]-#
```

The ugo+x argument to chmod means "turn on the executable bit (x) for the 'user', 'group', and 'other' sections." If we'd used ugo+rwx, then the permissions would look like -rwxr-wxrwx. If we then did another chmod with ugo-w, the write bit would be turned off for users/groups/other and we'd get -r-xr-xr-x. You can also specify permissions explicitly by specifying the bits in octal. Doing a chmod 777 <file> sets the permissions to -rwxr-wxrwx. chmod 640 <file> sets the permissions to -rw-r-----, etc.

Anyway, back to our script. If our script has read and execute permission for the owner of the file, (root), then it can be executed:

```
=[tivo:root]-# pwd
/var/tmp/mydirectory
=[tivo:root]-# ls -l doit
-rwxr-xr-x   1 0        0             5 Mar 17 01:39 doit
=[tivo:root]-# /var/tmp/mydirectory/doit
Hello, the date is:
Mon Mar 17 01:24:00 localtime 2003
=[tivo:root]-# ./doit
Hello, the date is:
Mon Mar 17 01:24:05 localtime 2003
=[tivo:root]-# doit
bash: doit: command not found
=[tivo:root]-#
```

You'll notice that we're able to run it by invoking it with a full pathname, or by specifying it off of a relative pathname (./doit means the file called doit in the current directory), but for some reason we weren't able to just type doit. This is because of something called our PATH environment variable. Basically, when you type a command, the shell looks for a file with that name in all of the directories contained in the PATH variable. Since /var/tmp/mydirectory isn't in our PATH variable, doit isn't found. We can solve this by either moving doit into a directory that *is* in our PATH variable, or by changing the PATH variable to include "." (which always means the current directory). We'll talk more about setting variables in the next section.

There's an important distinction between running a script and including a script via the source command. Running a script causes a new shell process to be created — a new instance of bash. Including commands via source instead causes those commands to be run by the existing shell process. The most noticeable result of this is that a script like:

```
#!/bin/sh
cd /var/hack
```

wouldn't have the desired effect if you ran it, since the cd command would change to the /var/hack directory *within that subshell*. Then the subshell exits, and the parent shell is still in whatever directory it had been in originally. If you executed that script with source however, it would be the existing shell that does the cd, moving you to /var/hack.

Variables

There are a few different shells with different syntaxes in the Unix world, but the one we're dealing with is bash. bash is derived from the original Unix shell called sh, and shares much of the same syntax (in fact, sh scripts should always run ok under bash). Other shells like csh or tcsh have a different syntax for variable declarations, conditionals, redirection, and so on. You shouldn't run into this difference in the TiVo world, because TiVo boxes only ship with bash, and no one has ported tcsh over yet.[1]

[1] Just for the record, I personally consider this both a good thing and a bad thing. It's good in that it has simplified what it takes to explain things to new users (on forums and elsewhere) who don't know much Unix. It's bad in that tcsh is my favorite shell, and I'm used to using it.

To set a variable in `bash`, you type a variable name, an = directly after it with no spaces, and then a value after that (no spaces), surrounded by quotes if needed. It can later be referenced by using a $ before the variable name:

```
=[tivo:root]-# NAME="Jeff Keegan"
=[tivo:root]-# echo "My name is $NAME"
My name is Jeff Keegan
=[tivo:root]-#
```

You can get a list of all existing variables that have been set, and their values, by typing "`set`".

If you wish a variable to be passed down to other subshells, however, you need to use the export command. For the above example, you could either say:

```
=[tivo:root]-# export NAME
```

or you could replace the original variable declaration line with:

```
=[tivo:root]-# export NAME="Jeff Keegan"
```

Another way to refer to a variable is with the syntax $ { *variablename* }. Suppose that you wanted to output the string TUESDAYKEEGANBACKUP, except KEEGAN might be other names as well. If you had a variable called NAME that was set to KEEGAN, it would be incorrect for you to say:

```
echo "TUESDAY$NAMEBACKUP"
```

because instead of looking for a variable named NAME, it would look for a variable named NAMEBACKUP (which isn't what we want). Instead, you can say:

```
echo "TUESDAY${NAME}BACKUP"
```

to get the output you want.

There are also special variables that mean something to the shell. For the purposes of this appendix, there are only four variables I'm going to bother describing.

HOME is the location of a user's home directory. When you type `cd` with no arguments, this is the directory you're brought to. It's also the directory you start out in when you log in. If you've installed the distribution on the accompanying CD-ROM in Chapter 4, then your HOME directory will have been set to /var/hack/root. You don't really need to know this, but you might see it in Unix scripts somewhere and wonder what it is, so I'm mentioning it here.

LD_LIBRARY_PATH contains a colon-separated list of directories in which Linux should look for shared libraries. The distribution on the accompanying CD-ROM sets this to /var/hack/lib, which is necessary for some of the executables in the distribution to run (such as `vi`).

PATH contains a colon-separated list of directories in which bash should look for executables that you type on the command line. When you type `date` for instance, bash goes through the directories in PATH, searching each one for an executable file named date (which it finds in /bin/date, since /bin is in the PATH variable). If one of the entries in PATH is ".", then the current directory will also be checked for executables; otherwise, you'll have to explicitly specify a full pathname (or one relative to the current directory with "./"), as described above.

PS1 is the prompt for bash's command line. In the examples you've seen here, PS1 had a value of "=[tivo:root]-# ". You can set it to anything you want:

```
=[tivo:root]-# export PS1="# "
# echo "Hello there this is a test"
Hello there this is a test
# export PS1=""
echo "Hello there this is a test"
Hello there this is a test
export PS1="-->"
-->echo "Hello there this is a test"
Hello there this is a test
-->export PS1="[\t]=> "
[17:01:57]=> echo "Hello there this is a test"
Hello there this is a test
[17:02:05]=> export PS1="\w # "
/var/tmp/mydirectory # echo "Hello there this is a test"
Hello there this is a test
/var/tmp/mydirectory # cd ..
/var/tmp # echo "Hello there this is a test"
Hello there this is a test
/var/tmp # export PS1="=[tivo:root]-# "
=[tivo:root]-#
```

(There are various special characters that can be used in a prompt, such as \t for the current time, and \w for the current directory. More can be found in the man-page for bash.)

This next thing isn't really related to variables but I'll mention it here anyway since this is a convenient place to do so. The ` character (on the same key as ~) allows you to have a section of text evaluated as a command, and have the output of that command substituted in its place. For example, if you said

```
mystring="The date today is `date`..."
echo "$mystring"
```

you'd get

```
The date today is Sun Mar 16 05:45:05 localtime 2003...
```

(The substitution happens at the time of the mystring="..." command)

Again, that isn't really related to variables, since in this example you could easily have said

```
echo "The date today is `date`..."
```

and gotten the same results.

Flow Control

There are various flow control mechanisms that let you control what code gets run, how often to run that code, etc. These are used more in scripts that you write than on the command line, though they can be issued there as well. Although you don't *need* to know these to get by, I'll at

least briefly mention them here so you will be familiar with them if you see them. I'm certainly glossing over all of the variations and condition types, so be sure to see the documentation (man-page) for bash for more info.

I'll describe three of the many flow control mechanisms available in bash: a simple conditional statement ("if"), and two styles of looping ("while" and "for").

if

The if command lets you specify that a collection of instructions should be run only if a specified condition is true. There are many types of expressions, all interpreted by either a command called "test" or a shell built-in command called "[". Let's start with a few examples; the following code will print a warning message only if the variable "PROBLEMSEXIST" is equal to "true":

```
if test "$PROBLEMSEXIST" == "true"
then
  echo "I've got a baaad feeling about this..."
fi
```

That could also be written as:

```
if [ "$PROBLEMSEXIST" == "true" ]
then
  echo "I've got a baaad feeling about this..."
fi
```

(Note the space after the "[" and before the "]". They are important.)

You can also use "else" and "elif" (*else-if*) to specify code to run if the condition fails:

```
if test "$USER" == "root"
then
  echo "Warning: Remember, running as administrator..."
elif test "$USER" == "jkeegan"
then
  echo "Welcome, Jeff"
elif test "$USER" == "laurie"
then
  echo 'Hi Laurie! Jeff loves you!'
elif test "$USER" == "emily"
then
  echo "Who's my little Emily? Daddy loves you"
else
  echo "Welcome, $USER"
fi
```

(As a side note, the reason some lines use single quotes (') instead of double quotes (") is because the "!" character is a special character used for command history, so it needed to be quoted. I could also have said "Hi Laurie\! Jeff loves you\!", escaping the "!" character with "\".)

while

The `while` command lets you repeatedly run a collection of instructions while a specified condition is still true. The same type of expressions that are used in the `if` command are used in `while`. Each time around the loop, the expression is evaluated to determine whether to run the instructions within the loop. For the following example, instead of using the `==` string comparison operator we used above, we'll use the `-a` operator, which returns true if the specified file exists:

```
while test "-a /tmp/foobarlock"
do
  echo "Lock file still exists. Waiting another 60 seconds.."
  sleep 60
done
```

A script running that process would sit around until the file `/tmp/foobarlock` was deleted by some other process, and would output that warning message every 60 seconds.

for

The `for` command acts like the `for-each` command that is present in many other languages — it lets you iterate over a set of values, assigning a iterator variable to a new value each time through the loop until the values have been exhausted.

```
for c in red orange yellow green blue indigo violet
do
  echo "The next color in the rainbow is $c"
done
```

The items you iterate through can come from a variable or from filename expansion via wildcards. The following script would check each file in the current directory to make sure that a thumbnail existed for it within a `thumbnails` directory:

```
for pic in *.JPG
do
  if test ! -a thumbnails/$pic
  then
    echo "Picture $pic was missing a thumbnail.. Creating.."
    createthumbnail $pic > thumbnails/$pic
  fi
done
```

(The program test treats the "`!`" character as a negation operator, which is why the if statement executes the code inside it if the thumbnail files does *not* exist.)

Processes

Every running program on a Linux machine is called a process. The shell that you're typing commands to is a process, and the commands that you run with that shell are processes of their

own. Some commands like "cd" and "echo" are actually built-in to bash, and don't get their
own process.

You can see what processes are running with a command called ps:

```
=[tivo:root]-# ps
  PID TTY STAT TIME COMMAND
  231  p0 S    0:01 /bin/bash -login
  257  p0 RW   0:00 ps
=[tivo:root]-#
```

Here we see the bash process we're typing our commands to (process 231), and the ps com-
mand itself (process 257). We can see more processes on the system by typing "ps x" (which
shows processes that don't have a terminal associated with them).

You can run programs in the background using & at the end of the command line, meaning
they will run at the same time as the shell you're using. To illustrate this, we'll use the program
sleep, which just pauses for a given number of seconds. If you were to type "sleep 60" and
hit return, it would take 60 seconds before you'd get your command prompt back again:

```
=[tivo:root]-# sleep 60
=[tivo:root]-#  <-- This wouldn't be displayed for 60 seconds
```

However, if you put a & after the command, your prompt would come back immediately. You
could then verify that sleep was still running by using the ps command:

```
=[tivo:root]-# sleep 60 &
[1] 266
=[tivo:root]-#  <-- This would be displayed immediately
=[tivo:root]-# ps
  PID TTY STAT TIME COMMAND
  231  p0 S    0:02 /bin/bash -login
  266  p0 S    0:00 sleep 60
  267  p0 RW   0:00 ps
=[tivo:root]-#
```

After 60 seconds of waiting, when hitting return on the command prompt you'd see:

```
=[tivo:root]-#
[1]+  Done                    sleep 60
=[tivo:root]-#
```

This indicates that the sleep process is finally done.

Of course, it doesn't make too much sense to run sleep in the background. A better example
of something to run in the background would be some lengthy batch script that didn't require
any user input or output.

If you didn't want to wait around for 60 seconds in the above example, you could have killed
the sleep process with the kill command:

```
=[tivo:root]-# ps
  PID TTY STAT TIME COMMAND
  231  p0 S    0:02 /bin/bash -login
```

```
   266  p0 S     0:00 sleep 60
   267  p0 RW    0:00 ps
=[tivo:root]-# kill 266
=[tivo:root]-#
```

Then, after hitting return again, you'd see:

```
=[tivo:root]-#
[1]+  Terminated              sleep 60
=[tivo:root]-#
```

Programs can trap the signals that are sent with the kill command, so sometimes a process that you are trying to kill might not actually die. The silver bullet that will kill any process is "kill -9 <processid>".

There's another way for a process to go into the background: job control. If you're in the middle of a command, you can type Ctrl-Z to pause the program.

```
=[tivo:root]-# sleep 60
        <-- type ctrl-Z here during sleep
[1]+  Stopped                 sleep 60
=[tivo:root]-# bg
[1]+ sleep 60 &
=[tivo:root]-#
```

Here, you paused the running program (sleep) by typing Ctrl-Z. It was stopped, and it was given a job number (1 in this case, from the "[1]+ Stopped ..." line). The bg program on the next line said to un-pause the most recently referenced job and put it in the background (you also could have used "bg %1" to explicitly specify job #1).

There is also an fg command. If before the 60 seconds were up you typed "fg %1", you would tell job #1 to come into the foreground, and you'd be waiting for the sleep to finish before getting your command prompt back again. There is a jobs command as well, which gives you a list of all the paused or backgrounded jobs. Jobs are actually processes, but they're processes that you've started from the command line and paused or moved to the background with &, Ctrl-Z, fg, and bg.

Lastly, the kill command can take the %<job#> notation as well. So, you could kill an existing job #1 with:

```
kill %1
```

(or "kill -9 %1" if it was being stubborn).

Caution

Obviously, be very careful what processes you kill. A simple typo can be the difference between killing the process you want, and killing an important process running on your machine. Also, any process that accesses MFS (such as tivosh, TivoWeb, various TCS processes, etc) should not be killed with kill; that can cause a reboot. TivoWeb and TCS both have ways in which you can instruct them to quit on their own for this very reason.

Commands

Now that you've got the basics down, here are some more commands and what they do (Table C-1). More information on all of these can be found in their man-pages (on another Linux box). Documentation (man-pages) are available on the web as well — do a Google search for "linux man pages". With many commands, passing in "--help" as an argument will display more information about the available options.

Table C-1 More Linux Commands

Command	Description
cp	Copy files. The syntax is "cp <source> <dest>". The second parameter can be either a filename, or a directory to put a file into.
dd	Used to copy partitions or entire disks from one drive to another, doing any necessary conversions. See dd's man page for more info.
df	Show disk usage for all of the mounted filesystems. df -k displays all sizes in 1024-byte blocks.
diff	Display differences between two files.
du	Show disk usage for a given directory, and all of its subdirectories. du -k displays all sizes in 1024-byte blocks. The -s option displays only the totals for the specified directories, without displaying subtotals for their children.
exit logout	Quit the current shell.
find	Search a given directory and its subdirectories for files matching certain criteria. See find's man-page for more info.
grep	Read in input, and output only the lines in it that match (or don't match) a given regular expression. "grep foo bar.txt" will print all lines from the file bar.txt containing foo, while the command "grep -v foo bar.txt" will display only lines from the file bar.txt that do *not* contain foo.
gzip gunzip	gzip and gunzip are compression/decompression tools. Actually, gunzip doesn't exist in the distribution on the CD-ROM; just gzip. gzip -d does the same as gunzip does.
head	Display the first *n* lines of a file.
history	Display a list of commands typed into the shell.
ifconfig	Configure a network interface. ifconfig -a will show you Ethernet information, what your current IP address is, and so on.

Command	Description	
`insmod`	Install a loadable kernel module. Normally there would be an `lsmod` executable to list all loaded kernel modules, but there isn't on the TiVo. Instead, look at the file `/proc/modules`.	
`joe`	Text editor. Also see `vi` below.	
`ln`	Create links between files. If you say `ln a b`, then it appears as if a new file b has been created that is identical to a. If you say `ln -s a b`, then a *symbolic* link called b is created that points at a. Symbolic links show up in long directory listings with a "l" (lowercase L) in the first character, so if you ran: `ln -s /var/hack /hack` then typed "`ls -l /hack`", the link would show up as: `lrwxrwxrwx 1 0 0 9 Jul 14 16:43 /hack ->` `/var/hack`	
`mknod`	Make block or character device files, as you'd have in the `/dev` directory. (In Linux, all devices have a "file" that corresponds to them).	
`more` `less`	`more` (or `less`, its enhanced equivalent) is a program that lets you view a file (like `cat`), but it pauses after every page, waiting for you to press Space to go on to the next page. Typing b in less brings you back a page, typing G brings you to the end, and typing 1G brings you back to the beginning.	
`mount`	Mount a filesystem onto a location in the directory tree (called a mount point). `mount /dev/hda9 /var` mounts the 9th partition of the primary master drive onto `/var`.	
`mv`	Move or rename a file or directory. The syntax is "`mv <source> <dest>`". The second parameter can be either a filename, or a directory to put a file into.	
`od`	Octal Dump. Display binary files formatted such that every byte can be seen. Outputs in octal, hex, decimal, ASCII, etc (-o, -x, -d, -c).	
`ping`	Tool to determine if another machine is up, and reachable.	
`reboot`	Reboot the machine.	
`rm`	Remove (delete) files. `-r` allows recursive deletion of directories. Obviously, be careful with this.	
`rmdir`	Remove (delete) an empty directory.	
`route`	Display and manipulate the IP routing table.	
`sed`	Stream editor to read input, replace parts of it using regular expressions, and output the results. `echo "abcdefg"	sed -e 's/c.*/FOO/'` outputs abFOO

Continued

Table C-1 (continued)

Command	Description
`sort`	Sort the lines of a text file alphabetically or numerically. `-n` specifies numeric sorting. `-r` specifies reverse order.
`tail`	Display the last *n* lines of a file.
`tar`	`tar` archiving tool to create/extract `tar` files.
`tee`	`tee` reads from standard input (stdin), writes that to a file, and then outputs it to standard output (stdout). This makes it like a "tee" for the command pipeline, letting you record what the data in a certain part of a pipeline looks like.
`umount`	Opposite of `mount`: `umount` un-mounts a mounted directory. You can specify as an argument either the device name, or the mount point.
`uniq`	Removes duplicate, consecutive lines within a file. Piping something to `sort` then `uniq` generally eliminates any duplicates.
`vi` `vim`	Text editor (pronounced vee-eye). `vi` has been around since the beginnings of Unix. `vim` is the `vi` replacement shipping with Linux distributions today. There are many tutorials on the web; you can try http://heather.cs.ucdavis.edu/~matloff/UnixAndC/Editors/ViIntro.html or just go do a Google search on "vi tutorial" or "vim tutorial".
`vmstat`	Display virtual memory statistics.
`wc`	Print the number of bytes, words, and lines in a file.

Index

Continued

Continued

Wiley Publishing, Inc.
End-User License Agreement

READ THIS. You should carefully read these terms and conditions before opening the software packet(s) included with this book "Book". This is a license agreement "Agreement" between you and Wiley Publishing, Inc. "WPI". By opening the accompanying software packet(s), you acknowledge that you have read and accept the following terms and conditions. If you do not agree and do not want to be bound by such terms and conditions, promptly return the Book and the unopened software packet(s) to the place you obtained them for a full refund.

1. **License Grant.** WPI grants to you (either an individual or entity) a nonexclusive license to use one copy of the enclosed software program(s) (collectively, the "Software") solely for your own personal or business purposes on a single computer (whether a standard computer or a workstation component of a multi-user network). The Software is in use on a computer when it is loaded into temporary memory (RAM) or installed into permanent memory (hard disk, CD-ROM, or other storage device). WPI reserves all rights not expressly granted herein.

2. **Ownership.** WPI is the owner of all right, title, and interest, including copyright, in and to the compilation of the Software recorded on the disk(s) or CD-ROM "Software Media". Copyright to the individual programs recorded on the Software Media is owned by the author or other authorized copyright owner of each program. Ownership of the Software and all proprietary rights relating thereto remain with WPI and its licensers.

3. **Restrictions on Use and Transfer.**

 (a) You may only (i) make one copy of the Software for backup or archival purposes, or (ii) transfer the Software to a single hard disk, provided that you keep the original for backup or archival purposes. You may not (i) rent or lease the Software, (ii) copy or reproduce the Software through a LAN or other network system or through any computer subscriber system or bulletin- board system, or (iii) modify, adapt, or create derivative works based on the Software.

 (b) You may not reverse engineer, decompile, or disassemble the Software. You may transfer the Software and user documentation on a permanent basis, provided that the transferee agrees to accept the terms and conditions of this Agreement and you retain no copies. If the Software is an update or has been updated, any transfer must include the most recent update and all prior versions.

4. **Restrictions on Use of Individual Programs.** You must follow the individual requirements and restrictions detailed for each individual program in the About the CD-ROM appendix of this Book. These limitations are also contained in the individual license agreements recorded on the Software Media. These limitations may include a requirement that after using the program for a specified period of time, the user must pay a registration fee or discontinue use. By opening the Software packet(s), you will be agreeing to abide by the licenses and restrictions for these individual programs that are detailed in the About the CD-ROM appendix and on the Software Media. None of the material on this Software Media or listed in this Book may ever be redistributed, in original or modified form, for commercial purposes.

5. **Limited Warranty.**

 (a) WPI warrants that the Software and Software Media are free from defects in materials and workmanship under normal use for a period of sixty (60) days from the date of purchase of this Book. If WPI receives notification within the warranty period of defects in materials or workmanship, WPI will replace the defective Software Media.